Christopher Grey's

ADVANCED LIGHTING TECHNIQUES

*Tricks of the Trade
for Digital
Photographers*

AMHERST MEDIA, INC. ■ BUFFALO, NY

Check out Amherst Media's blogs at: http://portrait-photographer.blogspot.com/
http://weddingphotographer-amherstmedia.blogspot.com/

Copyright © 2010 by Christopher Grey

All photographs by the author unless otherwise noted.

All rights reserved.

Published by:
Amherst Media, Inc.
P.O. Box 586
Buffalo, N.Y. 14226
Fax: 716-874-4508
www.AmherstMedia.com

Publisher: Craig Alesse
Senior Editor/Production Manager: Michelle Perkins
Assistant Editor: Barbara A. Lynch-Johnt
Editorial assistance provided by Sally Jarzab, Carey Maines, and John S. Loder.

ISBN-13: 978-1-58428-998-2
Library of Congress Control Number: 2009939766

Printed in Korea.
10 9 8 7 6 5 4 3 2 1

No part of this publication may be reproduced, stored, or transmitted in any form or by any means, electronic, mechanical, photocopied, recorded or otherwise, without prior written consent from the publisher.

Notice of Disclaimer: The information contained in this book is based on the author's experience and opinions. The author and publisher will not be held liable for the use or misuse of the information in this book.

CONTENTS

About the Author .4

Foreword .5

Introduction .6

1. An Extra Layer of Diffusion8

2. Studio Diffusion with Accessory Flash12

3. Fashion Light for High-School Seniors18

4. Making the Most of a Location Shoot22

5. Killer Accents with Side Lights27

6. Subtractive Lighting31

7. Underfill and Underlight33

8. Lighting for Fill39

9. Silver Reflectors in the Studio44

10. Cinefoil .48

11. Motion and Emotion54

12. Dragging the Shutter59

13. The Beauty Bowl66

14. Photography as Catharsis69

15. Gauze and Effect73

16. That Beautiful, Soft, Overexposed,
 Grainy, High-Key, One-Light Retro Look . .78

17. The Double Main Light83

18. The Two-Softbox Main Light86

19. The Wall of Light90

20. Working with the Sun98

21. Underexposure as a Creative Tool104

22. Unsung Heroes of the Studio108

23. Cheap Tricks112

24. Photoshop Contrast and Softness116

25. Adding Specific and Dramatic Highlights . .120

Afterword .123

Index .124

ABOUT THE AUTHOR

Christopher Grey is a talented and internationally recognized photographer and author. In this, his ninth book, Chris reaches more deeply than ever before into his voluminous bag of tricks to demonstrate more of the knowledge that has set his studio apart from those of his competition. In a highly competitive business like photography, professionals are often reluctant to tell others what has made them successful. That's never been true of Chris. His willingness to fully demonstrate his techniques has produced bestsellers of previous lighting books.

Chris lives in Minneapolis, Minnesota, with his wife Susan, dog Romeo, and cat Gracie. Their daughter, Liz, smartened up and is now living in Hawaii.

KUDOS

As always, a project like this would not be possible without the help of many talented people, and I'd like to take this opportunity to thank each of them for their participation and support. My sincere thanks to my models, Denise Armstead, Sarah Becker, Cami Belland, Erin Bourne, Victoria Bugayev, Jessica Chryst, Laurel Danielson, Tammy Goldsworthy, Christine Grether, Liz Grey, Stephanie Gustafson, Desiree Gutierrez, Amanda Harris, Davante Lee, Liz Lucaks, Devinair Mathis, Molly Nicholson, Jeremy Norred, Sarah Parker, Kelley Peterson, Patti Peterson, Madge Plasto, Kristi Riley, Jennifer Rocha, Jesse Rusk, Sahata, Margot Scheltens, Margaret Sinarath, Aleta Steevens, Nora Thomey, Anne Ulku, Alexandra Vang, Pistol Vegas, Robert Ware, Ily Yang, and Linda Yang.

To the talented hair and makeup artists who contributed time and material to this project: you truly are the unsung heroes of the studio. Thanks to Sandra Avelli, Nicole Fae, Susan Grey, Nahla Sonbol, and Derkie Thor.

Thanks to my buddy Joey Tichenor for another great author photo.

To Barbara Lynch-Johnt, my editor and the woman whose attention to detail guarantees my appearance of literacy, my thanks as well. If things I wright ever gets the wrong tense, they know she'll correct it.

I hope we can all work together again, and soon.

To Sue and Liz—you two sweet people—and to my folks, who were instrumental in my life's direction: I can't thank you enough.

Photo © Joseph Tichenor.

FOREWORD

I was taken aback and honored when my friend Chris Grey asked me to write the foreword for this book. Let me explain: I've been seriously involved with photography and lighting for over thirty years. I usually work with assistants who are new to the field. My helpers are beginning the steep learning curve of professional-level photography, and they are often intimidated by what I have learned about lighting. My response to all of them is always the same: "It doesn't matter where you are in your development as a photographer. There is always someone out there who knows a little more than you do and someone who knows a lot more!" Chris Grey is one of "those" photographers that I turn to for knowledge, inspiration, and the occasional creative "kick in the behind." He and I write monthly columns for www.prophoto resource.com. The beauty of writing for such a forum is that I get to learn each month too—and Chris' articles are "must-reads" for me.

The opportunity to review this volume came at a perfect time. I'm human, and I go through periods of creative stagnation like every other photographer. I was fighting through one such lull when I received the preview for Chris' new book. There, laid out in concise, short chapters, were twenty-five nuggets geared to get me back on track! Each chapter focuses on a different aspect of Chris' creative eye, but I think that the main lesson that I took from this book was much more global—and, I think, more important. There was a very subtle undertone that weaved throughout the diverse styles and techniques described here that constantly reminded me that photography is as much (or more) mental as it technical. Don't get me wrong—Chris is a master technician and knows what he calls the "dry" science side of photography inside and out. However, if you buy this book strictly for the techniques shown, you will be missing the point. Yes, he

will show you some very different approaches to creating unusual and often evocative images, but the underlying challenge is for you to take and use these ideas as springboards to get you out of a mechanistic and routine way of working.

I am a self-proclaimed lighting geek. I love the "dry" physics behind light and lighting. There was plenty of technical meat in this book for me to sink my teeth into. Chris' understanding of light has reached the point where the extremely subtle nuances become intuitive. He presents a couple of exercises where the outcome is changed dramatically by modifying the distance between the light source and the model. Chris truly is master at understanding that the distance between the light and the model plays a major role in the final image. This is an idea that may take some time to grasp, so review those chapters carefully, take the book into your studio, and play with the ideas until you understand the concept.

The format for this type of book works nicely. The chapters are not necessarily meant to build upon each other. Rather, each presents a different idea in isolation, allowing the reader to spend as much time as needed to learn, digest, create, and finally re-create the ideas in his or her personal style. There are many golden tidbits hidden away, so read carefully! One of my favorite morsels was the way Chris tracks the setting sun on location. I guarantee that I'll use that one. I also appreciated the chapter called "Cheap Tricks." I'll be modifying one of my own $2.00 reflectors in an attempt to create a version of the reverse cookie.

I could go on, but you get the point. Besides, I suddenly have a lot of homework. Thank you, Chris, for continuing to teach this old dog new tricks. Now, where is my twenty-year-old roll of Cinefoil?

—Stephen Dantzig, Psy. D.

INTRODUCTION

Photography is great fun, and it's a terrific way to make a living, but it's controlled chaos whenever anyone is in front of your camera (which is the point of the cover shots I've produced for my lighting books). You, of course, have the most important decisions to make: the lighting angle, body position, and lens focal length are just a few of them. How should that light be aimed? What modifier will work best? How many more lights do you need, and where should you place them?

I think you should approach any shoot as a fluid moment, and by that I mean that your pre-visualizations of what you wish to accomplish should never be cast in stone. A willingness, a desire, to adapt and change will reward you with better images. Ultimately, the only important part of the set is the part that will be cropped into a final image.

By comparison, your subject's greatest decision will be whether or not to get "in the moment" and give you the best performance possible, something that most people have a fair amount of trouble with, especially at the start of a session. Unfortunately, coaxing your subject to perform for the camera is part of your job, so you have one more important decision to make: how, exactly, will you get that performance?

In my opinion, getting a fantastic performance from a client is as much a matter of practice as it is of confidence. When your lighting skills are equal to your vision, you're free to charm your client with whatever it takes to get "the" shot, knowing full well that it's your technical skill and directive banter that will make it happen.

In my book *Christopher Grey's Studio Lighting Techniques for Photography,* I wrote about how to massage a shot to get a series of great photos that are difficult for the client to decide upon. When you can do it, well, that's great! You want to present your client with a set of proofs that make a decision difficult. Your client will be convinced that you're so good it's tough to decide, while you get the benefit of the great word-of-mouth advertising your client will give you. Like

the old TV commercial's tagline, "She'll tell two friends. And they'll tell two friends. And so on, and so on."

I wrote extensively about how light works, and why it works the way it does, in *Christopher Grey's Studio Lighting Techniques for Photography*, all tricks a serious photographer needs to know. This book digs substantially deeper into the tricks of the trade and how to use them. After all, they set one photographer apart from another. A creative professional, armed to the teeth with practical, applicable knowledge will beat the pants off Uncle Roy (with apologies to any professional photographer uncle named Roy) and his consumer-grade DSLR any day of the week. I've also outlined a couple of my favorite Photoshop tricks, de-

signed to give your images a look unobtainable by the camera alone. Use them often or use them sparingly, but they may be a couple of stepping stones to a personal style that no competitor can touch.

1. AN EXTRA LAYER OF DIFFUSION

Here's a nifty little trick that will actually increase the softness of light coming from any softbox—without costing you an arm and a leg.

We know, of course, that softboxes produce an almost perfect light, light that's not specular, with minimal falloff at an ideal distance. For me, the ideal distance from the subject is equal to the sum of the height and width of a given softbox, as measured in feet. Thus, a 4x6-foot softbox would throw its best light at a distance of 10 feet from the subject. Beyond that, the highlights would become progressively more specular and the shadows progressively sharper and better defined.

I wanted to see if I could make a small softbox act like a much larger source by moving it farther away from the subject and, in the process, produce light at least as soft as that from a larger box.

My lighting was about as simple as it could be (see diagram 1A). I mounted a 2x3-foot softbox on a strobe and set it about 10 feet from the subject, twice what its 5-foot ideal distance is. To fill the shadows a bit, I set a white foamcore bookend 3 feet from the subject on the opposite side. As you can see in image 1.1, the shadows are quite well defined and, even though she did a great job applying her makeup, my model's skin is starting to acquire specular hot spots.

Photoflex makes an inexpensive, collapsible circular diffuser that unfolds to a diameter of about 50 inches. It's typically used to diffuse hard sunlight falling on a subject outdoors and is held by an assistant who will move it wherever it's needed. That's not necessary in a studio situation, where everything is tightly controlled, so accessories like this are not typically used in that manner. I mounted mine on an Avenger accessory arm and placed it far enough in front of the softbox so that it was completely lit by the softbox. I made sure that no light spilling around the diffuser would fall on the model or the background.

The difference this extra layer of diffusion adds to the softness of the light is instantly recognizable. The shadows have been opened up and significantly softened. Look at the shadow from her hair at camera left. What had been very hard shadows are now much softer. The catchlights in her eyes are larger, too, because the diffuser has been turned into a larger softbox that is positioned closer to the model. Note that the diffuser absorbed

Above—Diagram 1A.

THE DIFFERENCE THIS EXTRA LAYER OF DIFFUSION ADDS TO THE SOFTNESS OF THE LIGHT IS INSTANTLY RECOGNIZABLE.

Top left—Image 1.1.
Bottom left—Image 1.2.
Right—Image 1.3.

some of the light's strength and I had to power up the strobe a bit to use the same f-stop. See image 1.2.

Of course, it's not necessary to buy something like the Photoflex diffuser, although it is an elegant solution. You can easily do the same thing, even create a larger source, with something as simple as a white bedsheet. I clamped mine to a boom arm and swung it into place, but it could be hung on almost anything. Wrinkles are not a problem, but you should be certain that the cloth does not fold over itself in any area that's lit because the amount of light that can pass through the cloth will be cut, possibly shadowing the subject or background.

In order to get the most coverage from the softbox to the sheet, I moved the softbox back yet another 5 feet, so it was 15 feet from the model and 10 feet from the sheet. As you can imagine, this required another increase in strobe power.

The final image (image 1.3), with the huge catchlights in the subject's eyes and extremely soft overall light, is quite lovely.

Left—Image 1.4.
Right—Image 1.5.
Above—Diagram 1B.

When you do something like this, be sure to custom white balance each time you add a layer of diffusion, no matter what it may be. Bluing agents in the bedsheet, which make it appear whiter than it would ordinarily be, will affect the color of your image if you don't neutralize them beforehand.

This somewhat unorthodox use for a bedsheet works extremely well with a larger softbox, too.

To create the next set of images, I used a 4x6-foot softbox set about 12 feet from my model. To illustrate the change that will occur, I asked my model to sit about 4 feet from the background. I would not normally do this because it's difficult to control any shadows from the subject that fall on the background unless the light is placed some distance off center (to either side), which could create unflattering shadows on the subject's face. Even though the softbox is a large light source, you can plainly see the model's shadow on the right side of the image. See image 1.4.

I moved the sheet between the softbox and the model, about 6 feet away from the source, and matched the angle of the box so that the sheet would be evenly lit. It was a very simple setup. See diagram 1B.

The extra layer of diffusion almost totally eliminated the shadow in image 1.5, evening it out to the point where it's no longer a distraction. This is supersoft light that wraps around the subject but still allows enough modeling to give her face dimension.

BE SURE TO CUSTOM WHITE BALANCE EACH TIME YOU ADD A LAYER OF DIFFUSION, NO MATTER WHAT IT MAY BE.

Should you desire a little more contouring on the shadow side of the face and figure, simply insert a black card or bookend next to the model (but outside of the frame) to absorb some of the light. In a way, this "subtractive" light reflects black onto the model, darkening the skin and shadow. See image 1.6.

This technique will work with any size softbox, of course, but you will have to move smaller softboxes farther away from the bedsheet in order to light the entire cloth.

Right—Image 1.6.

IN A WAY, THIS "SUBTRACTIVE" LIGHT REFLECTS BLACK ONTO THE MODEL, DARKENING THE SKIN AND SHADOW.

2. STUDIO DIFFUSION WITH ACCESSORY FLASH

I've never been a fan of some of the minimalist lighting web sites that preach five-star results on a one-star budget (think: Look! I made a beauty bowl from a cake pan!), but I have often been asked if the effects of large studio strobes can be duplicated with small accessory flash units. Simply, the answer is no. Accessory flash units are just that—accessories— and they have a limited potential, mostly due to their small power output. That said, and with a little planning, accessory flash units can be used to create stunning lighting effects that, in limited ways, will mimic conventional softbox effects.

Whether you own a softbox or not, here's an easy and inexpensive way to turn common gear into a large, soft source that works just as well with studio strobes as it does with accessory flash units. It will even work with hot lights, although a certain amount of caution is necessary.

For comparison's sake, here's a shot of my model made with an unmodified strobe. It's very contrasty, showing deep, well-defined shadows. See image 2.1.

I discussed the effects of softboxes, specularity, and depth of light in detail in *Christopher Grey's Studio Lighting Techniques for Photography*. If you've read it, you'll remember that the degree of softness a softbox will give you depends on its size and distance from the subject. The farther a softbox is from the subject, the harder its shadows will be. When a source is placed closer to the subject, the shadows open up and the light appears softer. This same principle holds as true for this trick as it does for a softbox.

The most important part of any softbox is its diffusion panel, the white nylon front that spreads the light. I'm going to cheat by using a 52-inch Photoflex white translucent LiteDisc as my diffusion panel. A collapsible disc like this is an affordable accessory, and many photographers use one as a bounce card to kick a little reflected light back onto the subject. The disc I purchased is translucent, a type that outdoor photographers will often use as a shield between the subject and the sun to soften the sunlight. Outdoors, this shield necessitates a new meter reading because it absorbs some light (mine sucks up $1\frac{1}{2}$ stops), which will make the background brighter. It will also require an assistant to hold it.

Note that, before you begin, you'll have to figure out how to fire your flash from the camera. Your gear may accommodate a long cord, or you

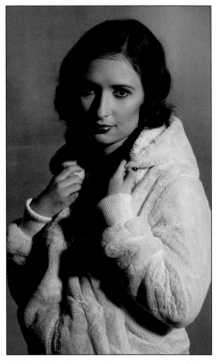

Above—Image 2.1.

may need a radio or infrared signal transmitter and receiver. If you have two (or more) flash units made by the same manufacturer as your camera, you may be able to use a unit on camera to send a signal to the other(s) to fire without an on-camera flash burst. Check your gear's instruction manuals to see if this can be done with your equipment.

Mount the disc to two light stands with simple clamps or use an Avenger accessory arm and place it between the flash and the model.

On a separate stand or tripod, mount a studio strobe or accessory flash unit (a tripod head mounted on a stand is perfect because it can be angled where you need it). You'll need a fair amount of power, especially if you want appreciable depth of field, and you'll need to set your flash to manual mode. If you use flashes with your camera set on auto, you will get minimal power through the fabric because the flash will measure the bounce back and turn itself off prematurely. Also, you may have to move a flash forward or backward to get a proper meter reading, as they are (generally) adjustable in only one-stop increments. I like to use my Quantum because it's so powerful, but you can use almost any accessory flash. The trick is to place the flash head far enough from the disc so the flash fills it when fired, but not so far as to allow spill around the sides and onto the subject or background. It's easy to test and adjust it by checking its position on your camera's LCD screen; just look for brighter light that doesn't belong where you see it.

When you're ready and your subject is in position, meter as you normally would and set the camera accordingly. Use the camera's LCD to judge the angle of the light and adjust if necessary.

As you can see in image 2.2, the light falling on my lovely model has opened and softened. The overall shade of the background has not changed because the light-to-subject distance remained the same.

It would be very easy to open up the dark shadows with a white card or bookend, which is exactly what I did to produce image 2.3. I moved in a white bookend to camera left and placed it about 3 feet from the model.

The setup is shown in image 2.4. Note that nondiffused light is not falling on any part of the background that is seen by the camera.

Below—Image 2.2.
Bottom left—Image 2.3.
Bottom right—Image 2.4.

You can carry the minimal gear for this setup easily. Take a second collapsible reflector with you for fill and you'll be able to do simple but saleable portraits almost anywhere (see image 2.5). For those of you who are pressed into service for business portraits, this beats the heck out of just lining someone up against a wall in the cafeteria.

This technique is great for non-portrait work, too. It's simple and effective: image 2.6 was set up, tested, and finished in less than an hour. A small white card was set up on camera left to add a fill light reflection on the other side of the glass.

Another benefit to using accessory strobes is that they typically have a shorter flash duration than studio strobes. What I mean is that studio strobes usually flash at around $\frac{1}{2000}$ second (it varies between manufacturers), whereas accessory strobes are over and done with in the $\frac{1}{4000}$ to $\frac{1}{6000}$ range. You can exploit this by using an accessory flash along with studio strobes if you need to stop action that's too fast for studio gear. You may wonder what actions could not be stopped at $\frac{1}{2000}$ second—and the answer is quite a few, especially when dealing with close-up compositions. In this next series, the first image (image 2.7) was made using only studio strobes. The edges of the pouring wine don't appear as crisp as they should.

Below—Image 2.5.

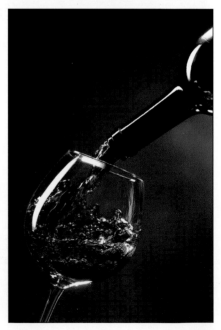

Left—Image 2.6.
Center—Image 2.7.
Right—Image 2.8.

For a more frozen image (image 2.8), I substituted my accessory flash for the studio strobe and softbox that had been placed over the wine bottle, aiming it at the Photoflex diffusion panel to soften the light. The shorter-duration flash stopped more of the action, giving the impression that all action had been frozen and providing additional highlights.

In the market for translucent panels? In addition to Photoflex (www.photoflex.com), you might want to take a look at the Skylight (www.lastolite.com). It's a more complete system than a single collapsible panel and may have more practical applications for your work.

Here's another way to approach this: I had contracted for a beauty/glamour shoot with Alex, a beautiful young Hmong woman who wanted some glamorous images to offset the editorial flavor of her existing portfolio. I often approach these shoots on a number of levels and ask myself several questions between the booking and the shoot: How can I get the most mileage out of this session? What can I do that will stretch my technique? Could this be an educational experience for my readers? Where am I going for lunch?

THE FLASH UNITS MUST BE SET ON MANUAL POWER AND YOU MUST USE A FLASH METER TO MEASURE THEM.

For years, I've used large (4x6-foot) softboxes to produce very soft, even light. These are terrific light modifiers, but they are quite expensive, regardless of the manufacturer. I decided I'd try to use something completely different—white bedsheets along with small accessory flash units—to create an even softer look than I was used to achieving with the large softboxes. I used my trusty Canon flash for the main light, but the other two flashes were very inexpensive slave units I'd purchased years ago. As long as the unit has manual output and a built-in slave, you're good to go, and you can find older, lower-priced gear on eBay or similar web sites.

I began by hanging a white, twin-size bedsheet on each side of a 4x8-foot piece of insulation Styrofoam that I'd previously painted in shades of blue and gray. The sheets were hung about a foot from the edges of the background. I placed a small accessory flash unit outside of each sheet, about 3 feet away, directly across from where Alex would be standing. I placed a third flash directly over the camera, beaming it into a 52-inch white diffusion panel. This flash unit was set far enough from the panel to fill the space and light most of the panel, but not so far that light would spill over or under it. Each strobe measured the same power when fired individually onto the spot where my model would stand. See diagram 2A.

Below—Diagram 2A.

A couple of words of caution here: The flash units must be set on manual power and you must use a flash meter to measure them. If you use flashes set on auto, you will get minimal power through the fabric because the flash will measure the bounceback and turn itself off prematurely. Also, you may have to move a flash forward or back to get a proper meter reading, as they are (generally) adjustable in only one-stop increments (some may be adjustable in thirds of a stop). Be sure to meter each flash individ-

Image 2.9.

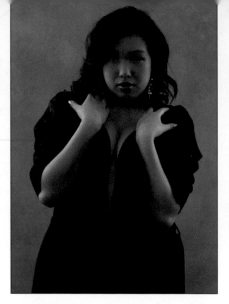

Image 2.10.

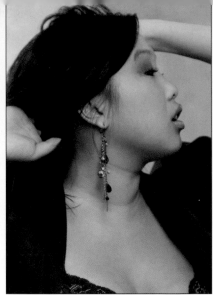

Image 2.11.

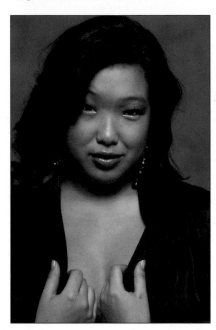

Image 2.12.

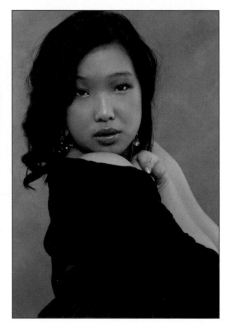

Image 2.13.

ually until you get even readings, then meter them all together to get the working aperture. One other "must-do" is to perform a custom white balance at the working aperture, ensuring that any color discrepancies in the diffusion materials will be neutralized (image 2.9).

All three of the flash units were at full power, but I wanted to cut the power on the overhead by two stops without making an aperture change, so I changed the power from $\frac{1}{1}$ to $\frac{1}{4}$, a two-stop change. Flash ratios are noted in multiples of two: $\frac{1}{1}$ is full power, $\frac{1}{2}$ is one stop less output than full power, $\frac{1}{4}$ is two stops less, $\frac{1}{8}$ is three stops less, $\frac{1}{16}$ is four stops less, and so on. At minus two stops from the overhead unit, Alex's face is shadowed but nicely rim lit (image 2.10).

I added small colored gels to each of the side lights and moved them farther back so that the light would just kiss the edges of the model's face

and hair. There is no set formula for this, as different gels will absorb and transmit light at different percentages. You'll need to do some re-metering (as I did) to determine the correct ratio. Notice how this simple addition changes the feel of the entire setup (image 2.11).

Because the model had white reflective cloth on both sides of her, I was able to turn off both of the side flashes and light her just with the overhead flash. Even though she was only 4 feet from the camera (and about 8 feet from the background), there was enough light bouncing around from the single flash to illuminate everything quite nicely, even the background (image 2.12).

One of the problems you'll encounter if you use accessory flashes is the lag in recycling time, especially when batteries start to wear down. When I got tired of waiting for all three flashes to recycle, I swapped them for studio strobes fitted with small (2x2-foot) softboxes and placed the two side boxes back in the original positions of the accessory strobes. The double diffusion produced softer light, but the effect is close to that shown in the first image because the softboxes are small. See image 2.13.

The white bedsheets became individual softboxes, each about 8x10 feet. As I didn't have to contend with the hassle of speed rings or sandbags, I was able to easily move the "softboxes" into the frame and use them as compositional elements. I moved the lights back to the rear of the set, positioned them so that they would light the fabric all the way to the edges, and powered them up to plus one stop over the main light, measured on the model. See diagram 2B.

After a quick background swap and wardrobe change, we produced lovely results (image 2.14).

The bottom line here is that, while you'll never get a cake pan to act like a beauty bowl, you can accomplish nice imagery with minimal equipment if you think the project through. Visualize a final image in your mind, take a critical look at the equipment at your disposal, think it through, and make it happen.

Top—Diagram 2B.
Bottom—Image 2.14.

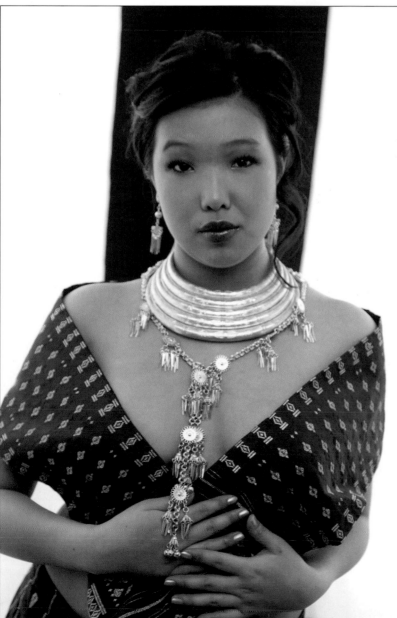

3. FASHION LIGHT FOR HIGH-SCHOOL SENIORS

In the realm of fashion photography, and in fashion advertising in particular, one style of lighting seems to dominate the rest. Flat, almost perfectly even light over the background accents a model who is lit from one side and who shows deeper than usual shadows on the unlit side. The net result is an image that projects a heightened reality, something larger than life. I've found this very valuable for a number of applications, in this case a high school senior's photo shoot.

As you can imagine, there are a number of ways to achieve that kind of lighting. In a dedicated fashion production studio, for example, the background might be a large cyclorama (also called an "infinity wall" or "cove"), a large, perfectly flat wall with a built-in sweep at the bottom to eliminate a sharp corner. That perfect wall might be lit with both floor and ceiling-mounted lights, painstakingly feathered across the surface until exposure values are consistent across the entire field. It's a difficult scenario to set up, and no one in the studio is too anxious to tear it down after the shoot's over, either.

I don't have the luxury of that much space in my studio. Because of the wide variety of work that crosses my threshold—portrait, food, product, etc.—my sets are always changing. Consequently, I've found a shortcut or two for shooting similar fashion images with just one light that you might find useful for your own work, whether it's fashion or senior portraiture.

The key to the first setup (image 3.1) is nothing more than height. As you should know, light gets dimmer over distance, losing strength. This tendency is described by a very dry law of physics known as the Inverse Square Law, which states that light that has to travel as far from point B to point C as it did from point A to point B will be

THE NET RESULT IS AN IMAGE THAT PROJECTS A HEIGHTENED REALITY, SOMETHING LARGER THAN LIFE.

Below—Image 3.1.

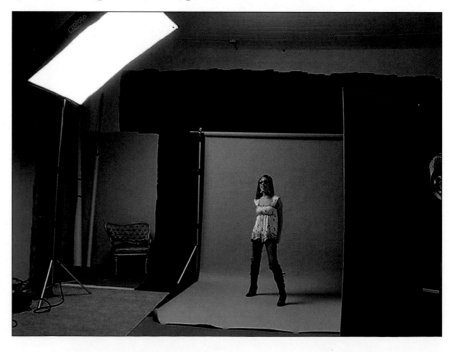

only ¼ as strong when it gets to point C. You can prove this point with a flash meter, but just trust me for now.

I put my largest softbox, 4x6 feet, as high as I could, butting it right up against the 13½-foot ceiling (smaller softboxes will work nicely, but the shadows will be harder) and aimed it down at a severe angle. I wanted to feather the light, keeping it as evenly distributed as possible over the model and the seamless paper background.

This light allowed for beautiful medium shots as well as full-length poses (images 3.2 and 3.3).

I know that many of you do not have the kind of ceiling height that I take for granted. If you have white walls in your studio, you can accomplish much the same thing by bouncing a small softbox onto a wall at the side of your subject. A smaller softbox will give you a stronger and less diffused light than a larger one. Aim it so it hits the wall and then angles up

Left—Image 3.2.
Right—Image 3.3.

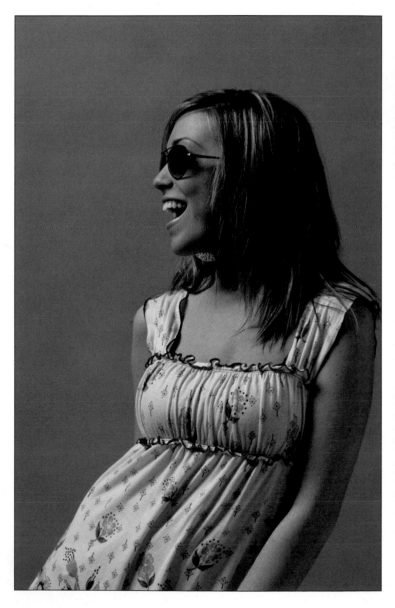
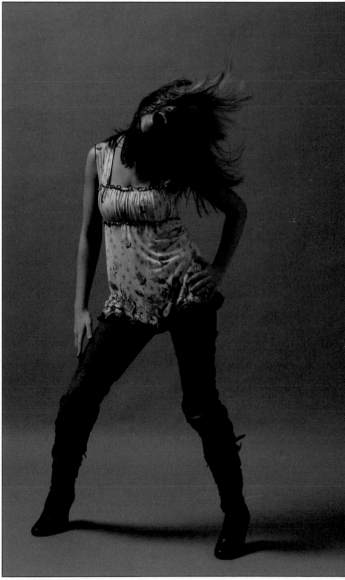

to the ceiling. Doing this turns your wall and ceiling into a huge softbox, and you'll get beautiful side light on your subject (be sure to custom white balance to counter any color casts). If I had a wall configuration like this in my place I would have shot a sample. Unfortunately, you'll have to make do with a lousy diagram (diagram 3A).

For the next setup, I wanted even deeper shadows. The model wanted to wear a hat, which presents a problem because of the brim. I could have kept the light in the same position, but I would have been forced to keep her head raised if I had any hope at all of seeing her eyes.

Instead, I brought the light and large softbox down to a more traditional height, about 24 inches over her eye level. To deepen the shadows, I moved a black foamcore bookend in to camera right, just outside of the frame. See image 3.4. A black gobo will actually absorb light (this is called subtractive lighting) on the shadow side, causing deeper shadows than you'd expect. In a way, you are reflecting black light onto the model.

I also moved the light and the model closer to the camera. Because the single source was farther from the background, the medium gray paper received weaker light and, as a result, appears darker. Notice the difference in background tone and shadow density after those two simple changes were made (images 3.5 and 3.6).

For my last shots of the session, I wanted to concentrate more on the model and increase the drama of the light. I kept the model at the same

Below—Diagram 3A and image 3.4.
Bottom left—Image 3.5.
Bottom right—Image 3.6.

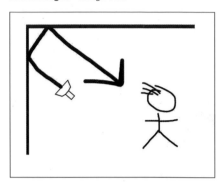

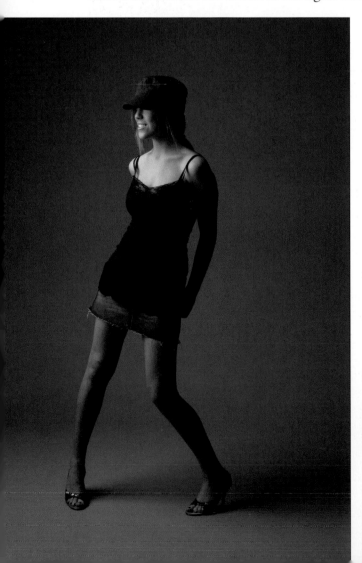

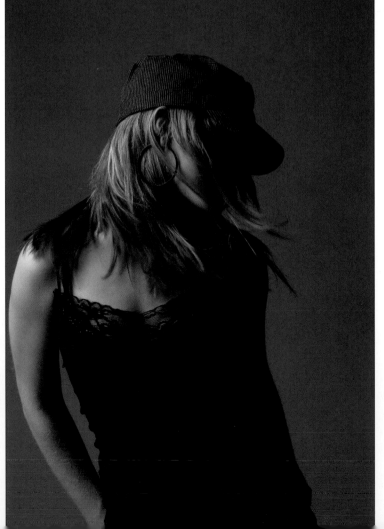

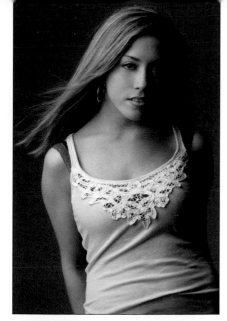

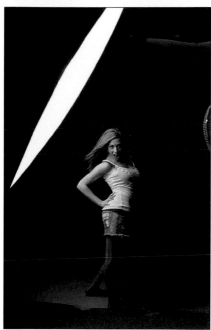

Top left—Image 3.7.
Bottom left—Image 3.8.
Right—Image 3.9.

distance from the background as she was in the previous set (about 9 feet). I moved the black bookend in closer, about 1 foot from the right edge of the frame, to make the shadows a bit more dense. See image 3.7.

To ramp up the drama of this beautiful light even more, I moved the light and the black gobo even closer to the model (see image 3.8 for the setup), then raised the light another foot or so to maintain the angle of the nose shadow (there is no set formula for this). Being so close means the strength of the light will fall off faster, while the nearness of the gobo ensures that very little of it will be bounced back. I'd been shooting with a handheld camera, zooming in and out and moving as I pleased. I was so taken with this expression and composition in image 3.9 that, even though I saw the edge of the bookend as I swung into the shot, I didn't much care (it could be removed in postproduction). My eye, brain, and finger were one with the universe.

4. MAKING THE MOST OF A LOCATION SHOOT

When I go on location, I try to minimize the amount of equipment I'll need. Photo gear, especially lighting gear, is heavy and bulky. I prefer to bring only what I know I can get by with and still create a variety of looks. The shoot I'm writing about, a high-school senior portrait session, was made out of town at a location I had to fly to, so the weight and amount of equipment was an even more important issue.

Top—Diagram 4A.
Bottom—Diagram 4B.

You'll learn some important tips in this chapter, but the most important tip, which is not immediately evident, is to take your time and give the location a thorough and thoughtful once-over before you set your first light. If the shot list includes both indoor and outdoor shots, check the angle of the sun. It could be that the sun is in its optimum position now, not later, and you'll need to get cranking if you want to use it in the shots.

Gauging the travel arc of the sun when you're in a strange location is difficult just by eyeballing it. To be totally accurate, you'll want to know exactly how it will arc in relation to the property you're on and, perhaps, where it will set. Here's an easy way to determine that arc in just a few minutes.

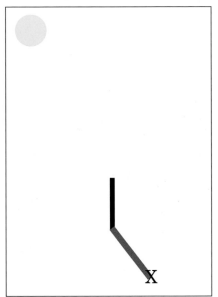

First, find a stationary object that's throwing a shadow on an unmoving surface. Place a coin or small rock, or make a small mark with a pencil or piece of chalk, on the outside point of the shadow. Make sure there are no other shadows that might hide the mark. See diagram 4A.

Wait fifteen to twenty minutes and continue your walk around the property, looking for attractive foreground/background combinations. At the end of that time (and that time's not critical, you only need enough time for the sun's shadow to move), take another look at the mark. The shadow will have moved a bit in the interim. Take any straight object like a pencil or ruler and place it across the first marker to where the shadow is now. The straight object will point to where the sun will set, exactly, and you'll know how the sun will track across the sky. See diagram 4B.

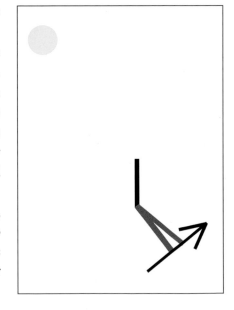

As I was pre-visualizing the shoot while walking through the property, it occurred to me that I would be facing some problems that you also may face when doing location portraiture, and that my approach to these problems might give you some insight to the successful conclusion of your own assignments.

The first half of the shoot was to be indoors. The parents' taste, I noticed, was somewhat eclectic but leaned toward contemporary. Our first location, the living room, featured white upholstered furniture with crisp lines and zero frou-frou, white walls, and a hardwood floor. Obviously, this room was primarily white with minimal accents, a fact I took into account when reviewing my subject, Stephanie's, wardrobe.

Image 4.1, taken on the couch, saw Steph in a simple white top and blue jeans. I set up my two lights, fitted with a medium softbox, on the camera-right main light, along with a hair light fitted with a grid at camera left. The two channels on the power pack I brought with me are symmetrical, which means they push out equal amounts of power per channel. To get to my ideal ratio, which made the hair light ⅓ stop brighter than the main light, I simply moved the strobe head toward the subject until my meter indicated the correct exposure, aiming the hot spot at the same place for every move. I set my shutter speed fast enough so ambient light would not pose any significant problem, even at my target aperture of f/9. I moved the couch about 6 feet away from the wall, which allowed that background to appear darker (because the light that fell upon it was weaker than the light striking the subject) and helped separate the subject from the background. It was a simple but very effective change. See diagram 4C.

For another setup, I asked Steph to change into a dress with stronger color. It was interesting to note that my wife, a makeup artist and stylist in a former life (and who came out of retirement to do Stephanie's makeup), thought the color was too strong for her light complexion. Steph's dad and I thought the saturated color actually accented her skin, while her mom declined comment. What is important is that the dress passed the test of peers

Top—Diagram 4C.
Above—Image 4.1.

after it was purchased and that its owner liked it and was comfortable wearing it. Equally important (perhaps more so) is that the photographer was inspired by it.

We changed the angle of the furniture and asked Stephanie to rest across one of the arms, where she settled in place while I made my main light meter reading. I hadn't yet set the position of my background light (it was too low; its edge is just barely discernible behind her camera-left

Left—Image 4.2.
Top right—Image 4.3.
Bottom right—Image 4.4.

shoulder) but realized Steph had arranged herself in a comfortable and compositionally pleasing manner. Without worrying about the second light (I already knew the main light would light the background evenly), I picked up the camera and shot.

Whenever you see something happen spontaneously, it's important that you shoot immediately. It's also important that you shoot dispassionately, by which I mean you need to critically look at what you just did and think about how it might be improved. As I made the shot, I noticed that Steph had put too much of the weight of her head into her hand. I still had the camera to my eye when I asked her to adjust her weight, and as soon as she took the pressure off her hand I shot again.

WHENEVER YOU SEE SOMETHING HAPPEN SPONTANEOUSLY, IT'S IMPORTANT TO SHOOT IMMEDIATELY.

I rarely shoot portraits with the camera on a tripod, even when using my 70–200mm zoom (as I did here). Tripods are just too restrictive for me, and I like to tilt the camera or move up or down, accommodating my client's position and my own sense of composition "on the fly." I would suggest you consider the same approach. Not even the finest ball head or smoothest camera stand can keep up with a photographer on a roll. Note for this shot how a slightly more dramatic tilt of the camera worked with the model's directed posture to produce a beautiful photo (see image 4.2).

For the rest of the series (images 4.3 and 4.4), I directed Stephanie through a sequence of subtle changes, ending with a soft, genuine smile that is one of my favorites and hers, too.

We then moved outside to the upper-story deck. The sun was at Stephanie's back, just sliding over center and to her camera-right side. If you were just looking at her on the deck, the light would be beautiful. Unfortunately, cameras don't see things the same way.

When the light is behind the subject and there's nothing to bounce light back into the face, the net result is a face that's heavily shadowed, especially in the middle, where the shadows cannot be mitigated by any wraparound light. Image 4.5 was made without any fill.

Given the lens I was using, the 70–200mm zoom, I had positioned myself about 15 feet from Stephanie, a distance that gave me the most flexibility with the lens. I had originally hooked up an accessory flash with a softening modifier to the camera, in hopes that the thing could produce enough light at that distance. Unfortunately, most small accessory flash units, mine included, are relatively worthless beyond 12 feet or so. Working in TTL mode (as most of us want to do when using such equipment) is not the way to go, and the results are mediocre at best, if for no other reason than that the catchlight from the flash will be centered in the model's eyes.

I moved the portable studio flash and the softbox onto the deck and metered it to be one stop greater than the ambient light that fell on Steph's face. Doing so guaranteed two things: the highlight from the sun

would still be the brightest part of the image and the background would be darker than the ambient. The result (image 4.6) is quite lovely.

The softbox was left in its original position and I instructed Steph to move around within the area evenly lit by the box. Professional equipment is more difficult to set up than just using an accessory flash, but the results are so much better than what I could have expected by using a piece of gear beyond its limits. Granted, I could have pumped up the ISO on the camera, but I prefer to shoot at ISO 100 whenever possible because it will produce the most noise-free files with any camera. See image 4.7.

A common mistake when working on location is thinking your clients expect you to be ready in minutes and then trying to meet that deadline. The truth is, your subjects and clients will appreciate your vision even more once they see how much thought and effort you put into it. Besides, it helps justify your fee.

Top left—Image 4.5.
Bottom left—Image 4.6.
Above—Image 4.7.

5. KILLER ACCENTS WITH SIDE LIGHTS

We all know the value of a "kicker" light, a light that's usually set opposite the main light to add an accent to the hair and shoulder, visually "kicking" those parts away from the background. Doing so prevents shadows from merging into a dark background and adds dimensionality to a flat, two-dimensional print. Generally speaking, these lights are typically called hair lights, and they are usually aimed to cover just a small part of the body.

In this chapter, I'll show you how to create a much broader accent, and I'll do it using modifiers you may not have thought of before: two separate softboxes set side by side but powered differently. Additionally, in these demonstrations, the softboxes won't be set as high as one would usually set a hair light, with the strobe heads raised slightly higher than the subject's face but not as high as the main light itself. This will allow the light to spread over the side of the face and body as opposed to the top of the head and shoulders.

You'll need to think a little differently when setting up a shot like this one. Usually, we set the main light and power it up to an f-stop we're comfortable with, then power the hair light and background light to complement the key. In this case, we'll set the accent lights—the side lights—first, then power the main to complement them. Diagram 5A shows the first setup.

With all the other lights turned off, I powered the smaller softbox, a 1x6-foot strip light box and strobe, to f/9, aiming my meter directly at the light from where my model would be sitting.

I turned the small softbox off, and lit the larger, 2x3-foot box, adjusting the power to ⅓ stop less than the other, or f/8.

Once that was done, I turned the first box back on and measured the two together. Remember that the effects of light are cumulative. Light added to light equals brighter light. My two lights together equaled f/11, and this would be the value that I would have to work with when setting the main light.

My main light was a strobe aimed into a 48-inch umbrella. I love the light that thing produces, which is why I used it. Any other modifier would work just as well, but the look would be different. It's only necessary to use whatever modifier you have—umbrella, softbox, or parabolic—

REMEMBER THAT THE EFFECTS OF LIGHT ARE CUMULATIVE. LIGHT ADDED TO LIGHT EQUALS BRIGHTER LIGHT.

Below—Diagram 5A.

Left—Image 5.1.
Right—Image 5.2.

that will give you what you need to make your client look great. I powered the main light to be ⅓ stop less than the cumulative power of the two softboxes, or f/10, which is where I would set the camera's aperture.

Here's how it looked, as photographed at f/10 (see image 5.1). The first softbox, the 1x6-foot strip light, illuminated the back edge of the face quite nicely.

The second softbox was much broader because it was aimed so much more at the side of the model's face. You'll notice that it hit the side of her nose. This is normally considered to be something you won't want to do, as it puts undo emphasis on the nose, but, trust me, it will look great with this setup because it's designed to be an accent, not a mistake. See image 5.2.

When the two lights are used together, the true look of the light becomes apparent. A brighter highlight at the back and a slightly dimmer highlight toward the front produces a look that's much more dimensional than one light alone or a simple fill card. As you've probably figured out, the secret to this is the two separate power settings for the lights.

Once the main light is turned on, the results are terrific. The main light, set at camera right, fills in the shadows that so often are the result of side light yet allows those side lights to sculpt the image, producing a

final shot, even with the hit on the nose, that's evocative, beautiful, compelling, and different. You won't see a cheap studio do something like this!

Now, let's see what happens if we change the position of the main light.

I took a long, hard look at the position of the lights, in particular the main light. On most levels, I like the look of it. However, I noticed the main light threw a shadow onto the camera-left side of the model's face, conflicting with the shadows thrown by the side lights. It's especially noticeable next to her nose, just below her eyebrow. It's not a deal breaker, but the look could be better.

For the next set, I moved the main light to camera left, the same side as the accent lights. I did this because I wanted the light to flow around the model, creating what would look like a wall of light that began with a hot edge at the rear.

The first shot with the new configuration was made without any fill on the shadow side. It looks very nice, I think, because the face is so nicely sculpted. See image 5.3.

I know that for many uses, such as headshots or publicity portraits, shadows are not wanted. It was a simple matter to tone down the shadows by moving in a white bookend, set about 3 feet from the model and at camera right (image 5.4). Be sure to re-meter if you do this. My exposure jumped by $\frac{1}{10}$ stop, which meant I had to either power down the strobe

Left—Image 5.3.
Right—Image 5.4.

Left—Image 5.5.

YOU MUST BE PRECISE WITH THIS
APPROACH. PLAY WITH IT AND
UNDERSTAND IT BEFORE ADDING IT
TO YOUR REPERTOIRE.

generator (preferred) or move the main light a few inches farther away from the model to get the correct aperture power.

My final result (image 5.5) is a perfect headshot portrait. You'll note that the accents, even though they do hit the side of the nose, create a perfect, sculpting light that complements the main light to produce a wraparound light that makes the model look great.

You must be precise with this lighting approach. Play with it and understand it before adding it to your repertoire. You could also use a 2x3- and 3x4-foot softbox to achieve a broader but slightly softer effect.

6. SUBTRACTIVE LIGHTING

As much as photographers like soft, gentle fill to open up shadows, there are times when a deeper and more saturated shadow is desired. As you work through this book, you'll see occasional references to adding a little "subtractive light" in the text. It's easy to do. Instead of using a white bookend on the shadow side, just add a black one. A piece of black cloth hung from an accessory arm works just as well (but probably won't look as professional).

Consider this simple, two-light portrait (image 6.1). My model was sitting about 7 feet in front of a gray background and was lit by a medium softbox (the main light). Her hair light was a beauty bowl fitted with a 25 degree grid and powered $\frac{2}{10}$ of a stop over the main light because of her blond hair. To open the shadows, I positioned a white bookend to camera left, about 2 feet away from her. It's pretty normal stuff, but it looks very nice nonetheless.

Replace the white bookend with a black one, and the complexion of the image changes (image 6.2). Subtractive light actually takes light away

Left—Image 6.1.
Right—Image 6.2.

Left—Image 6.3.
Right—Image 6.4.

from the subject by reflecting black. I know that sounds a bit abstract, but it works for me, and the picture is the proof.

You can use an additional black bookend, on the lit side, to add to the subject's contouring as well as to take some light off the background and make it appear darker. This is an easy way to shade the background from a darker to a lighter tone, giving the impression that it's been lit in a more sophisticated manner than just by spill from the main light. The effect shown in image 6.3 is subtle because the black card is on the same side as the light. Still, its use adds dimension to the model's hair.

You can, of course, take this to the extreme and open a black bookend behind the model, essentially wrapping the subject in a black V. For image 6.4, the light was adjusted to match the meter reading from the previous images, but notice how much more saturated the colors are in the model's skin. Notice also that there is still detail in her black dress.

Granted, this is not a technique that should be used with every model. Darker hair will merge, tonally, with the background unless you add a carefully applied hair light. In my case, the 8-foot-tall bookend didn't leave much room for a hair light, but black foamcore is available in 5-foot lengths as well and would allow plenty of room to sneak light in and keep it off the background at the same time. You'll also have to rely on your camera's LCD to determine where the shadow's boundary is and how sharp it might be. Subtlety is the key.

YOU CAN USE AN ADDITIONAL BLACK BOOKEND, ON THE LIT SIDE, TO ADD TO THE SUBJECT'S CONTOURING.

7. UNDERFILL AND UNDERLIGHT

This chapter will build on many of the techniques I've written about thus far, although I'll break a "rule" or two along the way. We'll take a look at underlighting, a technique in which a bright highlight is added to the subject from below. No, it's not the old flashlight-under-the-face trick that's scared more than its share of cub scouts. What I'll demonstrate can be subtle or bold and, in each case, will contribute more than its share of zip to the image.

First, I wanted to work with traditional Hollywood lighting techniques using only *soft* light. Traditional Hollywood lighting used mostly hot lights with relatively small reflectors. Fill, if any, was created with bounce cards or hot lights set in a large, curved surface. Given the ease of working with studio strobes, I can only imagine how uncomfortable it must have been posing so close to those sources, holding a position and attitude for as long as it took to focus, load, and shoot the 11x14-inch view cameras that were so often used. I wanted to make it easier on the model—and even easier on me.

Lights, no matter where they're placed, require distance from the subject to do their jobs properly. Since I wanted to do a reclining portrait that looked as though the model's chair was on the floor, I first had to build a platform to give the lights some room and hide them from the camera. Three collapsible sawhorses and a sheet of ¾-inch plywood, placed about 9 feet in front of the background, did the job nicely. See image 7.1.

LIGHTS, NO MATTER WHERE THEY'RE PLACED, REQUIRE DISTANCE FROM THE SUBJECT TO DO THEIR JOBS PROPERLY.

Right—Image 7.1.

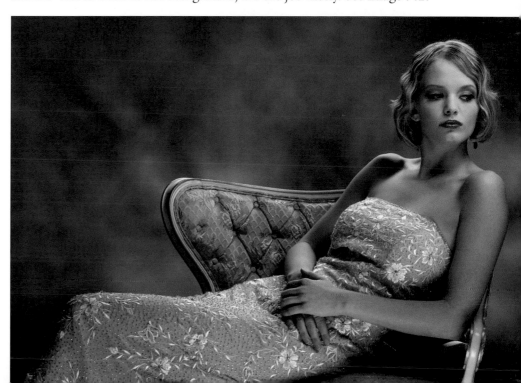

I set a head with a standard parabolic reflector about 12 inches in front of the background. I used my reverse cookie (see chapter 19) to get the splotchy background, leaning it against the middle sawhorse at an angle to reflect light from the parabolic back onto the paper. This strobe was also responsible for the small curved highlights on the chair frame in the shadow of my model's back. Once the main light was set, the parabolic was powered to read one stop less at the brightest part of the reflection, measured at the background.

My main light was a 2x3-foot softbox, set slightly to camera right. It was also placed close, within 18 inches of the model's face, so the light would fall off quickly and not light her evenly. Most of the light you see across her body is from the 1x6-foot strip light softbox I used for her hair light. The strip light was powered to equal the main light, as measured at her hair, so it naturally would fall off a bit as it made it to her dress.

The underlight was a 2x2-foot softbox, set on the floor underneath the main light. It was powered one stop less than the main light when measured at the model's face. Working exactly the opposite of the hair light, the underlight was more powerful on the model's body than on her face. See diagram 7A.

It was a complicated setup, but the results were certainly worth the trouble. The underlight added interest and contour to her left forearm, hip, and chest. It also filled in under her chin and brow without being bright enough to detract from the main light. A second shot, converted to black & white, shows the true "spirit of Hollywood" scenario. Notice the low catchlights in her eyes and the reflection on her upper lip. The shot (image 7.2) is smokin' hot.

NOTICE THE LOW CATCHLIGHTS IN HER EYES AND THE REFLECTION ON HER UPPER LIP.

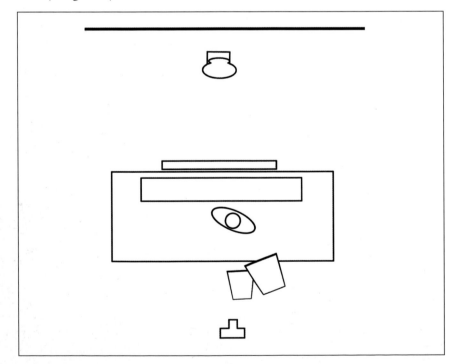

Left—Diagram 7A.
Facing page—Image 7.2.

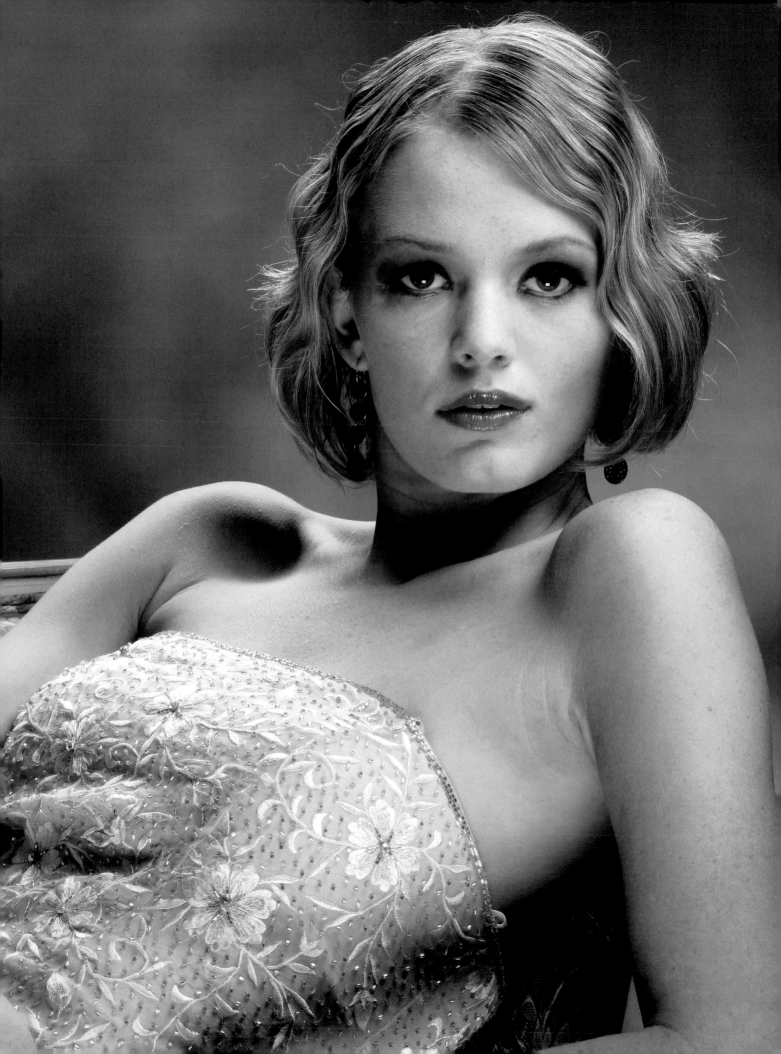

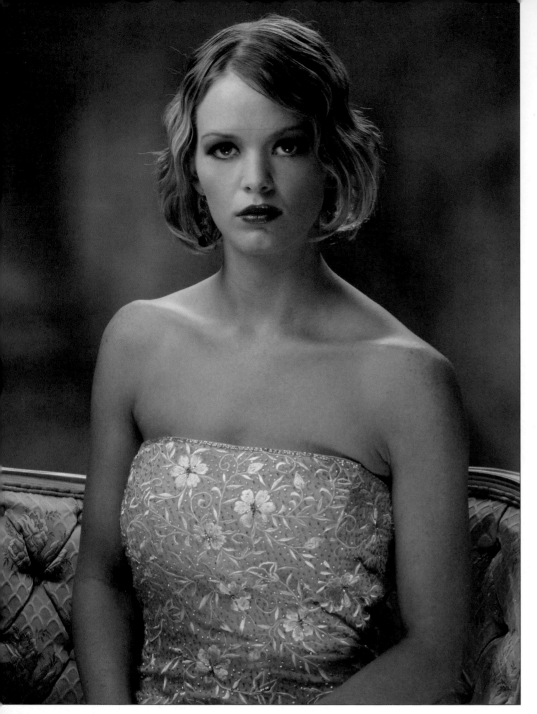

As complicated as this setup is, it is actually quite versatile. By moving only the main light, now at camera left, we changed the entire look of the image. The effect, shown in image 7.3, is subtle but beautiful.

Harder light, by virtue of its additional contrast, will boost highlight accents and sharpen them.

The model went to change into something less formal, a swimsuit and top. While she was in wardrobe and makeup, I removed the reverse cookie and the light that had been aimed at it, substituting three heads with parabolics on the floor close to the rear of the platform. Each was fitted with a grid to control the spread of the light and positioned to light the model from below and behind. The light at camera left carried a

20 degree grid and was powered to plus ⅔ stop at its brightest point. The rear light struck the bottom of her hair and the inside of her camera-right arm, while light from the camera-right unit struck her side. Both were fitted with 30 degree grids and powered to plus ⅓ stop over the main light at their hot spots. An additional light, a beauty bowl with a 25 degree grid, was aimed at the top of her head from a boom arm.

My main light was a 7-foot umbrella placed slightly off-axis to camera right. I love the light the thing produces, but it does take up a lot of real estate. A large, standard umbrella or softbox would do the job nicely. See diagram 7B.

For image 7.4, my model was instructed to move into a position that could take advantage of the three lights. The lights were tweaked as necessary (and re-metered, of course). Because the hot spot of the camera-

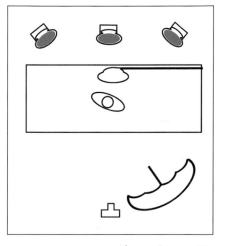

Above—Diagram 7B.
Right—Image 7.4.

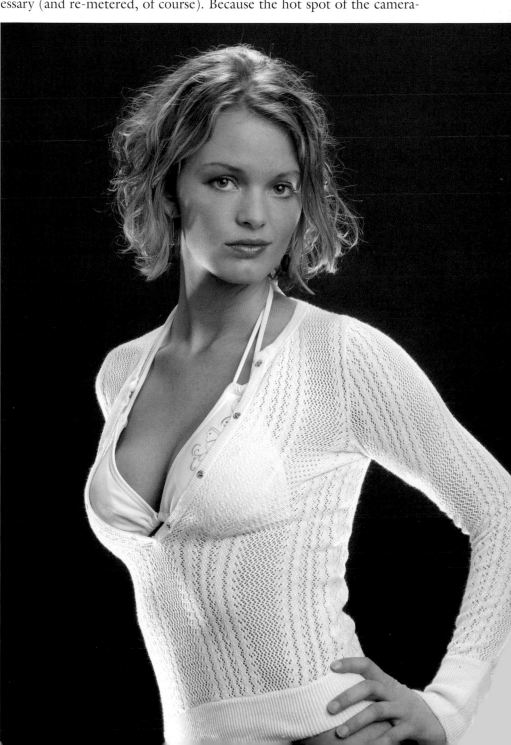

left light was aimed and metered at her torso, the kiss of light on the side of her jaw is softer and less bright. Notice also how stray light from the camera-right unit barely tags the underside of her eyebrow and the side of her cheek. These two small accents lend a great deal of dimensionality to the model's face.

There are a couple of details you should be aware of when lighting from below:

- Underlight must be brighter than the main light; otherwise, it's just fill light.
- The underlight should never be the main light on a face unless you're going for the "bad horror movie" look. Instead, let the light "kiss" the face in areas that are not overly important to the physicality of the model such as the edges of the mouth, nose, and forehead.
- Watch all up-shadows. Angle your lights so shadows falling on the body are minimal, if they are there at all.
- Follow the usual guidelines for main light placement. Make sure the nose shadow follows the line of the cheek in a graceful and attractive manner.

I'm sure you can see the value of this extra accent lighting whether you use it for fashion or straight portraiture. As long as it suits your subject, any time you can add extra zip to your images (no matter how many lights you use), you're one step ahead of your competition and one step closer to developing a drop-dead personal style.

UNDERLIGHT MUST BE BRIGHTER THAN THE MAIN LIGHT; OTHERWISE, IT'S JUST FILL LIGHT.

8. LIGHTING FOR FILL

NEVER USE A SECOND LIGHT AT THE SAME BUT OPPOSITE ANGLE AS THE MAIN LIGHT.

There isn't any particular trick to adding light to open up shadows and add contouring to your images. It's as simple as using a piece of white foamcore or a similar surface. You can use the extra light from the main or hair light to bounce light back to the subject. Personally, I favor foamcore bookends because they are large, lightweight, and really inexpensive—but you could use bounce panels stretched across frames, collapsible reflectors, or even the white side of a collapsible white balance target. Almost any device will work to help you reflect light, provided it's large enough and neutral in color.

I prefer to use bounced light as fill because it does not require additional power or create an additional catchlight in my subject's eyes. I'm aware that many of you prefer to light for fill, so here are a couple of tricks to make it easier to deal with.

First, here's what not to do: never use a second light at the same but opposite angle as the main light, no matter what the exposure ratio might be. Doing so will either create deeper shadows from the main light or create new shadows from the fill. This was a reasonably popular technique that began somewhere around the 1930s and has been ugly ever since. I've seen tenured college photography instructors telling their students that this is how it's done, essentially dooming them to a career rife with mediocrity unless the students figure out for themselves why their pictures are, essentially, visual junk.

As image 8.1 illustrates, using two lights creates two shadows on the background. This is not good. I know that many of you work in relatively small studios and must keep your subjects close to the background, so this is a mistake you'll not want to make.

Another reason to avoid this scenario is the double shadows created around the nose and eye sockets. Neither light is allowed to create a full shadow, but neither shadow is completely filled, either.

If you want direct fill and your camera has a built-in flash, you can use it provided the camera is not so far away as to be outside of the flash's range (generally no more than 12 feet). You will get your best results when you use your camera's flash exposure compensation feature (or whatever your camera's manufacturer calls it) to dial in a factor that is at least one stop less than the power of the main light (a medium softbox for

these samples). Bear in mind that any resulting shadows or catchlights will be hard and sharp and will almost certainly need to be retouched. Those catchlights will be easy to find, as they'll be dead center in the eyes. See image 8.2.

You can be extremely accurate if you use the manual flash exposure and make power adjustments directly to the flash, not through the camera. You'll have to use your handheld light meter to figure out how strong you'll need the output to be.

If your camera doesn't have a built-in flash, set another strobe, fitted with a standard parabolic reflector, directly over the lens, as close to the lens and its axis as possible. This will give you a flatter light than you'd get with the built-in flash and will allow you more subject-to-camera distance if you need it.

YOU'LL HAVE TO USE YOUR HANDHELD LIGHT METER TO FIGURE OUT HOW STRONG YOU'LL NEED THE OUTPUT TO BE.

However, the fill light will open up some of the main light shadows. To create image 8.3, I used a one-stop difference between the main light and the fill, with the main light being brighter, of course. You'll need to decide if you like the effect, and you'll need to retouch the extra catchlight in

your final files as well (I've left it in place here). It may be difficult to get the light in the perfect position (note the extra shadow behind my subject's head), but it can be done.

Center an umbrella or small softbox directly over the lens and use that light for fill. It will be broader and softer than either of the previous suggestions. If you use an umbrella, be sure to set the light, not the umbrella, over the lens to avoid flare. Experience will tell you how much power will be ideal for your images. Image 8.4 shows the effect of an umbrella powered one stop less than the main light.

In each case, you'll need to meter each light separately, with the other turned off, to get the correct ratio. Once that's done, turn both lights on and re-meter. Make any minor adjustments to the fill light, not the main light, to get a reading that represents a whole f-stop or a perfect third.

Left—Image 8.3.
Right—Image 8.4.

Image 8.5.

Image 8.6.

When both lights are correctly powered, you'll be creating images with a proper main:fill light ratio.

Now, let's amp this up a bit. I've added a strip light at camera left, along with a black bookend to keep its light off the lens (see diagram 8A). I've powered it up to ⅓ stop over the main/fill light combo. The angle of incidence makes it appear brighter, but there's detail throughout the highlight. My subject has terrific, strong lines in his face, and the side light produces a great accent. See image 8.6.

I wanted a little more fill, but not from the fill light. I took advantage of the accent light and placed a 36-inch circular reflector below the frame and bounced some of the spill back to him, underlighting him slightly. An added bonus was a little additional light on his dark shirt. See image 8.7.

In many ways, adding fill light from strobes is much more difficult than using a bookend or fill card. I'd suggest you try both, on the same model and with variations in fill light strength, until you find the combination that gives you the look you want. I think you'll opt for the easy way.

Above—Diagram 8A.
Facing page—Image 8.7.

9. SILVER REFLECTORS IN THE STUDIO

We're all familiar with using white reflectors, usually bookends or panels, to bounce light into shadow areas and open them up. White reflectors are usually better than fill flash, as they won't add shadows of their own or overpower the main light.

Gold reflectors are often used to warm up skin tones, especially when working outside. However, traditional gold reflection on digital images can sometimes look a little weird.

So, what about silver? When shooting outdoors, using a silver reflector can produce a look that's a bit harsh, as the silver surface throws a "snappy" and more contrasty light than white (of course, the decision to use it is purely a matter of taste). In the studio, silver reflectors can act as

Left—Image 9.1.
Right—Diagram 9A.

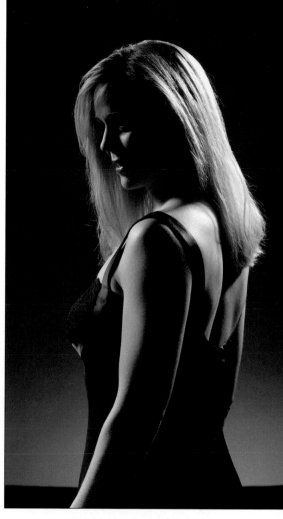

THE SIZE OF THE REFLECTION IS
DIRECTLY RELATED TO THE SIZE OF
THE REFLECTOR.

either a main light or as fill and will impart a "certain something" to an image that's visually intriguing but subtle and difficult to pin down.

Bear in mind when working with any reflector that the size of the reflection is directly related to the size of the reflector. Larger reflectors are more efficient and cover more area than smaller ones.

Aside from the background, the first image (9.1) was lit with only one light. I mounted a parabolic reflector fitted with a 30 degree grid behind my model (see diagram 9A) and skimmed the edge of its light over the back of her head. Most of the light, including the center hot spot, was aimed at the silver reflector. It's important to control the skimmed light, as too much of it will overexpose the back of the model's head. The reflected light, which was metered to act as the main light, looks like a large and contrasty source but with minimal specularity, something that's tough to achieve with a standard light/reflector combination.

It's also important to angle both the source light and the reflector properly (see diagram 9B) in order to get shadow lines that complement the model and the image. My subject was standing for this shot (image 9.2), which meant the background had to be raised to get the proper nose shadow. I anchored the reflector frame to an Avenger accessory arm that spanned two light stands (sandbags are a must for this) and raised it to the proper height to get a perfect Rembrandt shadow on the model's cheek. I also turned my source a bit more toward her, to brighten her hair. Notice how the large reflector highlighted her arm.

Should you turn the model away from the reflector and add another light to act as the main light, the silver reflector can add an attractive ac-

cent on the shadow side. For image 9.3, I moved the hair light so it hit only the reflector, not the model. I'd also moved the reflector more behind her, so the light on her was not as broadly directed as in the previous images. See diagram 9C.

I wanted an image with hot reflections both front and back. So to create image 9.4, I first moved the main light to camera left, at the same angle as her face to the camera. Once that was set I moved the hair light back into play and let it spill generously over her hair and shoulder. I knew from the light meter that I would have areas of serious overexposure in the image, but in view of the drama such light can create, I was content to let

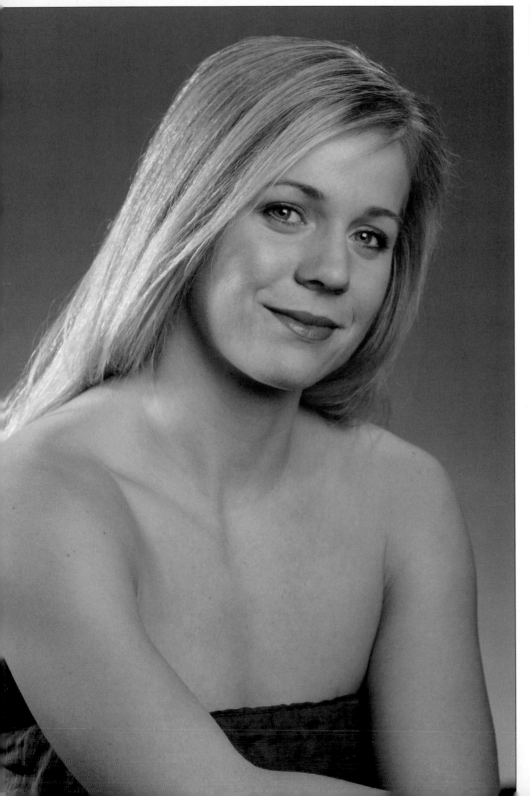

Left—Image 9.3.
Above—Diagram 9C.

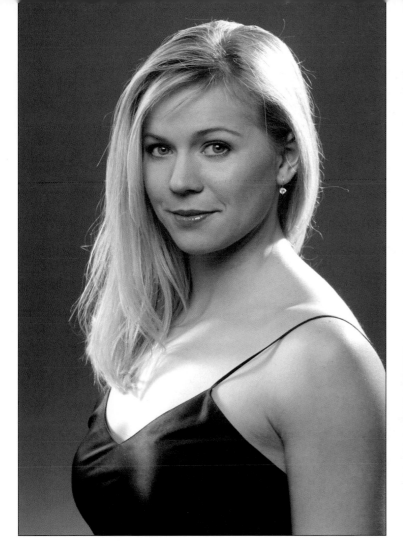

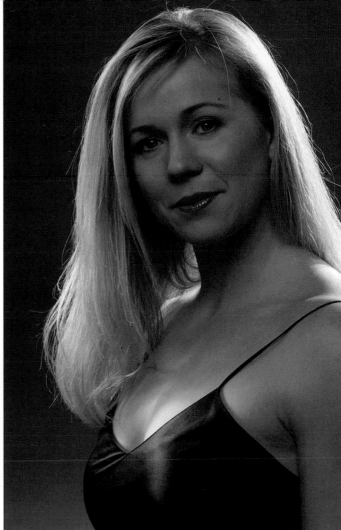

Top left—Image 9.4.
Above—Diagram 9D.
Top right—Image 9.5.

it go. Overexposure in most forms of portraiture will not be tolerated, but in fashion or glamour photography it can be a terrific tool. I also moved the reflector closer to the model to strengthen the reflection. See diagram 9D.

My final example for this chapter (image 9.5) exhibits a warmer, more subtle look, which was easily accomplished. By powering down the main light by $1\frac{2}{3}$ stops (but maintaining the same aperture as in image 9.2), the skin tones, as well as the background (the density of which is influenced by any light that falls upon it), darken and exhibit deeper saturation.

Each of these examples was made more interesting by using a modifier in a slightly unusual manner. Personally, I think we need to look at each of our modifiers and what they do, finding ways to work with them that produce different and nontraditional results. Like most techniques that are borderline unorthodox, you may not use it often. Still, it's a valuable trick to pull out of your hat when you need one.

For these images, I used a 39x72-inch silver/white Photoflex panel (www.photoflex.com). Similar gear may be investigated on sites maintained by Lastolite (www.lastolite.com), Westcott (www.fjwestcott.com), and others.

10. CINEFOIL

I sometimes forget one of the many tricks I've played with over the years, and it's only when I stumble upon the accessory, packed neatly into a drawer or stored in a box, that the light goes on. This happened recently when I found a roll of Rosco Cinefoil (http://www.rosco.com/ us/video/cinefoil.asp), a heavy-duty, matte black aluminum foil that's used more in the film and video industry than in ours to gobo off lights, create snoots or barndoors, or even as a "cookie" to form shapes to throw shadows on a background. When I came across the roll, the light came on: I knew I could use this to create a moody and evocative image of the model coming to the studio later in the day for a stock photo shoot.

Cinefoil is an extremely durable product. I've had this particular roll for probably twenty years and still have the original 6 feet of it, in sections, usable and certainly not worth tossing out.

To use it, I wrapped the original sections around a bare-tubed strobe, using clothespins to attach the pieces to the light (see image 10.1). To keep the foil from actually contacting the hot flash tube cover, I built the makeshift snoot around a speed ring. The strobe was angled so it would be parallel to the floor when it was raised to its working height and was angled so the model would mostly be in front of the light.

I intended to break a few "rules" with this shoot, most notably the one that says you should avoid tonal merger, that pesky problem that rears its ugly head when the shadows of the subject merge with the background or with themselves. That rule holds true for classic portraiture but, like all rules, can be broken for effect, which I surely would do by using only one light, no fill, and no spill from reflections off the studio walls.

The net result of using a light with hard, directional shadows on only a small portion of the model (and against a background that would register no detail at all) was exactly what I wanted (see image 10.2). The image was moody and evocative, with an unexpected richness due to the mystery created by the light. To soften the focus, I used a piece of peach glitter organza fabric over the lens. See chapter 15 for more information on using this cool trick.

Now, I love the look of bare-tubed strobe, and I use it a lot as a main light because the shadows are almost as defined as those made by sunlight. It's also great as a hair light. Using Cinefoil allows me to flag the light and

Above—Image 10.1.
Facing page—Image 10.2.

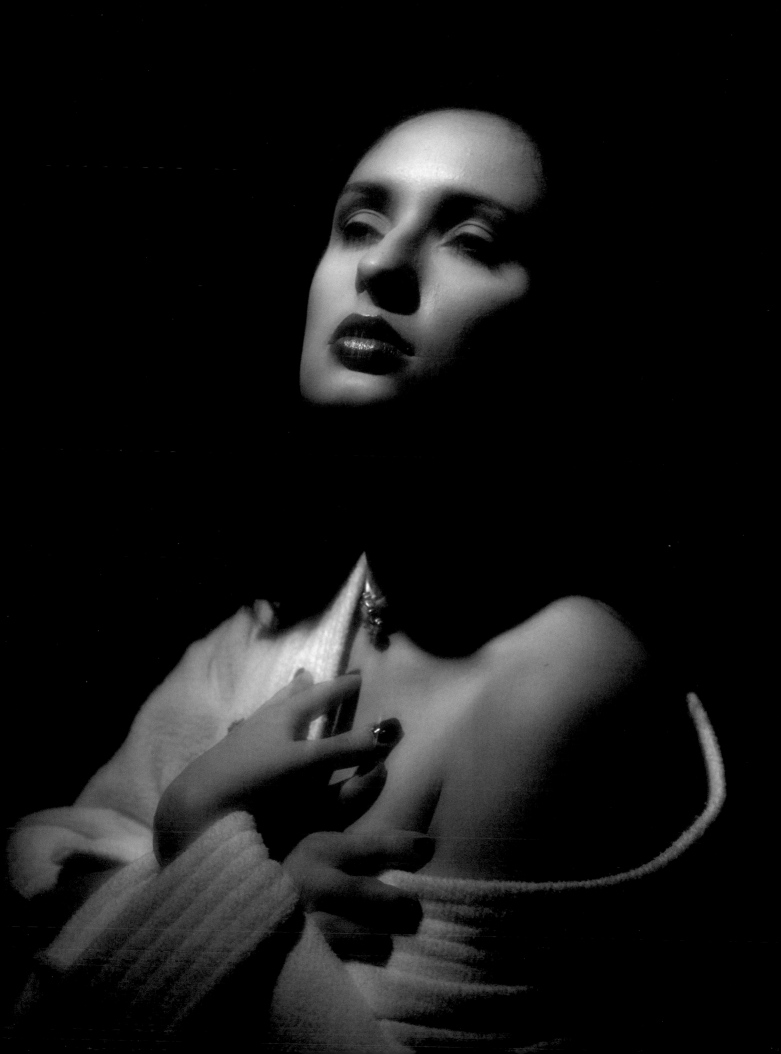

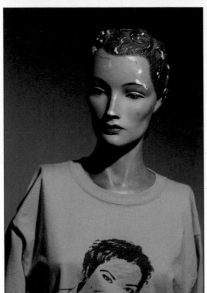

keep it off the background, resulting in an entirely different look. I'll use my trusty lighting assistant, the lovely and talented Madge, to demonstrate the technique.

Left—Image 10.4.
Center—Image 10.5.
Right—Image 10.6.

Hang a piece of foil on an accessory arm between the model and the background (image 10.3), and you've effectively eliminated most of the light falling on that background. Even a pure white background becomes a beautiful neutral gray when the light is flagged off. Be sure to set the Cinefoil so the shadow falls where you want it when you raise the light, and put another piece between you and the light to keep flare off your lens. Note that the results you get may be different from what you see here, just due to the amount of reflection in your studio and the distance between the light and the background.

Be sure the shadow falls where you want it to fall. Mostly, I imagine you'll want it to fall across the sweep where the background meets the

floor. However, when you couple an angled Cinefoil gobo with a powered-down strobe (for a large diameter f-stop and short focus), you can get some beautiful effects. See image 10.4.

Move the light a little closer to the subject and you've got both a hair light and background light. Crumple the Cinefoil into an interesting shape and you'll get background light effects that you can't get with traditional modifiers (image 10.5).

I mentioned earlier that Cinefoil can be used to create a "cookie," a theatrical term for the shadow thrown by something off-stage. You can create a cookie by first wrapping the bare tube with Cinefoil and placing the cookie shape in front of it. Even something as simple as a large piece of gauze can create great shapes (see image 10.6). You'll need to experiment with the depth of the wrap and the distance from the cookie to the background. Be sure that the cookie's strobe does not spill on your subject or on any part of the background that's important to the image.

With Madge back in her office, and while waiting for my model to arrive, I placed a bare-tubed strobe on a boom arm behind where my model would be standing. I intended to use this strobe to light the background as well as my model's hair and shoulders. Two sheets of Cinefoil (about 10x16 inches each) were attached to the boom in an inverted "V" shape, creating a cookie that would spill some light on the background while holding it off the rest.

A second bare-tube strobe was set on another boom above and in front of where the model would be. This source would be the main light. To keep the bare tube from flaring into the lens, I wrapped the backside with another small piece of Cinefoil.

I hung another sheet of Cinefoil above the model, using clothespins to attach it to an Avenger accessory arm on a standard light stand. This Cinefoil piece would keep unwanted light from the main light off of the background and would also act as a gobo to keep light from the rear tube off the lens. See diagram 10A.

The rear light was powered at $\frac{1}{3}$ stop brighter than the main light to give the model's hair a bright, strong highlight and to produce a shadow that would travel toward the camera. See image 10.7.

For this shot, I wrapped Cinefoil in a loose circle around a parabolic reflector, creating a large rough snoot. I wasn't worried about making a perfect circle; I think this effect is best when the snoot is imperfect. I found my preferred camera angle first, then placed the light with the Cinefoil snoot directly over the camera, in much the same position as that of an on-camera flash unit.

A second light, whether bounced into the ceiling or coming from a softbox, will be necessary to get an overall light that will fill in the deep shadows produced by the snoot. Keep the exposure value of this light at

I WRAPPED CINEFOIL IN A LOOSE CIRCLE AROUND A PARABOLIC REFLECTOR, CREATING A LARGE ROUGH SNOOT.

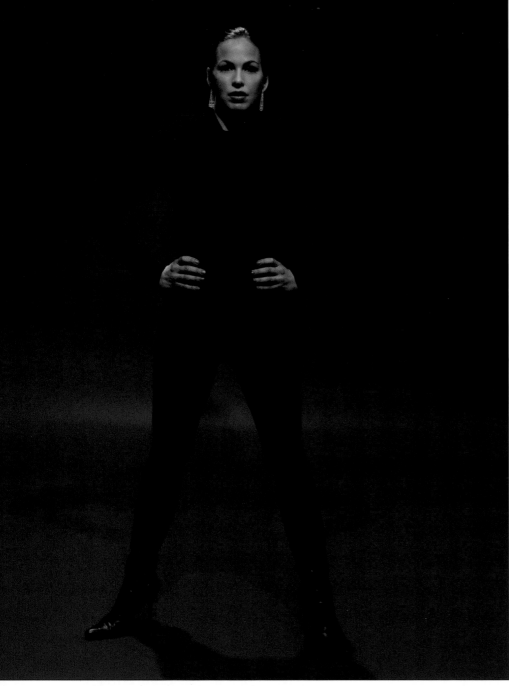

Above—Diagram 10A.
Left—Image 10.7.

least one stop below that of the snoot and be sure the second light does not create any shadows of its own on the subject. Double shadows, especially across a face, are very unattractive.

For image 10.8, I moved a piece of background material quite close to (almost butting up against) my model. You can see how close the background is by looking at the shadow cast by my subject's head. I measured each light separately to get the proper ratio, then together to get the final, working f-stop. The result is an intimate portrait with both a snapshot feel and an element of mystery.

Another interesting portrait approach is to put a white background behind the subject and light it evenly or use a sheet of milk-white Plexiglas or a Lastolite HiLite softbox (as detailed in *Christopher Grey's Studio*

Lighting Techniques for Photography). This is exactly what I did to create image 10.9. Create a long snoot by bringing two sheets of Cinefoil together, wrapping them around a parabolic reflector, and connecting the sides (to keep light from spilling out) with tape or spring-type clothespins. Narrow the throw of the snoot's by crimping the end using finger pressure, and then position the light as you wish. When metering, measure from the center of the snoot's throw, as that is where the light will be brightest.

Always looking for options, I opened the snoot into a more perfect circle and moved it into position. I also had to move the light closer to the subject, raising it to keep the edge of the snoot from intruding into the photo (see image 10.10). When you try this, you'll find that Cinefoil will throw a "spot" light with less edge falloff than that from a grid but will be slightly more difficult to control because the light will expand faster from a Cinefoil snoot than from a gridspot.

I keep a number of small black foamcore cards in the studio to use as flags or gobos, which keep light away from areas where it's not wanted. In some cases, the lightweight cards are too heavy for the job or can't be bent into whatever shape is needed. Cinefoil is a perfect solution for this problem, as it can be hung easily and weighs almost nothing.

I was very happy to have run across this material again. Since I did, I've found a number of uses for it in my portrait, beauty, and glamour sessions. It lends a look that's unusual and hard to duplicate.

Top—Image 10.8.
Bottom left—Image 10.9.
Bottom right—Image 10.10.

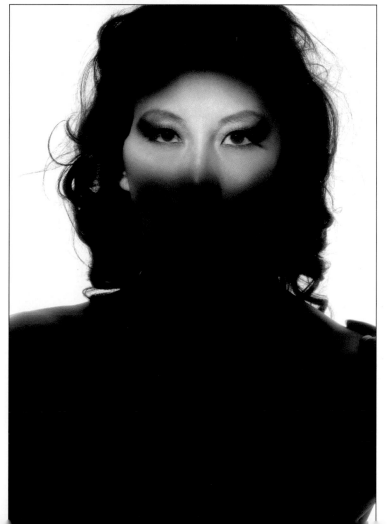

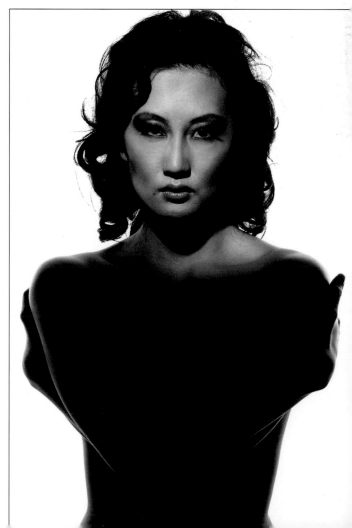

11. MOTION AND EMOTION

I'm fascinated by the ability of studio strobes to freeze action. However, I'm equally entranced by motion itself and will often supplement a portrait shoot with images made by the modeling lights alone. Making pictures in this manner, with long exposures and a hand-held camera is something of a crapshoot, as most of the shots are unusable. With film, of course, that measure of luck had to be balanced against the cost of processing. Since digital allows us the liberty of shooting as much as we want for free, why not roll the dice and take time to experiment?

I've found the emotion expressed through movement to be very different from that found in "normal" photography. Here are a few ways you might approach motion with your own work.

This first photo (image 11.1) was made during another photographer's shoot. I had been working for several days with Austin, Texas, photographer Keith Kesler. While Keith was directing his first shoot with model Sarah Parker, I took a few steps up a short ladder and looked down at the scene. From my vantage point, Sarah was in a beautiful position. An ISO of 400 allowed for an exposure of 1/15 second at f/4.5—not enough to completely stop my very slight movement on

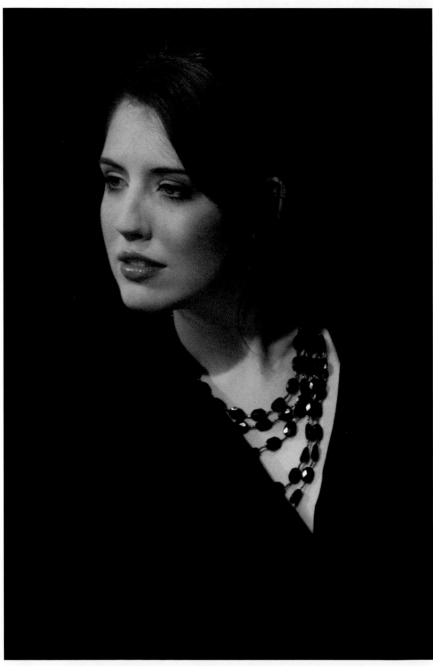

Above—Image 11.1.

Right—Image 11.2.

ONE OF THE WARDROBE STYLISTS HAD
BEEN PLAYING WITH SOME FAUX HOLLY
BERRIES AND HAD FASHIONED A
HEADPIECE OUT OF THEM.

the ladder. The final portrait has a degree of softness not attainable by other means.

Keith had set up a lighter background behind Sarah, to avoid tonal merger. Keith's single umbrella, which he had positioned directly over the lens's axis, threw plenty of light on the background but also illuminated the dark wall that I could see from my position. His second light, a small accent on the back of the model's head, separated the edges of her hair from the background and gave them life.

One of the wardrobe stylists had been playing with some faux holly berries and had fashioned a headpiece out of them that happened to fit her perfectly. Never one to miss an opportunity, Keith pressed her into service as a model. My exposure for this shot (image 11.2) was considerably longer, ½ second. Since I was bobbing and weaving around the set (to avoid getting into Keith's space), there is more motion and blur than there

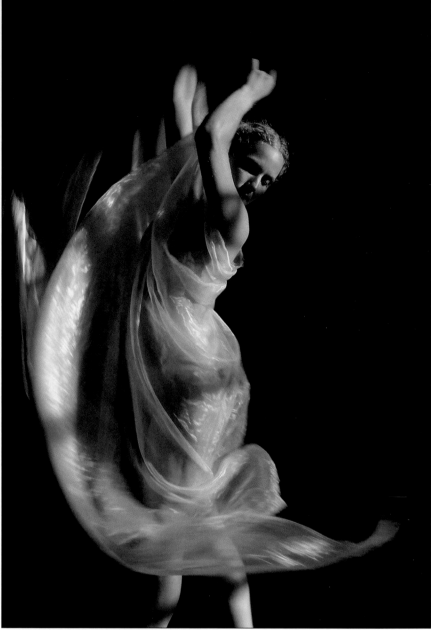

was in the previous example, even though I would go as still as possible when pressing the shutter. Her movement was the wild card; it was impossible to predict. Still, the dramatic lighting and colorful headdress made for compelling imagery.

Another technique is to move with the subject, shooting at the end of a predetermined movement. For image 11.3, I asked my model to simply rock back and forth. When she reached the end of the movement, her head was stationary for a moment, although the rest of her body was still moving. I moved back and forth with her, keeping her eyes in the same place in my viewfinder throughout the movement. The shutter speed for this image was ¼ second. I used only light from the modeling lamps in the large softbox at camera left and the strip light at camera right. The two lights had to be moved toward or away from the model to get the correct exposure balance. The result is a nice mix of motion and stasis.

Interestingly, you may not always have to shoot at a slow shutter speed to get images with a lot of motion.

Twice a year, for about a month at a time, the sun provides stunning light through my studio windows. During spring and fall, it's just low enough in the sky and in the right position to throw perfect, window-shaped shadows onto one of the shooting walls.

Left—Image 11.3.
Right—Image 11.4.

I ALSO ENJOY SHOOTING DANCE OUTDOORS, AND FOR THE LAST FEW SUMMERS, I'VE WORKED WITH MY FAVORITE DANCER.

I prepared for the shoot by placing a black background at an angle to the wall and out of the sunlight. My dancer had a relatively small space to work in but did a great job, nonetheless. A shutter speed of ⅟₆₀ second, metering the brightest portion of the sunlight, was enough to almost perfectly freeze her at the peak of action but wasn't enough to avoid capturing the blur of the still-moving cloth. The result is quite dramatic. See image 11.4.

Sunlight is always at least a little unpredictable. If you have this opportunity in your studio, you should spend some time looking at how the sun moves across the window and how the shadows will impact your concepts. Note also that you could set up a softbox with an exposure value one or two stops under that of the sun to fill the shadows, but that will affect how much action is stopped.

I also enjoy shooting dance outdoors, and for the last few summers, I've worked with my favorite dancer, Denise Armstead, collaborating on a body of work that's both unusual and evocative (see image 11.5). I've

Right—Image 11.5.

determined that I'm most pleased with images made with even longer exposures, up to a full second. Getting the shots with such long shutter speeds necessitates the use of a neutral density filter—especially in bright sun.

My favorite images happen when I'm moving in a way that's opposite to what my dancer is doing. In other words, if my dancer is moving sideways, I will move vertically or diagonally. Tracking a moving target with the mirror locked up for so long means the success rate for these images is even lower, perhaps only one in a hundred, and while I wouldn't want to pay film and processing charges for such a return, digital makes my little experiment quite painless.

THE ONLY WAY TO DETERMINE IF ANY OF THESE TECHNIQUES ARE VIABLE FOR YOUR OWN WORK IS TO PRACTICE.

The only way to determine if any of these techniques are viable for your own vision is to practice with them. Find a repetitive motion and vary the shutter speed. Use your camera's LCD screen to gauge the effect until you find a combination of motion speed and shutter speed that you like, then bang away. Shoot much more than you typically would, and be merciless when you edit. Deliberately shooting with motion, and without the benefit of flash (see the next chapter), will mean your success-to-fail ratio will be low. That's OK. You'll find that the ratio will improve with experience.

12. DRAGGING THE SHUTTER

"Dragging the shutter" is an old-school phrase for keeping the shutter open long enough when using flash to register ambient light and make it part of the composition. While wedding photographers frequently allow 35 to 40 percent of ambient light to register along with the flash, it's usually done using shutter speeds that rarely go below $\frac{1}{60}$ second to avoid background blur.

My studio is not set up for ambient light sets, so I reserve this trick for those times when I'm on location and can find spots where the ambient light is both attractive and useful. Of course, the color of the ambient light is a concern; incandescent light can be quite pretty, while fluorescent light rarely makes the grade, at least for color images.

THE FIRST THING YOU SHOULD DO ON LOCATION IS THOROUGHLY SCOUT YOUR SURROUNDINGS.

The first thing you should do on location is thoroughly scout your surroundings. Think in terms of mild to strong telephoto lenses because normal or wide angle lenses see too much and may pick up junky architectural details that interfere with successful compositions. When you decide on a spot, set up the camera and roughly frame in the shot. Meter the ambient light so you'll know what you're up against and think of how bright you want it to be.

Now, set the strobe (the main light) in position and attach the modifier of choice. This first image used a large, 4x6-foot softbox which, since I was constrained by space, had to be placed relatively close to the shooting area. This meant I would be limited as to how low I could power the unit—f/7.1 at ISO 400 (allowing me some depth of field), which also meant that I would have to gauge the effect of the ambient based on that f-stop.

When we work with strobes, we rarely need to concern ourselves with shutter speed because, even at the maximum the cameras will sync at, $\frac{1}{250}$ second in many cases, the flash burst is over and done long before the shutter closes. However, when we mix sources, we have to figure in the effect of the dimmest light, in this case the spotlight on the wall behind where my model would stand. Because the flash duration is so short, simply turning off the modeling light will eliminate any problem with extra light from that unit.

I had determined that an exposure of $\frac{1}{3}$ second at f/7.1 would produce a fully toned image of the spotlight, complete with a hot spot.

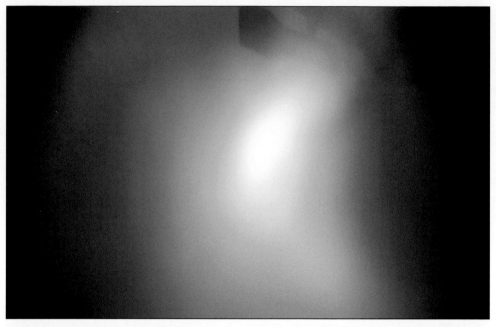

Image 12.1.

Image 12.2.

Left—Image 12.3.

This was way more than I wanted (image 12.1). I wanted only the hot spot to register, and quite softly at that. A couple of quick tests told me that an exposure of $\frac{1}{40}$ second would show only the hot spot, substantially dimmer than what I first saw and reduced to being only an accent light.

With the light in place, I made a test at $\frac{1}{40}$ second at f/7.1 from my chosen angle (see image 12.2). You can see a slight influence from the main light on the wall, but it's not much since the main light is so close to where the model will be and has lost a great deal of its strength by the time it gets to the wall.

Left—Image 12.4.
Right—Image 12.5.

With my subject in place, the result is a great mix of strobe and ambient light (image 12.3). The spotlight becomes the only color in an almost neutral environment and adds much needed warmth to the shot.

I wanted to use a corner in this location to lend a little dimension to the next shot. I set my 4x6-foot softbox in the adjacent room and aimed it at my new model's back. I knew that she would be overexposed in places but felt that would actually add to the shot.

It was rather dim in the room she was standing in, so I hung a white reflector panel on a stand to bounce some of the unused softbox light back onto the model. I was able to get the reflector high enough to see a passable nose shadow, but I would have preferred another foot of height in the room to get a more graceful sweep under the cheek. The reflector did its job admirably, but I was not impressed with the shadow from the lock of hair on her right eye. She tried keeping it out of the way, but it had a mind of its own. Image 12.4 was exposed at $\frac{1}{200}$ second at f/7.1.

As I said, the room was dim, but there was enough ambient light from windows at camera right to illuminate her at $\frac{1}{30}$ second, f/7.1. Image 12.5 was almost magical. The slightly warmer light from the street, much

softer than what had been reflected, gave her face a softness that appeared to wrap around from the softbox. It also did wonders for her naturally red hair and lit more of the wall she was standing against.

You can take this one step farther (many steps, actually) by using your studio lights to create a mixed light setup and slowing the shutter dramatically.

Set your strobes for low power output, the lowest possible, and create a lighting scenario that's appropriate for your moving subject. Use your light meter to measure the output of the strobe's modeling lights to determine a shutter speed that will provide enough streaks from the highlights, perhaps a full second, maybe longer (it will depend on how fast the subject moves and how repetitious the action). Measure the output of the strobe and tweak it until it matches that of the ambient. This is only a starting point, and you should test it using your camera's LCD to determine how much streaking is necessary to get the effect you want. When the two sources are properly matched, the image is a nice mix of motion and stopped motion. Image 12.6 was made at 1.3 seconds, f/16.

Yet another approach is to gel the strobe with a full CTO gelatin filter to convert its color temperature to that of incandescent light (approxi-

Below—Image 12.6.

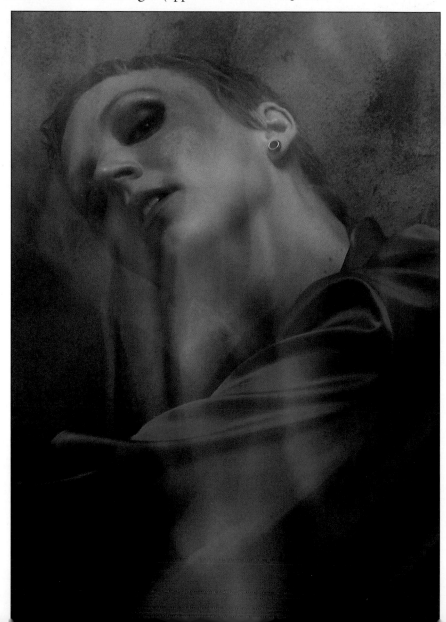

mately 3400K) while lighting the background with incandescent bulbs. In so doing, the color temperature of the two lights will match, but the strobe will freeze action, while the incandescent light will necessitate a longer exposure to register properly. Setting the camera's white balance setting to incandescent will produce a neutral exposure.

The model in image 12.6 was lit by a strobe that had been wrapped in a full CTO gel, to get its color temperature to that of incandescent light, and the modeling light was turned off. The background was lit by aiming an incandescent spotlight into my reverse cookie (see chapter 19 for more information) to splash a pattern of light back to the painted wall.

The shot of a belly dancer (image 12.7) was made at ⅓ sec-

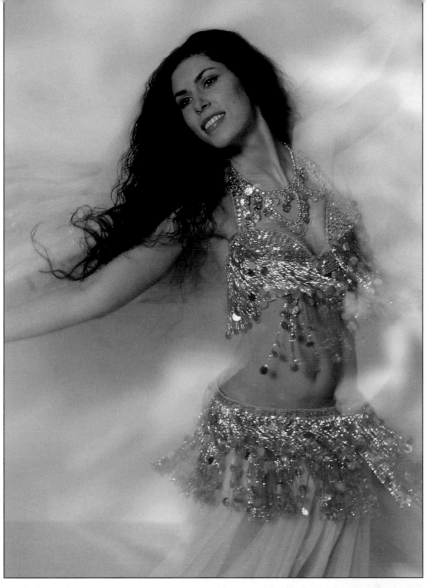

ond, but the proper exposure was ⅙ second. To get the background brighter than normal, I allowed the shutter to stay open for a full stop's worth of extra light.

I watched my dancer carefully, timing my exposures to the peaks of the movements of her head. I didn't care where her arms or torso went, only that her head stayed in approximately the same position for the length of the exposure. Needless to say, it took a large number of frames to get a terrific shot, with her head in place, the expression correct, and a beautiful semitransparency to the parts of her that moved throughout the exposure.

This last shot (image 12.8) was great fun to figure out. It's a combination of gelled strobe, modeling light, and camera flash, all put together to create a charming image of a beautiful woman.

The idea popped into my head when I came across a disposable film camera at a garage sale. The price was fifty cents, not nearly enough to ruin my day. When I saw it on the table, I knew I could do something cool with it.

I WATCHED MY DANCER CAREFULLY, TIMING MY EXPOSURES TO THE PEAKS OF THE MOVEMENTS OF HER HEAD.

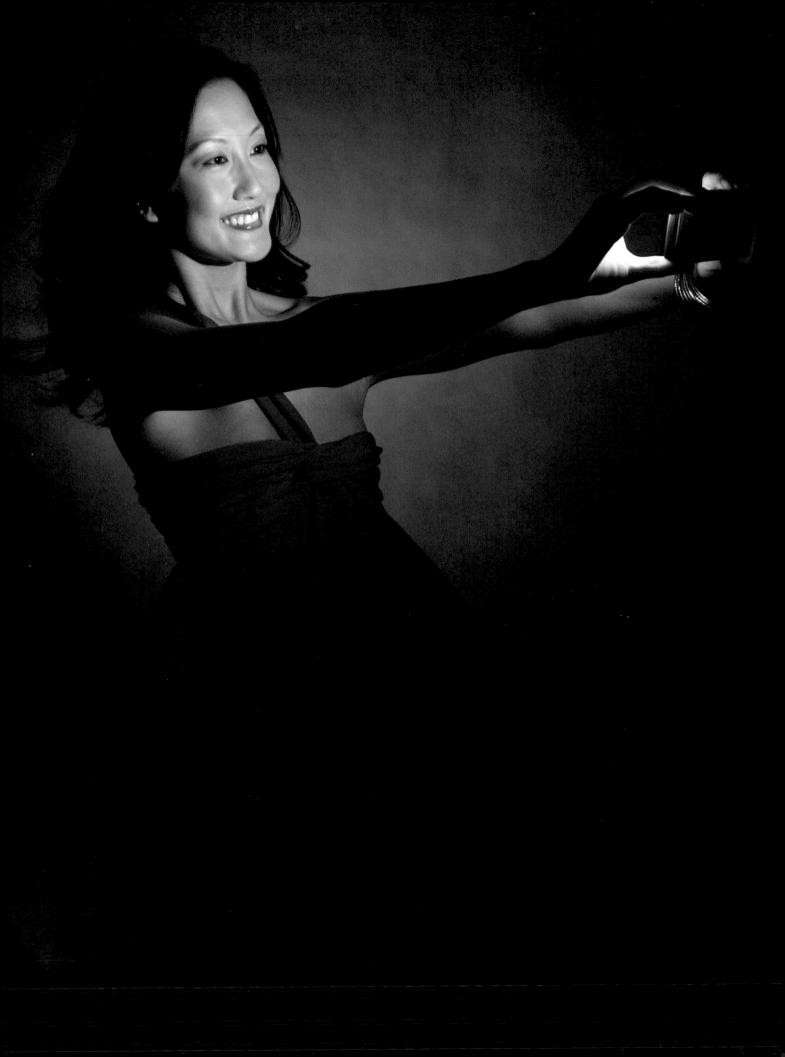

Above—Diagram 12A.
Facing page—Image 12.8.

THE MOST IMPORTANT LIGHT BECAME
THE MODELING LAMP ILLUMINATING
HER DRESS.

The key to the success of the image would hinge on all of the light sources having the same color balance. The strobe and camera flash would be daylight balanced, but any light I used for a long exposure accent would have to be incandescent. Diagram 12A shows how I positioned the lights. Take a look and keep it in mind as I discuss the situation.

Prior to getting the model on the set, I taped a small piece of full CTO gel over the camera's flash and used up one of the exposures, aiming it at the meter from arm's length just to know what f-stop I would need if I wanted a correctly exposed flash on her face. The meter read f/6.3, but I wanted the flash to be brighter, overexposing the image a bit to make it obvious that it was done with a flash from a camera. With that in mind, I set a strobe with a 30 degree grid and aimed it at the background with a full CTO gel wrapped around it to bring its color close to that of incandescent light. I powered that light to f/5.6 at the hot spot and turned off the modeling light so there would be no additional spill from it.

I'd decided that an exposure on my model's face, from the disposable camera's flash, would look great if it was ⅓ stop over the background. I knew the flash would be brightest where it hit her fingers and would also focus itself on her face if she aimed it properly.

The most important light became the modeling lamp illuminating her dress. This light, fitted with a 20 degree grid, would allow her dress and legs to blur over the course of the exposure. I wanted a long exposure, but not the longest possible. An exposure too long will turn the image to mush; if it's too short, you won't get the idea across. I can't tell you what is correct for your idea. You'll need to play with your toys and determine that for yourself.

The only unit that was emitting light was the modeling light aimed at the model's legs and skirt. The exposure, at f/5.6 at ½ second, was not enough to register properly since she was moving (it would have been fine if she was stationary). A couple of tests determined that an exposure of 1⅓ second at the same f-stop would brighten the skirt enough to make it interesting but keep all the other values the same. This exposure time would also create the right amount of motion.

My plan was to have the model spin across the frame and, at a predetermined point, press the shutter button, smiling into her camera's lens and setting off that camera's flash. The one studio strobe that was set to fire (on the background) would be tripped by its slave function. The other light (on her skirt) was on a different circuit that would not fire.

It took a few tries and a few minor adjustments in her end position before we got it right (image 12.8), but we did it with only a fifty-cent camera and within the small amount of exposures left after the tests.

13. THE BEAUTY BOWL

A beauty bowl (also called a beauty dish) is nothing more than a broad and fairly shallow reflector that fits over your studio strobe just as a simple parabolic does. While it acts as a reflector, there are modifications built into it that substantially change the quality of the light. The most prominent of these additions is a baffle, usually opaque, placed in front of the strobe tube so that light cannot exit the unit in a straight line. Instead, the baffle forces the light to flow to the sides of the bowl, where it mixes with the light that was naturally sent to the sides. The dish reshapes the light into a broader and softer beam, which is then sent toward the subject.

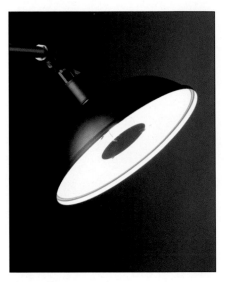

Above—Image 13.1.

I'm not familiar with every manufacturer's product, but I know that virtually every lighting manufacturer makes a beauty bowl. They all work the same way, with a baffle that's either built in or placed into the reflector through the umbrella slot, after it's mounted. The difference is in the design of the sides of the bowl and how efficiently that design works the light, as well as the quality (contrast, color, and direction) of that light. It is up to you to determine if your strobe brand's bowl does a good job for you.

The average diameter of such a reflector is 18 inches, more than enough to produce a unique look. As nice as the light is, there is a little secret to getting the most out of it. I'll grant you that the secret is a subtle one, but it makes a great difference in the final look of the image. That secret, simply put, is the distance between the light and the subject. While many photographers have a beauty bowl, most overlook this reality.

At 10 feet, a beauty bowl will act much like a parabolic reflector (see image 13.2). At that distance, it's a relatively small light source and, as such, it will produce fairly contrasty light with hard and defined shadows. You'll also see specular highlights (reflections of the small source that appear unnaturally bright). The light is not quite as hard as a parabolic because it's roughly five times the size of one (although it certainly can be used as a hard light in many circumstances), but its light falls short of its potential as a soft light modifier.

At 5 feet, the shadows appreciably open up, while the specularity of the light diminishes (see image 13.3). With a portrait, you'll notice that the contours of the subject's face become more modeled, which puts

Image 13.2.

Image 13.3.

Image 13.4.

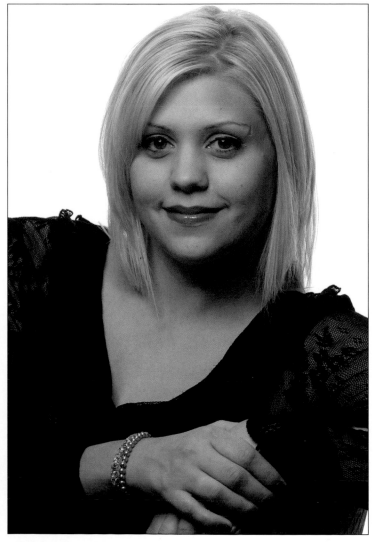

Image 13.5.

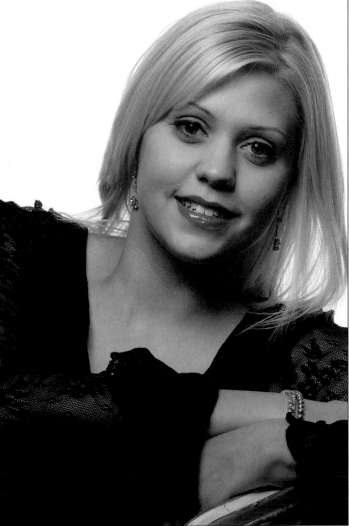

Image 13.6.

more personality into the face. This is very nice light, and it is certainly usable without major problems.

When I moved my light to a distance of 3 feet from my model, the beauty of this modifier's light became apparent (see image 13.4). Yes, it's closer to the subject than most shooters would place any light, but it's perhaps worth a little claustrophobia on the model's part to get light that looks like this.

Shadows are apparent but soft and open. Because of the proximity of the light to the model, additional shadows aid in contouring her face, under her cheeks, and around her jaw. Specularity is nonexistent, and the light looks almost liquid. As an aside, I asked my model, Jesse, if she was bothered by the closeness of the light. The answer was no. Studio strobes have a very short burst, measured in thousandths of a second. They are rarely a bother because they are so short.

BECAUSE OF THE PROXIMITY OF THE LIGHT TO THE MODEL, ADDITIONAL SHADOWS AID IN CONTOURING HER FACE.

At 2.5 feet, it would appear the beauty bowl hit the wall (see photo 13.5). Even with the light positioned right over the top of the lens, the shadows, especially around the model's eyes, were too pronounced to be considered acceptable for this portrait, although it's possible that a light as close as this to a subject would work well for a different facial structure.

In an earlier chapter, I postulated that by adding the width and height of a softbox, you could determine the most efficient softbox-to-subject distance. I think the same is true for beauty bowls. This series was done with an 18-inch diameter dish, and the height and width together equal 3 feet, which equals what I think is the optimum distance, at least for my taste and this situation. If you have a larger beauty bowl, be sure to try my "formula" to see if it works for you.

By the way, grids are available for beauty bowls, too. Should you want a little falloff of light, a grid is the way to go. (Image 13.6 was made at a distance of 3 feet with a 25 degree grid—look at the model's arms.) Depending on your brand, the price of the grid will vary but will still seem rather pricey. I think they're worth it, because a beauty bowl with a gridspot works well as a main light and also as a hair light. You'll note that I've used it many times in this book.

14. PHOTOGRAPHY AS CATHARSIS

Photography is as much about technique as it is about opportunity. As photographers, we constantly explore the opportunities each shot presents to us; the play of light upon the subject, the body language of the person in front of us, shutter and aperture combinations, etc. The list of things to think about as we're working is a long one, to be sure.

What about when we're not working? Many of us will come across places we might want to use for a shot "someday" or see an object that we think would make a dynamite prop. Sometimes we follow through, but often we don't, content to file the idea away for later and then forgetting about it entirely.

In this chapter, I would like to take a little departure from the norm and tell you about an opportunity that presented itself almost a year before it became a reality. I also want to briefly investigate the value of waiting for the right moment.

Over the years, I've been told by a number of clients that their photo shoot was a liberating experience, that they never thought they could look as good as they did or that they would have so much fun while working as hard as they did. Many photographers, myself included, believe that a properly directed shoot is not only fun but cathartic as well. In other words, the client's psyche benefits as much or more by the act of being photographed as the client does by the finished product. It's a lot like psychotherapy, but without the couch.

During a break in the cover shoot for a book, my model told me the story of her failed marriage and bitter divorce. The experience was so traumatic for her that she had destroyed every physical remnant of the relationship except her wedding dress. She explained that she had kept it because she wished to destroy it on camera and was waiting for the right concept to come along. She also said she'd mentioned this to some of the other photographers she'd felt comfortable working with, and though it wasn't a contest, there would be only one opportunity to get the shot.

The image that immediately popped into my head was a sequence of shots of her tearing the dress off her body and throwing it to the floor, but I knew it would be premature to present the idea. At the time, I didn't know how the photo sequence should begin or, more importantly, how it should end.

OVER THE YEARS, I'VE BEEN TOLD BY A NUMBER OF CLIENTS THAT THEIR PHOTO SHOOT WAS A LIBERATING EXPERIENCE.

I didn't want to rush the thought process, but I didn't want to forget about the job, either. Over many months, I let the mental picture develop slowly, like a print in a darkroom tray, until I saw the entire image in my head. At that point I not only knew the beginning and end of the story but I also knew how I had to pose it and even how to light it.

My shooting bay is, thankfully, rather large, about 22x35 feet. I realize that many of you do not have this amount of space. This lighting technique will work in smaller spaces, too, as long as the walls and ceiling are white.

I used the same principle for the basic lighting as I propose in chapter 19 except that I used four lights to create the main light and one additional light, mounted on a boom over the model and aimed at the model's back. The additional light was fitted with a 40 degree grid to keep light off the background itself. The background light was powered to plus $\frac{1}{3}$ stop over the main light and would guarantee the floor would photograph white.

I wanted to begin on a happy, hopeful note, so the first image would be a formal bridal portrait of her. What would happen after that I couldn't know, only imagine, but I knew it would be emotional as she ripped her elegant (and expensive) gown to shreds. The sequence was to end on a note of elation and release.

I contacted her immediately to present my concept. To my surprise and delight, she still had the dress and loved my idea.

On the day of the shoot she was nervous and apprehensive. She wasn't sure how she would react but warned the makeup artist that there would probably be tears. We tried to keep the atmosphere light but couldn't stop the rush of emotion when she put the dress on. After the artist repaired her eye makeup, we moved to the set where we discussed the sequence and pre-stressed certain seams of the dress with X-acto knives so that it could be ripped as planned.

I know this is a long prologue to the photo (image 14.1), but what we got was worth your wait. The sequence you see is the actual timeline of the shot. We got one good bridal portrait before emotion washed over her. Hope, fear, anger, tears, rage, release, and elation were all captured beautifully over the course of seventeen extremely intense minutes and eighty-nine dramatic frames. What you see are full-frame, uncropped images. The only shot that was repeated was the very last, as she walked out of frame, to get her body in the correct position without cropping.

When we finished the shoot, the relief on my model's face was quite evident, in spite of the tears she'd shed. I loved what I was able to achieve with her, and I'm certain she was just as happy with the shoot itself (she sent a poster-sized copy to her ex as a Christmas present!). We photographers rarely get a chance to produce images with this much power, or

Above—Diagram 14A.
Facing page—Image 14.1.

I KNEW IT WOULD BE EMOTIONAL

AS SHE RIPPED HER ELEGANT

(AND EXPENSIVE) GOWN TO SHREDS.

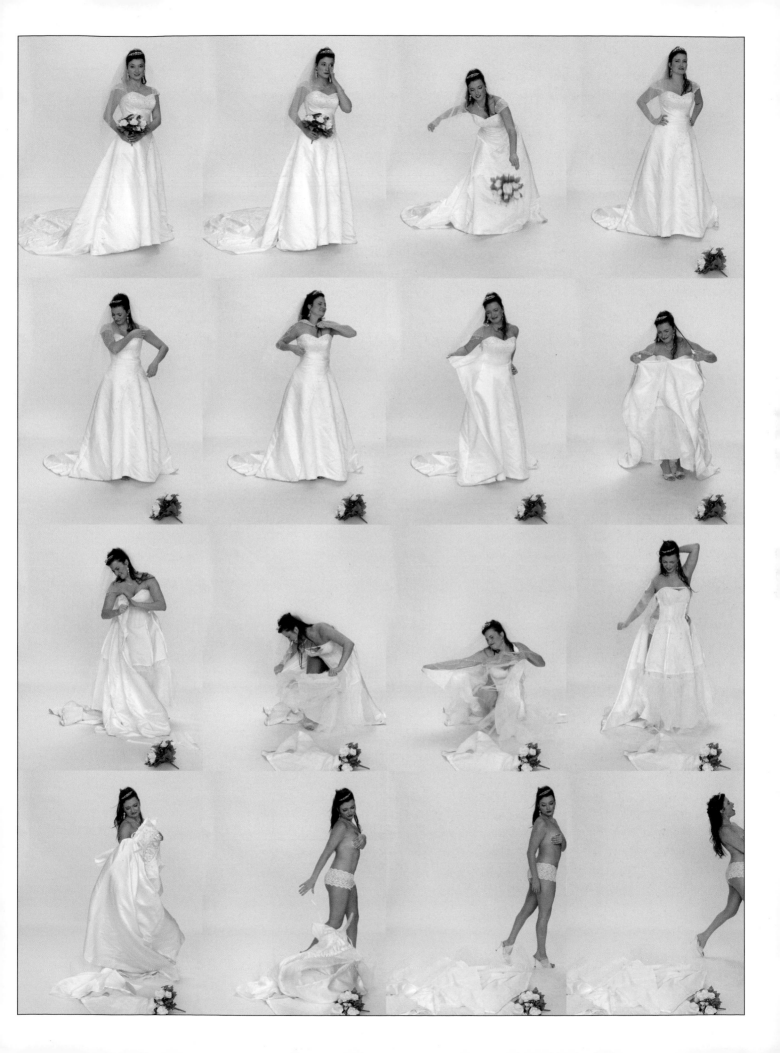

which impact our clients in such a profound and positive manner, but we should never let those opportunities out of our sight. Creating shots like this series is the greatest win-win ever, and something that won't be presented to any of us every day.

This shoot proved to be a truly cathartic experience for my model, whose demeanor became light and sunny as soon as we were done. She may remember the end of the session as the moment she was able to put her bad experience behind her once and for all.

So, what's the bottom line? Take the time to think the shot through and let the concept gel in your mind. Whether you have minutes or months before you have to pull the trigger, you have time to think, to plan your shoot strategy, and to create imagery that goes above and beyond. If you need more time, tell your client and take it. Don't let your clients rush you. It's in their best interests to let you do your job.

THIS SHOOT PROVED TO BE A TRULY CATHARTIC EXPERIENCE FOR MY MODEL.

15. GAUZE AND EFFECT

If you were shooting during the 1970s, you'll remember the popularity of soft focus imagery and the variety of soft focus filters and attachments available to produce it. Soft focus photographs were used for weddings and portraits, of course, but also for advertising, editorial, and stock images.

In the 1980s, soft focus fell out of commercial favor but stayed strong in the portrait universe. As Photoshop became more sophisticated, art directors sought out images that were "edgy" and hard, relying on altered hues and higher contrast to get the visual message across. Because the hard look was the exact opposite of soft focus, its use was very successful. The new look also fit nicely with contemporary style influences from punk rock, "heroin chic," and goth fashion.

Photoshop and digital imaging changed the professional approach for wedding and portrait shooters, too. "Photojournalistic" replaced "misty" as the most interest-generating buzzword on the wedding side, with portrait artists using Photoshop to tone down zits and wrinkles and Gaussian Blur instead of soft focus filters.

The hard look is still widely used, but trends come and go. Perhaps it's time to bring soft focus out of the closet and back into the gadget bag.

There are a lot of ways to achieve soft focus. Manufacturers such as Tiffen and Hoya make soft focus glass filters designed to screw into the filter rings of your lenses. Cokin's square plastic filters slid into a rack (that screwed into the filter ring), allowing for up to three to be used at a time, without vignetting. Cokin filters are now available mostly through outlets such as eBay.

Unfortunately, most commercially available soft focus filters just don't look right when used with digital. There's something about the effect that doesn't quite work. That's my opinion, of course, but I haven't used a commercially produced soft focus filter in years for that very reason.

My dear friend and mentor, the late Merle Morris, would use the cellophane wrapper from his cigarette pack. After tearing a small hole in the center, to keep part of the image totally sharp, he would manually hold the wrapper in place in front of the lens, shooting when ready. Although this is an inexpensive option, this author doesn't advocate smoking as an effective means of acquiring soft focus.

UNFORTUNATELY, MOST COMMERCIALLY AVAILABLE SOFT FOCUS FILTERS DON'T LOOK RIGHT WHEN USED WITH DIGITAL.

 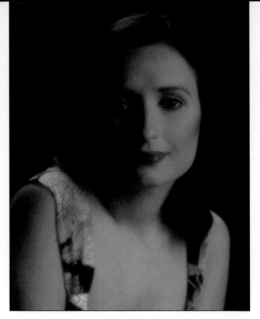

Left—Image 15.1.
Center—Image 15.2.
Right—Image 15.3.

Because ready-made filters are problematic, I wanted to find an inexpensive alternative that would work in either the digital or film environments, and I found what I needed at a local fabric outlet where I was able to purchase ⅛ yard each of a selection of gauzy fabrics. I had previously purchased a 58–72mm step-up ring as well as a 72mm UV filter. The samples were cut to fit inside the step-up ring and flattened against the UV glass. Buying a filter that much larger than my lens's filter ring meant I could be a little sloppy with the cutting and that I wouldn't see any vignetting in the corners of the frame.

Testing these fabrics requires nothing more than a simple lighting setup. I placed a medium softbox to the right of my camera. I positioned a beauty bowl, fitted on a gridspot, on the opposite side and aimed it at my model's shoulder. Both lights were powered equally.

I avoided using any fill light. I knew the shadows would be deep but wanted to see if any of the fabrics would affect them in any way.

The first photograph (image 15.1) was made using white (veil) netting. With a relatively wide weave, about 2mm between threads, this fabric produces a subtle softening effect, just enough to create visual interest.

Some of the fabrics were available in black, as was the veil netting. Because the black fabric will not carry any light along the strands (and mildly dilutes some tones), the effect is slightly different than with the white netting, but it is still very subtle. See image 15.2.

The cloth used in image 15.3 is known simply as "underskirt" material and is used to add flow and bulk under a gown. It's a pretty dense weave, so it will carry and "copy" light from one strand to another, sort of like a fiber optic. If your highlights are bright enough, you may see some flaring, "ghost" images. Its very narrow weave ensures a very soft image as well as some contrast reduction. If you look at the specular highlights on the model's lips and the catchlights in her eyes, you'll notice a characteristic four-pointed star.

BUYING A FILTER THAT MUCH LARGER THAN MY LENS'S FILTER RING MEANT I COULD BE A LITTLE SLOPPY WITH THE CUTTING.

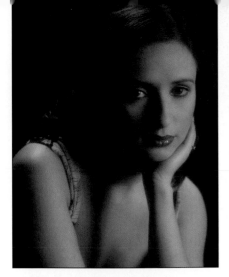

Image 15.4.

Image 15.5.

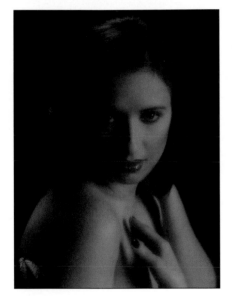

Image 15.6.

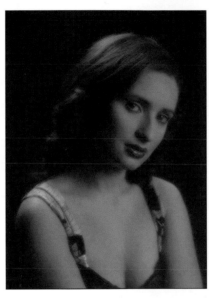

Image 15.7.

ONE CAN USE THE COLORED VERSIONS OF THESE FABRICS IN MUCH THE SAME MANNER AS COLOR CORRECTION FILTERS.

Not quite as dense as the under-skirt material, polyester organdy is woven tightly enough to flare the highlights but doesn't significantly reduce the contrast. It does tend to blend the tones though. I love what this fabric does to the highlights in image 15.4. The slight flare is a very charming effect.

Nylon glitter organza has extra-shiny thread woven into it so it catches and reflects light as the wearer walks around. These shinier strands seem to act as little mirrors, flaring and extending highlights, while their extra density cuts sharpness more than most of the fabrics I tested. It's a cool trick, though, if you're looking for a strong effect that's really different. See image 15.5.

One can use the colored versions of these fabrics in much the same manner as color correction filters, except that you won't be correcting anything, just improving it. Without changing the camera's white balance setting, place a piece of colored cloth into the step-up ring and make the pictures. Shots like image 15.6, made with a peach-colored nylon glitter organza, can be fabulous.

Of all the fabrics I've tested, basic nylon organdy is my least favorite. It's not that the effect is bad—it's actually quite nice, very soft and dreamy (see image 15.7)—but it's very difficult to work with because the weave is very dense and easily affected by light that bounces back from the subject as well as stray light in the studio. I found that I had to build a makeshift lens hood out of black illustration board that formed a "tunnel" at least 8 inches long before I got what I felt was an acceptable look.

These samples were made under basic conditions and meant to show the basic effects of the fabrics. Brighter highlights or more contrast will create more dramatic flares. Image 15.8 was made with peach glitter organza under a single light. Note the dramatic catchlights in her eyes.

You can also increase the effect by adding to a single piece of fabric with additional layers of the same or different material. I used two layers

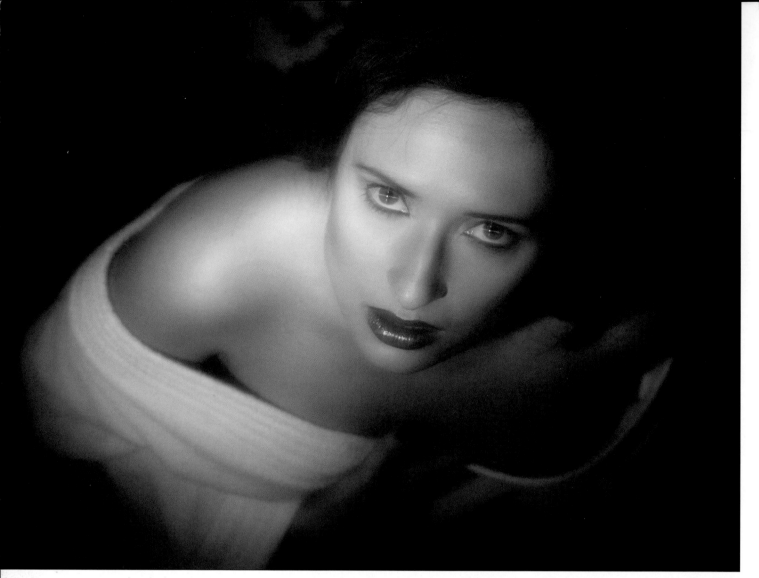

of black netting to get the effect shown in image 15.9. It's quite stunning, and it's a look that can't be achieved with commercial soft focus filters.

Because we're dealing with semiopaque, optically imperfect materials, the greatest threat to the success of your images is light that might fall on the fabric. Under normal circumstances, your lens will tolerate a minor and oblique light spill without noticeably damaging the integrity of the image. This is not true when you are using the materials I've just described. If a device can affect the shape of the light that falls on the subject, it can be affected by light that falls upon it. Be sure your lens is adequately shielded by a bellows, shade, or a flag.

The density of the fabric may require a small exposure increase, but that's easy to figure out. Take a meter reading of the main light and note the value. Now, just wrap an extra piece of fabric over the incident dome on your light meter and take a second reading from the same location. The density of the fabric will be accurately measured by the meter, and you can adjust your lights accordingly. It's also a good idea to custom white balance with the fabric in place over the lens before actually starting the shoot (except when a change in color is wanted).

Above—Image 15.8.
Facing page—Image 15.9.

THE DENSITY OF THE FABRIC MAY REQUIRE A SMALL EXPOSURE INCREASE, BUT THAT'S EASY TO FIGURE OUT.

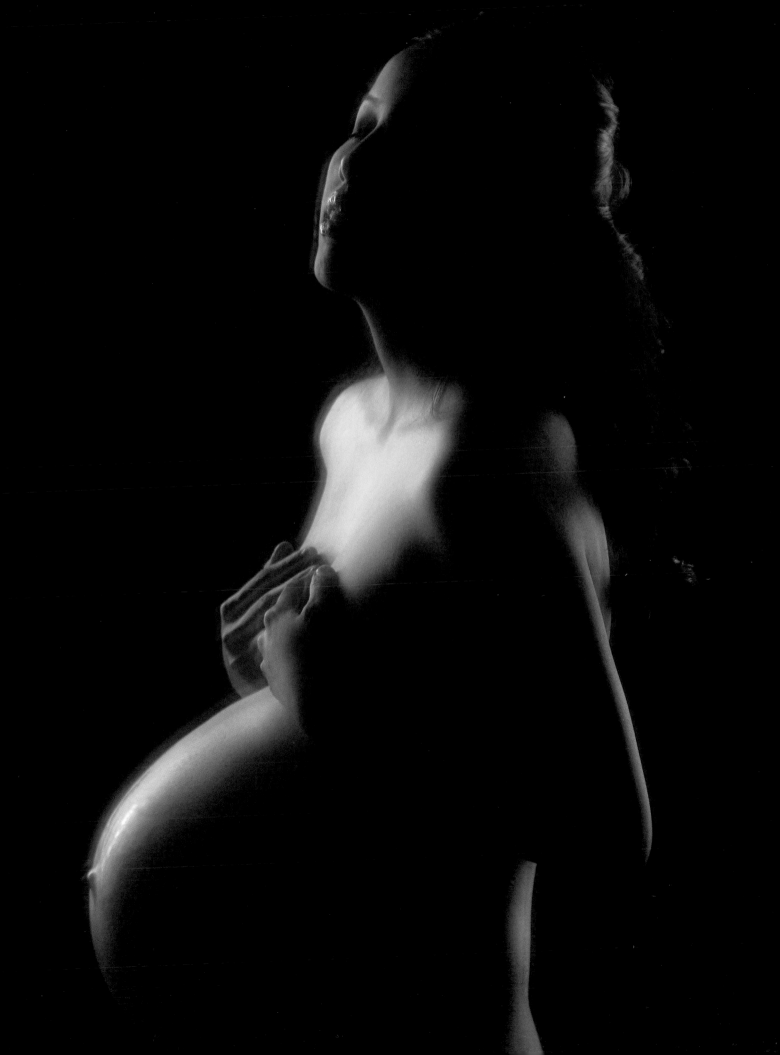

16. THAT BEAUTIFUL, SOFT, OVEREXPOSED, GRAINY, HIGH-KEY, ONE-LIGHT RETRO LOOK

There are techniques that we used to be able to get on film that are difficult to achieve in the digital environment, and exposing for the shadows with high speed (read: grainy) film is one of them.

Retro styles are important to understand because they are always viable for sales. Techniques, as I've always maintained, are as important to your business as a command of digital photography and the restraints it demands. The more you understand, the deeper your bag of tricks—and there is no limit to what the depth of the bag should be.

In *Christopher Grey's Studio Lighting Techniques for Photography*, I wrote at length about what happens when a subject is placed directly in

Left—Image 16.1.

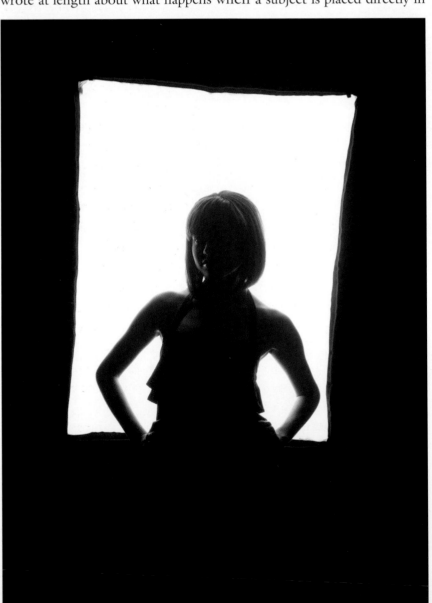

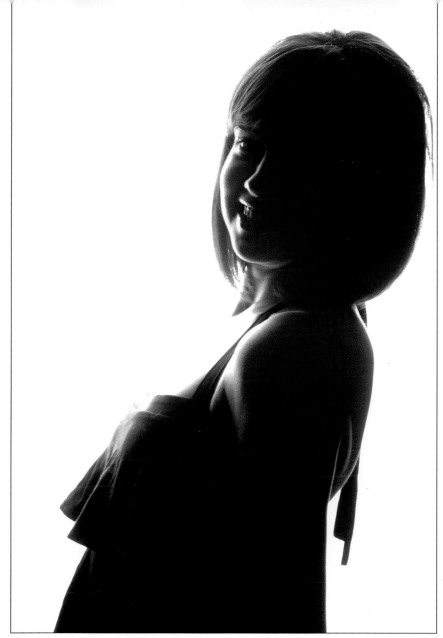

Above—Image 16.2.

front of a softbox. This chapter is based on that technique but takes it a step farther.

Back in the 1970s, high-speed color transparency film was push-processed to increase contrast and grain. Images were often made with a soft focus filter on the lens, to lend an air of mystery to the image that went with the times. As I've said, soft focus filters do not work well with digital cameras—the effect is just not the same and looks less than wonderful. That puts the burden on us to replicate the effect, digitally, and to contemporize the look in the process.

For this chapter, I will break a few rules and use Photoshop to create a look that is both vintage and evocative. Did I mention I'll only be using one light?

My light here is a simple 3x4-foot softbox, and my subject will be placed right in front of it. I want the light so close to her that it will flare and wrap around her to the point that her contrast is seriously lowered. Bear in mind that the far-ther your subject is from the light, the more accentuated the silhouette effect will be. For this exercise, I wanted as much flare as possible, so I placed the model right next to it (image 16.1).

When I set the softbox, I metered the light by placing the light meter flat into the surface and popping the flash. The meter read f/22. After some experimentation, it appeared to me that the correct f-stop to get the detail (or lack thereof) that I wanted was at plus five stops, or f/4 in this case. When you try this, you'll need to have a flash strong enough for a big pop, but it's not that tough because you'll be working with the light at its source. Falloff won't be an issue.

By itself, the image is less than stellar (image 16.2). It's flared, washed out, and flat. Note that, in the digital world, areas of pure white can't be reclaimed—there's no way to bring detail back into them. That's a bad thing for most shots, but it's something I count on for this technique.

Image 16.3.

Image 16.4.

Image 16.5.

Next, I took the image into Photoshop. I began by duplicating the layer, then I set the new layer's Blending Mode to Multiply and duplicated the layer again (see image 16.3). The Multiply mode creates density in any detail except pure white. For my shot, the second duplication was too dark, so I dialed the opacity back to a point that I liked. In this case, it was 30%.

I flattened the three layers and made two new duplicates. Next, I turned off the uppermost layer and selected the middle layer to work on (image 16.4). I used Levels to burn out more of the highlights (image 16.5).

Image 16.6.

Image 16.8.

Image 16.7.

My next task was to select Filter>Blur>Gaussian Blur. For this sample, I used a radius of 10 pixels (image 16.6). I then selected Image>Adjustments>Hue/Saturation and desaturated the layer by 75% (image 16.7). I moved the layer to the top of the queue and set its blending mode to Soft Light (image 16.8).

As my next step, I re-selected the middle layer and used the Magic Wand tool to select all of the areas of pure white (when you do this, be sure that the Contiguous box is unchecked) with a Tolerance of 20 for this image. I chose Select>Inverse to change the selection to non-white areas (image 16.9) and then chose Select>Feather and entered a feather amount of 2 pixels. This ensured a smooth transition (image 16.10).

Next, I chose Filter>Texture>Grain (image 16.11, following page). I selected Grain from the top pull-down menu and then set the Grain Style field to Regular to add the fake grain structure. My settings were Intensity: 30 and Contrast: 50. You can use my settings or adjust them to suit your preferences. See image 16.12.

For the final touch, I removed the RGB colors of the grain by changing the Blending Mode of the grain layer to Luminosity. My last steps were to flatten the layers and save the image.

Left—Image 16.9.
Below—Image 16.10.

The end result (image 16.13) is beautiful, soft, and compelling. It also looks a whole lot better than any result we could ever get with film because the whites are so much cleaner. (By the way, you can add even more grain to any image by de-flattening the layers and creating another Luminosity layer. It will be at the top of the list, so just hit Control-F or Command-F. When you're happy, flatten the layers and save the image.)

Right—Image 16.11.
Bottom left—Image 16.12.
Bottom right—Image 16.13.

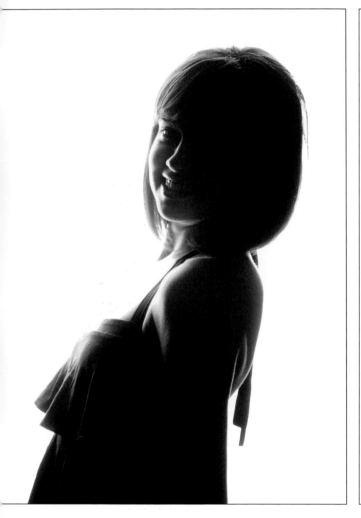

17. THE DOUBLE MAIN LIGHT

Above—Image 17.1.

I've written about using a double key light approach several times, both in my *Master Lighting Guide for Portrait Photographers* and in my columns for shootsmarter.com and prophotoresource.com. It's such a cool technique that I imagine I'll write about it again in the future, as I keep finding uses for it and new ways to work with it. If you play with it just once, I'm sure you'll be impressed by the level of its coolness and will find many applications for it in your own work.

The principle is simple: Use a large softbox (the bigger the better; in this case, I opted to use a 4x6-foot unit), along with another light fitted with a gridded parabolic reflector or beauty bowl (image 17.1). The softbox will provide an underexposed but overall soft light, and the reflector will give the most important part of the image a correct and proper exposure.

To prepare for the first series, I began with a grid-spotted beauty bowl and set both lights approximately 6 feet from where my model would be standing. I placed the softbox behind the beauty bowl, keeping both lights at roughly the same angle. This meant that the softbox (as measured at the height of the strobe unit) would be higher than the beauty bowl when the beauty bowl was centered against it. Think of it as a straight line between both strobe units, because we want the same angle to the light so that we can avoid any possibility of conflicting shadows.

This setup takes a little extra time because both sources must be measured separately, then together. While my model was in makeup, I found the hottest area from the gridspot and measured it with my flashmeter, tweaking the power output from the pack until I had a perfect f/11.

I wanted the softbox light to be two stops under the other light. I turned the beauty bowl light off and sparked up the softbox, changing the power output until it was a perfect f/5.6—two stops less than the other light.

When I switched the other light back on and again metered at the hot spot, I found that the extra light increased the exposure by $\frac{1}{3}$ stop (the effects of light are additive), which meant my camera's effective aperture would be f/13.

Finally, I placed a strip light on a boom, centered directly over the model's space but about 2 feet behind it to avoid having light spill onto

the top of her nose. This light was powered up ⅓ stop brighter than the double main light.

Left—Image 17.2.
Right—Image 17.3.

Once you have the position of the lights figured out, it's a simple matter to make adjustments if you change the position of the gridspot or the softbox: simply turn off whichever light you didn't move and change the power of the other until you get to the same, original, f-stop. I had to do that for this first shot (image 17.2) because the 25 degree grid threw a light that was too broad at its distance from the subject and the actual effect of the double main light was diminished. I found I had to move the beauty bowl in about halfway, to about 3 feet from the model, in order to get the effect I was looking for—a combination of the two lights that would show both underexposure and perfect exposure on the same subject and location.

Notice how the gridspot forms a gentle circle of soft light that seems to dissolve in from the slightly darker light below. This is the beauty of the double main light setup. You can spotlight your subject but still maintain a great deal of detail in the remainder of her form.

Of course, you can use regular parabolic reflectors, too. For the next shot (17.3), I removed the beauty bowl and replaced it with a parabolic reflector and a 20 degree grid. I had to re-meter and re-power the parabolic as its light is more concentrated than that of a beauty bowl. When I had achieved my target reading of f/11, my model and I were good to go, and we continued with the shoot. Notice that the background is slightly darker here because the reflector is more narrow. You'll also note that the circle of light is more tightly defined and the shadows are harder because the light source is smaller.

When your subject wears white or light-colored clothing, you can drop the exposure from the softbox even more than two stops and still retain detail. If your strobes don't allow linear power changes (and are accurate when making adjustments up or down), you'll have to turn off the gridspot each time you re-meter the softbox. The exposure from the softbox, for this shot (image 17.4), was dropped an additional full stop to an effective f/4. You will still have to re-meter the two lights together to get a working f-stop because the sum output of the two lights will change.

I switched to a 10 degree grid for the next shot (image 17.5) to show what a narrow gridspot would look like. It's a look that I personally like

A TECHNICAL TIP

I recently read about the Bowens Grid Diffuser (www.bowensusa.com). It is made to attach to the Bowens 75 degree Softlight reflector. Essentially a double main light, it's built with a center grid surrounded by white diffusion and features an unchangeable 3:1 ratio (1½ stops) between the sides and the center. It won't be as adjustable as what I just demonstrated but you might want to take a look.

very much, and I often use it for senior portraits because my clients like the unusual look as well. I also bumped the power from the softbox down an additional stop, making it four stops below the parabolic. I could tell from my camera's LCD that the exposure on the background was becoming dangerously dark and would soon be ineffective for this series. The solution was to move all of the lights farther from the background (ahh! the Inverse Square Law at work!). By moving everything farther from the background, the amount of exposure reduction due to falloff was reduced and background detail was maintained. The ratio and spacing of the three lights to the model remained the same.

This double main light technique is something you'll never see the "fast photo" outlets attempt. They use preset lighting scenarios that, to my eye, look like junk. They are simple, foolproof, and without a spark of creativity. Play and practice with techniques like the double key and you'll produce results that those practitioners can only dream about.

Please note that your results, based on your equipment, shooting style, etc., will, and should, be different from mine. The amount of reflectivity from the walls of your studio, the size of your studio, and other factors will make a difference in your results. However, the premise is sound and will work beautifully. Your assignment is to make it work for you.

Left—Image 17.4.
Right—Image 17.5.

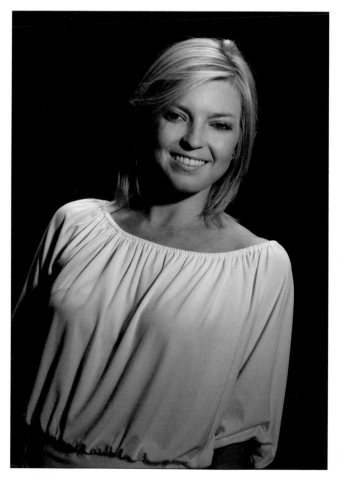
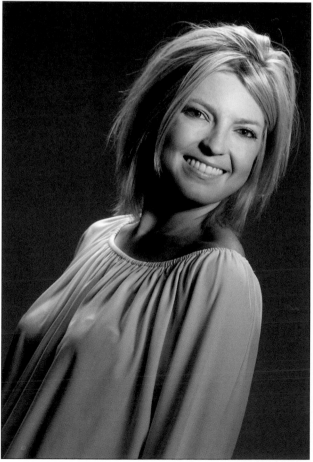

18. THE TWO-SOFTBOX MAIN LIGHT

In this chapter, we'll continue our search for soft light by using two softboxes to do the work of both main and fill lights—but we'll make the shot look as if it is is lit using only one source. The reason this will work so well is because, when you use this technique, the lights are placed very close together and each side can be individually controlled.

I've said many times (and it's true, every time) that larger sources equal softer light. It's also true that softer light makes more mature clients look better because it tends to wrap around those badges of age, wrinkles. While I have no problem with such things, and have certainly earned every one of mine, I can also understand why someone would want them minimized. This light will do that beautifully.

Above—Diagram 18A.

I'VE SAID MANY TIMES (AND IT'S TRUE, EVERY TIME) THAT LARGER SOURCES EQUAL SOFTER LIGHT.

Begin by setting up two softboxes—the larger the better. I used my two large 4x6-foot softboxes, but two medium softboxes will work as well, provided they are set closer to the subject. Also, bear in mind that this is a technique that, in my opinion, will work best on no more than two individuals together—a couple perhaps—because the light on one side or the other will be dimmer.

To begin, I turned the softboxes at an opposing angle of approximately 45 degrees and set them close enough so the corners almost touched. I racked both of them to the correct height to get a proper nose shadow. (Note that the angle between the boxes will allow you to shoot through them, while the height will make the light attractive.) I centered the subject between the two softboxes.

Here's a model's-eye view diagram of the lights (image 18A).

Next, I measured the output of each light individually. I wanted the light on camera right to be one stop less than the other, so I metered both lights separately. (When you do this, you'll want to be precise, and the only way to be accurate is to measure the lights separately. When you have the correct ratio, measure the units together, as the output will change.) This new reading was the working aperture. There are times when a photographer must tweak the power output to reach a whole stop or perfect

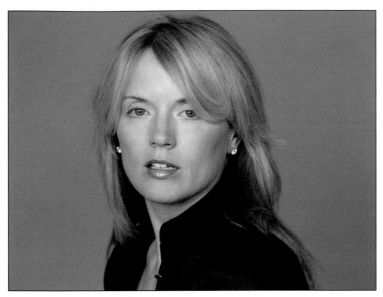

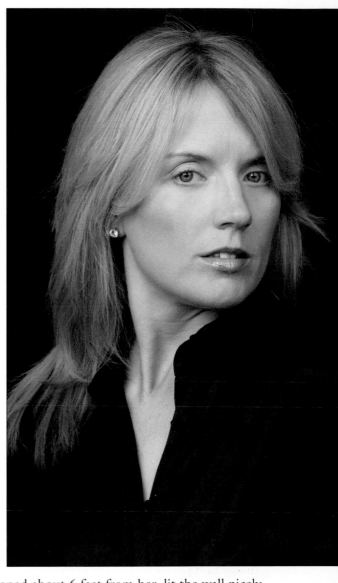

Left—Image 18.1.
Right—Image 18.2.

third, and it's best to do it on the lower power side. For this scenario, the adjustment won't be more than a tenth or two of a stop and will not seriously impact the look of the light.

For the first shot (image 18.1), I placed my model 6 feet from the background, which was simply a gray wall. Because she was relatively close, the two lights, positioned about 6 feet from her, lit the wall nicely and returned a tone slightly darker than its actual value.

I liked the effect but felt the shot would be more dramatic with a darker background, and the solution was very simple: I moved the model and the two lights another 6 feet from the background. The amount of light that fell on the model was exactly the same, as was my working f-stop, but the light on the background was only ¼ as strong, reducing the value of the light gray wall to a charcoal gray. This is just one of the many ways you can make the Inverse Square Law work for you to control the look of your images. See image 18.2.

This will also work if both softboxes are set vertically, although the catchlights in the subject's eyes may have more of a "cat's eye" look, especially if the lights are very close. This is not necessarily a bad thing; you'll have to make that decision for yourself, as there's no "rule" about such things. It's all about the look.

I LIKED THE EFFECT BUT FELT THE SHOT WOULD BE MORE DRAMATIC WITH A DARKER BACKGROUND.

Like horizontally placed softboxes, the effect of power output differences is subtle but valuable. The next photograph (image 18.3) was made with two large softboxes set vertically and with equal power. It's quite lovely.

Without moving anything, I stopped down the power of the camera-right softbox by one stop. Those of you whose strobes do not power down in equal stages will have to remeasure one strobe against another, one at a time, to get the correct output, then meter again to get a final working aperture. If your gear powers up or down in equal stages, you'll

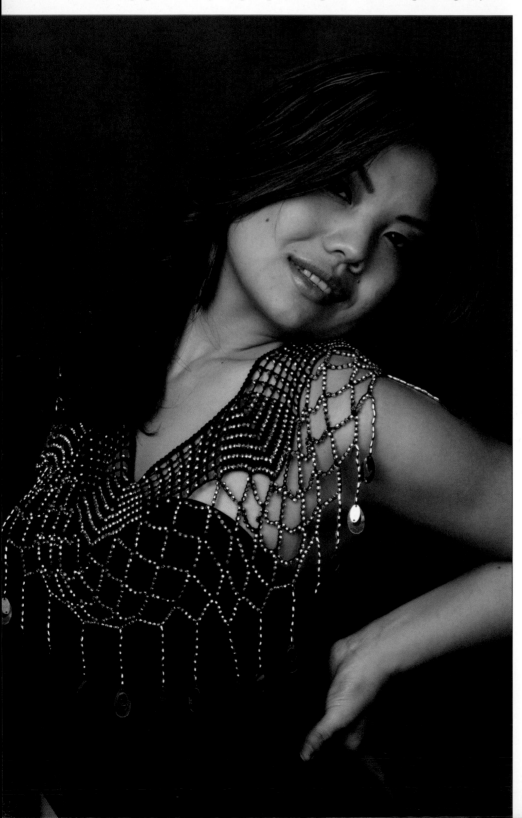

Left—Image 18.3.

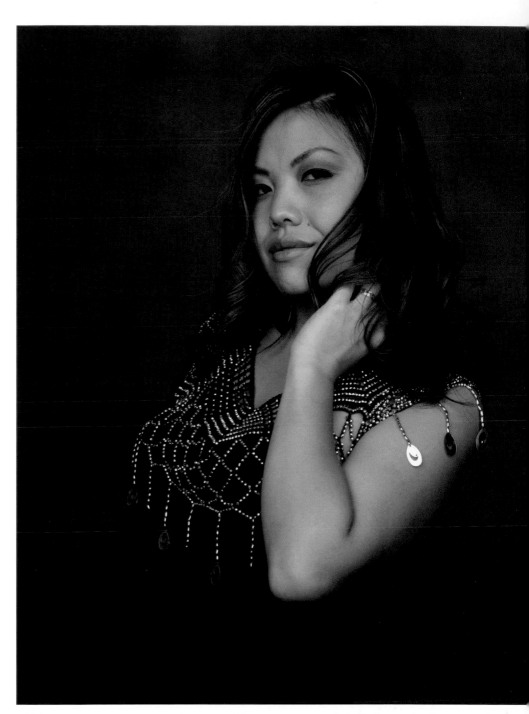

still have to re-meter to get a new working aperture, as it will change and the change must be dealt with or your exposure will be incorrect. As I said earlier, the effect may be subtle, but it sure is beautiful. See image 18.4.

As I always do, I suggest you find a subject and play with this technique until you thoroughly understand it. You may find you like a ratio of $\frac{1}{3}$ stop, maybe even two full stops. It's entirely up to you, and that is one of the many things that will distinguish your work from that of others.

19. THE WALL OF LIGHT

We all look for soft light. Umbrellas are useful, to a point. Softboxes, by design, are perhaps even more useful. Both will provide the softest light they're capable of when placed close to the subject because a broad source equals soft light. Unfortunately, there are times when that pesky law of physics, the Inverse Square Law, rears its ugly head and spits on your parade. For example, if you want a large area lit softly and evenly, so your model has room to move against an unchanging background, there's no way you can set the softbox or umbrella you need close enough to your subject to do the job you need it to do while giving the model and yourself the space you need to work in.

Now, I'm counting on the fact that your studio space is painted at least some shade of a relatively neutral color. After all, no one wants to see reflection from a chartreuse wall in the eyes of a portrait subject. In truth, this technique will work with just about any color of wall, perhaps even chartreuse (never tried it myself—I'm professionally allergic to chartreuse), because you can use your digital camera's ability to custom white balance to almost any color whether it's Robin's Egg Blue (sheesh!) or Tucson Taupe (I'm rooting for Tucson).

What we'll do here is use the back wall of the studio as the light source, aiming several strobes into it and using the bounce to light the subject. The result, a very large source, will allow our model to move around on the set (if that's desired) because the extra distance provides so much more depth of light.

I've set three strobe heads aimed at the back wall of the studio at a height of about 8 feet and angled them so the light will bounce from the wall to the ceiling and back to the model. The size of this large blast of light makes that entire side of my studio a light source. The larger the source the softer the light, remember? Also, because I place each strobe about 6 feet from the wall itself, the distance of the strobe to the wall, plus the distance of the bounce to the ceiling, plus the distance to the subject adds up to a great deal of depth of light, the distance over which the strength of light is constant. See diagram 19A.

When you use the lights as I've indicated, and against any color of background sweep, the floor of the sweep will photograph darker (see image 19.1). It will begin near the model's feet and get darker as the light

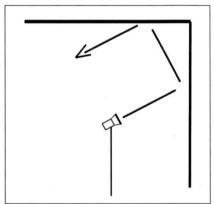

Top—Diagram 19A.
Bottom—Diagram 19B.
Facing page—Image 19.1.

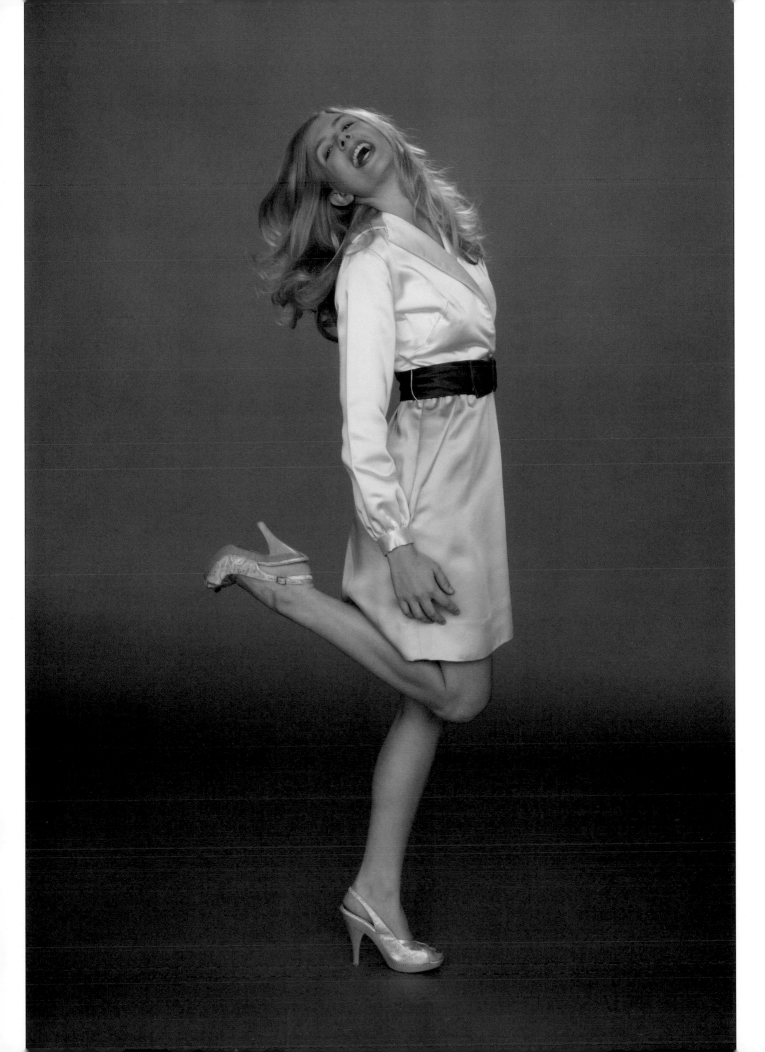

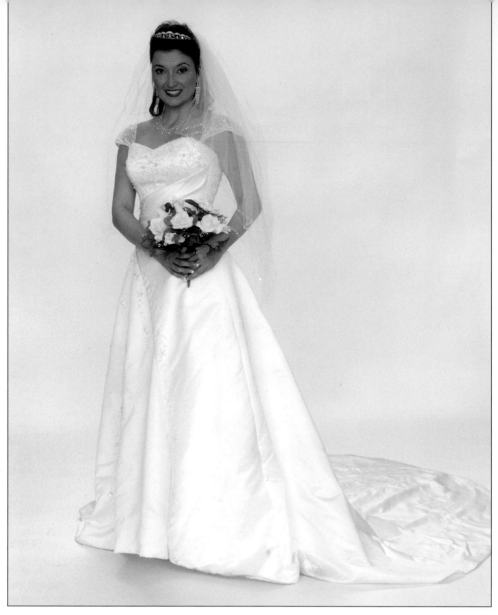

Left—Image 19.2.

BY THE TIME THE LIGHT HIT THE
FLOOR, IT BRIGHTENED IT ENOUGH TO
EVEN IT OUT.

moves to the far edge of the background. This happens because the angle of incidence is not working in your favor. In other words, there is no bounce back or fill to the camera from that light and it's falling off as it loses strength, even though the vertical portion of the background is lit perfectly and evenly.

This is easily rectified, if you want to do it, by adding a large source hair light behind the subject and aiming it downward to fill the part of the background that's not hit by the bounce. If you look at image 19.2 amd image 14.1, my subject from chapter 14, you can see the difference created by the extra, overhead, light, metered at $\frac{1}{3}$ stop over the main light, as measured at the model's veil. By the time the light hit the floor, it brightened it enough to even it out.

I've been called in to consult with many photo studios to demonstrate how they might use their small, mall spaces to their best advantage. Many of them use the two-umbrella approach—with one umbrella-fitted strobe on either side of the camera. This will produce soft light but is visual medi-

ocrity to my eyes. You have the means (a few bucks for paint at the hardware store), the dedication (you want to kick your competitors' butts) and the desire (you want to try things that will separate you from the rat pack nipping at your heels) to make this happen. I've frequently recommended this approach to studio owners, as I feel it would significantly improve the look of their images, and I am now recommending it to you.

When the lights are set, it's necessary to meter each one individually and from the spot where the model will be positioned. Tweak the power as necessary to get the same f-stop from each light. When all three register the same, take another reading with all of the strobes firing. The net result will be the working f-stop.

This is beautiful light, showing great detail and contour, despite being extremely soft (see image 19.3). Look at the hair falling over the model's face. Other modifiers—even softboxes—would create a shadow under the hair.

You can add accent lights, of course. In this case, I added a 2x3-foot softbox at camera left, slightly behind the model. When metering this

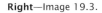

THIS IS BEAUTIFUL LIGHT, SHOWING
GREAT DETAIL AND CONTOUR,
DESPITE BEING EXTREMELY SOFT.

Right—Image 19.3.

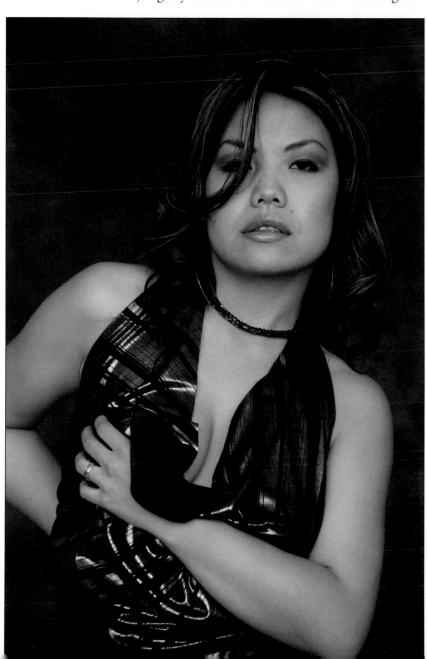

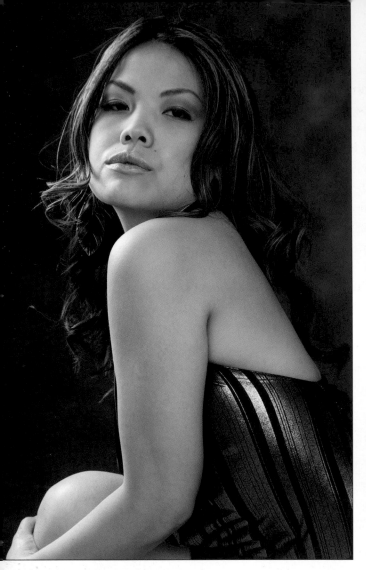
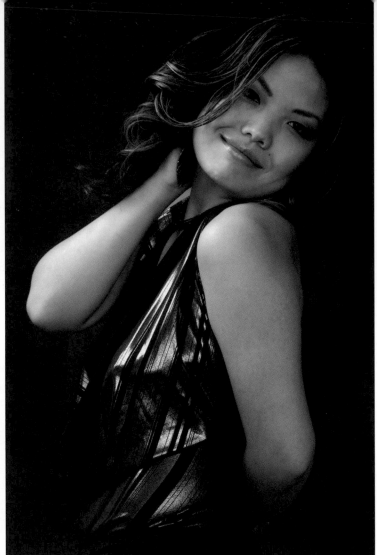

Left—Image 19.4.
Right—Image 19.5.

light, you'll need to place the meter at a spot where it overlaps light from the wall. I placed my meter close to the model's chin and adjusted the power until the highlight on the left side was ²⁄₃ stop brighter than the right side. Now, you have two options: The first image (19.4) was made at the correct f-stop for the main light, which meant the accent light was brighter. The second image (19.5) was made by setting the camera to the f-stop indicated by the accent light. The three-light main light is still soft but now registers darker. The background is also darker, although the main:background light ratio remained the same.

You can run into a little trouble here if the wall and ceiling you're bouncing the light off of is a weird color (chartreuse definitely falls into this category). Once you custom white balance to that light, your camera is locked in. Adding accent lights without color correction to match the bounce will not work. Should your wall actually be chartreuse, the accent light will photograph as its reverse (complementary) color, and that will be bad.

Top—Image 19.6.
Bottom—Image 19.7.

THE REVERSE COOKIE

Let's amp this up even more. Shortly before I wrote *Master Lighting Guide for Portrait Photographers* I created what I call a "reverse cookie." With lighting, any form that light passes through to create a shadow pattern on any part of the set is called a "cookie." It comes from the Latin term *cucolaris,* but "cookie" is much easier to say. The reverse cookie was made by breaking 1/8x12x12-inch mirror tiles and gluing the pieces onto a sheet of 1/4-inch plywood (see image 19.6). Light hitting the pieces could then be directed to the background, creating a pattern of light instead of shadow. Wear heavy-duty gloves when you make yours and be sure to use a glue meant to hold glass.

The reverse cookie is attached to a Matthews clamp by a nail plate (also called a baby plate) and placed on a light stand (image 19.7). As you can imagine, a board covered with shards of glass could be a dangerous thing and is probably not a practical accessory in a children's studio. Wear gloves when moving or attaching it, and use a sandbag to secure the stand. One very positive thing about this accessory is that it can be easily rotated to find the right placement for the highlights.

I set the reverse cookie behind and to the left of the model, aiming it toward the background. To light it, I used a standard parabolic with a grid to control the spread of the light. I placed a black bookend to keep spill light off the model. The reverse cookie was between the camera and its light, and thus became its own flag, keeping light from hitting my lens. I metered the reflection at one of the hot spots and adjusted the power to equal that of the main light. My model was standing about 12 feet in front

Left—Diagram 19C.
Right—Image 19.8.

Left—Image 19.9.
Right—Image 19.10.
Facing page—Image 19.11.

of the background, so the power of the light fell off by the time it reached the background. The light from the reverse cookie created highlights because its power at the background was the same as the main light at the subject. See diagram 19C and image 19.8.

Cranking up the power on the reverse cookie's light to one stop, and then two stops, over the main light created a buoyant, energetic background that would be difficult to get any other way. Image 19.9 shows the reflection at plus one stop. Image 19.10 shows the reflection at plus two stops.

The next shot (image 19.11) is neither soft nor evenly lit, but it shows another neat use for the reverse cookie. I've set up a light with a standard reflector on a boom arm directly over and just slightly behind my model. I set the reverse cookie about 6 feet in front of the model, tilting the unit slightly so the light from the parabolic reflects into it and back to the model as well as onto the background. The parabolic was set just slightly behind the model so that just the edge of the light would hit her hair but not overexpose it.

The reflected light is mysterious and evocative. This is just one more technique that you can pull out of your bag of tricks.

20. WORKING WITH THE SUN

If there's one rule that gets drilled into the heads of photographers of every skill level, it's that the worst time of the day to shoot outdoors is between 10:00AM and 4:00PM. During that span of time, the sun is high and very bright. The angle of the light is completely unattractive and so contrasty that shadows are too deep to be attractive. You may look at your subject and think the sun's highlight is beautiful (it might be), and you may think that if you expose for the shadows the now overexposed highlight will add to the composition (it probably won't).

The secret to successful outdoor images under harsh sunlight is some sort of fill. In this chapter, we'll look at a couple of different ways to soften that awful light and turn it into something more useful.

As we were preparing to shoot image 20.1 and were finding the photogenic spots our location had to offer, I turned and looked at my model, Molly, who was standing in exactly the light I just described. Molly is a beautiful woman, but her good looks were no match for the awful angle of the light.

Scrims (also called "silks") are translucent panels that can be used in the sun as a sort of softbox. An assistant holds the scrim in such a way as to throw its shadow over the subject. Using a scrim will necessitate taking a new meter reading, of course, because the fabric absorbs some of the light passing through it. See image 20.2.

As you can see in image 20.3, the scrim softened the light considerably. The deep, contrasty shadows are now soft and open. A side benefit of this technique is that the background lightened up because the exposure changed on the model. When the highlights were brightened, the shadows opened up and looked like what we might see if we were to look at the scene with our eyes, rather than through the lens.

> THE SECRET TO SUCCESSFUL OUTDOOR IMAGES UNDER HARSH SUNLIGHT IS SOME SORT OF FILL.

Left—Image 20.1. **Center**—Image 20.2. **Right**—Image 20.3.

 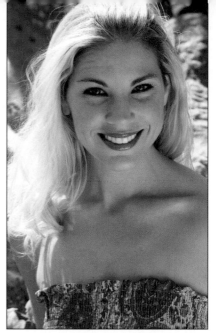

IF YOUR GEAR IS STRONG ENOUGH,
YOU CAN MAKE THE SUN AS WEAK AS
A STUDIO HAIR LIGHT.

Instead of using a scrim, many photographers prefer to bounce some light back into the scene with a reflector, maintaining a sense of strong light but opening up the shadows. Some use a scrim such as the one my assistant held, while others prefer an opaque reflector. Opaque reflectors bounce more light back to the subject because none of the light passes through. Silver, gold, and combination reflectors are available, too, and they add more punch to a shot than simple white reflectors do. I've found them useful in many situations, but I've also found that they can be so bright that they make the model's eyes water.

I've noticed that many photographers have their assistants catch the light from below the model and bounce it back up, as it is the most efficient way to do it. Is it the best way?

I generally have an issue with a bounce from that position when the bounce is evident and is brighter than the shadows on the other side of the face. This next shot (image 20.4) would be too strong for my taste because the light reflected from the scrim is close enough to create an upward nose shadow. Note also how it illuminates the underside of her eye.

Using an opaque reflector at that angle is a bit more problematic, in my view, because the light is so much stronger. My assistant stepped back 3 feet, but the effect of the harder reflection is quite evident (see image 20.5). Now, the undersides of both eyes are highlighted as are the undersides of Molly's cheeks. Also, because we used a smaller source as the bounce light, the light the reflector threw is more contrasty than before.

My favorite position for a reflector panel is with the center of it slightly higher than my model's head and aimed downward, catching the light from above her. To me, this is the best of both worlds. In image 20.6, the shadows have been opened up, the highlight from the sun is still very strong, and the model looks great. Please understand that I'm not saying you can't bounce from below, just be aware of the possible consequences.

One problem you will frequently have when using bounced light as fill is that the eyes will be darker than you like to see. Fortunately, that's an easy fix with Photoshop.

My favorite way to fill sunlight outdoors is to use flash fill. If you're content with using accessory flash without modifiers, you'll be able to get by with just about any unit. Most will be relatively useless beyond 10 feet or so, as they just don't have the power to match the requisite f-stop for bright sun imagery. At ISO 125, for example, bright sun will require an exposure of $\frac{1}{125}$ second at f/16, which is beyond the capacity of many units, even in manual mode. And, of course, the shadows they throw are hard and contrasty, exactly what we should avoid.

Should you find yourself doing a lot of outdoor portraiture, you should invest in a unit with considerably more power. In bright sun, your aperture selections are dictated by the fastest flash sync speed your camera is capable of, so you'll need enough to at least get f/13 at 10 feet when aimed into a modifier. The net result is a minus $\frac{2}{3}$ stop fill when the aperture is f/16 or a plus $\frac{2}{3}$ stop overexposure of the highlights when the working aperture is f/13.

Left—Image 20.6.
Right—Image 20.7.

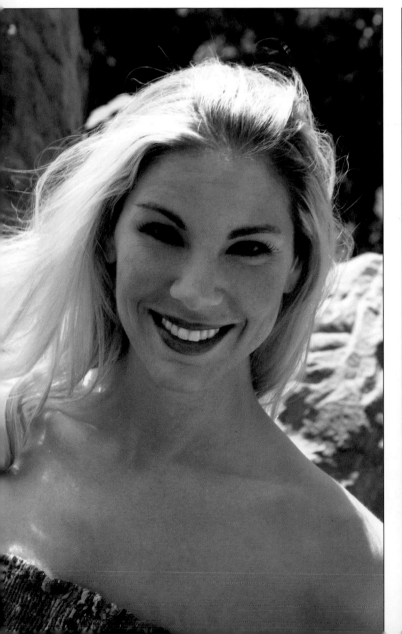
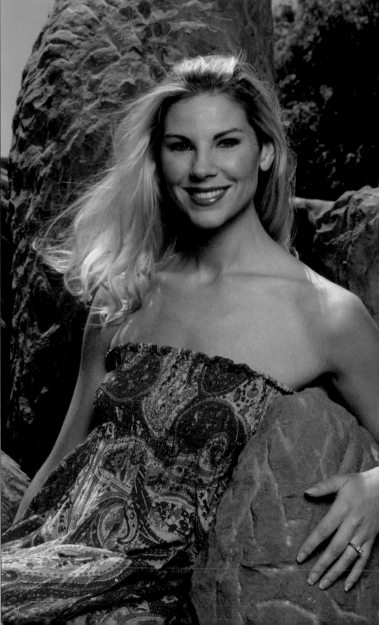

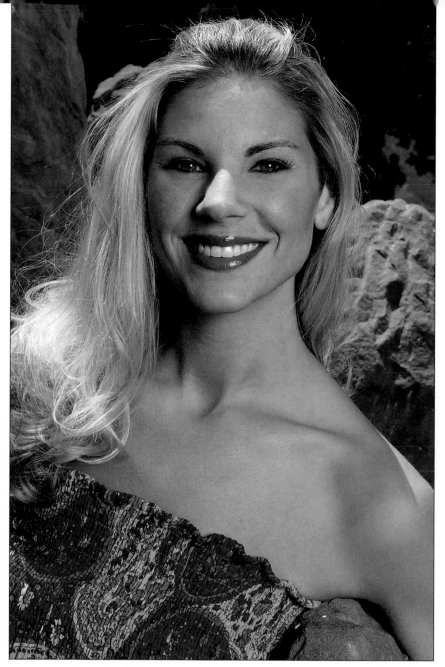

Above—Image 20.8.

I like to direct my strobe's light through a medium (3x4-foot) softbox. The nice thing about having enough power to do that is that I can place the softbox wherever I can find a level place for the stand (within reason, of course) and still get a lot of juice out of the gear. Image 20.7 was made at f/18, ⅓ stop less than the sunlight, to keep the highlight in her hair. Of course, a softbox from any manufacturer, as well as simple scrims, will absorb light. Make sure whatever you purchase, whether it's battery-powered studio strobes or an accessory strobe with lots of muscle, can be locked into a modifier to produce what you need to deal with the sun while producing great results.

Here's something to avoid: when the sun is high, it's quite likely that the sun will spill over the top of your model's head. When that happens, the first part of the body to catch extra light will be the model's nose.

Given the ratio of sunlight to flash that we're working with in image 20.8, along with the fact that the effects of light are cumulative (e.g., light from the sun plus light from the strobe equals brighter light on areas where the two sources overlap), an additional ½ stop of light was added to the light on the nose of my model. I did ask her forgiveness when shooting this, and she agreed to forego her gorgeousness for the sake of the lesson. So, keep an eye on where the sunlight is falling, especially where it overlaps your fill light, and don't make this mistake.

OVERPOWERING THE SUN

It's also possible, assuming your strobe(s) have enough power, to overpower the light of the sun to make the sky and surrounding background darker. This is a trick that can lend an exceptional level of drama to almost any image made with the sun behind the subject.

To create image 20.9, I used the same softbox as in the previous images but set the power of the unit to equal that of the sun's light on the back of the model's head. The sun is still strong enough to highlight the strands of her hair. Hair is something like a fiber optic cable, and it will carry light. Notice, though, that the light on the model's face is equal to the exposure of the portions of the image that are not affected by the strobe.

I'll be the first to admit that my camera angle is not the best, so you can refrain from sending me an e-mail about the issue. Book production is especially time consuming, and sometimes we authors have to squeeze in as much as possible in a short time frame. We had a small window in which to work with this model and the makeup artist and, while I would have preferred to drag this shoot out for a few more hours, I had to make the most of the time I had. Rest assured that this technique works as well with a lower sun as it does with the noon sun I was stuck with, and will probably look better, too. The point, that the sun can be overpowered, is just as valid.

I powered the strobe up one full stop over what the daylight reading was and shot again (image 20.10). My model's hair still appears nicely highlighted, but the sky is darker and more dramatic than in the previous image. Her skin tones, because they were in shadow to begin with, appear almost exactly the same as in the first shot.

I'LL BE THE FIRST TO ADMIT THAT MY CAMERA ANGLE IS NOT THE BEST, SO YOU CAN REFRAIN FROM SENDING ME AN E-MAIL ABOUT THE ISSUE.

Left—Image 20.9.
Right—Image 20.10.

Right—Image 20.11.

IF YOUR GEAR IS STRONG ENOUGH,
YOU CAN MAKE THE SUN AS WEAK AS
A STUDIO HAIR LIGHT.

When the intensity of the light is doubled again, to two full stops over that of the sun, the true drama of this trick reveals itself (see image 20.11). You'll note that the sky is now a shade of blue that you may only see if you're surrounded by bright sunlit snow and your irises have contracted to the size of pinheads. The model's skin tones remain the same, as they were illuminated by only the strobe, yet there is still some highlighting from the sun itself.

You can carry this trick further to three—or maybe four—stops over the power of the sun. If your gear is strong enough, you can make the sun as weak as a studio hair light, if that's your idea of a good time. The final look of your images will depend entirely on your equipment, the effect you wish to achieve, and the strength of the sun at your location.

21. UNDEREXPOSURE AS A CREATIVE TOOL

Part of my never-ending search for creative separatism from my peers means looking for new ways to break the rules, methods that give my work a look that those competitors have trouble figuring out.

We know, of course, that underexposure by more than 6/10 stop will result in images that, while they can be reclaimed in Photoshop, will never look "normal" (i.e., the images will never again show the subtleties in skin tone and lighting that you may have envisioned when the image was created).

What if you don't want them to look normal? What if you want them to look *uber normal*? Understand that I'm not giving you license to screw up. Like any good trick, the effects of underexposure (and its relationship to Photoshop) must be understood before it can be put to good use.

My first sample (image 21.1) was made with very simple lighting. My main light was a 36-inch umbrella and the hair light was a medium soft-box, which explains the consistent light along the model's side. I placed

Left—Image 21.1.
Top right—Diagram 21A.
Bottom right—Image 21.2.

Above—Image 21.3.

a black bookend just to the side of the model to keep flare from the softbox off my lens. See diagram 21A.

I powered the lights evenly, then set the camera's aperture to that value. Next, I reset the power on the main light to be ⅔ stop less than the aperture value. Any lab prints of this image will look a bit muddy without adjustment, as does the reproduction in this book. You can see from the histogram the image is lacking brighter tones.

We can fix this easily, but since we're at the limit of exposure latitude, we can expect to see some changes beyond simple lightening. It's a good idea to convert the image to 16 bits before doing any exposure adjustment in Photoshop, then convert it back to 8 bits when you're done. You'll fool Photoshop into thinking there's more information in the image than there actually is, and the final histogram will be much smoother.

I've adjusted the histogram by moving the brightness slider right to the edge of the working pixels. See image 21.2.

Look what happened in image 21.3: The whites from the hair light brightened considerably, to the point of being blown out, but framed her body quite beautifully. Notice also how the shine on her face brightened, giving her face an extra glow. This is subtle but gorgeous.

I wanted to see what would happen to specular highlights if I pushed the limits quite a bit more.

I used the same lighting scenario, but with a couple of changes. I swapped the background by propping up a piece of painted Styrofoam behind the model. I used a black bookend, moved in from the left, to throw a shadow on about half of the background and added a white bookend to the camera-right side to open up the shadows. The main light was powered back up to its original strength, but I cut the hair light back by ⅔ stop. I knew it would still register as additional light, but didn't want

Left—Image 21.4.
Right—Diagram 21B.

Facing page, top left—Image 21.5.
Top right—Image 21.6.
Bottom left—Image 21.7.
Bottom right—Image 21.8.

it to be brighter than the main light. Even with the extra gobos, it was still just a simple two-light setup. See diagram 21B.

After a wardrobe and hair change, we were ready to go. A quick spritz with a spray bottle created the extra specular highlights I wanted. The result—image 21.4—was properly exposed.

The first set of photos (image 21.5 and 21.6) was underexposed by one full stop, and the histogram was adjusted the same way (after the image was converted to 16 bits). The resulting bright speculars add a lot of visual interest. As you can see, the color contrast has increased a bit, as well.

My last series was underexposed by two full stops. Image 21.7 was definitely too dark to be considered salvageable. I'd asked my model to turn a bit so her arm would shadow her face, as I was curious as to what would happen to such a dark section of the image.

The result was very interesting, but I found I needed to bring up the midtones about 20% in addition to the highlights. Color contrast increased even more (this could be fixed with a Hue/Saturation Adjustment Layer), but the overall relationship of the tones stayed true. See image 21.8.

There's a quality about these images that's almost larger than life, and I'm certain you'll find a place for the technique in your mental gadget bag. But, if you're at all worried about this, shoot the images RAW+JPEG. If you don't like the JPEG or decide you want a correctly exposed image, make the appropriate exposure adjustment to the RAW file before processing. Conversely, you could shoot strictly RAW and process a correctly exposed image to an underexposed TIFF.

I'M CERTAIN YOU'LL FIND A PLACE FOR THE TECHNIQUE IN YOUR MENTAL GADGET BAG.

22. UNSUNG HEROES OF THE STUDIO

I've used makeup artists as often as possible ever since I turned pro. They are required on commercial and fashion shoots, of course, as there is so much money involved in production that it would be silly to not have one. Any problem they can fix in real time is one less problem that must be fixed in postproduction. I also strongly advise my business and personal portraiture clients (even men!) to let me hire a makeup artist. Men often object until they see how much more "natural" they look with balanced skin tones, hidden sunburn, and less visible eye bags.

It's money well spent, and it's an expense that's billable to the client.

I have two makeup artists that I use on a regular basis plus two more for backup, and all of them are skilled hairstylists as well. I've become so accustomed to the styles that my two primaries are capable of that nothing more than a brief conversation about my goals is necessary before they get to work.

Left—Image 22.1.
Right—Image 22.2.

Above—Image 22.3.

My model, Kelley, arrived right on time, fresh-faced and ready to go. Nicole Fae, the makeup artist, and I took a look at the clothing Kelley brought with her and made a wardrobe decision. It's necessary to do this prior to application so the correct makeup colors will be used.

Most makeup artists will begin with "basic corrective," a totally natural look that blends skin tones, creates some contouring, and hides blemishes. Generally speaking, this is all that most male clients require, as it is unnoticeable in finished photographs. It's also the reason why men take less than 15 minutes in the chair (women average about 40 minutes start to finish, more for high fashion). Here's Kelley before (image 22.1) and after (image 22.2) basic corrective makeup and under the same lighting setup. Notice how even and matte her skin is after the makeup application.

Nicole then went to work, glamming Kelley up to high-fashion status (image 22.3). This is a good time to reset and test the lighting, catch up on your e-mail, or clean out the storeroom, for this is never a quick fix.

When Nicole was finished working, the final makeup was flawless and outstanding. What a difference! It's hard to believe it's the same woman.

A creative makeup artist is invaluable for "concept" shots as well. Once she understands what you are producing, she can tailor the makeup to the concept, and your shoot will much more successful.

My other prima makeup artist is Sandra Avelli. Sandra has a background in television acting, having played a recurring character in at least one series. She understands conceptual imagery (and loves the challenge) and can translate my ideas using her makeup kit—with amazing results.

I wanted to use one of my favorite subjects, Denise Armstead, to create an image in keeping with her character—slightly wacky, metaphysical, and charming. Denise is a professional dancer and choreographer who is

very focused when working and off the wall when she's not. She's a great pleasure to know and to photograph because she'll try anything and put her heart and soul into the job, whatever it may be. See image 22.4.

I wanted to do a shot of a gypsy fortune-teller that would be over the top. I wanted a crystal ball, of course, but I wanted it to glow and float. This would be an easy job for Photoshop, but tougher on Denise, Sandra, and me. Denise would need to get into the character (and work with an imaginary crystal ball), Sandra would have to design the character (wacky, metaphysical, and charming), and I would have to light the set to be believable (how does the light from a glowing, floating, imaginary thing look, anyway?).

While Denise was in makeup I built a set, hanging a piece of shiny cloth over a boom arm for the background and moving in an antique French chair. I had a light on each side of the chair, both fitted with 10 degree grids and aimed to their opposite sides. These lights would produce the glow on Denise's hands. A small softbox was placed on a boom above and behind the chair, to act as a hair light and also to illuminate the back of the chair, while a gridspot was placed off-center behind the chair to light the cloth. Denise would be lit by a gridspot set on the floor in front of her and aimed at her chest. I wanted her face to be lit by residual light from the gridspot, not the hot spot, because I wanted a feeling of brighter light on her costume, the glow from the ball. See diagram 22A.

The center light would also create a perfect, small catchlight in the center of each eye, giving the impression of light coming from the ball.

Sandra and Denise totally outdid themselves, and the end result (image 22.5) is exactly what I had in mind.

Yes, makeup artists are the unsung heroes of our profession. Without their patience and creativity, there would be a lot of terrific concepts that would never make the grade.

Needless to say, you may want to see who's available to do makeup in your town. Most makeup artists will do a free test session so you can see what they are capable of. Take advantage of that and find the two best people you can, bearing in mind that makeup for photography is not the same as makeup for the street. Use them and convince your clients that they're necessary. Your clients will appreciate the time and attention and will not mind paying for their services.

Top—Image 22.4.
Above—Diagram 22A.
Facing page—Image 22.5.

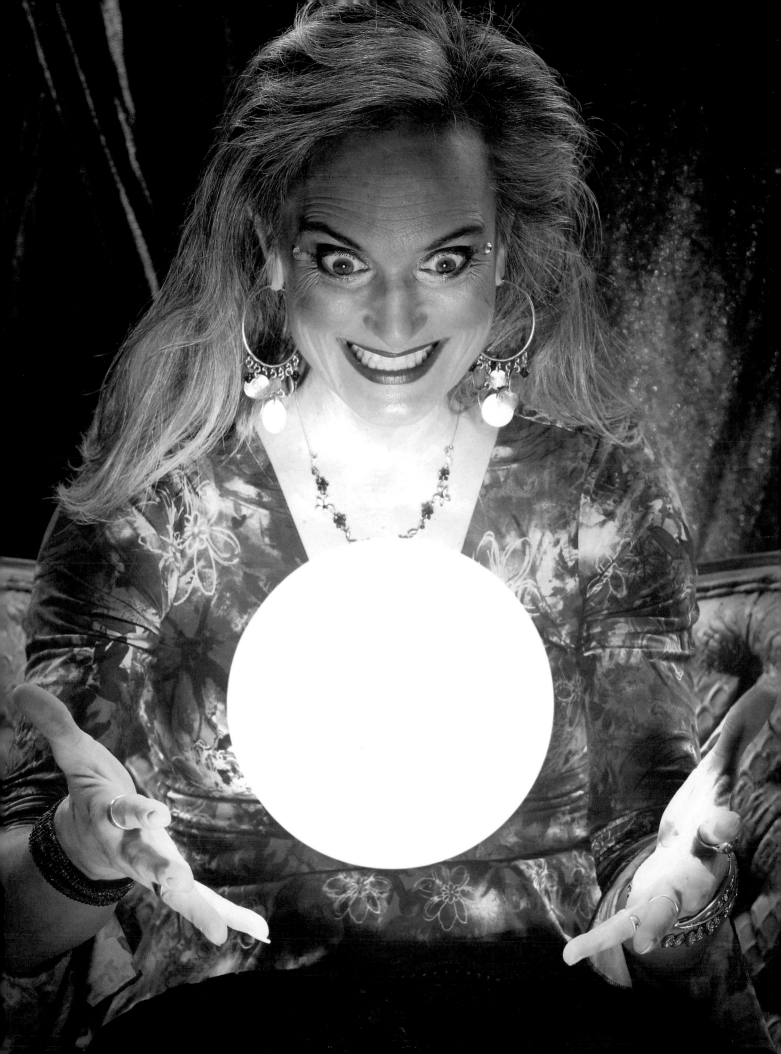

23. CHEAP TRICKS

The success of an image may depend on ancillary tricks as much as a correct lighting scenario.

As much as I'm a high-tech guy, I'm low-tech, too. I believe in having the right equipment for the job, but I'll be the first to admit a professional love for cheap tricks. My reverse cookie (which I discuss in chapter 18) and the bookend bounce panel (which I wrote about in *Christopher Grey's Studio Lighting Techniques for Photography*) are two examples of simple, inexpensive materials used in new and visually exciting ways to produce a photographic look unlike that from any commercial product.

With that in mind, I thought it would be fun to look at a few items, some that are only available at certain times of year, and see how they might be applied to photography.

FANS

Most studios have a fan, and it's often a "window" variety, meant to sit in a window frame and blow in air from the outside. Fans of this type are quite cheap, often around $10.00, but they are not very versatile in a studio, as they must be placed on some sort of support to get them high enough to move a model's hair. The same holds true for "table" fans, those little oscillating units, about 18 inches tall, that sit on the floor or table and circulate the air in a room. They are nice on a hot day but difficult to use in a studio.

On the slightly higher end of the scale are "standing" fans (image 23.1). These units are adjustable from about 18 inches to about 36 or more inches and are much more valuable in a studio. What makes them more desirable is that the fan column of many units will separate from the supplied stand and fit directly over a light stand. Now you have the option of positioning the business end of the fan at precisely the height you need. You can also clamp the column to a counterbalanced boom arm (image 23.2) and direct the airflow from above.

STYROFOAM PANELS

Another cheap trick: Styrofoam insulation panels come in a number of precut sizes, including 4x8 feet, a perfect size for many portrait backgrounds, especially if you use a telephoto lens. A 2-inch thick piece of

Top—Image 23.1.
Bottom—Image 23.2.

Styrofoam is less than $20.00, weighs next to nothing, and can easily be painted (image 23.3). I have a number of these in my studio that I repaint frequently, with different colors on each side.

When you go to buy such an item, check both sides for texture. These panels are cut from huge blocks of foam, and often show some texture from the cutting tool. I've found some with texture that I like, but I usually opt for as flat a surface as possible. You'll find them at larger hardware stores like The Home Depot.

PAINTING ACCESSORIES

As long as you're at the hardware store, check out a painting device called "The Woolie." Among other products, they manufacture a double roller system that's terrific for painting mottled backgrounds. Simply use two hues of the same color. Fill the two bins of the special roller tray with the colors and paint away. It's very easy to figure out (even if you screw it up, you can always repaint), and the results are beautiful. My primary shooting wall is approximately 18x12 feet, and I can typically repaint the portrait background portion in about an hour.

Above—Image 23.3.
Right—Image 23.4.

WALLBOARD

Larger hardware store locations have selections of wallboard, melamine paneling products that are often employed when remodeling bathrooms or kitchens. The 4x8-foot panels are available in a variety of textures and colors (although some are so hideous they could make a freight train take a dirt road) for about $15.00 each. Get a semigloss white board and place it on your white seamless paper sweep. You'll get an interesting reflection of your subject when doing a full length, high-key image or silhouette (see image 23.4). There will usually be no need to retouch the edges, but any line that may show where the wallboard

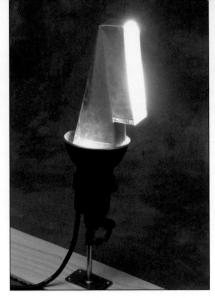
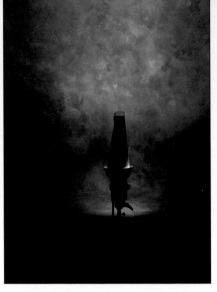

meets the paper can be easily fixed in Photoshop. It's also very easy to digitally whiten any area that doesn't photograph bright enough.

REGISTER BOXES

My favorite hardware store cheap trick is found in the heating and ventilating aisle. Called "register boxes," these aluminum sheet metal pieces of duct are made to direct heat or air conditioning from the main ductwork through grates in walls or floors, and they currently cost less than $10.00 each. If I place a strobe with a basic parabolic reflector on the floor and aim it straight up to the ceiling, I can set one of these right-angled register boxes into the parabolic. The light will be directed to the background, and the result will be a beautiful light that's spread out in a configuration I can't get with any other modifier. Please note that these are sheet metal products and may have sharp edges or corners. Be careful, but be sure to buy both a horizontal and a vertical box. See images 23.5 and 23.6.

NAIL PLATES

I've found the best way to deal with a parabolic on the floor is to attach the strobe to a piece of plywood with a nail plate (image 23.7). Nail plates (also called baby plates) are available at some camera stores but are more typically found at professional film and video supply houses. You can also obtain them from a manufacturer like Matthews (www.msegrip.com).

SMOKE MACHINES

Commercial smoke generators, like those used by movie crews, typically cost upward of $500.00—way too much for a small-time user like me. A few years ago, some manufacturers began offering, in mid to late September, small smoke machines for those of us who like to set a spooky atmosphere for Halloween (image 23.8). These machines use water-soluble chemicals to produce a safe and nontoxic smoke that will fill a studio in a very short time. Two years ago, I bought an excellent generator for

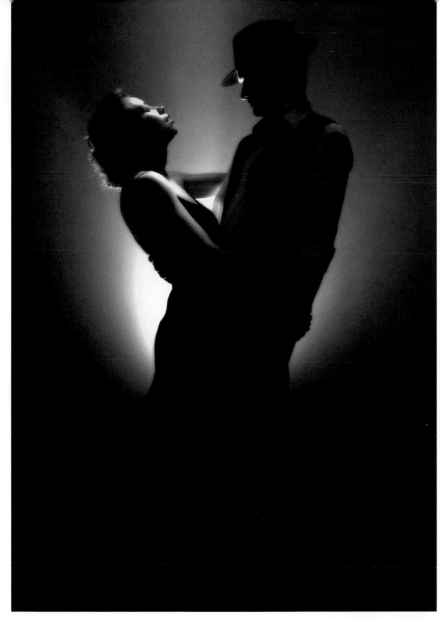

Above—Image 23.9.

$50.00, but on a recent trip to another store, I found a smaller unit for less than $30.00, including a pint of the smoke-producing liquid (buy more than you need for your shoot; it's off the shelves on November 1).

The smaller units come with a wired remote, so you can fire a burst of smoke when you need it. The larger unit comes with a wired remote and a built-in intervalometer, which will send out a fresh stream of smoke every, say, 30 seconds or more. If you can't find these in your town, check out this manufacturer's site: www.chauvetlighting.com. The goofy faceplate some of the units come with is laughable, but the smoke effect they produce can be stunning in the studio, especially when backlit (see image 23.9).

FABRICS

I also ran across some interesting fabric backdrops. They're designed to turn a room into a creepy environment, so they're quite large. I thought a couple of them could be interesting when used as a *very* out of focus background, especially since they're only $20.00. You can take a look at www.amscan.com.

Halloween would also be a good time to buy a pair or two of angel wings. They're perfect for kid portraits and not nearly as expensive as those found in studio supply catalogs.

REPEATING STROBE UNITS

Chauvet Lighting also manufacturers small, repeating strobe units. These units cannot be fired by slaves, Pocket Wizards, or sync cords, but they do feature adjustable flash rates. Though not very powerful, they may still have some value for your work— just turn them on and open the shutter (be sure to meter and white balance first). At about $20.00 each, they're worth a look and, at that price, you could turn your studio into a disco for under a hundred bucks.

Cheap tricks. Gotta love 'em.

24. PHOTOSHOP CONTRAST AND SOFTNESS

Need a little magic for your images? Here's a quick and nifty way to add contrast and softness—at the same time—to any image of your choice. This little trick will add a little of that ol' "howdy doodat?" magic in less than two minutes with just a few simple Photoshop steps. I believe this trick is also possible with Photoshop Elements, but the interface will be different.

Let's begin with image 24.1, a publicity portrait of Sahata, a beautiful and talented entertainer.

1. In Photoshop, I began by duplicating the Background layer (image 24.2).
2. Working on Layer 1, the new layer, I went to Image>Adjustments>Hue/Saturation and moved the Saturation slider all the way to the left to desaturate the layer. See image 24.3.
3. Next, I went to Filter>Blur>Gaussian Blur. Note that the amount of blur will vary by image type and image size, but don't be afraid to try quite a bit (you can always back up in the History palette). For this image, I used a radius of 50 pixels to produce a substantial blur. See image 24.4.
4. I used Levels to dramatically boost the whites and midtones of Layer 1. I like to boost the whites until they show some burnout, and I like to boost the midtones about 30%. Note that if you have an image with numerous bright areas, you may wish to only boost the midtones (image 24.5). At this point, the image should look something like image 24.6.)

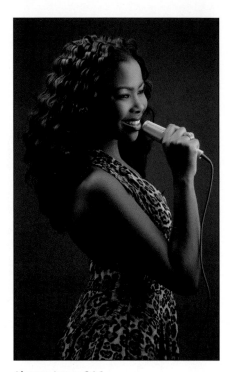

Above—Image 24.1.

Left—Image 24.2.
Right—Image 24.3.

Left—Image 24.4.
Right—Image 24.5.

Right—Image 24.6.

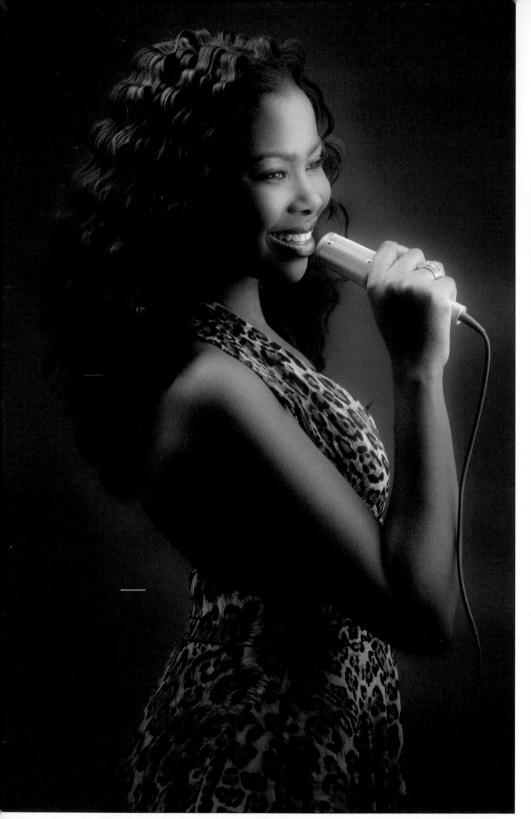

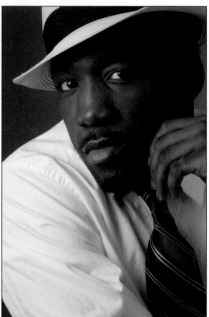

Left—Image 24.7.
Top right—Image 24.8.
Bottom right—Image 24.9.

5. Finally, I set the Blending Mode of Layer 1 to Soft Light, flattened the layers, and saved the image. (Note that you can move the Opacity sliders to the left to reduce the effect if it seems too strong. If the contrast or burn is too great, back up a few steps in the History palette and take another whack at it. It will only take a minute or two to redo it.) See image 24.7.

When working with grayscale images, it's not necessary to reduce the color saturation, but you may have to play with Levels a bit until you get an effect you like. It won't take long; you can try a number of variations in just a few minutes. See images 24.8 and 24.9.

You can boost color contrast and saturation by ignoring the Hue/Saturation command and using Layer 1 with its enhanced color changes. This is a matter of taste, and it is totally up to you and the look you like (and can sell) in your final product. Still, it's an option that you should explore. The second layer of this image was not desaturated at all. See images 24.10 and 24.11.

Be sure to try this with some non-studio images, too. There is a visual dimension added to an image that cannot be attained by other means. I think you'll like this simple little technique enough to add it to your own bag of tricks. See images 24.12 and 24.13.

Left—Image 24.10.
Right—Image 24.11.

Bottom left—Image 24.12.
Bottom right—Image 24.13.

25. ADDING SPECIFIC AND DRAMATIC HIGHLIGHTS

Here's another simple Photoshop trick that will allow you to add extra drama to otherwise ordinary images or to spice up images that are dramatic to begin with. To show you how it's done, I'll start with this one-light portrait (image 25.1).

1. I began by duplicating the Background layer, then selected Levels (image 25.2). While the Input Levels sliders adjust brightness and density, Output Levels remove actual black or white. With the duplicate layer active, I moved the right-hand Output Levels slider until I removed about half of the white value in the image, an output Level of 126. Your taste and image may dictate a different amount.

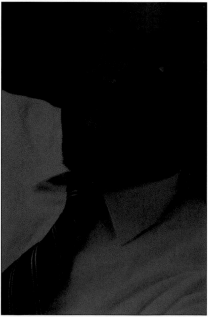

Left—Image 25.1.
Top right—Image 25.2.
Bottom right—Image 25.3.

Top—Image 25.4.
Above—Image 25.5.

Left—Image 25.6.
Right—Image 25.7.

If you had to live with the result shown in image 25.3, you might be forced to change careers.

2. I used the Add Layer Mask button to create a white mask, which was invisible on the duplicate layer. See image 25.4.

3. I selected a round brush from the Brush palette and made sure it had 0% Hardness and that the Foreground and Background colors were set to black and white, respectively. I selected a brush size that fit the area I wished to highlight. With the Brush Opacity set to 10%, I painted over the duplicate layer to reveal the original layer below. Painting with such a low opacity and a soft-edged brush pretty much guaranteed a mask of graduated tones. Note that my mask has areas of 100% black (which allows 100% of the layer below to be seen) as well as areas of lesser density. See image 25.5.

When I was satisfied with what I'd revealed from the layer below, I duplicated the original Background layer and set its Blending Mode to Soft Light, which increased the contrast within the masked areas. See image 25.6.

You can see how the changes affect only the masked areas. Should you wish to make additional changes or rectify an error, you can reselect the mask in the uppermost layer and paint with black to reveal more or paint with white to hide the effect. See image 25.7.

4. Next, I duplicated the Mask layer again. The new layer was automatically set to Soft Light, but if I'd wanted a bit more contrast, I could have set the Blending Mode of the new layer to Hard Light (see image 25.8).

5. The end result is quite spectacular, with deep shadows (most still with detail) and bright highlights (also with detail). Images like this are reminiscent of those created after hours in the darkroom by master printers, photographs that cost a small fortune per print and were very difficult to repeat with a high degree of consistency.

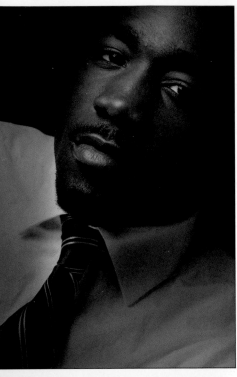

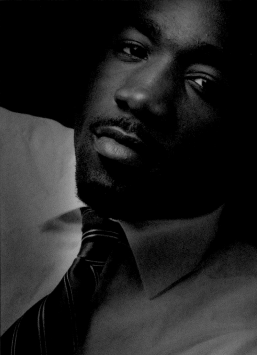

Left—Image 25.9.
Right—Image 25.10.
Above—Image 25.11.

Left—Image 25.11.
Right—Image 25.12.

You can use the Channel Mixer in Monochrome mode and achieve beautiful, rich black & white images that will be envy of all your friends and, perhaps, make a few bucks toward the purchase of those new shoes the baby needs so desperately. See images 25.09 and 25.10.

Of course, this little trick can be used on a wide variety of subject matter, all to a successful conclusion. See images 25.11 and 25.12.

AFTERWORD

Competition is the greatest motivator, if you're up to the challenge.

I've been doing my job professionally for almost forty years, and I've loved every minute behind the camera. You can read between the lines, if you wish, for owning and operating a small business is not easy. The number of hats one might wear over the course of a week may be heavy enough to sink a small boat. Still, I don't think there's any other profession that can create memories to outlive both the creator and the recipient, bring tears to the eyes of clients, or joy to someone who simply opens a holiday card, like that of a photographer who truly cares about the craft.

There is, to my mind, nothing better than being a photographer, the job I wanted since I was in eighth grade.

Now, it's your job. And the competition is stiff. You can drive down the middle of the road, or you can knock 'em dead. It's your call.

It is my most sincere wish that my books, my columns (sign up for a free account and see the latest at www.prophotoresource.com), or my somewhat sporadic blog, http://chrisgreylighting.com, will help you achieve the look and quality you need to take your studio business to a new level, not just the next level. I encourage you, as I always will, to take the techniques I've written about and make them better. Bend them to your will, change them, and make them your own. Your clients will thank you (and pay more) for going the extra mile.

Your competition may weep.

INDEX

A

Accessory arms, 13, 50

Accessory flash, *See* Flash, accessory

Action, stopping, 14, 54–58

Additive nature of light, 27, 83, 101

Adobe Photoshop, 73, 79, 80, 81, 101, 104, 105, 110, 116–19, 120–21

 Blending mode, 80, 118

 Gaussian blur, 73, 81, 116

 History palette, 116, 118

 Hue/Saturation, 116, 119

 Levels, 80, 105, 119, 120–21

Adobe Photoshop Elements, 116

Advertising photography, 18

Ambient light, 26

Angle of incidence, 42

Aperture, *See* F-stop

Assistant, 12

Automatic mode, 14, 15

 camera, 14

 flash, 15

B

Baby plates, *See* Nail plates

Backgrounds, 17, 19, 26, 32, 39, 87, 115

Barn doors, 48

Battery power, 17

Beauty bowls, 31, 37, 66–68, 74, 84

Beauty photography, 15, 53

Bedsheets, 10, 15

Blending mode, *See* Adobe Photoshop

Bookends, 8, 13, 20, 29, 44, 95, 105, 112

Boom arms, 9, 37, 51, 83, 96, 110, 112

Bounce cards, 12

Business portraits, 14

C

Camera, disposable, 65

Catchlights, 8, 25, 39, 40, 87, 110

Catharsis, 69–72

Cinefoil, 48–53

Clamps, 95, 112

Composition, 25

Color temperature, 65; *See also* White balance

Commercial photography, 108

Conceptualizing the shot, 69–72

Contrast, 74, 75, 79

Cookies, 34, 36, 48, 51, 95–96

Couples, 86

Cyclorama, 18

D

Dance photography, 56–57

Dantzig, Stephen, 5

Depth of field, 13, 51

Depth of light, 12, 90

Detail, shadow, 32

Diffusion, 8, 12, 48, 73–76, 115

Diffusion panel, 12

Dimensionality, 27, 38

Distance, 9, 10, 13, 17, 20–21, 30, 40, 66–68, 79, 95–96

 camera-to-subject, 17, 40

(Distance, cont'd)

 light-to-subject, 9, 13, 30, 66–68, 79, 87

 subject-to-background, 10, 20–21, 95–96

E

Elements, *See* Adobe Photoshop Elements

Exposure, 9, 23, 27, 28, 30, 54, 65, 76, 79, 84, 86–87, 98, 104–6, 125

 f-stop, 9, 27, 28, 65, 79, 86–87

 histograms, 125

 ISO, 54

 overexposure, 47, 78–82, 98

 shutter speed, 23, 56, 57

 underexposure, 84, 104–6

Eyes, shadowing around, 39, 68

F

Fabric, diffusion with, 48, 73–76, 115

Falloff, 8, 21, 92

Fans, 112

Fashion photography, 18, 47, 108

Fees, session, 26

File formats, 106

Fill light, 38, 39–42, 86, 98–103

Film photography, 54, 78, 79

Filters, 73; *See also* Fabric, diffusion with

Flags, 49–50

Flare, 41, 51, 74, 79

Flash, 12, 14, 15, 17, 25–26, 39–40, 44, 51, 79, 100

(*Flash, cont'd*)
 accessory, 12, 14, 15
 on-camera, 51
 power packs, 23
 recycle time, 17
 slaves, 13
 studio, 25–26
 sync speed, 100
Flash meter, 15–16, 19, 83
Flat lighting, 18
Focus, soft, 73
F-stop, 9, 27, 28, 65, 79, 86–87

G
Gaussian blur, *See* Adobe
 Photoshop
Gauze, 51, 73–76
Gels, 16–17, 65
Glamour photography, 15, 47, 53
Gobos, 20, 21, 48, 51, 106
Grain, 78–79
Grids, 23, 31, 36, 37, 45, 53, 68,
 74, 83, 84, 95, 110
Gridspots, 23, 53, 68, 74, 84

H
Hair, 23
Hair lights, 23, 32, 46, 92, 103,
 104, 105, 110
Handholding the camera, 54
Highlights, 120–22
Histograms, 105
History palette, *See* Adobe
 Photoshop, History
 palette
Hollywood lighting, 33–34
Hot lights, 12
Hot spots, 8, 37, 65, 83, 95

I
Infrared flash trigger, 13
Inverse square law, 18–19, 87
ISO, 54

K
Kesler, Keith, 54–55
Kicker lights, 27

L
Ladder, 54
LCD screen, 13, 58
Lenses, 25
Levels, *See* Adobe Photoshop
Lights, 8, 9, 12, 14, 15, 17, 22,
 23, 25, 27, 28, 34, 37,
 38, 39–42, 44, 46, 48,
 56, 65, 74, 79, 83–85,
 86–89, 98–103, 104
 barn doors, 48
 beauty bowls, 31, 37, 66–68,
 74, 84
 color temperature of, 65
 fill, 38, 39–42, 86, 98–103
 flash, 12, 14, 15, 17, 25–26,
 39–40, 39, 44, 51, 79,
 100
 hair, 23, 32, 46, 92, 103, 104,
 105, 110
 hot lights, 12
 gridspots, 23, 53, 68, 74, 84
 kicker, 27
 main, double, 83–85, 86–89
 modeling, 56, 65
 parabolic reflectors, 27, 34,
 45, 95, 114
 snoots, 48, 53
 softboxes, 8, 9, 12, 15, 20,
 26, 27, 30, 74, 79, 83,
 86–89
 strip lights, 27, 28, 34, 54, 83
 strobes, 8, 9, 12, 14, 48, 90,
 101, 103, 114, 115
 sunlight, 22, 25, 98–103
 umbrellas, 27, 37, 41, 90,
 92–93, 94, 104
Light ratios, 23, 39, 41, 86, 89,
 94, 101

Light stands, 13
Location photography, 22–26

M
Main light, 83–85, 86–89
Makeup, 8, 23, 108–10
Makeup artists, 23, 108–10
Metering, 13, 15–16, 24, 27, 30,
 76, 79, 83, 84, 86
Mirrors, 95
Modeling, facial, 66–68
Modeling lights, 56, 65
Modifiers, light, 8, 10, 12, 13,
 14, 15, 16–17, 20, 23,
 25, 29, 31, 34, 36, 42,
 44–47, 48, 49–50, 51,
 53, 65, 74, 78, 90–97,
 99, 101, 104, 105, 106,
 110
 barn doors, 48
 beauty bowls, 31, 37, 66–68,
 74, 84
 bedsheets, 10, 15
 bookends, 8, 13, 20, 23, 29,
 44, 95, 105, 112
 bounce cards, 12
 cookies, 34, 36, 48, 51,
 95–96
 diffusion panel, 12
 flags, 49–50
 gels, 16–17, 65
 gobos, 20, 21, 48, 51, 106
 grids, 23, 36, 45, 53, 83, 84,
 95, 110
 mirrors, 95
 parabolic reflectors, 27, 34,
 45, 95, 114
 reflectors, 8, 13, 14, 20, 23,
 27, 29, 34, 36, 42,
 44–47, 90–97, 99
 reverse cookies, 34, 36,
 95–96
 scrims, 20, 98, 101

(*Modifiers, light, cont'd*)

snoots, 48, 53

softboxes, 8, 9, 12, 15, 20, 25, 26, 27, 30, 74, 78, 90, 93, 101, 104, 105, 110

strip lights, 27, 28, 34, 54, 83

Styrofoam, 112–13

wall, 90–97

umbrellas, 27, 37, 41, 90, 92–93, 94, 104

Morris, Merle, 73

Motion, 14, 54–58, 65

N

Nail plates, 95, 114

Nose, shadows from, 39, 45, 86, 99, 101

O

One-light setups, 78–82

Organza, *See* Fabric, diffusion with

Outdoor sessions, 22, 57–58

Overexposure, 47, 78–82, 98

P

Parabolic reflectors, 27, 34, 45, 95, 114

Photoshop, *See* Adobe Photoshop

Portrait length, 19

Power packs, 23

R

Radio trigger, 13

Recycle time, 17

Reflectors, 8, 13, 14, 20, 23, 27, 29, 34, 36, 42, 44–47, 90–97, 99

Register boxes, 114

Rembrandt lighting, 45

Reverse cookies, 34, 36, 95–96

Rim lighting, 16

S

Sandbags, 17

Scrims, 20, 98, 101

Senior portrait photography, 18–21

Separation, tonal, 48, 55

Shuter, dragging the, 59–65

Shutter speed, 23, 56, 57

Side lighting, 42

Silhouettes, 79

Slave, 13

built-in, 13

infrared, 13

radio, 13

Smoke machines, 114

Snoots, 48, 53

Softboxes, 8, 9, 12, 15, 20, 25, 26, 30, 74, 78, 83, 86–89, 90, 93, 101, 104, 105, 110

Speed rings, 17, 48

Step-up rings, 74

Strip lights, 27, 28, 34, 56, 83

Strobes, 8, 9, 12, 14, 48, 90, 101, 103, 114, 115

Styrofoam, 112–13

Subtractive lighting, 11, 20, 31, 32

Sunlight, 22, 25, 98–103

overpowering, 101–3

Synch speed, 100

T

Telephoto lenses, 112

Tripod, 13, 25

U

Umbrellas, 27, 37, 41, 90, 92–93, 104

Underexposure, 84, 104–6

Underlighting, 33–38, 42

W

Wallboard, 113–14

Wall of light, 90–97

Wardrobe, 17, 23–24, 36, 109

White balance, 10, 20, 76, 94

Window lighting, 56

Wraparound light, 10, 25, 30, 79, 86

Wrinkles, 86

Z

Zoom lenses, 25

OTHER BOOKS FROM

Amherst Media®

MASTER LIGHTING GUIDE
FOR PORTRAIT PHOTOGRAPHERS

Christopher Grey

Efficiently light executive and model portraits, high and low key images, and more. Master traditional lighting styles and use creative modifications that will maximize your results. $29.95 list, 8.5x11, 128p, 300 color photos, index, order no. 1778.

CHRISTOPHER GREY'S STUDIO LIGHTING TECHNIQUES FOR PHOTOGRAPHY

Grey takes the intimidation out of studio lighting with techniques that can be emulated and refined to suit your style. With these strategies—and some practice—you'll approach your sessions with confidence! $34.95 list, 8.5x11, 128p, 320 color images, index, order no. 1892.

ADVANCED WEDDING PHOTOJOURNALISM

Tracy Dorr

Tracy Dorr charts a path to a new creative mindset, showing you how to get better tuned in to a wedding's events and participants so you're poised to capture outstanding, emotional images. $34.95 list, 8.5x11, 128p, 200 color images, index, order no. 1915.

500 POSES FOR PHOTOGRAPHING BRIDES

Michelle Perkins

Filled with images by some of the world's most accomplished wedding photographers, this book can provide the inspiration you need to spice up your posing or refine your techniques. $34.95 list, 8.5x11, 128p, 500 color images, index, order no. 1909.

ON-CAMERA FLASH
TECHNIQUES FOR DIGITAL WEDDING AND PORTRAIT PHOTOGRAPHY

Neil van Niekerk

Discover how you can use on-camera flash to create soft, flawless lighting that flatters your subjects—and doesn't slow you down on location shoots. $34.95 list, 8.5x11, 128p, 190 color images, index, order no. 1888.

LIGHTING TECHNIQUES
FOR PHOTOGRAPHING MODEL PORTFOLIOS

Billy Pegram

Learn how to light images that will get you—and your model—noticed. Pegram provides start-to-finish analysis of real-life sessions, showing you how to make the right decisions each step of the way. $34.95 list, 8.5x11, 128p, 150 color images, index, order no. 1889.

DOUG BOX'S
GUIDE TO POSING
FOR PORTRAIT PHOTOGRAPHERS

Based on Doug Box's popular workshops for professional photographers, this visually intensive book allows you to quickly master the skills needed to pose men, women, children, and groups. $34.95 list, 8.5x11, 128p, 200 color images, index, order no. 1878.

500 POSES FOR PHOTOGRAPHING WOMEN

Michelle Perkins

A vast assortment of inspiring images, from head-and-shoulders to full-length portraits, and classic to contemporary styles—perfect for when you need a little shot of inspiration to create a new pose. $34.95 list, 8.5x11, 128p, 500 color images, order no. 1879.

ROLANDO GOMEZ'S
POSING TECHNIQUES FOR GLAMOUR PHOTOGRAPHY

Learn everything you need to pose a subject—from head to toe. Gomez covers each area of the body in detail, showing you how to address common problems and create a flattering look. $34.95 list, 8.5x11, 128p, 110 color images, index, order no. 1869.

PROFESSIONAL WEDDING PHOTOGRAPHY

Lou Jacobs Jr.

Jacobs explores techniques and images from over a dozen top professional wedding photographers in this revealing book, taking you behind the scenes and into the minds of the masters. $34.95 list, 8.5x11, 128p, 175 color images, index, order no. 2004.

THE ART OF CHILDREN'S PORTRAIT PHOTOGRAPHY

Tamara Lackey

Learn how to create images that are focused on emotion, relationships, and storytelling. Lackey shows you how to engage children, conduct fun and efficient sessions, and deliver images that parents will cherish. $34.95 list, 8.5x11, 128p, 240 color images, index, order no. 1870.

THE PHOTOGRAPHER'S GUIDE TO
MAKING MONEY

150 IDEAS FOR CUTTING COSTS AND BOOSTING PROFITS

Karen Dórame

Learn how to reduce overhead, improve marketing, and increase your studio's overall profitability. $34.95 list, 8.5x11, 128p, 200 color images, index, order no. 1887.

MASTER POSING GUIDE FOR WEDDING PHOTOGRAPHERS

Bill Hurter

Learn a balanced approach to wedding posing and create images that make your clients look their very best while still reflecting the spontaneity and joy of the event. $34.95 list, 8.5x11, 128p, 180 color images and diagrams, index, order no. 1881.

ELLIE VAYO'S GUIDE TO
BOUDOIR PHOTOGRAPHY

Learn how to create flattering, sensual images that women will love as gifts for their significant others or keepsakes for themselves. Covers everything you need to know—from getting clients in the door, to running a succesful session, to making a big sale. $34.95 list, 8.5x11, 128p, 180 color images, index, order no. 1882.

MASTER GUIDE FOR
PHOTOGRAPHING HIGH SCHOOL SENIORS

Dave, Jean, and J. D. Wacker

Learn how to stay at the top of the ever-changing senior portrait market with these techniques for success. $34.95 list, 8.5x11, 128p, 270 color images, index, order no. 1883.

SCULPTING WITH LIGHT

Allison Earnest

Learn how to design the lighting effect that will best flatter your subject. Studio and location lighting setups are covered in detail with an assortment of helpful variations provided for each shot. $34.95 list, 8.5x11, 128p, 175 color images, diagrams, index, order no. 1867.

STEP-BY-STEP WEDDING PHOTOGRAPHY

Damon Tucci

Deliver the top-quality images that your clients demand with the tips in this essential book. Tucci shows you how to become more creative, more efficient, and more successful. $34.95 list, 8.5x11, 128p, 175 color images, index, order no. 1868.

POSING TECHNIQUES FOR PHOTOGRAPHING MODEL PORTFOLIOS

Billy Pegram

Learn to evaluate your model and create flattering poses for fashion photos, catalog and editorial images, and more. $34.95 list, 8.5x11, 128p, 200 color images, index, order no. 1848.

MASTER LIGHTING GUIDE

FOR COMMERCIAL PHOTOGRAPHERS

Robert Morrissey

Use the tools and techniques pros rely on to land corporate clients. Includes diagrams, images, and techniques for a failsafe approach for shots that sell. $34.95 list, 8.5x11, 128p, 110 color photos, 125 diagrams, index, order no. 1833.

MORE PHOTO BOOKS ARE AVAILABLE

Amherst Media®
PO BOX 586
BUFFALO, NY 14226 USA

INDIVIDUALS: If possible, purchase books from an Amherst Media retailer. Contact us for the dealer nearest you, or visit our web site and use our dealer locater. To order direct, visit our web site, or send a check/money order with a note listing the books you want and your shipping address. All major credit cards are also accepted. For domestic and international shipping rates, please visit our web site or contact us at the numbers listed below. New York state residents add 8.75% sales tax.

DEALERS, DISTRIBUTORS & COLLEGES: Write, call, or fax to place orders. For price information, contact Amherst Media or an Amherst Media sales representative. Net 30 days.

(800)622-3278 or (716)874-4450
Fax: (716)874-4508

All prices, publication dates, and specifications are subject to change without notice. Prices are in U.S. dollars. Payment in U.S. funds only.

WWW.AMHERSTMEDIA.COM
FOR A COMPLETE CATALOG OF BOOKS AND ADDITIONAL INFORMATION

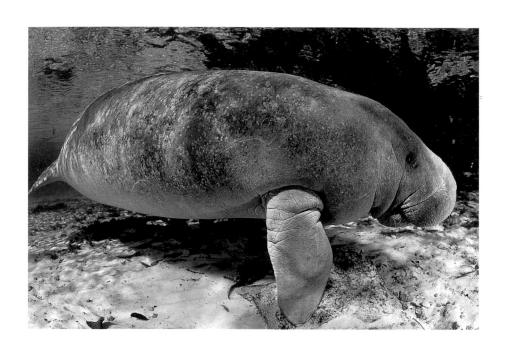

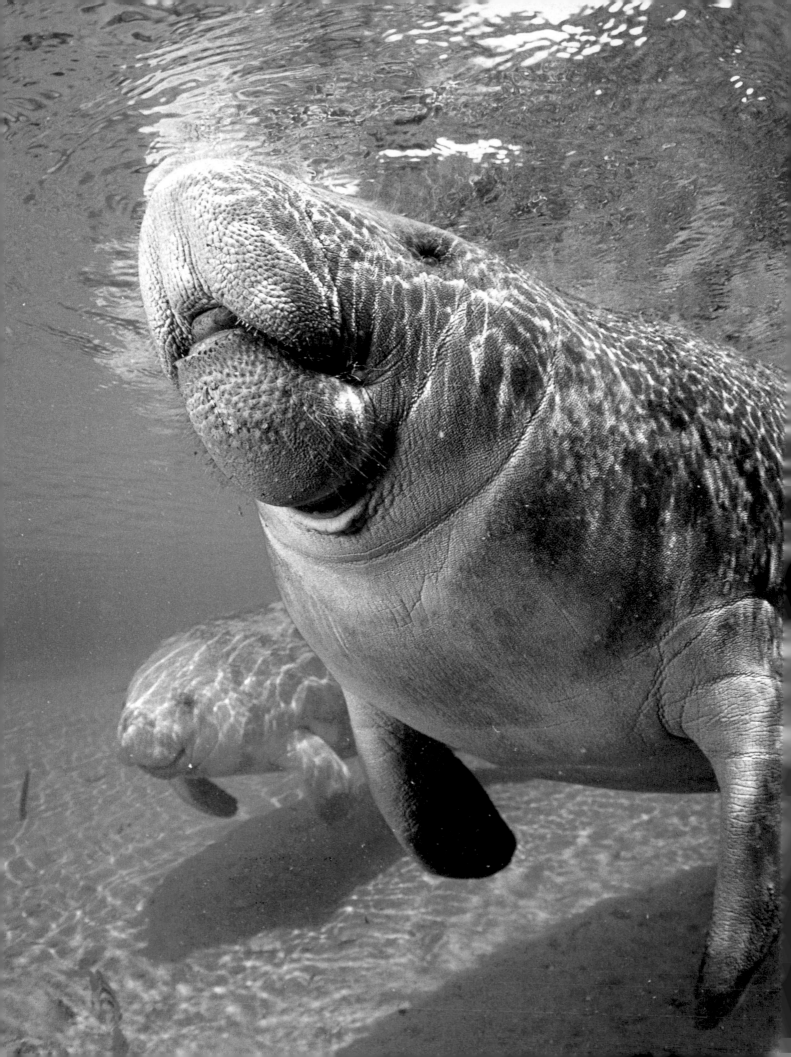

Manatees
and Dugongs
of the World

Text by Jeff Ripple
Photography by Doug Perrine

TOWN AND COUNTRY
PUBLIC LIBRARY DISTRICT
112 N. MAIN STREET
ELBURN, IL 60119

*World*Life
Discovery Guides

VOYAGEUR PRESS

Dedication

For my grandmother, Neva Ripple, who always
believed in me
—Jeff Ripple

Text copyright © 1999 by Jeff Ripple
Photographs copyright © 1999 by Doug Perrine except where noted for individual photographs

All rights reserved. No part of this work may be reproduced or used in any form by any means—graphic, electronic, or mechanical, including photocopying, recording, taping, or any information storage and retrieval system—without written permission of the publisher.

Edited by Danielle J. Ibister
Designed by Kristy Tucker
Printed in Hong Kong

99 00 01 02 03 5 4 3 2 1

Library of Congress Cataloging-in-Publication Data
Ripple, Jeff, 1963–
 Manatees and dugongs of the world / text by Jeff Ripple ; photographs by Doug Perrine.
 p. cm.
 Includes bibliographical references.
 ISBN 0-89658-393-7
 1. Sirenia. 2. Sirenia Folklore. I. Title.
 QL737.S6R56 1999
 599.55–dc21 99-22721
 CIP

Distributed in Canada by Raincoast Books, 8680 Cambie Street, Vancouver, B.C. V6P 6M9

Published by Voyageur Press, Inc.
123 North Second Street, P.O. Box 338, Stillwater, MN 55082 U.S.A.
651-430-2210, fax 651-430-2211

Educators, fundraisers, premium and gift buyers, publicists, and marketing managers: Looking for creative products and new sales ideas? Voyageur Press books are available at special discounts when purchased in quantities, and special editions can be created to your specifications. For details contact the marketing department at 800-888-9653.

PAGE 1: *A Florida manatee, near Crystal River, Florida.*
PAGES 2 — 3: *A Florida manatee rises to the surface to breathe in a spring near Crystal River, Florida.*
PAGE 3 INSET: *Aboriginal rock art portrays a dugong on a cave ceiling in northern Queensland, Australia. Photograph © Ben Cropp Productions/Innerspace Visions.*
PAGE 5: *A Florida manatee in a spring near Crystal River squeezes its eyes shut, possibly for a nap or to ignore the photographer.*

Contents

6 Foreword *by Judith Vallee, Executive Director, Save the Manatee Club*

8 Author's Preface: *Heeding the Siren's Call*

10 Photographer's Preface

13 CHAPTER 1
A First Glimpse

27 CHAPTER 2
Manatees

65 CHAPTER 3
The Dugong and Steller's Sea Cow

87 CHAPTER 4
Sirens in Myth and Tradition

107 CHAPTER 5
Finding Sanctuary

Appendices

132 I. Guidelines for protecting manatees
134 II. Manatee area signs
136 III. Organizations involved in manatee and dugong conservation

138 Bibliography

142 Index

Foreword

By Judith Vallee, Executive Director, Save the Manatee Club

SAVING MANATEES IS no easy task. When I first became interested in manatees in 1983 as a volunteer, I had no idea what was in store for me. I thought all the manatee's problems could be fixed by educating the public and by regulating boat speeds. I reasoned that if our elected officials and the public were apprised of the problem— that on average one out of every four manatees reported dead each year is killed by a boat—they would be motivated to do something. I didn't yet understand that education and boating restrictions are only temporary solutions unless habitat is also protected, because manatees, like all other beings on earth, need places to live.

Are there answers? Maybe. If we care enough, if we are passionate enough to speak out for the manatee, if we are forever vigilant, manatees may have a chance. We must continue to educate all of Florida's citizens and visitors about manatees and the behaviors that endanger their existence. But make no mistake. Education alone is not the answer. We must also regulate. And as more people flock to develop manatee habitat and as the number of boats increases, so does the need for additional regulations increase exponentially.

Sanctuaries where no motorboats are allowed must be set aside throughout the manatee's range in Florida. Further, the pollution of our waterways must be prevented to protect manatees' food sources, and their winter refuges must be safeguarded to ensure adequate warm water will sustain the population. We need more enforcement officers on the water, and we are going to have to limit both the quantity and speed of boats using Florida's waterways. It is time for our elected officials and decision-makers to find the intestinal fortitude to make tough decisions.

How much are we willing to give up to save a manatee's life? Manatees work hard to survive in an environment that has been altered by an avalanche of human population growth. Is it too much to begin thinking seriously about our state's carrying capacity and resources? Is it too much to curb coastal development in manatee habitat? Is it too much to just slow down through manatee habitat, even if it takes a little longer to get where we are going?

My answer is unequivocal. It was once a T-shirt slogan: "I don't want to live in a world without manatees." Do you?

A Florida manatee is mirrored by its reflection at the surface of a Florida spring.

Author's Preface

Heeding the Siren's Call

I ENCOUNTERED MY first manatee in Florida's Ten Thousand Islands in Everglades National Park nearly 10 years ago. Canoeing alone on the Turner River, I was startled by a loud exhalation and stubby, bewhiskered snout, followed by nearly 13 feet of tubby, paddle-tailed mammal that rose to the surface and lingered beside my 14-foot canoe. The manatee was close enough to photograph and even touch, but I did neither, mesmerized by the sudden appearance of such an unlikely-looking creature. After a minute or two, it sank beneath the reddish water of the Turner, surfaced briefly to breathe about 200 feet away, and then I did not see it again. In the ensuing years, I've seen many more manatees and, during the research for this book, finally donned wet suit, mask, and snorkel to encounter them in their own element at Crystal River National Wildlife Refuge. They are no less improbable-looking underwater, but endearing just the same.

Manatees and their Indo-Pacific relatives, dugongs, are in grave danger of extinction due primarily to human activities. These animals are loved by millions of people and are increasingly popular tourist attractions, but most people have never seen one and know nothing about their life histories, the intriguing legends and traditions that surround them, the dangers they face each day, and what must be done to protect them and their habitat. *Manatees and Dugongs of the World* offers a broad introduction to manatees and dugongs. Hopefully, it will entice readers to explore further the fascinating lives of these aquatic mammals and to learn about what can be done—individually and collectively—to ensure their survival.

A number of people and organizations assisted me in gathering the information I needed to write the text for *Manatees and Dugongs of the World*, and I would like to take this opportunity to thank them: The staff and scientists at The Sirenia Project, particularly Karen Ausley and Bob Bonde; Sea World of Florida; U.S. Fish and Wildlife Service; University of Florida; Dr. Bruce Ackerman, Florida Marine Research Institute; Nancy Sadusky and Patti Thomson, Save the Manatee Club; Susan Dougherty, Art Yerian, and Dr. Mark Lowe, Homosassa Springs State Wildlife Park; and the staff and biologists of the Crystal River National Wildlife Refuge. Daryl Domning's *Bibliography and Index of the Sirenia and Desmostylia* has been an invaluable reference resource, and my text would have suffered without it. I am indebted to Drs. Helene Marsh, Dan Odell, Daryl Domning, and Mr. Bob Bonde for graciously agreeing to review drafts of the manuscript. Thanks also to Doug Perrine and Lisa Tun-Diaz, and of course, to my lovely wife Renée, for friendship and support. Any errors of fact in *Manatees and Dugongs of the World* are due to my misinterpretation of published research and information recounted to me, and I apologize for them in advance.

A juvenile crevalle jack shelters under a Florida manatee, Crystal River.

Photographer's Preface

WHILE WILDLIFE PHOTOGRAPHY can be a lonely pursuit, requiring long hours of solitude in the field, it is rarely accomplished by the efforts of one person alone. In creating the photographs displayed on these pages, taken over a 16-year period, I have had the invaluable assistance of numerous good-willed people. I hope those persons who I will inevitably neglect to mention in the following list will forgive the oversight. My thanks then to (in no particular order): Jim Reid, Bob Bonde, Dan Odell, Galen Rathbun, Frank Murru, Danny Paul, Wayne Hartley, Phil Courter and family, Sharon Alberdi and family, Tasso Welawo, Sandy Ben, Paul Parras, Linda Goodman, Tony Preen, Paul Anderson, Helene Marsh, Craig and Jesse Shankland, June Hunt and family, George McCotter, Susan Dougherty, Tom Linley, Shane Moore, Jesse White, Howard Hall, Bob Friel, Betsy Dearth, the Sirenia Project, Save the Manatee Club, American Pro Diving, SeaWorld of Florida, Homosassa Springs State Wildlife Park, C.A.L.M., Blue Springs State Park.

Many of the manatee photographs were taken in the waters around Crystal River, Florida, a town that has experienced great changes and tremendous growth over the last two decades. Due to the efforts of the Nature Conservancy, the State of Florida, and the federal government, much critical manatee habitat in this area has been protected, but parts remain vulnerable. As this book goes to press, the "Three Sisters Spring"—the actual site where many of these pictures were taken—is for sale, and may end up in the hands of developers. To urge the State of Florida to purchase and conserve this property and other properties adjoining manatee habitat, readers can contact the Florida Conservation and Recreational Lands Office by writing to 3900 Commonwealth Blvd., Mail Station 140, Tallahassee, FL 32399, or by calling (850) 487-1750, or contact the Save the Manatee Club at (800) 432-5646 for an update and to find out what needs to be done. Much of the federal effort to protect manatees is mandated by the Endangered Species Act, which needs to be reauthorized every few years. We should all appeal to our senators and representatives to resist any efforts to weaken this vital legislation.

Though development has been halted on certain parcels, the manatee's environment continues to change rapidly, as a result of our collective presence. Water quality is affected by the runoff from lawns, golf courses, septic tanks, farms and dairies, and so on. Spring flow is reduced by the pumping of water for a myriad of human needs. Aquatic plants imported from other areas choke out native vegetation and decompose into layers of anoxic muck. The greatest threat to sirenians used to be direct hunting by humans. Now that threat is greatly reduced, but they are in greater danger than ever before, simply because their environment is being destroyed by the ever-encroaching presence of humans. We strike them accidentally with our boats. The seagrass beds they feed upon are destroyed by pollution from urban and agricultural sources, and by fishing trawlers. They suffer mass mortalities due to red tides, which appear to be increasing in frequency, possibly due to excess nutrients running down our rivers from both agricultural and urban

A Florida manatee cruises its tank at SeaWorld of Florida.

sources.

If manatees and dugongs are to survive, we must not only act directly by protecting them and their environment, but also indirectly by limiting our own numbers. Sirenians and other wildlife simply cannot cope with the changes accumulating as a result of the ever-expanding human population. Every three days the human population of Florida increases by a number equal to the total number of Florida manatees in existence. We can ensure that our grandchildren will be able to see manatees and dugongs only if we have fewer grandchildren.

CHAPTER 1

A First Glimpse

L E F T : *A Florida manatee is backlit
by sun rays in the clear waters of Homosassa Springs, Florida.*
A B O V E : *An Antillean manatee feeds on seagrass
(Thalassia testudinum) in the Caribbean Sea
off the coast of Belize.*

TENDRILS OF FOG rose slowly from the placid, crystalline window of Three Sisters Spring and climbed through a tangle of shoreline trees before escaping into the blue December sky. The water stirred and parted as a pair of nostrils broke the surface, snuffed like a person breathing through a snorkel, and then slipped below again. These nostrils were followed by another pair, and then three or four more pairs rose together, blowed, and sank from sight. Manatees had entered the spring from the Crystal River, seeking its warm, sweet water and the unbroken silence of dawn. Below the surface, a mother manatee nursed her calf, rolling slightly to one side to allow the calf a better grip on the nipple beneath her left flipper. The calf suckled eagerly for a couple of minutes, and then both mother and calf broke the surface to breathe.

By this time, more than fifteen manatees occupied the spring, in various stages of repose. Some clustered near a log, flippers wedged into the sandy bottom, asleep. Occasionally one would rise as if levitating, breathe, and then descend in the same, trance-like state. A couple of manatees scratched their backs vigorously against another submerged log. Another investigated the limestone confines of the spring, nibbling vegetation from an overhanging bush. It arced backward, did a couple of lazy barrel rolls, and moved toward the narrow run that led to the river.

This describes manatee life at its most idyllic. Unfortunately, they rarely enjoy such moments of peace, particularly during the day, when curious swimmers and boaters crowd around, anxious to have a "manatee experience." Three Sisters Spring and others in the Crystal River are critical sanctuaries for many of the fewer than 3,000 manatees that survive in Florida. Manatee populations have been eliminated or significantly reduced in many areas of western Africa, the Caribbean, and the Amazon River Basin. Dugongs, a close relative of manatees, are now rare along coastal countries around the Indian Ocean and elsewhere throughout their range; they are only relatively abundant in the coastal waters of northern Australia. In some places, they have disappeared completely, as did the Steller's sea cow, a gigantic sirenian nearly 30 feet (9.1 m) long that lived in the frigid waters of the Bering Sea. This grand animal was overhunted to extinction less than thirty years after Georg Steller brought it to Europe's attention in the eighteenth century. Manatees and dugongs have few predators other than humans, and only humans can be held accountable for the current predicament of these ancient aquatic mammals. This book is devoted to helping people better understand manatees and dugongs, and to improving the relationship between humans and sirenians in this fragile world.

Taxonomy and Relationship to Other Mammals

Manatees and dugongs, commonly described as "sea cows," belong to the taxonomic order Sirenia (named after the sirens of Homeric legend) and are collectively referred to as "sirenians." Within the order Sirenia are two families containing four living species. Family Trichechidae consists of the West Indian (including Florida and Antillean subspecies), the Amazonian, and the West African manatees. Family Dugongidae includes the dugong and the recently extinct Steller's sea cow.

Sirenians are not noted for their attractiveness, despite being named for the infamously beautiful Greek sirens whose rapturous voices lured many a sailor to a shipwreck death. One English scientist,

A dugong, accompanied by golden pilot jacks, feeds on sea grass (Halophila ovalis) off the coast of Australia.

A manatee appears to balance on its tail in the clear waters of Three Sisters Spring near Crystal River, Florida.

Several manatees rest undisturbed near the bottom of a spring near Crystal River, Florida.

upon seeing a West African manatee in the wild for the first time, commented, "Floating idly just below the surface of the water, maybe munching a water lily stem, the manatee looks to me disarmingly like a cross between a dirty barrage balloon and a gray maggot." Most people find them endearingly homely. All sirenians have large, streamlined, spindle- or cigar-shaped bodies with no externally apparent neck; flippers; and a large, flattened tail for locomotion. In manatees the tail is shaped like a wide, flat paddle, while dugongs have a fluked tail like whales and dolphins. All sirenians have a sparse covering of hair over their bodies. Sirenian bones are thick and solid and heavy, and the small cranial cavity houses a brain many scientists consider rather small for such a large animal. Despite the manatee's small brain, however, many scientists consider them quite intelligent. All extant sirenians have teeth, and all species have horny plates in the mouth to help crush fibrous aquatic vegetation. Despite the mythical allure of the siren's song, sirenians use only a small repertoire of squeaks and chirps; some scientists suspect that manatees, like elephants, may also communicate via infrasonic sounds indiscernible to human ears.

Sirenians are marine mammals, as are whales, dolphins, seals, sea lions, walruses, sea otters, and polar bears. Like all mammals, they breathe air through lungs, possess hair, give birth to live young, and produce milk for their young. On a superficial level, they most closely resemble cetaceans (whales and dolphins) and pinnipeds (seals, sea lions, and walruses), with whom they share a similar body shape. Like these animals, sirenians are physiologically adapted to life in the water, possess vestigial remnants (such as finger bones and pelvic structures) that hearken back to their ancient life as land dwellers, and depend on aquatic habitat for survival. In fact, as recently as the nineteenth century, scientists incorrectly surmised manatees to be strange,

The Order of Sirenia

Family Trichechidae
 West Indian manatee (*Trichechus manatus*)
 Florida subspecies (*T. manatus latirostris*)
 Antillean subspecies (*T. manatus manatus*)
 Amazonian manatee (*Trichechus inunguis*)
 West African manatee (*Trichechus senegalensis*)
Family Dugongidae
 Dugong (*Dugong dugon*)
 Steller's Sea Cow (*Hydrodamalis gigas*)

tropical forms of the walrus and placed both animals in the same family.

Despite these similarities, manatees and dugongs bear no evolutionary kinship with any other groups of living marine mammals. Their closest living relatives are elephants and, unlikely as it may seem, they are distantly related to hyraxes (small, furry, rodent-like creatures) and aardvarks. Sirenians share with these animals certain proteins that suggest a common ancestry, as well as similar dental characteristics, lack of a collarbone, and toenails or hooves rather than claws. Sirenians are also closely related to an extinct group of marine mammals called desmostylians, which were hippo-like herbivores that lived during the Oligocene and Miocene epochs, roughly five million to thirty-five million years ago.

Sirenian Evolution

Much of what we know about the evolution of sirenians is the result of fossil studies by Dr. Daryl Domning of Howard University and his colleagues. The following evolutionary information is based largely on his findings. Sirenians probably first appeared some fifty million years ago during the early Eocene epoch. Although the oldest known fossils come from Jamaica, most scientists think sirenians evolved in the Old World—Eurasia and Africa—and within a few million years proliferated into several different genera, all as completely aquatic as modern manatees and dugongs but somewhat different in appearance. Most known fossil remains belong to a diverse group of ancient dugong-like creatures called dugongids, which were distributed along coastlines worldwide (including in the Caribbean, where only manatees are found now). Dugongid fossil remains dating back to the Middle Eocene have been found in marine deposits (areas of sedimentary rock once covered by water) from Spain to Egypt, western Europe, the southeastern United States, the Caribbean, South America, the North

Pacific, and the Indian Ocean. Dugongids reached their peak in abundance and diversity during the Miocene epoch five to twenty-five million years ago, when tropical conditions held sway over much of the planet. The most widespread genus at the time, *Metaxytherium*, was likely the forefather of a more recent subfamily of dugongids that included the Steller's sea cow.

South America is considered the ancestral home of manatees (trichechids), descendants of ancient sirenians that reached the South American continent, perhaps during the Eocene, and subsequently became genetically isolated from other sirenians over several million years. Evidence of the earliest known trichechid, *Potamosiren*, came from Middle Miocene fossil deposits in Colombia. Early manatees were probably confined to coastal rivers and estuaries in South America, feeding on freshwater vegetation, while dugongids grazed seagrass meadows in the Caribbean, western Atlantic, and elsewhere. Geologic events during the Late Miocene closed the Pacific entrance to the upper Amazon River, temporarily isolating manatees in the Amazon basin. These animals, which adapted to consume the floating meadows of vegetation on Amazon lakes, eventually became the Amazonian manatee.

One of the principal features that seperates manatees from dugongs is their dentition, or teeth.

A Florida manatee calf nurses from its mother.

Manatees have a large number of small molars that fall out when worn, and are replaced by others further back in the mouth. Extinct dugongs had fewer teeth and, in some cases, large, bladelike tusks, which they used to uproot the nutritious rhizomes, or underground stems, of seagrass. (Modern dugongs do not use their tusks, except perhaps for fighting.) As the Andes formed, tremendous amounts of nutrients and silt were dumped into South American rivers, increasing the amount of aquatic vegetation, including nutritious, but abrasive, grasses. By the late Miocene or Pliocene, manatees evolved specialized teeth to take advantage of this abundant new food source. During the Pliocene, Indo-Pacific dugongs evolved ever-growing cheek teeth as continental glaciation lowered sea level and increased erosion and silt runoff into the seagrass meadows where dugongs fed. According to Daryl Domning, Caribbean dugongs, unlike manatees, may have failed to adapt their dentition to the new feeding conditions and therefore, over time, became extinct.

Today, only four species of sirenians remain, and only near the mouth of the Amazon do more than one species of manatee occur together. No one is certain what caused the decline in the diversity of sirenians, although some combination of changes in climate, quality, and variety of aquatic plants, and competition with other herbivores may be responsible.

Humans and Sirenians

Why are humans fascinated by manatees and dugongs? People are attracted to their rarity, their large size, and their gentle nature. Educational programs tell us sirenians are in danger of extinction and will survive only with our help. In Florida, people flock by the thousands to see manatees in aquariums and in warm-water springs where they gather during the winter. Wayward manatees, such as Chessie, who ventured into Chesapeake Bay at the wrong time of year and required rescue, attract wide-scale media attention and public empathy.

Historically, sirenians have been revered by humans in myth, in religious tradition, for their medicinal value, and as an important food source. In Indonesia the meat is believed to give strength,

A head-on view of a dugong.

ABOVE: *In this mural painted by Ely Kish,* Metaxytherium, *a small-tusked dugong, and her calf feed on sea grasses in the Caribbean Sea more than three million years ago. A variety of fishes, other marine mammals, and the ancient toothed whale* Basilosaurus *accompany them. Photograph © Chip Clark, The Smithsonian Institution*

RIGHT, ABOVE: *A skull of a fossil dugong* Metaxytherium floridanum *from the mid-Miocene (left) and skull of a modern manatee (right) from the Florida Museum of Natural History, Gainesville. Differences in the size of the skull, the downward angle of the rostrum, and the teeth are immediately apparent.*

RIGHT, BELOW: *A fossil dugong tusk (left) and molar (top) compared with a fossil manatee molar (bottom). Teeth are among the principal features that set apart manatees from dugongs.*

A manatee feeds on hydrilla, an exotic aquatic plant. Manatees have been used in many parts of the world, including Florida in the 1960s, to help clear aquatic weeds, with varying success.

the fat is used in obstetrics and cooking, the siren's tears are a love potion, and the incisors are thought to render their owner invulnerable to harm. In many native cultures, manatees and dugongs figure prominently in legends that define cultural conduct. The Rama Indians of coastal Nicaragua believe that if a hunter fails to return a manatee's bones to where it was killed, he will be unable to find manatees on future hunts. Near the Stewart River on the Cape York Peninsula of northern Australia, the sandbeach natives used to believe that any dugong remains must be discarded into the river (rather than burned) to avoid horrible luck.

Many stories have been told to explain how manatees and dugongs came to be. The Kilenge people of the northwest coast of New Britain in Melanesia say that the dugong was originally a wild pig that underwent a transformation. A Lamu story holds that dugongs are the descendants of women who were lost at sea in ancient days. Classical authors gave the siren the attributes of a seductive girl, based on stories by sailors who fixated on the exposed genitals and teat under each flipper. As recently as 1971, fishermen in Zanzibar who captured a female dugong had to swear that they had not "interfered" with it.

Many native cultures that traditionally relied on sirenians as a food source are no longer permitted, or no longer find it feasible, to hunt these animals because they are so scarce. Others still hunt on a subsistence level, although that practice is limited to fewer places than in the past. Overhunting has caused sirenian declines in some areas, but manatees and dugongs are disappearing more often as a result of other human activities, including coastal development, dam construction, shoreline netting, and increased boating. A number of conservation groups and government agencies worldwide are working to produce programs and materials to educate people about manatees and dugongs and how we can share the world with them. (See Appendix III for addresses and phone numbers of organizations you can contact if you want to become involved in sirenian conservation.) Most countries have banned or severely limited the hunting of sirenians, although enforcement of these laws

Sun rays bathe a manatee with light in the shallow spring run of Blue Spring State Park, Florida.

varies widely among countries.

None of this is new. We have heard this same story connected with the histories of thousands of other life forms, some still with us, some not. But it boils down to this: We must become better citizens of our planet. If we cannot curb our own runaway population growth and conscientiously factor the survival needs of wildlife and the environment into our day-to-day actions, we stand no chance of saving manatees, dugongs, or any other species. In the long term, unless we step back from the notion that human needs come first, we will not even save ourselves.

Children observe a manatee through a glass window at Homosassa Springs State Wildlife Park, Florida.

Snorkelers interact with a manatee in the Crystal River National Wildlife Refuge, Florida.

Manatees

LEFT: *A Florida manatee in Crystal River, Florida.*
ABOVE: *A Florida manatee grazes on algae coating a rock in a spring near Crystal River.*

MANATEES LIVE PRIMARILY in warm tropical and subtropical waters of the Americas and western Africa. There are three species—West Indian (*Trichechus manatus*), West African (*Trichechus senegalensis*), and Amazonian (*Trichechus inunguis*)—and all belong to the family Trichechidae. The West Indian manatee is further divided into two subspecies—the Florida (*Trichechus manatus latirostris*) and Antillean (*Trichechus manatus manatus*). All are rare and threatened with extinction.

There has been much discussion of the derivation of the word "manatee." "Manatee" comes from the Spanish word *manatí*; the conflict arises over the word from which *manatí* originates. It was believed to be derived from the Carib Indian (a cannibalistic West Indian tribe) word *manatui* (or a similar spelling), which is often reported to mean "big beaver." This belief was disputed in 1941 by George Gaylord Simpson, who suggested that *manatí* comes from a Carib word for "a woman's breast." This word differs slightly in various dialects, including *manati* (Arekuna), *manatë* (Makuche), *manate* (Galibi), and *manadu* (Akawai), among others. Simpson's suggestion is plausible because the small, wrinkled teats of female manatees are a distinguishing characteristic. Others credit the common name as a reference to the Spanish word *manos*, meaning "hands"—alluding to the manual dexterity of a manatee's foreflippers and possibly the presence of nails on some species' flippers.

The Florida Manatee

The Florida manatee (*Trichechus manatus latirostris*) is probably the only sirenian known to most North Americans. This subspecies appears on calendars and in books, and stars in the occasional documentary. An estimated 2,200 to 2,600 Florida manatees (based on 1997 survey results) live in the wild. A handful of aquariums have them on exhibit in various parts of the United States, primarily Florida and California. Still, many people do not know what a manatee is, what it looks like, or where it lives. Most Floridians have probably never seen this massive yet secretive animal in the wild.

Despite its discreet nature, and in large part because of its endangered status, the Florida manatee is the most studied sirenian in the world. Millions of dollars have been spent studying virtually every aspect of this animal, in captivity and in the wild, since the late 1960s. The Antillean and West African manatees share many traits with the Florida manatee in regards to anatomy, physiology, social behavior, reproductive behavior, and to some degree use of habitat. Studies of the Florida manatee, therefore, can often be applied to these animals as well.

The Florida manatee can be physically distinguished from the Antillean subspecies mainly by certain characteristics of the skull. Put them side by side in the flesh and even trained biologists may have difficulty telling them apart. Florida manatees live primarily in bays, estuaries, rivers, and coastal areas where seagrasses and other aquatic vegetation are abundant. They can live in and move freely between freshwater, brackish, and marine habitats, although scientists don't know how long they can remain in salt water before having to find a freshwater source. Manatees spend most of their time in water three to seven feet (1–2 m) deep, and avoid flats and shallows that are not adjacent to deeper water. They do, however, use high tides to reach feeding grounds, such as those on seagrass flats, that are too shallow during low tide. When traveling along the coast, manatees typically stay in water from ten to sixteen feet (3–5 m) deep, avoiding water more than twenty feet (6 m) deep and currents greater than three miles per hour.

Range

The range of Florida manatees varies somewhat depending on the season. Their historical range is thought to have centered in southern Florida, with small groups wintering in warm-water springs in northern Florida. During the last thirty years, loss of habitat in south Florida and the construction of several power plants in coastal central and northern Florida and Georgia have compelled more manatees to remain farther north during the winter than in the past. These power plants produce warm-water discharges in which manatees like to congregate. In general, Florida manatees are restricted to peninsular Florida north to southern Georgia. During the summer, however, they may range as far north as Rhode Island and as far west as Mississippi and Louisiana. There have been sightings of manatees at West End, Grand Bahama, about fifty miles (80 km) east of West Palm Beach, Florida. Most reports of manatees from

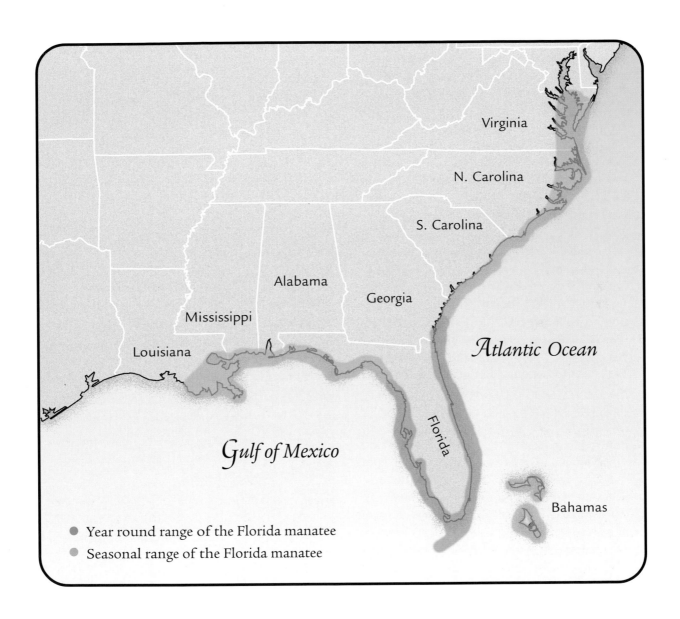

Virginia

N. Carolina

S. Carolina

Alabama

Georgia

Mississippi

Louisiana

Atlantic Ocean

Florida

Gulf of Mexico

Bahamas

● Year round range of the Florida manatee
● Seasonal range of the Florida manatee

southern Texas, northern Mexico, Bimini, and other southern Bahamian islands are probably Antillean manatees rather than far-ranging Florida manatees. Manatee sightings in Louisiana and Mississippi have increased as the population of Florida manatees in the Big Bend area of Florida has grown, while Texas sightings have decreased as the Mexican population of Antillean manatees has dwindled.

In the Gulf of Mexico, Florida manatees are rarely found more than half a mile from the mouth of a river, ranging along the coast from the Ten Thousand Islands in southwest Florida north to the Suwannee River throughout the year. These manatees typically spend their summers in estuaries and grassbeds in rivers. On the Atlantic Coast, manatees are found from the St. Johns River in northeastern Florida south to Miami and infrequently in the Florida Keys and Florida Bay. Manatees rarely cross Florida Bay between the Atlantic and Gulf coasts of Florida, so the two populations generally remain separate. The Indian River Lagoon in east-central Florida, especially the northern Banana River, is a critical feeding area year-round. As many as 245 manatees have been seen there during the spring and more than 100 during the summer. Warm-water effluents in Georgia also attract many manatees year-round.

Several dozen manatees have been tagged with radio or satellite transmitters by scientists to track their movements. Data from studies of tagged individuals have shown that most of their travel occurs seasonally as they move between favored winter and summer grounds. They generally travel alone or in small groups and can cover long distances. One tagged manatee traveled 528 miles (845 km) between Blue Spring in the St. Johns River to Coral Gables, south of Miami. Another traveled more than 143 miles (229 km) in four days from the Indian River to southern Georgia. Chessie, a tagged adult male manatee received extensive media and scientific attention after traveling more than 1,500 miles (2,500 km) from Florida to Rhode Island, breaking records for the longest migration by a West Indian manatee and the most northerly location for that species.

Florida manatees live primarily in bays, estuaries, rivers, and coastal areas where seagrasses and other aquatic vegetation are abundant.

ABOVE: *Two manatees nuzzle in Homosassa Springs, Florida.*
RIGHT: *Florida manatees gather in a Miami canal near a warm water discharge on a cold, winter morning.*

Winter Range

Some manatees live in the St. Johns River throughout the year, and they congregate at Blue Spring in Blue Spring State Park during cold winter weather. The number of manatees at Blue Spring has increased during the last fifteen years because some of the manatees have successfully raised calves and other manatees have migrated from other areas. Because northern Florida in winter is subject to sudden cold snaps—which can be fatal to manatees—most of the population migrates south during the winter. They congregate in warm-water discharges from coastal power plants, including Florida Power & Light's plants at Cape Canaveral, Port Everglades, Riviera Beach, and Fort Myers. Manatees have become accustomed to these warm-water refuges, and interruptions in the discharge from these plants could be devastating.

On the Gulf Coast, most wintering manatees congregate in the springs of the Crystal River and around coastal power plant discharges near Crystal River, at Tampa Bay, and in the Caloosahatchee River at Fort Myers. A few manatees linger during the winter months in large springs on the Suwannee River, including Manatee and Fanning springs.

Physical Description

The Florida manatee, like all sirenians, has what has been described as a "spindle-shaped" body. Adult females may reach a length of thirteen feet (3.9 m) and weigh more than 3,000 pounds (1,500 kg). An average adult manatee is about ten feet (3 m) long and weighs about 1,200 pounds (500 kg). Calves are dark at birth, but lighten to gray after about a month. As with all manatees, the tail is flat and rounded into a broad paddle. They have a pair of short, amazingly flexible, paddle-shaped front flippers, tipped with three to four fingernails. Although there are no apparent hind limbs, vestigial pelvic bones remain deep in the pelvic musculature.

The skin, textured much like a football and sparsely covered with hairs, ranges in color from gray to brown and may vary depending on what organisms—such as algae—are growing on it. The surface layer of skin constantly sloughs off, perhaps to reduce the buildup of algae, barnacles, and other growths. Beneath the skin is a layer of blubber less than an inch thick, and fat deposits occur among muscles and around the intestines.

On some manatees, the head looks much too

A Florida manatee, Homosassa Springs.

small for the rotund body. The face is round and wears a perpetually placid expression. The manatee has prominent whiskers, known as vibrissae, on the large, flexible, upper lip. Manatees use their lips and flippers to handle vegetation when feeding. The nostrils, located on the upper surface of the nose, are tightly closed by valves when the manatee submerges. A manatee's eyes are small and located on the sides of the head. Its ears, which lack external lobes, are visible only as tiny openings located just behind the eyes.

Scientists use a manatee's inner ear bones to estimate the animal's age once it has died, counting growth layers much as they would count the rings of a tree. A captive manatee at the Bradenton Museum in Florida is known to be more than 50 years old, and a manatee named Rosie at Homosassa Springs State Wildlife Park is estimated to be over 35 years old.

The Sensory Manatee

Manatees use all the senses familiar to humans to survive in their world, including sight, sound, touch, taste, and smell. The retina of a manatee's eye has both rods and cones, suggesting manatees can see in both dim and bright light, and they may be able to see colors; their eyesight is thought to be good.

Although manatees hear slight sounds, such as dripping water, from 160 feet (50 m) away, and cows respond to squealing calves more than 200 feet

(60 m) away, recent studies suggest manatees have difficulty hearing the frequency emitted by boat engines. Slow-moving boats appear to be especially difficult for manatees to hear, indicating that a manatee struck by a boat may simply not hear the engine in time to move out of danger. Still, manatees are renowned for their ability to detect sound among some South American tribes, and it is a great compliment when a person is said to "hear like a manatee." Some scientists think the manatee receives sound best not through the ear openings, but rather within a large area near the animal's cheekbones, which are in direct contact with the internal ear bones. Manatees, like elephants, may be able to produce and hear infrasonic frequencies, sounds too low to be detected by humans. While some marine mammals, such as cetaceans, use ultrasonic sounds for echolocation and navigation, manatees use their sounds solely for communication. Most of the sounds they make can be heard by humans.

Manatees communicate with chirps, whistles, and squeaks that presumably are produced with the larynx. They vocalize to maintain contact with each other, during play, or when they are frightened or sexually aroused. Scientists believe manatees can convey different information by varying the pitch, loudness, and duration of calls. Manatees may call often to maintain contact when traveling or feeding, particularly in murky water, and they appear to vocalize more rapidly when greeting new arrivals or when startled as a group and fleeing an area.

There has been little research regarding how well manatees can taste or smell. Manatees have taste buds on the back of the tongue, and scientists think they use chemoreception (physiological responses of a sense organ to chemical stimulus) to choose preferred foods and avoid eating noxious plants.

Scientists think that manatees may also communicate by touch, taste, or smell, because manatees are often observed touching and mouthing one another. Taste and smell may help manatees recognize one another. Males, as with many other mammals, may use taste and smell to determine if a female is in estrus. The short hairs scattered over the skin may heighten a manatee's ability to detect water movements caused by nearby manatees or the touch of other species.

Manatees seem to enjoy being touched. Females and calves maintain lots of body contact, and manatees are often seen nuzzling each other or scratching their bellies on rocks, submerged logs, or the bottom. While many manatees ignore swimmers and studiously avoid any contact with them, some manatees at Crystal River actively seek people out, having learned that swimmers never seem to tire of stroking them.

Manatee anatomy and physiology

Manatee bones are massive and heavy, and the ribs and long bones of the forelimbs lack marrow cavities. The heavy bones may act as ballast to offset the buoyancy caused by the manatee's large lungs, and by gas generated during the digestion process. Some scientists think the extreme density of the bones may be a result of the manatee's slow metabolic rate. Manatees are different from most other mammals (including dugongs) in that they have only six cervical vertebrae rather than seven.

Manatees' teeth are constantly being replaced. Grinding molars form at the back of the jaw and

A Florida manatee arrives from the ocean, its back covered with barnacles.

Barnacles festoon the tail of a Florida manatee, recently arrived from the ocean to a freshwater spring. Scars where others have fallen off after the manatee left salt water are also plainly visible. Algae frequently grows on manatees living in fresh water and is often grazed upon by mullet and sometimes other manatees.

A Florida manatee and her calf.

gradually move forward as front molars fall out. This tooth replacement mechanism is an adaptation to the manatee's diet of abrasive plants that are often mixed with sand. Wrinkles in the molars' surface enamel may also help reduce wear. The front teeth of Florida manatees often show extreme wear: this may be caused by the quartz sand substrates common on the Atlantic and Gulf coasts.

Manatees possess a digestive system much like that of horses, one adapted to digest high-fiber, low-protein vegetation. The cardiac gland, a large structure that protrudes from the stomach, coats swallowed food with mucus. This protects the lining of the digestive system from abrasive plant material as it moves through the digestive tract. Once food leaves the stomach, it passes to the intestines, which in an adult manatee can measure 130 feet (40 m) in length. The bulk of digestion occurs in the rear part of the gut, where intestinal bacteria break down cellulose from plant material. Food may take a week to move through the animal, and the slow digestive process produces copious quantities of methane gas.

Manatees are usually submerged when they feed and so must be able to hold their breath for long periods. Manatees breathe through two valved nostrils situated at the tip of the nose. They exhale at the surface and, like whales and dolphins, can renew about 90 percent of the air in their lungs in a single breath. (When at rest, humans ordinarily renew only about 10 percent of the air in their lungs with each breath). The manatee's lungs are flattened, about three feet (1 m) long, and situated along the back.

The shape, position, and internal structure of the lungs help manatees float horizontally in the water. By changing the volume of their lungs, they can hang motionless in the water column and move up or down with little effort. This ability, combined with their heavy bones, gives them excellent buoyancy control and allows them to feed efficiently them near the bottom.

When manatees dive, they hold their breath like humans. Manatees have been reported to stay submerged for up to 20 minutes, but scientists doubt they can dive beyond about 33 feet (10 m). The average time between breaths at rest is two to four minutes, and smaller manatees need to breathe more frequently than larger ones. During strenuous activity a manatee may need to take a breath every 30 seconds.

A manatee swims by flapping its tail and steering with its tail and flippers. Manatees can be quite acrobatic, doing barrel rolls, gliding on their back, performing somersaults, and standing on their head or tail. Their average cruising speed is about two to six miles (4–10 km) per hour, but they can reach speeds of more than 15 miles (25 km) per hour for short bursts.

Metabolism and susceptibility to cold

Manatees are extremely intolerant of cold water. Scientists believe this intolerance is due primarily to their low metabolic rate, which is only 15 to 22 percent that of a land mammal of similar body weight. A low metabolic rate benefits large tropical mammals because it allows them to stay cool in warm water and survive on a nutrient-poor diet. But Florida is on the northern edge of the West Indian manatee's range, and winter cold fronts that bring several consecutive mornings with lows at or near freezing can kill Florida manatees. Juvenile animals are particularly susceptible to cold weather mortality, because their smaller body size creates a greater potential for heat loss. Nursing infants are

A Florida manatee calf nurses from its mother.

virtually unaffected, perhaps because the rich milk from their mothers helps compensate for their small size and because their mothers take them to warm water when necessary.

Manatees spend less time eating during cold weather. They may quit eating altogether if water temperatures drop to near 50°F (10°C). Dead animals recovered by researchers after severe cold snaps generally have empty stomachs, have depleted their fat reserves, and show signs of dehydration. Several studies indicate that a manatee's layer of blubber may not provide sufficient insulation against cold water and that its metabolism may be unable to increase sufficiently to counteract the loss of body heat brought on by sudden cold. Forty-six Florida manatees are thought to have died from cold-related stress in 1989, and exposure to cold is blamed for many deaths in the winters of 1977, 1981, and 1984.

An adult manatee's normal body temperature hovers at about 97.5° F (36.4° C), but may vary seasonally or with water temperature. Manatees generally start looking for warm water when the air temperature drops below 50° F (10° C) or water

Like all marine mammals, sirenians need to surface to breathe air.

temperature dips to 68° F (20° C). During a typical year, most Florida manatees migrate to southern Florida or converge on springs and other warm-water sources throughout the state. This migration usually lasts from November through March. Some individuals move between warm-water refuges during the winter. Between cold fronts, most manatees make short feeding trips that last up to a week or more, from their refuges to feed. Other animals stay in coastal areas or bays where there is steady water temperature and a reliable food source, such as the shallow nearshore waters of Everglades National Park in extreme southern Florida.

Some studies indicate that manatees may acclimate to cold temperatures as winter progresses to spring. A study by Dr. Daniel Hartman in the late 1970s showed that when November air temperatures dropped to 50°F (10°C), manatees flocked into the Crystal River for warmth, but the air temperature had to plummet to near 41°F (5°C) to force the same manatees back into the river in March. Studies of wintering manatees at power plants demonstrated a similar pattern. Some scientists, however, argue that the lower temperature required to force manatees back to warm water late in the winter may reflect the manatee's increased need to feed rather than acclimation to cold weather. During the winter, a manatee's blubber layer shrinks as the animal taps into its energy reserves. It is therefore less willing in early spring to abandon food sources and rush back to warmer water.

Diet and Feeding

Manatees often spend more than eight hours a day feeding. In that time, they can consume nearly 10 percent of their body weight in wet vegetation. They are opportunistic herbivores, grabbing and tearing plants with their lips and then passing the material back to the molars for chewing. Florida manatees are known to eat more than sixty species of plants, preferring submerged vegetation over emergent, floating, and shoreline varieties. In fresh water, Florida manatees dine on a wide array of plants, including two invasive exotics—hydrilla and water hyacinth. At Blue Spring State Park, manatees were observed rooting for and devouring acorns that had fallen to the bottom from the live oaks

A Florida manatee resting on the bottom displays its flipper and elephant-like toenails.

overhanging the spring run. When necessary, manatees will even haul themselves partially out of the water to browse shoreline vegetation.

In salt water, a manatee's primary food is seagrass, including turtle grass, manatee grass, and shoal grass. Manatees have also been known to consume mangrove leaves and seedlings.

When feeding on seagrass, manatees crop the leaves. One report mentions manatees digging out the nutritious rhizomes of seagrass with their flippers, while others say manatees only eat rhizomes that are exposed by some other disturbance, such as strong currents. Their manner of feeding may depend largely on the species of seagrass being grazed. For example, small, tender species of seagrass are easily uprooted and consumed whole. Seagrasses of the genus *Thallasia*, on the other hand, are typically hard to dig up, so their rhizomes are rarely eaten. Although manatees frequently graze heavily on seagrass beds and occasionally eat exposed rhizomes, their feeding rarely makes a

When a manatee breathes, only the tip of its snout protrudes above the water, which makes it difficult to see by boaters.

lasting impact on the seagrass community.

Manatees prefer to feed on the edges of seagrass beds, where they can escape to deeper water if disturbed. They also seek out protected water behind barrier islands, where they are sheltered from wind and currents. Wading birds, such as little blue herons and reddish egrets, often feed on small fish and invertebrates flushed out by grazing manatees.

Although manatees are primarily herbivores, they do consume small animals incidentally and opportunistically. A variety of invertebrates that cling to the leaves of mangroves or seagrass blades are unintentionally eaten; adding important protein to the manatees' diet. But there are instances of intentional carnivorism. Along the northern coast of Jamaica, fishermen complain that manatees suck the meat off the bones of fish caught in their gill nets, leaving the skeletons hanging in the mesh. Biologist Buddy Powell watched manatees in this area move from net to net as they looked for entangled fish. At Marineland of Florida, staff began feeding their manatees fish as a protein supplement after seeing manatees sucking the flesh off fish left by Amazonian dolphins sharing the tank. Biologist Sharon Tyson watched manatees in southeast Florida linger near fish-cleaning tables at the water's edge to claim the discarded remains of redfish, grouper, and flounder (while ignoring other kinds of fish). Tyson also observed one manatee catch a small flounder while feeding in thick seagrass. The manatee rose to the surface with the wriggling fish in its mouth and was about to swallow it when another manatee came along and tried to steal it. Perhaps the strangest manatee meal was reported by biologist Bob Bonde, who was observing manatees from a Brevard County dock when a dead rat floated out from under the dock and was quickly devoured by one of the manatees.

Social Behavior

Manatees are generally described by scientists as semi-social animals with relatively uncomplicated behavior. Scientists say that because manatees evolved in regions with warm temperatures, plentiful food, and few natural predators, these gentle mammals rarely needed work together to find food or shelter, or to defend themselves against enemies. They congregate at warm-water refuges during cold weather and occasionally feed in small groups at other times of the year, but these associations are

ABOVE: *Manatees "kissing" at Blue Spring State Park, Florida.*
LEFT: *A Florida manatee feeds on water hyacinth, another problem aquatic plant not native to Florida.*

A Florida manatee rests just below the surface of a spring, Crystal River, Florida.

The short hairs scattered over its skin may heighten a manatee's ability to detect water movements caused by nearby manatees or the touch of other animals, such as the crevalle jacks surrounding these manatees in Homosassa Springs, Florida.

temporary. The only strong, basic social relationship believed to exist between manatees is the bond between a female and her calf; the male manatee plays no role in rearing the calf. A calf is fully formed at birth and able to swim with its mother within a few moments of taking its first breath. It calls to its mother just after birth; this vocalization is thought to be part of the bonding process. It remains close to its mother's side, usually swimming directly behind her flipper. The calf relies solely on its mother for nutrition and guidance regarding feeding and resting areas, travel routes, and warm-water refuges. If a human or another manatee approaches the calf, the mother may position herself between the intruder and the calf, but she will not attack. If she feels threatened or senses danger in any way, she and her calf will flee, calling to each other as they swim away.

The bond between a mother and calf is strong. In one instance, a manatee cow and her calf were separated by a closed floodgate for several hours and constantly called back and forth until the gate was raised. When a cow and calf are trapped in an unsafe area, rescuers frequently will catch the calf first and use it to coax the mother to safety. This bond has historically been observed—and utilized—by people who came into contact with manatees. Friar Cristovao de Lisboa wrote in 1632 in *History of Animals and Trees of Maranhao*, "I saw a female get killed and skinned, and they threw the skin on the ground at the edge of the water. And the next day, going to get water, they found the offspring stretched out over the skin and they took it."

Manatee life centers around a few daily activities with no set schedule. Of course, much of the day is spent eating, while several more hours are spent resting, traveling, investigating curious objects, and socializing by "kissing," mouthing, bumping, or chasing other manatees. These activities occur intermittently throughout the day and night. During cold snaps in the winter, activities such as feeding may be regulated by daytime temperature cycles. Manatees also have

been known to schedule activities such as feeding and resting to avoid harassment by divers and boaters.

Manatees rest either suspended near the surface or lying on the bottom, usually for several hours at a time. On cold days when the water is warmer near the surface, manatees tend to rest at the surface. If resting on the bottom, they rise to the surface to breathe in an almost hypnotic state. Manatees generally surface to breathe every two to four minutes, but when bottom resting may not surface for twelve minutes.

Manatees frequently rub themselves against logs, rocks, ropes, and even the hulls of boats. Females tend to rub more than males, and often the areas they rub are places where glandular secretions may be produced, such as the genitals and around the eyes, armpits, and chin. Scratching may relieve itching, but some scientists speculate that it may also leave a scent message regarding the presence and reproductive condition of resident females.

Manatees within a group do not dominate others, nor are they territorial or aggressive. Groups form casually without regard to sex or age, with the exception of cow-calf pairs and temporary bachelor herds of juvenile males excluded from breeding. Occasionally, though, an individual manatee will instigate an activity that other manatees will follow. This may include games of "follow the leader," during which two or more manatees move together in

A Florida manatee stirs up bottom sediments while eating hydrilla.

ABOVE: *A Florida manatee rubs its head against a rock.*
RIGHT: *Male Florida manatees jostle for position around a female manatee in estrus.*

OPPOSITE PAGE:
TOP: *A female Florida manatee in estrus is pursued by six males in the Crystal River National Wildlife Refuge.*
BOTTOM: *Florida manatees frequently engage in tactile or sex play.*

single file, synchronizing their breathing, diving, change of direction, and other activities. Researcher John Reynolds watched five adult manatees in Blue Lagoon Lake body surf together for more than an hour in the flumes created by a salinity intrusion barrier. Four animals followed the lead of a fifth, calling to each other and nuzzling between rides. Manatees may play for hours, but generally only after they have fed and when they are not harassed.

Mating Behavior and Reproduction

The estrous cycle of mature female manatees lasts about a month. They can have more than one estrous cycle a year and usually continue cycling until they become pregnant. When a female manatee comes into estrus, she attracts a crowd of males, and together they form a mating herd that may stay together for between a week and a month. The bulls do not defend territories around the cow, but rather jostle each other in attempts to remain at her side. Each wishes to be the first to mate with her when she becomes receptive. As the bulls pursue the cow, she often swims into shoals or shallow water, twisting and turning violently, perhaps to prevent them from reaching her underside to mate. The fracas frequently attracts more males. Sometimes the female runs aground or slaps males with her tail, prompting unseasoned observers to call with reports of a manatee in distress. Once the female is receptive, she may mate with one to several males in quick succession. Mating can take place at the surface or underwater, and no single posture is assumed during copulation. Some pairs remain horizontal in the water column, others vertical. Frequently, the bull turns upside down and swims below the female, but mating can also take place with the animals on their sides, facing each other. After the female is impregnated, the mating herd breaks up and the males and female go their separate ways.

Most females first breed

successfully when they are seven to nine years old. Some females may be physically able to breed as early as four or five years of age, but they may not be able to raise a calf successfully. Gestation generally lasts about a year, whereupon females find a quiet place to give birth alone. Calves can be born either head-first or tail-first. The cow usually produces one calf with each pregnancy, although twins are occasionally born. Other females may care for orphaned calves. A healthy female usually gives birth to a calf every three years or so, although a female that has lost her calf could have another within two years. Calves are born throughout the year, although in Florida more seem to be born in spring and summer.

Newborn manatee calves weigh an average of 66 pounds (30 kg) and range in length from 4 to 4.5 feet (1.2–1.4 m). A calf begins to nurse within a few hours of birth. Although it is born with teeth and will begin nibbling on plants within a few weeks, it continues to depend on milk for its nutrition. A manatee calf nurses underwater for up to three minutes from a single teat located in each of the mother's armpits. As it grows older, the calf will nurse longer and more often. Manatee milk contains more fats, proteins, and salt than does cow milk, but no lactose. Although a manatee calf is

Two Florida manatees rise to the surface for a breath.

A Florida manatee nurses her calf in a spring, Crystal River.

usually weaned by the time it is a year old, it stays with its mother for up to two years. Some calves spend their adolescent lives near their mothers as well.

The sex of a manatee is difficult to determine without viewing the underside of the animal. Both sexes have an umbilical scar midway along the belly; in males, the genital opening is located close to the umbilical scar, with the anus by itself near the tail. In females, both the anal and genital openings are close to the tail. A female can also be identified, of course, if it is accompanied by a nursing calf or if it is visibly rotund as a result of pregnancy.

Natural Mortality

Although Florida manatees have few natural predators, an average of 175 deaths occur each year. Some of these are due to natural causes, but many are caused directly by humans or indirectly by human activity. During 1997, a total of 242 manatee deaths were recorded in Florida. This number is below the record 415 deaths documented in 1996 (which included a major red tide-related die-off), but well above both the ten-year (1986-1995) annual average of 161 and the five-year (1991-1995) average of 175. In fact, it is the second-highest total since scientists began keeping records in 1974.

The largest identifiable mortality factors are collisions with boats and barges. These and other human-related causes of death are discussed in detail in chapter 5. Most natural manatee deaths are perinatal or related to catastrophic events, including unusually cold weather and infrequent, but lethal, outbreaks of red tide. Other natural causes of death include disease, parasitism, injuries unrelated to human activity.

Perinatal deaths are those that occur around the time of birth, from the later stages of gestation to the first few months of life. The deaths of newborn manatees, stillborns, and miscarried fetuses are grouped in this category. A baby manatee may die from poor nutrition, infection, diarrhea, or separation from its mother. Perinatal deaths are most common from March through July—probably because that is when the bulk of calving occurs—and account for about 25 percent of all manatee deaths.

Although a manatee calf is born with teeth and begins nibbling on plants within a few weeks of birth, it continues to depend on its mother's milk for nutrition for nearly a year.

TOWN AND COUNTRY
PUBLIC LIBRARY DISTRICT
112 N. MAIN STREET
ELBURN, IL 60119

From 1974 to 1992, 425 perinatal deaths were recorded, an average of 24 deaths a year. In 1997, 61 perinatal deaths were tallied.

As discussed earlier in this chapter, cold weather can be fatal to manatees. Following a severe cold spell in the winter of 1989–90, 56 manatee carcasses whose deaths were attributed to cold stress were recovered in five southeastern states. Because cold-related mortality was not listed as a separate category until 1986, exact numbers of cold-related deaths before that time are unknown. However, exposure to cold is believed to have caused many deaths in the winters of 1977, 1981, and 1984.

In March 1996, more than 150 manatees died along the southwest Florida Gulf Coast (10 percent of the Gulf Coast population) after an outbreak of red tide. Red tide is caused by a bloom of algae—dinoflagellates of the genus *Gymnodinium* (and possibly other genera as well)—that stains seawater reddish-brown. These blooms occur naturally in the world's oceans and are common along the Gulf Coast. Unfortunately, one byproduct of red tide is brevetoxin, a powerful irritant that attacks a part of the nervous system that controls breathing. Many manatees literally suffocated after exposure to brevetoxin, said Dr. Scott Wright, chief manatee pathologist for the State of Florida. Necropsies of the affected manatees revealed discolored, fluid-filled lungs.

The 1996 red tide was not the first to kill manatees. In spring 1982, 37 manatee deaths in southwest Florida were blamed on exposure to red-tide neurotoxins in the Fort Myers area (Caloosahatchee River basin). Then, biologists had no sooner finished assessing the impact of the death toll from 1996 when another red tide occurred in November 1997. This outbreak, fortunately, was less severe, but another 16 manatees perished from brevetoxin poisoning. While red tides are a natural event, some scientists speculate that the increasing frequency and severity of red tides may be linked to higher levels of pollutants in the world's oceans.

Antillean Manatee

The Antillean manatee (*Trichechus manatus manatus*) is virtually indistinguishable from the Florida manatee by appearance alone. An average adult Antillean manatee weighs about 1,200 pounds (500 kg) and measures about 10 feet (3 m). Large adult females may weigh more than 2,200 pounds (1,000 kg) and reach a maximum length of about 10 feet (3 m). Like the Florida manatee, Antillean manatees live in coastal areas, seeking sheltered bays, estuaries, and slow-moving rivers with plenty of aquatic vegetation on which to feed. They also can move freely between salt and fresh water. Scientists believe most aspects of their social and reproductive behavior and use of habitat are similar as well.

The Antillean manatee ranges throughout the greater Caribbean area (including Mexico and southern Texas) and northeastern South America, including Brazil, Surinam, Guyana, Trinidad, Venezuela, Colombia, Panama, Costa Rica, Nicaragua, Honduras, Guatemala, and Belize. More than sixty manatees are thought to live along the coast of Puerto Rico, and perhaps thirty-two live along the coast of Haiti. According to records from the sixteenth and seventeenth centuries, the Antillean manatee was once found almost as far south as Rio de Janeiro, Brazil. Many of the regions in the Antillean manatee's range have not been completely surveyed, so neither the complete distribution of the species nor a good estimate of its population is known.

The Antillean manatee is not evenly distributed throughout its range, in large part because of the patchiness of suitable habitat. Manatees need both vegetation and fresh water, and local populations in some areas appear to move in conjunction with the rainy season. Manatees move upriver when water levels are high and retreat downstream when water levels drop in the dry season. Antillean manatees are relatively abundant in Mexico and Belize where large areas of quality habitat still exist.

An Antillean manatee feeds on Thallasia *seagrass.*

Amazonian manatees swim under the floating aquatic plants common in their range. Photograph © Nick Gordon

Antillean manatees are susceptible to many of the same causes of death as Florida manatees, although they rarely encounter water cold enough to cause difficulties. Entanglement in fishing nets and collisions with motorboats are leading causes of death, and although Antillean manatees are protected in nearly every country they inhabit, they are still often hunted for meat, either for personal consumption or for sale on the black market.

Amazonian Manatee

Many scientists consider the Amazonian manatee (*Trichechus inunguis*), known among local people throughout its range as *peixe-boi* (Portuguese for ox-fish) or *vaca marina* (Spanish for sea cow), as the most specialized of the living species of manatees. It was not recognized as a distinct species until 1830, and then it was virtually forgotten except by those who hunted it.

Range

The Amazonian manatee is the smallest living sirenian and the only one restricted to fresh water. Endemic to the Amazon basin, it prefers water temperatures ranging from 77° to 86° F (25°–30° C) and seeks calm flood plain lakes and the channels of whitewater rivers with abundant vegetation. (*Whitewater* here refers to water that is less acidic and high in suspended sediments and nutrients, not fast-moving like "whitewater" rivers in North America.) This region has a marked dry season and wet season, and water levels may change as much as 30 to 50 feet (10–15 m) between seasons.

The Amazonian manatee's range includes the Amazon River and its tributaries in Brazil, along the Brazil-Guyana border, in Peru, in Colombia, and in Ecuador. According to sirenian researcher Daryl Domning, both Amazonian and Antillean manatees frequent regions near the broad mouth of the Amazon River in Brazil. This is likely the only place in the world where two species of sirenian occur together.

Physical Description

Smaller and slimmer than its West Indian and West African cousins, the Amazonian manatee may measure up to 9.2 feet (2.8 m) in length and weigh as much as 1,056 pounds (480 kg). By comparison, the average West Indian manatee measures 10 feet (three meters) long and weighs about 1,200 pounds

(500 kg). Its color varies from dark gray to black, and most animals have distinctive white or pink unpigmented patches on the belly. There is no difference in size between males and females.

The Amazonian manatee is different from West Indian and West African manatees in other ways as well. Its specific name, *inunguis*, means "without nails" and refers to the lack of toenails on its pectoral flippers; both West Indian and West African manatees have toenails. Amazonian manatees also have proportionally longer flippers, smaller teeth, and a longer, narrower rostrum (the anterior portion of the skull) than other manatee species. The skin of the Amazonian manatee after infancy is smooth, unlike the pebbled texture of the skin of other manatees. On the cellular level, Amazonian manatees have fifty-six chromosomes, while the West Indian manatee has forty-eight. The scientific community once believed this chromosomal difference left little chance of hybridization between Amazonian and West Indian (Antillean) manatees where the two species share habitat at the mouth of the Amazon, but new unpublished findings indicate hybridization may indeed occur. The number of chromosomes in the West African manatee

Range of the Amazonian manatee

has not been determined.

The Amazonian manatee, like other manatees, has only molars. Vestigial incisors remain in the upper jaw, but they never become functional. As with other manatees, the molars of Amazonian manatees are stimulated by chewing to move horizontally from the back of the jaw forward. These molars replace those that have become worn and fallen out at the front, prompting some scientists to dub them "conveyor belt teeth." The entire tooth row moves forward about one millimeter a month throughout a manatee's life.

As mentioned before, the rostrum of the Amazonian manatee is narrower than in other species. It is also deflected about 30°. Thus the Amazonian manatee's "forehead" curves downward less than that of the West Indian manatee, whose rostrum is deflected about 38°. This lesser curvature of the head, together with specific features of the muscles and articulation of the neck, appears to be an adaptation for feeding on floating and emergent aquatic plants. In other physiological aspects, including its bones, digestive system, and lungs, it is similar to its West Indian and West African cousins. Like other manatees, it can stay submerged for up to twenty minutes when resting.

Metabolic Rate and Temperature Regulation

Like other manatees, the Amazonian manatee has a low metabolic rate (about 36 percent of what is typical for a mammal its size) and an intolerance of cold water. Scientists believe the low metabolic rate is a result of evolving in a stable, warm-water environment, and that it allows a manatee to hold its breath for long periods when submerged. The Amazonian manatees' low metabolism may also allow it to survive long periods without food.

Social Behavior

Unlike the Florida manatee, which frequently approaches boats and cavorts with swimmers, the Amazonian manatee is elusive and practically impossible to observe in the wild. When it rises silently every few minutes to breathe, it never exposes more than the tip of its snout. Its secretive nature is probably in large part a response to centuries of hunting by humans. Also, the water where it lives is usually murky, which prevents observation of the animals underwater.

Within the last century, large herds of feeding Amazonian manatees were reported. Now, when they can be found at all, they are seen feeding in small, loosely organized groups of four to eight individuals.

Most of what is known about Amazonian manatees is based on the results of studies conducted by members of the Brazilian Manatee Project, or Projeto Peixe-Boi, initiated in 1975 by the Brazilian government's Instituto Nacional de Pesquisas da Amazonia (INPA) at Manaus, in the heart of the Brazilian Amazon. While research regarding distribution and basic ecology was done with wild populations of manatees, studies on various aspects of physiology, behavior, and captive rearing of young and adult animals involved manatees housed at the Aquatic Mammal Laboratory of INPA. Most manatees arrived at INPA as orphaned calves and were hand-raised and bottle-fed until weaned. Rescued individuals that could not be released remained in captivity for study, eliminating the need to capture more wild manatees.

Studies of these captive animals indicate that their social and reproductive behavior resembles that of Florida manatees. Captive manatees often clasp each other with pectoral flippers and chase each other in the water, engage in sex play, and communicate with high-pitched squeals. The only lasting bonds form between a female manatee and her calf. Based on studies done by Dr. Robin Best at INPA, captive Amazonian manatees spent four hours each day resting, eight hours feeding, and twelve hours simply swimming. A radio-tagged manatee that was followed for twenty days was equally active during the day and night and traveled about 1.7 miles (2.7 km) a day.

Like Florida manatees, Amazonian manatees form mating herds when a female comes into estrus and attracts a crowd of bulls. Wild Amazonian manatees gather together in feeding areas, but—contrary to observations of captive manatees—little interaction between animals has been observed. In at least one instance, captive manatees were observed assisting another that was in trouble. One of the manatees was having trouble reaching the surface to breathe, prompting two of its poolmates to support it on either side and help the weakened manatee rise to the surface.

The white, unpigmented belly markings on this juvenile Amazonian manatee are typical of the species. Photograph © Daryl Domning

Two Amazonian manatees sidle up to
the shore to have their heads scratched
by a member of the Brazilian Manatee
Project. Photograph © Fernando
Trujillo/Innerspace Visions

Reproduction

Reproduction in Amazonian manatees is closely linked with the hydrologic cycle of the Amazon Basin. Research done by Robin Best has shown that most copulation occurs when the waters of the Amazon begin rising from December through June, with most births coming between February and May. Best believed that during this period, the plants on which manatees feed are abundant and nutritious, allowing females to replace the energy they've lost during the last stage of pregnancy and the beginning of lactation. Amazonian manatees probably become sexually mature between five and ten years old (based on estimates made for the Florida manatee). Each successful pregnancy produces one calf, and a female may become pregnant every two-and-a-half to five years. Newborns are at least 30 inches (80 cm) long, and captive animals increase in length by about one-half inch (1.4 cm) per week. There is no information about the weight of Amazonian manatees at birth, but captive animals gained an average of about two pounds (one kg) per week. Captive calves were weaned at about a year old.

Movement and Habitat Use

While Amazonian manatees do not migrate to escape cold weather, they do migrate in response to seasonal changes in water levels and the availability of food. As water levels rise during the rainy season (December to June), vast, flooded, nutrient-rich areas called *várzea* form along the rivers (primarily whitewater rivers), producing enormous quantities of aquatic and semi-aquatic plants, many of which are favored by manatees. Manatees also travel into the igapó, or flooded forest, to feed on tender, new plant growth. As the river levels fall from July through November during the dry season, manatees move into river channels, deep-water canals, or permanent—usually blackwater—lakes. These lakes are much less acidic than the blackwater swamps and rivers of the southern United States. If a dry season is exceptionally long, manatees may die of starvation. Because Amazonian manatees migrate in response to changing water levels, movement patterns of manatees in the upper and middle Amazon basin may be completely different from those of manatees in other areas.

Mortality

Amazonian manatees face dangers from natural predators that other manatees do not. Jaguars, caimans (a relative of the alligator), and sharks have all been known to prey on Amazonian manatees. Human predation is a problem as well, despite legal protection, particularly during the dry season, when manatees are forced to congregate in small areas of suitable habitat, leaving them susceptible to poaching.

While no precise figures exist for the number of Amazonian manatees remaining in the wild, they are considered rare or close to extinction in Peru and Colombia and uncommon throughout their range in eastern Ecuador. Hunting deserves most of the blame, although catastrophic natural events also have contributed, such as the long dry season of 1963, during which hundreds of manatees died when lakes and rivers dried up.

West African Manatee

The West African manatee (*Trichechus senegalensis*) is thought by paleontologists to have originated from West Indian manatees that crossed the Atlantic less than five million years ago. Because environmental conditions on both sides of the Atlantic were similar then and continue to be similar now, there has been no evolutionary pressure for the species to develop remarkably different characteristics. For this reason, the two species are remarkably similar in appearance, physiology, reproductive and social behavior, and habitat requirements.

Whereas the West Indian manatee is perhaps the most studied sirenian in the world, the West African manatee is the least known, in part because there is no center of research for this species as there are for other manatees and the dugong. West African manatees are widely distributed in fresh water and coastal marine waters in a dozen countries from Senegal to Angola in western Central Africa. In Liberia and in other west African countries, the manatee is called "mammy-water." In Gabon, the manatee is called *manga*. The historical range of West African manatees seems to differ little from their current overall range, although their numbers have dwindled and local populations have been exterminated by hunting and habitat loss. They have few predators other than humans and the occasional crocodile or shark.

A West African manatee swims in its tank at the Toba Aquarium, Toba, Japan. The West African manatee is the least-studied living sirenian species, and photographs of them in the wild are rare. Photograph © Toba Aquarium

AFRICA

Atlantic
Ocean

● Range of the
West African
manatee

Like West Indian manatees, West African manatees prefer quiet coastal areas, large rivers, lagoons, and connected lakes where they have easy access to fresh water and adequate food. They also need water that is at least 64° F (18° C).

Physical Description

The West African and West Indian manatees are comparable in size and shape, have the same brown to gray wrinkled skin, and have similar sparse coverings of body hair. There are, however, a few notable differences between the two species. The skull bones of the West African manatee are different, and its body is not quite as rotund as that of its West Indian relative. Its rostrum is deflected downward less than the West Indian manatee's. Scientists believe that this adaptive characteristic reflects the West African manatee's primary diet of floating aquatic plants rather than bottom vegetation. Its eyes bulge more than those of the West Indian manatee, and it has been described as pug-nosed because of its blunt snout.

Diet and Feeding

West African manatees rely heavily on a variety of floating aquatic plants, as well as on some submerged plants. When these plants are not available, manatees may graze mangrove leaves or shoreline vegetation. In some areas, mangrove leaves provide the bulk of the manatee diet, and if mangroves die off, as they did along the Allahein River in coastal Gambia, the manatee population can decline dramatically. Like the West Indian manatee in Puerto Rico, West African manatees have been reported to feed opportunistically on clams.

Movement and Habitat

West African manatees use coastal rivers in much the same way as Antillean and Amazonian manatees. They move far upstream during the wet season to feed on the lush new vegetation in flooded areas, then drift downstream toward the coast as river levels fall during the dry season. Occasionally, manatees linger longer than they should in tributaries and lakes connected to larger rivers and become trapped by falling water levels.

West African manatees are protected in Senegal, Guinea, Sierra Leone, Liberia, Ivory Coast, Ghana, Togo, Dahomey, Nigeria, Gabon, Cameroon, Congo, Zaire, and Angola. Hunting by native people and incidental capture in gill nets remains a problem. Manatee meat is openly consumed and even sold in markets in some African countries, including Sierra Leone. Furthermore, proposed hydroelectric dams threaten manatees and their habitat on major rivers in countries such as Nigeria and Gambia. Because manatees are highly valued as a traditional food source, and because many African nations are placing great hope in hydroelectric power, biologists worry that conserving the West African manatee and its habitat may prove extremely difficult.

A manatee calf nurses from one of its mother's teats, located at the base of the flipper.

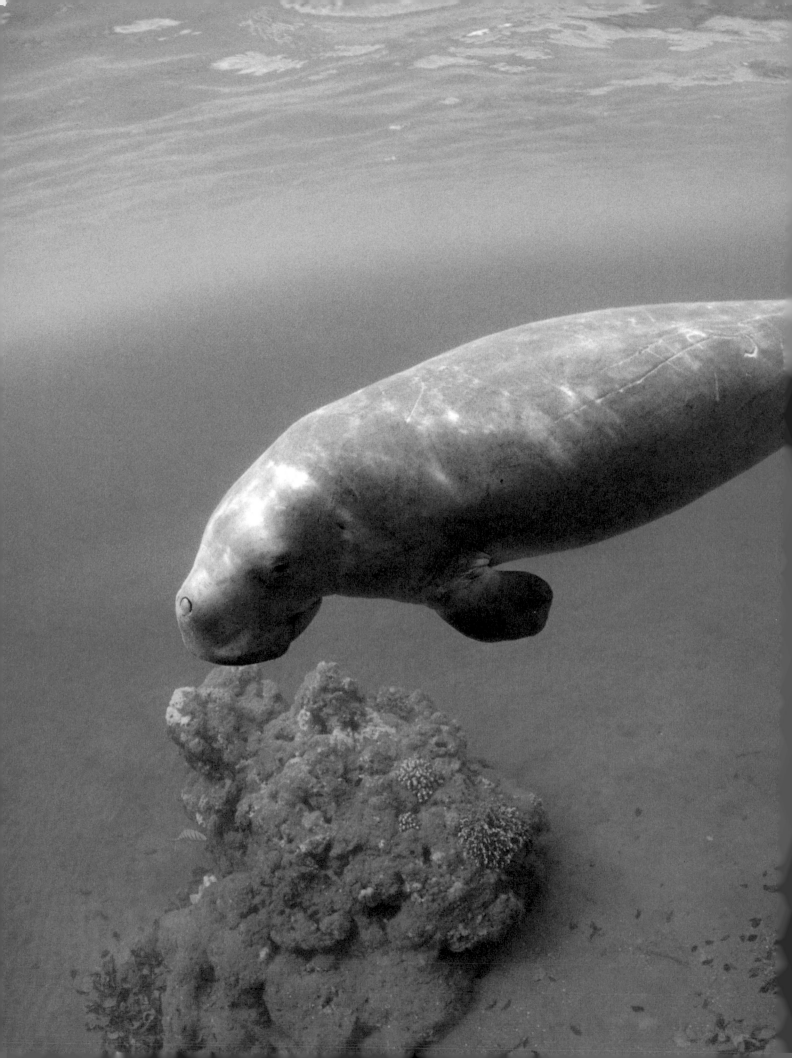

The Dugong
and Steller's sea cow

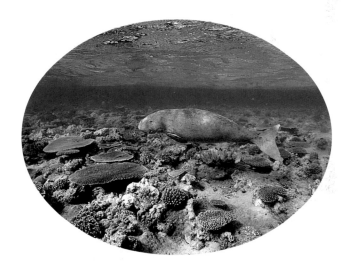

L E F T : *The dugong has the widest distribution*
of any of the sirenians, living in tropical and subtropical coastal and
island waters of the western Pacific and Indian oceans.
A B O V E : *A dugong swims over a shallow-water coral reef.*

ANCIENT MEMBERS OF the family Dugongidae are among the most common sirenians in the fossil record. One species, the dugong (*Dugong dugon*), survives today. The Steller's sea cow (*Hydrodamalis gigas*), a related species that lived in the North Pacific Ocean until only couple of hundred years ago, is believed to have descended from *Metaxytherium*, a widespread genus of dugongids that lived during the Miocene (5 million to 25 million years ago) and Pliocene (two to five million years ago). Sadly, the Steller's sea cow was hunted to extinction around 1768 by fur traders twenty-seven years after Georg Steller brought it to the attention of the scientific community.

The Dugong

Most Americans could probably identify a photo of a manatee and maybe tell you that the manatee is an endangered species. They may have heard about manatees on a news report, licked a manatee stamp from the U.S. Postal Service's Endangered Species series, or seen one on a marine life calendar. Ask an American about a dugong, however, and the response is invariably a blank stare, followed by "What's a dugong?" This reaction is to be expected, considering there are no dugongs—in captivity or in the wild—within several thousand miles of the Americas or Europe. This distribution has been the case for most of recorded history. And when European explorers came across dugongs or their remains, they were often mistaken for something else—manatees, hippos, and, yes, mermaids.

The association with mermaids, of course, dates back to sailors from classical times who had been too long at sea—in the sun—and without the company of women. You only need to look at a picture of a dugong to see the imagination needed to turn a large, bewhiskered marine mammal into an alluring, naked woman-fish. The popular depiction of a mermaid more closely resembles the dugong than the manatee, because a mermaid possesses the forked, dolphin-like flukes and less rotund build of the dugong.

Confusing a dugong with a hippo or manatee is somewhat easier to understand. In 1688, William Dampier, an English explorer sailing in the Indian Ocean along the western coast of Australia, noted that "manatees" were common there. He had seen

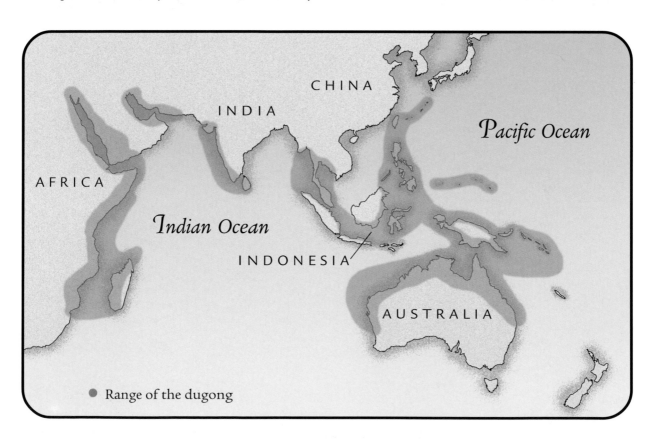

Range of the dugong

OPPOSITE PAGE: *An adult dugong swims in the waters of coastal Australia.*

manatees during cruises to the Americas and assumed, without getting a close look, that the dugongs were the same. On a later voyage in 1699, Dampier found the "head and boans of a Hippopotamus" with teeth up to 8 inches (20 cm) long in the stomach of a shark caught in Shark Bay, also along Australia's west coast. That shark would have had to swim a very long distance at great speed to reach Australian waters with African hippo bones still in its gut (even if a hippo had succumbed to the unlikely urge to head for the beach and swim in the surf). Dampier's "hippopotamus" remains are believed by modern biologists to have actually been the skull and tusks of a dugong.

Traditional names for the dugong throughout their Indo-Pacific range reinforce the popular perception that dugongs are something other than what they truly are—graceful, entirely aquatic, primarily herbivorous, marine mammals. The Malagasy name for the dugong, according to a letter

*A dugong browses on seagrass (*Amphibolis antartica) *in its winter feeding grounds in Shark Bay, Australia.*

printed in *Sirenews*, a newsletter for Sirenia scientists, is *lambondana*, which means "wild pig of the coral." The dugong is known in many Asian countries as "sea pig" and is often referred to in East African countries as a type of hippo. And of course, it is frequently hailed—like the manatee—as "sea cow."

The English word *dugong* comes from *duyong* in Malay. The dugong is also known as *mudu oora* in Sinhalese and *avolia* and *kadalpanni* in Tamil. It has the widest distribution of any of the sirenians, living in tropical and subtropical coastal and island waters of the western Pacific and Indian oceans from East Africa to the Soloman Islands and Vanuatu, including the Red Sea, the Persian Gulf, Asia, Micronesia, Melanesia, and Australia. Its range extends from about 26°–27° north and south of the equator, spanning the waters of more than forty countries. Most of the world's dugongs live in the waters of northern Australia, where they are a protected species. Dugong populations are widely scattered and declining throughout most of the rest of their range. Australian researcher Dr. Helene Marsh, a world authority on dugongs, estimates that 8,100 dugongs may live in the western half of northern Australia's Gulf of Carpentaria. More than 45,000 dugongs are thought to roam the Torres Strait between New Guinea and Australia, and as many as 70,000 may be roaming Australian territorial waters. No one is sure how many dugongs exist elsewhere.

Dugongs are often found in the shallow water—less than 16.5 feet (5 m) deep—of bays, shallows, and shoals that support extensive beds of seagrass protected from rough seas and high winds. They have been spotted, however, in water as deep as 122 feet (37 m) and near reefs up to 48 miles (80 km) offshore. They occasionally move into river mouths and up creeks.

Biologists in Australia, where most dugong research takes place, are adamant in pointing out that dugongs are not tropical Indo-Pacific manatees and go to great lengths to relate the differences between the animals. To wit:

Dr. Paul Anderson writes, "Mention of the manatee brings me to a sensitive point. The dugong is not just the manatee of the eastern tropical oceans. Dugongs and manatees are, zoologically speaking, about as alike as camels and giraffes. Just as the latter are in separate zoological Families belonging to the same Order, so [are] dugongs and

When cruising, a dugongs tucks its pectoral flippers against its sides.

ABOVE: *A dugong, surfacing to breathe in a nearly horizontal position, moves slowly forward.*
RIGHT: *A skeleton of a male dugong displayed at the Western Australian Museum.*

manatees. . . . Manatees are predominantly animals of quiet fresh or estuarine waters where they propel their tubby bodies with ponderous but not ungraceful undulations of broad, rug-like tails. Dugongs, swift, streamlined and with whale-like flukes, are marine."

Other disparities exist as well. First, dugongs grow short tusks, unlike manatees, and dugongs' teeth are much less specialized than manatees. Minor physiological and anatomical differences include the shape and possibly the capabilities of the kidneys. Dugongs often rest and feed in much deeper water, farther offshore than manatees, and feed in a somewhat different manner. Some data suggest they cannot stay submerged for nearly as long as manatees. In some areas, they gather to graze in large herds, returning to forage in the same area for up to a month, an adaptive behavior that helps propagate the species of seagrasses they prefer. Manatees, on the other hand, generally congregate only during cold weather or during mating and do not graze single areas so intensively. Dugongs take much longer to become sexually mature than manatees. Finally, competition among male dugongs for mating rights is usually more violent than among male manatees.

Physical Description

A dugong has a torpedo-shaped body that begins with a blunt, remotely pig-like head, broadens near the pectoral fins, and then tapers before ending with the wide, split flukes of the tail. Unlike the manatee, it has no fingernails on the pectoral fins. The dugong's thick skin is gray to gray-brown and smooth, with a sparse covering of short hairs. The skin is about 1.4 inches (3.5 cm) thick, including its thin layer of fat. An adult dugong averages about 9 feet (2.7 m) in length and weighs 550 to 660 pounds (250–300 kg). A large adult may measure up to 11 feet (3.3 m) and weigh more than 880 pounds (400 kg).

A pair of valve-like nostrils is located at the tip of a dugong's snout, so it needs only expose a small portion of its head above the water's surface to breathe. Its muzzle is turned distinctly downward, an adaptive reflection of its bottom-feeding habits, and ends with a broad, flattened area called the rostral disk. Its enormous, horseshoe-shaped upper lip is covered with bristles that it uses to locate and manipulate seagrass into its mouth. Small, delicate

species of seagrass are dug up by the roots with a fleshy knob at the front of the upper jaw, which is bounded on either side by a pair of short tusks that appear in mature males and some old females.

A dugong's eyes are small and its ears are pinholes in the side of its head, but both its sight and hearing are considered good. Scientists currently believe that dugongs produce only a few sounds—including chirps, squeaks, and barks—which they presumably produce with the larynx. Vision and hearing help dugong cows and calves to establish and maintain their strong social bond.

A dugong moves by undulating its flukes, and when cruising tucks the pectoral flippers against its sides. It uses its flippers for braking and turning, as well as to keep its nostrils above the waves when surfacing in rough seas. When a dugong is idle or resting, it lets its flippers droop. When feeding, a dugong may use them to prop itself off the bottom, but dugong flippers are probably less flexible than those of manatees and do not seem to be used for grasping food. Dugongs are generally slow swimmers, cruising at about two to four miles per hour (3.2–6.4 km), but they can accelerate to more than fifteen miles per hour (25 km) for short distances.

Dugong Anatomy and Physiology

The dugong's skeleton is similar to a manatee's, with thick, heavy bones, no hind limbs, and vestigial pelvic bones remaining in its musculature. It has seven cervical vertebrae as opposed to six in a manatee. Dr. Daryl Domning recently discovered that the pelvic bones of male and female dugongs are shaped differently, allowing the sex of a dugong to be determined from skeletal remains. As with manatees, the sex of a live dugong is determined by the position of the anal and genital openings in relation to the umbilical scar, as well as by the presence of teats under the armpits of female dugongs.

Unlike the highly evolved, conveyor-belt molars of manatees, dugong molars are simple and peglike, best suited for tearing small, soft, low-fiber, highly nutritious seagrasses. These make up the bulk of the dugong's diet. Although dugongs do not replace their teeth, they overcome tooth wear with the continuous growth of the last two molars in each quadrant of the jaw. A male dugong's distinctive tusks erupt through the gums from the upper jaw at puberty, when they are about nine or

ten years old. Females have tusks imbedded in their upper jaw as well, but these rarely erupt to grow like those of males. Scientists can count the growth layers in the tusks to determine a dugong's age, much like the growth layers in the inner ear bones of manatees or the rings of a tree. Analyses of tusks tell us that dugongs may live to more than seventy years, a life span similar to that of humans.

The lungs, digestive system, brain, and most other physiological features of the dugong resemble those of manatees. The kidneys, however, are quite different. Unlike manatees, dugongs are able to survive in a predominantly saltwater environment. Scientists think the dugong's kidneys may produce urine that is concentrated enough to remove the salt taken in with food. They are unsure, however, whether this capacity alone allows dugongs to exist in saltwater.

Diving and Surfacing

Dugongs generally surface to breathe at shorter intervals than manatees. When dugongs are grazing, they surface every minute or so, spending one or two seconds at the surface before submerging again. Cows with calves surface less frequently than unaccompanied adults, as do adults that are investigating a boat or other unfamiliar object. Dugongs rarely stay down for more than three minutes.

When a dugong surfaces, it does so at a nearly horizontal position, moving slowly forward. It exhales just below or at the surface and then inhales before submerging once again. In calm water, surfacing dugongs are often overlooked because only the nostrils are exposed, and these break the surface for little more than a second. If seas are rough, the dugong will rise at a steeper angle, throwing its head back to clear the waves as it inhales. A dugong feeding in calm, shallow water may only breathe once before submerging to graze. A dugong feeding in rough seas will breathe up to five times, resting just below the surface between breaths, before diving to forage again.

According to Paul Anderson, a dugong arches its back and rolls forward, raising the middle of its back above the surface, when beginning a foraging dive. A traveling or idle dugong surfaces to breathe while moving forward, but doesn't arch its back or roll. A dugong that surfaces vertically to investigate an object above the surface submerges by sinking tail first.

Studies have shown that dugongs, like manatees, are not suited to prolonged exertion and cannot stay submerged for very long. The ability of sirenians to carry oxygen in the blood and muscles is poor compared to pinnipeds and cetaceans. A dugong that is chased or forced to flee at top speed (from a speed boat, for example) tires quickly and must begin surfacing more frequently within two or three minutes.

Metabolism and Susceptibility to Cold

Dugongs are believed to have a low metabolic rate similar to that of manatees. However, little information is available regarding the effect of cold on dugongs. They seem to be sensitive to cooler water temperatures that occur during the winter at the southern extremes of their range in Australia. They either migrate seasonally to areas with warmer water or move locally to deeper water where the temperature is more stable.

In Shark Bay, for example, the winter distribution of dugongs is thought to be tied to water temperature. Dr. Helene Marsh and her team conducted aerial surveys over Shark Bay and found fewer than 4 percent of dugongs sighted to be in surface water colder than 64° F (18° C). In eastern Moreton Bay on the east coast of Australia, dugongs were spotted feeding heavily over sandbanks in winter surface waters of 63° to 64° F (17°–18° C), but these animals regularly traveled more than seven miles (12 km) between their feeding areas and warm ocean waters outside the bay, a journey they did not make during the summer when bay waters were warmer. More than 60 percent of dugongs seen in Shark Bay in July 1989 (winter in Australia) were in water thirty-three to sixty-six feet (10–20 m) deep, where the temperature remains somewhat more stable and warm.

Diet and Feeding

Dugongs are generally restricted to coastal areas because they depend on seagrasses for food. They prefer to forage on seagrass beds along the edges of offshore shoals or around points, where they have easy access to both shallow and deep water. Dugongs avoid confined bays or narrow inlets, even when the water is more sheltered and seagrass more abundant.

The leaves, stems, and rhizomes of several species of seagrasses provide food for dugongs, which are strictly bottom-feeders. Feeding dugongs often

A dugong opens its mouth to reveal its tusks, a possibly aggressive display.

leave visible, serpentine paths in seagrass beds called "feeding trails," where the plants have been grazed to bare sand. Because of their simple, peglike teeth, dugongs target seagrasses that are tender, will break easily, and are low in fiber. Dugongs only eat algae when seagrass is not available. They will even avoid seagrass with heavy growths of algae on the leaves.

Dugongs frequently feed in much deeper water than manatees. Large groups of dugongs have been spotted in water more than thirty-three feet (10 m) deep, and feeding trails have been seen in water more than seventy-six feet (28 m) deep. Results from aerial surveys suggest that deep-water seagrass meadows are found at most of the major dugong areas in Australia, including the Starcke River region, Shark Bay, Princess Charlotte Bay, Torres Strait, and Hervey Bay. Tidal ranges and currents, water turbidity, and wind intensity and direction all influence where and when dugongs feed. Although most dugongs forage over the entire 24-hour day, disturbance from heavy boating activity and/or hunting may force some populations to feed primarily at night.

How dugongs forage depends on what they are eating. When grazing low-growing seagrasses in soft-bottom sediments, dugongs root into the bottom to extract entire plants, including rhizomes, stems, and leaves, raising clouds of sediment in the process. Dugongs eating tall seagrasses in hard sediments—in which case the rhizomes are not accessible—strip the leaves, but rarely eat the whole plant. According to Paul Anderson, when dugongs feed heavily in an area and remove much of the seagrass, they reduce the cover for small fish and invertebrates and leave the area vulnerable to further damage by wave action. Thus, feeding dugongs maintain a seagrass community at an immature, fast-growing stage, which may cause a decline in the many fish and shrimp that depend on tall, mature seagrass beds for cover and food. This impact may bring efforts to conserve dugongs into conflict with efforts to protect and manage seagrass beds for other purposes, such as fishing.

How Dugong Grazing Impacts Seagrass Beds
Research conducted by Tony Preen in Moreton Bay

A dugong surfaces to breathe in Shark Bay, Australia.

A dugong stirs bottom sediments while feeding on seagrass.

has shown that dugongs prefer to feed in seagrass communities dominated by early pioneer species. A pioneer species is one that successfully establishes itself in a previously barren environment, thus starting an ecological cycle of life. Pioneer species, such as *Halophila ovalis* and *Halophila uninervis*, are typically more tender and nutritious and less fibrous than other species. Dugongs will also selectively feed on patches of these species within other communities. When dugongs feed in mixed seagrass communities, they concentrate on their favorite species. Because of their wide muzzles, however, they cannot isolate individual plants, and so often consume less desirable vegetation as well.

Dugongs in Moreton Bay usually feed in large herds of more than 100 animals and will graze the same location for a month or more. Heavy grazing significantly impacts the seagrass community, reducing the density of seagrass shoots, including the underground rhizomes, by as much as 95 percent. Despite the intensity and impact of dugong grazing, a seagrass community usually recovers within a few months, often to the benefit of pioneer species—which thrive in recently disturbed areas—over other species.

Seagrass' quick recovery depends in part on the plants' growth characteristics, and in part on the way dugongs feed. Dugongs do not graze like cattle, with each animal cropping adjoining small areas. Instead, each dugong forages in a long, meandering swath about as wide as its muzzle. Individual feeding trails overlap and intersect under heavy grazing, but small tufts of seagrass are always missed. From these tufts, new seagrass spreads. This type of impact differs from disturbances caused by sedimentation, ice scour, or other forms of seagrass die-off. In these situations, the effect is more uniform, and individual tufts rarely survive. Seagrass can then recover only through colonization by seeds or propagules, or by the spread of neighboring communities that were not affected. This type of recovery, too, can occur quickly.

By grazing intensively in large herds, dugongs increase the nutritional value of favorite feeding grounds. Tony Preen writes, "seagrass responds to cropping or clipping of leaves by increasing nitrogen levels and decreasing levels of lignin or ash in new growth." Thus new seagrass shoots are more nutritious to dugongs than older growth. Repeated, heavy grazing ensures that large areas of seagrass will remain in an "immature, rapidly growing state," providing the dugongs with gardens of favored seagrasses at their most nutritious stages. In mixed seagrass communities, heavy grazing increases the ratio of favored pioneer species to other seagrasses.

Omnivory in Dugongs
Moreton Bay lies in the eastern Australian subtropics. Seagrass in the bay, as in other subtropical areas, follows a seasonal pattern of abundance and productivity. In summer and fall, the growing season, seagrass is usually plentiful. New shoots provide nutritious food for dugongs and other grazers. In winter and early spring, seagrasses put out little new growth. The older leaves are more fibrous and less nutritious, with lower levels of nitrogen and soluble carbohydrate. Tony Preen has noted that in Moreton Bay, when their preferred seagrasses are nutritionally poor, dugongs deliberately feed on small invertebrates called ascidians. He thinks these animals may supplement the dugongs' intake of protein. In tropical areas, dugongs are not omnivorous, probably because seagrass growth differs by season. Also, Preen suggests, ascidians in tropical areas may possess a chemical defense that makes them distasteful.

Loss of Seagrass and Its Impact on Dugongs
A large-scale loss of seagrass can doom dugongs. Such an event happened in 1992, after two floods and a cyclone killed more than 400 square miles (1,000 km²) of seagrass in Hervey Bay in eastern

A dugong stirs a cloud of bottom sediments in an attempt to escape from pesky pilot fish, which follow the marine mammals in search of food scraps.

Australia. An aerial survey in August 1988 counted more than 1,750 dugongs over southern Hervey Bay. By November 1992, eight months after the floods and cyclone, only seventy-one dugongs remained. As many as 1,000 dugongs are believed to have fled the region, many to the neighboring Great Sandy Strait. Nearly 100 carcasses were recovered, some more than 540 miles (900 km) south of Hervey Bay. Most of the dugongs apparently died of starvation, six to eight months after the loss of seagrass. They probably tried to survive on algae, dead seagrass rhizomes, and anoxic (oxygen-poor) sediment.

Dugongs are returning to Hervey Bay as the seagrass beds recover. A survey in December 1993 estimated 600 dugongs in the region. Due in part to the slow reproduction of dugongs, researchers think it may take more than twenty-five years for the Hervey Bay population to regain its 1988 level.

Social Behavior

Dugongs are creatures of habit. When they find a foraging area they like, they use it over and over, even when the seagrass is sparse or depleted by heavy grazing. They may stay in one spot for one to four weeks, then move to a similar area several miles away. Many dugongs, particularly those at the southern edge of their Australian range, also migrate. This behavior may be associated with seasonal

A male dugong rakes the back of another male with its tusks in an apparent dominance display.

changes in water temperature, prevailing wind and sea conditions (such as choppy, rough, or smooth waters), and the growth of preferred species of seagrass. Paul Anderson explains that blood and other birthing fluids attract predators, including sharks, prompting dugong cows to seek protective habitat, such as very shallow channels among sand bars, in which to give birth.

Dugongs live in loose social groupings whose size may fluctuate depending on food supply, reproductive behavior (such as mating and calving), environmental conditions, local and long distance movement, and hunting pressure. Scientists think that, as with manatees, the bond between a female and her calf is the only solid social relationship dugongs form. Dugongs observed in the Torres Strait between New Guinea and northern Australia by Bernard and Judith Nietschmann traveled in pairs and in small groups of three to nine animals included young, sexually mature, and old individuals. The Nietchmanns rarely saw more than twenty animals together in the Torres Strait, except for small gatherings seeking shelter from storms.

Like manatees, dugongs have daily activity cycles, which they adjust in response to tidal patterns, other environmental conditions (e.g., water temperature, high winds, or rough seas), or the level of harassment or hunting by humans. For example, where tides permit and dugongs are not threatened by humans, they may feed on and off throughout the day and night. If their access to a feeding area is affected by tide, they move in with the flood tide to feed and retreat as the tide goes out. Where dugongs are regularly hunted, they tend to feed inshore only at night and remain offshore in deeper water during the day.

Paul Anderson, after watching groups of dugongs coordinate their actions to avoid slow-moving boats and rise to the surface to investigate the passing of fast-moving boats, suggests that dugongs may work together to defend against predators. He also suggests dugongs routinely choose the same feeding sites, calving sites, and routes and destinations during seasonal migrations.

Mating Behavior and Reproduction

Both male and female dugongs become sexually mature at about ten years old, although some females mature as late as fifteen years of age. According to Helene Marsh, not all sexually mature males

A small herd of dugongs swims across a coral reef.

A female dugong swims with her calf off the coast of Australia.

are reproductively active at the same time, and periods exist when none are active. Apparently, the most males are active when the females are active. In tropical areas of the dugong's range, breeding and calving occur on a year-round basis.

Dugongs' mating behavior resembles that of manatees. Male dugongs gather in small herds centered around a single estrous female and compete to mate with her. Tony Preen has described several phases in dugong mating behavior: a "following phase," in which up to twenty males cluster tightly around an estrous female; a "fighting phase" that includes violent splashing, rolling, and body lunges by males; and a "mounting phase," in which the victor of the fighting phase mounts the female from behind, while other males try to cling to them.

Preen, upon observing dugong behavior in Moreton Bay from a kayak, describes a typical dugong mating encounter:

"Groups of twenty or so dugongs occasionally formed within herds. They would race about energetically, jostling one another, but never really going anywhere. One cluster formed around an individual, presumably a female, that was evidently trying to outpace and outmaneuver them.

Sometimes fighting broke out within the cluster, the water seething from the surface and bodies lunged across bodies. These battles apparently determined mating rights, because mounting followed immediately.

The fighting lasted up to fifteen minutes. . . . On one of those occasions four males had mounted a female at once, clinging to her with their flippers. Meanwhile, about a dozen others circled anxiously. On the other occasions three males had attached themselves to a female.

The tension was electric as the dugongs separated. Up to sixteen agitated males, each weighing perhaps 400 kg, charged about looking for something to vent their frustration on. The atmosphere was like that in a bar when a brawl has been broken up."

Lek Displays

Paul Anderson observed some unusual sirenian social behavior among male dugongs in South Cove, an area in the eastern part of Shark Bay in western Australia. In the springs of 1988 and 1989, he watched twenty solitary male dugongs (he inferred they were males based on their behavior) defend small display territories, or leks, during their usual breeding season. This type of behavior is otherwise unknown among sirenians; although common among birds, lek displays occur among few of mammals. According to Anderson, in a classic lek, males gather and defend small display areas at a site they return to each year. There is usually little to eat, and females visit this site only to mate. This reproductive behavior contrasts sharply with the "mating herd" behavior typical in manatees and dugongs. In South Cove, says Anderson, it is possible for a male dugong in an established territory, typically a sandy area with sparse vegetation, to mate with a visiting female he has attracted by displaying and expect little interference from other males. Further, the female is not harassed by many males trying to mate with her at once.

Anderson makes a few other basic assumptions regarding the territorial dugongs of South Cove. First, because so little bottom vegetation was available, dugongs spending more than a few days on their leks must have been fasting. Second, the amount of seagrass in a territory may have determined how long a dugong could stay and may have been a measure of the quality of the territory. Finally, given that dugongs probably share the low metabolic rate of other sirenians, the defense and display activities Anderson observed must have used up extravagant amounts of energy and fat reserves. While this expenditure is uncharacteristic of dugong mating behavior, it is, Anderson states, "characteristic of male reproductive investment."

Dugongs on their leks chirped, squeaked, and barked throughout the day and night. Anderson also noted several of behaviors exclusive to resident dugongs. As they patrolled the perimeters of their territories, dugongs engaged in rooting, belly-ups, sit-ups, and bottom swims, as well as confrontations and fighting between dugongs.

When rooting, a dugong eats or gouges the bottom sediments to mark its territory. In a belly-up, a patrolling dugong rolls on its back in midwater and swims upside down for some distance.

The dugongs Anderson observed typically performed sit-ups in the center of their territory. A sit-up consists of a dugong rolling over (or doing a belly-up) and ascending vertically to the surface, coming straight out of the water with its chin tucked against its chest, facing away from the direction it had been moving. In some cases, nearly

half of the dugong's body rises above the surface. It then falls backwards or sideways, somewhat like a breaching whale. After a sit-up, the dugong continues its patrol in normal swimming position, generally in the direction it had been moving before the sit-up. The South Cove dugongs usually performed sit-ups singly, but sometimes an animal would do two or more in a row. One ambitious dugong followed a belly-up with twelve consecutive sit-ups, each decreasing in height as the animal tired, until only the animal's snout broke the surface on the last sit-up.

The purpose of a sit-up is unknown. Those of the South Cove dugongs appear unrelated to the activities of an animal's neighbors. Because this movement requires so much energy, Anderson thinks it may be a display to "convey vigor, territory ownership, readiness to mate and/or quality as a potential mate." He also speculates that males may perform the sit-ups in conjunction with infrasonic sounds to attract females, although no sounds were recorded.

Anderson describes a behavior he calls "bottom swimming," in which dugongs swimming on or near the bottom, usually when patrolling the borders of their activity zones, leave a continuous black line of disturbed sediment. Nearly half of all bottom swims occurred during boundary confrontations between two male dugongs, perhaps to draw proverbial lines in the sand. A dugong engaged in a confrontation may swim back and forth parallel to his opponent (sometimes with short bursts of speed), zigzag toward his opponent, or face the other dugong while remaining stationary, rooting around on the bottom, bottom swimming, doing belly-ups, or performing sit-ups. If one dugong doesn't back away, a fight may break out. Most fights in South Cove involved only two dugongs and occurred at the boundary between neighboring territories. Sometimes a fight broke out between a resident dugong and a newcomer to the area. One fight ensued after a dugong charged into a neighboring territory and attacked its occupant with no apparent provocation.

Anderson described the thirteen fights he witnessed during his two springs at South Cove as "brief, but violent." Combatants fought below and at the water's surface, using tusks to gouge each other on the lower back near the flukes. They often raised their flukes and then slammed them on the water's surface as if to crush their opponents. In two fights, one dugong rammed the other at top speed. In one of these rammings, the impact was great enough to throw the other dugong partly out the water. In more than half the fights, the losing dugong fled at top speed, pushing up a bow wave and lunging toward the surface to breathe. On four occasions, the victor chased the fleeing dugong for up to 1,650 feet (500 m). Afterwards, both combatants appeared exhausted and out of breath, surfacing to breathe as often as every twenty seconds. By measuring the intervals between breaths, Anderson estimated the dugongs took approximately an hour to fully recover.

Anderson emphasizes that matings were rare events among the South Cove dugongs, and that they probably accounted for only a tiny fraction of the annual pregnancies in the Shark Bay dugong population. He also warns that the dugong leks in South Cove may be a unique phenomenon and that the site should be fully protected.

Cows and Calves

A dugong cow produces a single calf every three to five years, after an estimated gestation period of thirteen to fourteen months. A newborn calf is usually just under four feet (1.2 m) long and weighs about 18 pounds (30 kg). It may begin to eat seagrass soon after birth, but relies primarily on its mother's milk for up to eighteen months. Researchers believe the nutrient-rich milk allows the calf to grow quickly and therefore be less vulnerable to attack as it gains size. Because a dugong calf is entirely dependent on its mother, a calf that loses its mother is more than likely doomed. A dependent dugong calf rarely strays more than two body lengths away from its mother. To date, no account has been reported of another dugong adopting an orphaned calf, although orphaned manatee calves are often adopted by manatee cows.

The dugong cow occasionally will rest quietly while her youngster nurses, but more often will graze or surface to breathe. A manatee cow, on the other hand, generally remains still while her calf is nursing, turning slightly to one side.

When a calf is small, it often rides "piggy-back"

Dugongs with accompanying shark suckers swim over an Indo-Pacific coral reef.

on its mother. Otherwise, the flow of water around the mother's body creates suction that helps the youngster along. According to Paul Anderson, calves are less vulnerable to predators when riding on their mother's back, but he worries this behavior puts them at greater risk of being crushed by fast boats in heavily trafficked areas.

A dugong cow is protective of her calf and will risk her life to save her offspring, although she will not attack to defend it. A report from Torres Strait tells of a female dugong that lured a threatening shark into increasingly shallow water until both the cow and the shark became grounded. Although the mother was fatally mauled, the calf was able to flee to safety. In another account, a dolphin harassed a cow and calf, until a small cluster of dugongs placed themselves between the dolphin and the mother-calf pair, ending the harassment. According to Helene Marsh, aboriginal people sometimes take advantage of the mother-calf bond when hunting. If either a mother or calf is captured, the other will stay nearby and thus is easily caught.

Mortality

Human activity is a significant cause of mortality in dugongs. Dugongs drown after becoming entangled in shark nets set off beaches to protect human swimmers and in gill nets set by fishermen. Some Australian Aboriginals and Torres Strait Islanders continue to hunt dugongs legally for subsistence purposes, and poachers take dugongs in other areas. Loss of coastal habitat and increasing boat traffic are also blamed for declines in dugong populations.

Natural mortality factors include storm surges from cyclones, parasites, disease, and predation by crocodiles, killer whales, and sharks. Stonefish and stingrays have been known to give dugongs fatal surprises as they browsed on seagrass, and accounts of shark attacks on dugongs are common.

An apparently ailing female dugong was spotted by a film crew aboard the research vessel *James Scheerer* in Shark Bay on June 27, 1997. Two small tiger sharks estimated at nearly 10 feet (3 m) long were harassing the dugong, but were chased away by the crew. No other dugongs in the area responded to the ill animal's plight. An hour later, three different tiger sharks appeared, each estimated at between 13 and 16.5 feet (4–5 m) long. Within an hour, the three sharks killed and consumed the entire

dugong, frequently pushing the carcass into the side of the *James Sheerer*, leaving only about a foot (30 cm) of intestine floating on the surface. Further studies by a new shark research program in Shark Bay reveal that tiger sharks may prey on dugongs with some regularity.

Dugongs have little physical capability to fight back against predators, but they may have evolved some behaviors to protect themselves during an attack. A Palauan fisherman once told Paul Anderson that when he saw a dugong attacked by a shark, it flattened itself against the bottom, attempting to protect its flippers and flukes as best it could and relying on its strong ribs and the thick skin on its back for defense. Anderson was originally skeptical about the report, but reconsidered after seeing a dugong with a healed shark bite on its back. Helene Marsh has reported dugongs with shockingly large healed wounds on the top of the head.

The important point to remember is that dugong mortality from *all* causes must remain low for dugongs to increase their numbers.

Steller's sea cow

The Steller's sea cow is named after Georg Wilhelm Steller, who first described the animal in 1741 after being shipwrecked with the Bering expedition on an uninhabited island near the Aleutian chain in the present-day Bering Sea. Fossil evidence indicates that ancestors of the Steller's sea cow lived along the Pacific Rim from Mexico to Japan for 15 million years. By all accounts, the Steller's sea cow was an immense, strange-looking animal, quite distinct from any other modern sirenians. It measured more than 25 feet (8 m) in length and may have weighed between 8,800 and 22,000 pounds (4–10 mt). It was unique among sirenians in that it lived in the cold waters of the Bering Sea, lacked teeth and finger bones, possessed a thick, corky skin, and was apparently unable to dive. It also subsisted primarily on kelp (a brown alga) rather than seagrass.

Georg Steller's written accounts of its anatomy indicate that the Steller's sea cow was internally similar to other sirenians. Its rotund body was black to blackish-brown and tapered significantly toward the whale-like flukes. A portion of the backbone that showed as a ridge beneath its hide was revealed in emaciated sea cows. Steller described the tiny head (about one-tenth the length of the body) as "somewhat [resembling] the buffalo's head, espe-

The Steller's sea cow was by all accounts an immense, strange-looking animal. This reconstruction was drawn by Pieter Folkens. Photograph © Pieter Folkens

cially as concerns the lips," with small eyes and earholes nearly lost in the wrinkles of skin on the head. Rather than teeth, the Steller's sea cow had "two broad bones (one on the upper jaw and one the lower) . . . with many crooked furrows and ridges" for crushing food. As with other sirenians, it had only pectoral flippers, but Steller describes them as "furnished with many short and densely set bristles like a scrub brush" for "[beating] the seaweed off the rocks on the bottom." Female sea cows had a teat under each flipper.

While Steller was stranded on the island, he was able to spend time observing and documenting sea cow behavior. According to Steller, they fed in large herds and grazed on the surface near shore for much of the day. When the sea cows wanted to rest, they floated on their backs in a quiet cove. They showed no fear of humans and remained in their favored feeding area no matter how many were killed by the crew. Steller noted they were resident in the waters around the island throughout the year.

According to Steller, sea cows mated in June, with only one bull pursuing one female. He did not observe "indications of an admirable intellect," but did state that "they have indeed an extraordinary love for one another, which extends so far that when one of them was cut into, all the others were intent on rescuing it and keeping it from being pulled ashore by closing a circle around it." Regarding their apparent close social ties and willingness to rescue

harpooned herd members, Steller also wrote: "Some placed themselves on the rope or tried to draw the harpoon out of its body, in which indeed they were successful several times. We also observed that a male two days in a row came to its dead female on the shore and inquired about its condition." By 1768, twenty-seven years after Georg Steller identified and named the Steller's sea cow, the unique sirenian was gone, hunted into extinction by Russian fur traders and explorers.

There is some doubt in the modern scientific community regarding the accuracy of Steller's behavioral observations, because they differ so dramatically from the loose social structure observed in living sirenians. Steller died at age thirty-seven, prior to the publication of his notes, and virtually all that is known about Steller's sea cow comes from posthumous publications that, in the words of marine mammal scientist Victor Scheffer, were "edited, copied, and translated without the help of the one man who knew the animal best."

Sirens in Myth
and Tradition

LEFT: *A dugong flanked by golden pilot jacks
rests on a sandy bottom off the coast of Australia.*
ABOVE: *This Australian Aboriginal painting depicts dugongs
going to a shallow reef to have their babies. It was painted
in 1995 for Dr. Helene Marsh by Djanga of the
Yarrabah Community, near Cairns*

PERHAPS NOTHING IS so intriguing about manatees and dugongs as the myths, traditions, and beliefs that surround them. Some myths, such as those describing manatees and dugongs as "sirens" or "mermaids," began as tales told by sailors, dating back to the ancient Greeks. Other stories arose from beliefs and traditions associated with the hunting of manatees and dugongs, typically by indigenous cultures in tropical zones worldwide. Universal among the stories from indigenous cultures is the reverence these people held for sirenians. In many cases manatees and dugongs supplied important food, and in some instances the ceremonies associated with hunting and feasting on these animals provided a cultural adhesive critical to the well-being of the community.

Traditional and subsistence hunting is not responsible for the overall decline of sirenian populations, as some people might like to believe. Market hunting in the nineteenth and early- to mid-twentieth centuries bears some of that burden, but the greatest impact has been caused by current human activities, including coastal development and the alteration of sirenian habitat, marine pollution, the damming of rivers, coastal commercial net fishing, and increased human use of waterways frequented by sirenians. Many of the accounts of ritual activities and customs in this chapter go back eighty years or more, and some are no longer practiced. For example, in the 1970s, some Papuan coastal tribes accustomed to a subsistence existence were encouraged by the government to change over to a cash economy. Their attitude toward much of the wildlife they hunted changed, as did many of their traditions. For the hunters from Daru, wildlife became less a source of food than a product used to buy food and other modern necessities. Hunting by this group has increased dramatically.

I have heard the mermaids
singing, each to each.
I do not think that they will sing to me.
I have seen them riding seaward on the waves
Combing the white hair of the waves blown back
when the wind blows the water white and black.
We have lingered in the chambers of the sea
By sea-girls wreathed with seaweed red and brown
Till human voices wake us, and we drown.

T.S. Eliot, from The Love Song
of J. Alfred Prufrock

Legends

As mentioned previously, the order Sirenia is named for the beautiful sirens of Greek mythology, whose sweet singing lured mariners to destruction on the rocks around their island. Marine mammalogists are quick to point out that manatees and dugongs are quite unlike their legendary namesakes: they do not sing, never spend time on the rocks, have never been described as "comely" or "bodacious," and it is unlikely that their charms ever lured anyone to an untimely death. Nonetheless, many scientists who pooh-pooh the sirens' spell devote virtually all of their waking moments to studying sirenians.

Classical references to mermaids or "mermen," often collectively referred to as "merfolk," may date back as far as the ancient Chaldeans, who ruled in Babylonia around 1000 B.C., and Phoenicians, who were the foremost navigators and traders of the Mediterranean by 1250 B.C. Their sea-god Ea (also known as Dagon or Oannes) was half man, half fish. The Bible mentions Dagon, as does John Milton in 1667 in Book I of *Paradise Lost*: "*Dagon* his Name; Sea Monster, upward Man and downward Fish." Among the first written accounts of mermaids was one from the Greek historian Megasthenes at the beginning of the third century B.C.E. He describes "monstere" (creatures) from the sea off Taprobanê, Sri Lanka, some of which were "in appearance like women, but instead of having locks of hair, are furnished with prickles." While unromantic, it is a relatively accurate depiction of the dugongs that frequented Indian waters during that time.

The tales told by Portuguese and Dutch sailors, however, are credited with popularizing mermaids as beautiful, seductive women-fish who wanted nothing more than to lure sailors to secluded reefs or distant seas. Mermaid stories continue today with movies such as Walt Disney Production's

With its slender build and forked flukes, this dugong could easily be mistaken for a mermaid.

A female dugong and her calf in Shark Bay, Australia. Many traditional legends tell of human mothers and daughters jumping into the ocean and becoming dugongs.

The Little Mermaid, based on a Hans Christian Andersen tale, and Hollywood's *Splash*, featuring Daryl Hannah as the lobster-munching mermaid who charms Tom Hanks into living with her forever in an undersea merfolk city.

Sirenian Creation Myths

Indigenous people tell a number of stories regarding the creation of manatees and dugongs. The Warauno of northern South America have a myth explaining the origin of manatees and tapirs. According to legend, two widowed sisters who live together quarrel fiercely. One of the sisters goes with her son to live in the forest; the other sister curses the mother and son, turning them into the first tapirs. In return, she is cursed to live in the water, and she and her unborn child become the first manatees.

Indians in Amazonas, Brazil, have a traditional belief that manatees and river dolphins are humans in a bewitched form. According to the story, the bottom of the Orinoco houses an underwater city, and people who go there, possibly by drowning, and eat the food are transformed into either manatees or river dolphins. A transformed person is called a *manari*.

In a dugong origin legend from the Trobriands, where swearing at relatives is considered highly disrespectful, a woman and her young daughter are working in the garden with the girl's uncle. After working for several hours, the daughter asks her mother to accompany her to the toilet. The mother insists that the girl ask the uncle to accompany her. The daughter asks, and her uncle consents. After the uncle and daughter return to the garden, they work for a little while more. Then, the girl asks her mother to use the toilet again. Once more, the mother insists the girl ask her uncle. When the girl asks her uncle, he becomes furious and tells her with foul language to use the toilet on her own. She runs back to her mother and tells what her uncle has said. The mother is shocked at the uncle's words and leads her daughter from the garden down to the sea. When they reach the water's edge, they continue walking into the sea until their grass skirts float loose and spread over the water's surface. In the sea, the mother and her daughter turn into a female dugong and her calf.

As late as the 1970s, hunters from the Trobriands carried grass skirts so that dugongs, thinking the skirts were those left on the water in the legend, would be unafraid and thus easier to catch. When a dugong was caught, the hunters wrapped the grass skirts over its nostrils until it suffocated.

In many Papuan villages, dugong hunters are not allowed to sleep with their wives for two weeks before a hunt. This story by Alpha Eko of Gabagaba village tells why:

Long ago a young couple got married. Soon the wife was expecting a baby. Near the time for her to give birth she told her husband to go to the garden to get some bananas to eat. She cleaned the house and on the way to take the rubbish to the sea, she felt that the baby was soon to be born. She hurried down to the sea and gave birth, not to a human baby, but to a Dugong. The woman became frightened of her husband because of this and returned every day to the beach to feed her infant without telling her husband.

After a few weeks the husband started to wonder about his wife and one day followed her to the beach and saw her feeding the baby Dugong. He ran to the house and got his spear and ran back to the beach and speared the Dugong. The woman let the baby go from her breast, but before the baby Dugong swam away, it said to the man, "Father you have tried to spear me, so I am no longer your

This painting of Torres Strait Islanders roasting a dugong in primitive style was created in 1979 by Aboriginal artist Goobalathalden, also known as Dick Roughsey to field anthropologists. From the collection of Dr. Helene Marsh.

daughter and if you wish to see or catch me, do not sleep with your wife for two weeks. Then come looking for me." With this the Dugong swam away.

Traditional Beliefs and Taboos

Many native cultures regarded manatees and dugongs highly for their food value, and a fascinating array of beliefs and rituals were involved in virtually all aspects of hunting, butchering, and feasting on sirenians. Perhaps the most intriguing examples come from the Rama Indians of Nicaragua and the Mälnkänidji of Cape York Peninsula, Australia.

During 1969 and 1970, anthropologist Franklin O. Loveland spent several months with the Rama Indians of southeastern Nicaragua. He

An Antillean manatee floats over a seagrass bed off the coast of Belize in Central America. These manatees have been hunted by people for thousands of years.

obtained a great deal of information regarding the role of both the manatee and the tapir in the Rama belief system. Much of what follows was gleaned from his fascinating essay "Tapirs and Manatees: Cosmological Categories and Social Process Among the Rama Indians." The Rama lived in small forest settlements, with easy access to rivers, an estuarine lagoon, and the Caribbean Sea. The Rama, whose name for the Antillean manatee of their region was *palpah*, believed the animal was intelligent and had an acute sense of hearing. They refrained from talking about the location of the manatee or the charms they were carrying for fear the animal would hear them and be forewarned of their hunting plans. They considered the manatee symbolic of the cultural world, representing quiet, social order, solidarity in the community, and resources of the water. In contrast, the tapir was associated with nature, asociality, and disorder. When hunting a manatee, a number of taboos were observed to increase the chances of success, while little symbolic significance was attached to hunting tapir. When a tapir was killed, no rituals were involved and no feast was held. However, if a manatee was killed, the butchering and distribution of meat was done with great care, and the feast that followed was an important event in the community.

The Rama performed several rituals for the preservation of manatees and successful hunts. To ensure the continued presence of manatees, they always returned manatee bones to the lagoon where the animal was killed. For success on future hunts, manatee meat was roasted and eaten immediately after the kill, and the hunters bathed in the animal's blood. The Rama also believed that manatees in the lagoon were protected by a large whale who could reverse the current and would devour anyone who tried to harm the manatees.

The striker, or person who threw the harpoon, was held in high esteem by the community. He was not allowed to eat the meat of the animal he killed, unless it was his first manatee, in which case he was given a piece of meat from above the heart to guarantee he would kill more. The striker was given the tail and breastbone, which he in turn would give away; he also received the ear bones, which he kept

A Torres Strait Islander hurls himself overboard in his effort to harpoon a dugong. Photograph © Ben Cropp Productions/ Innerspace Visions

Torres Strait Islanders on Boigu Island perform a traditional dance with harpoons that reenacts a dugong hunt. Photograph © Ben Cropp Productions/Innerspace Visions

as a charm for future hunts. The ear bone was used by the hunter as "magic" to prevent the manatee from hearing him. A striker would not share the techniques or charms he used when hunting. According to Loveland, at one time an excellent woman striker lived in the Rama community. By 1970, however, only a handful of manatee hunters remained and all were men.

Halfway around the world and more than forty years earlier, anthropologist Donald Thomson from the University of Melbourne spent several months with a group of fishing and seafaring tribes on the east coast of the Cape York Peninsula in northern Australia. These tribes, known by anthropologists as the Kawadji, the people of the east, called themselves Mälnkänidji, the sandbeachmen (*belonging to the sandbeach*). Thomson and his wife lived with the sandbeachmen in 1928; his excellent paper, *The Dugong Hunters of Cape York*, is the source of the following information on these people and their traditions.

Men of one of the smaller sandbeach tribes, the Yintjingga, were renowned for their abilities as canoemen and dugong hunters, their prowess with the long harpoon, and the potency of their dugong magic. Thomson described them as a tribe near extinction in 1928, but according to Helene Marsh, they have survived, although they have given up their traditional hunting techniques. The Yintjingga harpooners used magical bundles, which were simply lumps of beeswax called *mänkä* obtained from inland Aboriginals. On the afternoon preceding a hunt, the harpooner, or *wotadji* (dugong man, or *belonging to the dugong*) would discreetly perform a ceremony in which he warmed the lump of *mänkä* over a fire and pressed it just above his navel two or three times. When he hunted the next day, magic would cause the dugong or sea turtle he encountered to be sluggish and easily harpooned and secured. Apart from that rite, a dugong man might also speak or chant a spell that in English the natives called "singing the dugong." *Wotadji* whose hair and beards were gray were honored with the cognomen *Tjilbo*, the gray one. Dugongs were typically hunted during the day, but during certain seasons they were hunted by moonlight. The Yintjingga believed that hunting in the moonlight caused of premature grayness, but graying early did not earn a young dugong man the title of *Tjilbo*.

Luck was a major factor in bringing in a dug-

ong, and many things could cause bad luck to a *wotadji*. No one was permitted to burn the hide or remains of a dugong. Bones were collected and thrown into the river or estuary, to be gathered periodically and placed in neatly arranged piles until required for a human burial, where they adorned the top of the grave. According to Thomson, after a hunt "[h]air clippings, or any personal belongings, particularly objects impregnated with body sweat, were also carefully collected and thrown into water, never into a fire, where they can no longer be used by an enemy to work evil magic against the owner," specifically the *wotadji*. *Wotadji* were forbidden to touch or carry the body or bones of a dead person or to use dugong blood to dye the shafts of spears.

Among the Yintjingga, the butchering of a dugong was a social event carried out according to rigid tradition. This custom still holds true for many of the dugong hunters of the Torres Strait. The animal is carved according to a prescribed pattern and meat is distributed without cost throughout the community. The best cuts of meat typically go to the butcher and/or harpooner and crew before the remainder is shared. According to anthropologists Bernard and Judith Nietschmann, Torres Strait Islanders distinguish between at least forty-five different cuts of dugong meat. A total of twenty-seven different terms are used to describe the dugongs themselves to differentiate sex, size, reproductive status, and relative health and food-quality. The Nietschmanns also point out that for Torres Strait Islanders, "hunting is more than a subsistence trait,

After a successful hunt, Torres Strait Islanders butcher a dugong according to a prescribed pattern and meat is distributed without cost throughout the community. Photograph © Ben Cropp Productions/Innerspace Visions

a means to acquire meat, or an aberrant relic of past times; it is a way of life. Around marine hunting and the pursuit and capture of large herbivores revolves a complex system of logic and knowledge, environmental perception, social expectations and responsibilities, and the resilient roots of Islander myths and legends."

Not all native cultures valued sirenians as important entities. Some aboriginal communities to the west of Cape York Peninsula have never hunted dugongs. In Cameroon, West Africa, a Yale University student conducting research in the late 1980s was told by Akwen fishermen that West African manatees live in caves, are dangerous, and can drown people. In the village of Akpasang, some hunter/fishermen believe that manatees receive their power from the devil. In a 1933 story for *Natural History Magazine*, Guy Dollman described the fear of manatees among certain tribes along the Niger River:

Mr. Woods in his report on this animal

Amazonian manatees have long been a preferred meat source, in part because they are relatively easy to catch and provide a great deal of meat that is slow to decay, an important factor in the tropics. Photograph © Ken Lucas/Planet Earth Pictures.

states that to many tribes the manatee is "ju-ju." The Abos believe that it is certain death even to see one, and the same belief seems to exist amongst the Asaba and other tribes inhabiting the banks of the Niger. All the regular hunters of the manatee would appear to be Haussas, and when a carcass of one is being towed in, a warning drum commences to beat a special rhythm, which continues until the beast has been cut up. If killed at a distance or after a prolonged struggle, it sometimes happens that it is evening before the body arrives at the bank of the river, and then it is necessary for the drumming to continue all night until the carcass is cut up the next morning.

Even the relatively diminutive, exceedingly shy Amazonian manatee was feared by some tribes. According to Alexander von Humboldt, who explored the Amazon region from 1799 to 1804, the Piaroas of the Meta River (an Orinocan tributary) said that their people invariably died when they ate manatee meat. Luis Marden, on assignment in Guatemala for *National Geographic* in the 1940s, wrote that "Livingston people assured me solemnly that 'anyone struck with a manatee crop [whip], however lightly, will shrivel up and die. Just touch someone with it in anger, and soon he is a husk, just like a mummy.'"

Traditional and Commercial Uses

Sirenians have been hunted by humans for thousands of years. Dugong hide is believed to have been used in biblical times for the cover or "Outer Fly" of the Tabernacle, the portable sanctuary in which the Jews carried the Ark of the Covenant through the desert. People living along the coast of the Red Sea long used dugong hide for the soles of sandals. Archaeologists have found worked manatee bones, including carved figurines representing humans and a carved canoe, among spear heads and pottery rings on what is believed to be an ancient Mayan fishing site in Belize. As with whales and seals, virtually every imaginable part of the manatee and dugong has been put to practical use by humans at one time or another.

Sirenians are hunted primarily for their meat and fat. Manatee meat was preferred over beef by

A manatee and her calf feed on turtle grass off the coast of Belize, where they are protected from hunting by law, although poaching does occur.

A dugong rolls around on the sand bottom, possibly in an attempt to dislodge remoras.

European explorers, and Aborigines and Torres Strait Islanders still hold dugong meat in higher esteem than even the highly valued meat of the green turtle. The abundance of meat and fat from a manatee or dugong has historically made these animals valuable sources of protein to native cultures and European sailors. Manatee and dugong meat may vary in color and taste like pork, beef, or veal—depending on what part of the body the meat is taken from—due to differences in the amounts of myoglobin (a protein) in the muscle. Both the meat and fat are somewhat resistant to spoilage, which increases their value in tropical climates. European explorers raved about the taste of manatee flesh, and as Spanish missionaries and soldiers pushed ever deeper into Central and South America, the Catholic Church conveniently decreed the manatee a fish, making it fit to eat anytime, including Fridays, without sin. (Moslems reacted similarly, prizing dugong flesh as a pork substitute.)

Jose de Acosta, upon visiting the Windward Islands in 1588, had some qualms about the manatee, considering it "a strange kind of fish [which] when I did eat of it at St. Dominque on a friday, I had some scruple, not for that which is spoken, but for that in colour and taste it was like unto morsels of veale." According to one seventeenth-century account of the "fish," "The meat is very fat and tasty. His tail is like bacon, without any lean meat, which they melt as pork fat. It is used as butter that can be used like lard but with a better taste. The fish meat, cooked with vegetables, has the same taste as beef. It keeps the salt better, when seasoned, it looks and tastes like pork meat. If cured, it turns very red and will taste as extremely good pork meat after cooked."

The Carib consumed manatee flesh to cure indigestion caused by eating too many crabs, which were their primary food. In Venezuela, manatee meat was eaten fresh or salted, or was used medicinally, believed by some to be a remedy for syphilis and dental problems. In Brazil, manatee meat was valued more than beef and often boiled in its own fat to form a concoction called *mixira*. *Mixira* was tinned or stored in clay pots, where it would keep for several months.

On the Torres Strait Islands between Australia and Papua New Guinea, dugong meat remains essential fare at Islander feasts held to commemorate baptisms, weddings, funerals, and tombstone openings. Celebrations may draw as many as 1,000 people and require up to twelve dugongs. In the absence of dugong meat, green turtles are used.

Manatee and dugong blubber was occasionally eaten raw, but generally it was rendered into oil for cooking, medicinal uses, or use in lanterns. Some accounts state that as much as 220 pounds (100 kg) of fat could be carved from a single large manatee. In the eighteenth century, the French considered manatee oil as sweet as butter and sent it from Guyana to Cayenne, where it was incorporated into soups, fricassees, and pastries. In the Amazon region, manatee oil was mixed with pitch to caulk boats. In Venezuela, oil was used to relieve backaches and arthritis, and in Cameroon intestinal fat from the West African manatee is still rubbed on one's body to soothe aching joints.

Dugong oil is said to be similar to cod liver oil (but much more palatable), and up to eight gallons may be rendered from an average adult animal. It is thought by some indigenous groups to cure everything from tuberculosis to joint pain.

Other parts of sirenians have been used for a variety of purposes. Manatee skin has been boiled and mixed with rum as a cure for asthma; dried for use as whips, wrappings, mats, and shields "strong enough to resist arrows and even shot"; and cooked to an ash to be used as a preventative against diarrhea. Dugong tears are sold by fishermen in parts

The historic uses of dugong parts are various and inventive, including dugong hide covering the Tabernacle, dugong oil to cure tuberculosis, and dugong tears as an aphrodisiac.

of Asia as an aphrodisiac, and in parts of Africa, the consumption of male manatee genitalia is believed to help overcome impotence. Sirenian bones and teeth have been utilized as fishing hooks and lures, musical instruments, utensils, scraping tools, nut crushers, limesticks, jewelry, and garden charms (to better grow vegetables and pigs). Burned to ash, they find applications in treating insect bites, combating lung ailments, curing ulcers, and providing relief for women during menstruation.

The inner ear bones, or "stones," of manatees and dugongs have traditionally been used—and may still be used in some areas—for their magical or medicinal properties. Manatee stones were used as charms against witchcraft in the Yucatán and by the Miskito Indians of Nicaragua to prevent bad luck. In Panama and Guatemala, ear bones brought relief from painful childbirth. Early English travelers valued the stones as a remedy for colic and dysentery "when beat small and drunk fasting"—that is, when the ear bones are beaten to a small size and ingested on an empty stomach. In Venezuela, most remedies involving ear bones were applied to children. Children who wore an amulet made from ear bones were protected against diarrhea and teething pain. Among the Warauno, children could be cured of illnesses caused by bad people who stared at them with "an evil eye," but only if the boys wore the ear bones from a female manatee and the girls wore those of a male. Among the Chinese, the ear bones of dugongs are prized when finely powdered and taken to cleanse the kidneys.

Although all three species of manatee and the dugong have been subjected to past hunting pressure, some on a commercial basis, the exploitation of the dugong and the Amazonian manatee has been the best documented. Killing and processing dugongs for their oil provided a profitable commercial enterprise in Australia from the 1850s until dugongs received protection from commercial exploitation in the late 1960s. Meat was salted down and sold as a type of bacon. Fat was rendered and used in medicinal oils. Rib bones were burned and used as charcoal for sugar refining. Dugong hide was turned into coach brakes, glue, or thick leather for saddles. Tusks were polished for use as handles on meat carvers. The entire Moreton Bay dugong population is believed to have been destroyed by a cottage industry that exploited them for their oil from the mid-1800s to the 1940s. Fortunately, this population has recovered.

Brazil was the hub of the export of manatee products from the Amazon region for more than 150 years. From the 1780s to about 1925, the only manatee product common in Amazonian commerce was *mixira*, a food formed by boiling manatee meat in its own fat. Nearly 462,000 pounds (210,000 kg) entered the Belém market between 1876 and 1915. From 1935 to 1954, manatee hides were exported to southern Brazil and elsewhere to make heavy-duty leather. From 1954 to the banning of manatee hunting in 1973, manatees were again heavily exploited for meat. According to biologist Miriam Marmontel, *mixira* is still a delicacy in Brazil and commands high prices in towns. Although Daryl Domning states that manatee products never made up more than a small fraction of a percent of the Amazon trade, between 4,000 and 7,000 manatees are estimated to have been slaughtered annually—in addition to an unrecorded number killed for subsistence purposes—during the peak years of hide and meat production.

Subsistence Hunting and Its Demise

The array of hunting methods used by native tribes to dispatch manatees and dugongs could itself fill a book. Torres Strait Islanders harpooned dugongs from portable hunting platforms built over seagrass beds, until they switched to canoes in the early 1900s. Around that same time, the Kiwai people from Daru and the adjacent coastal areas of Papua

An Amazonian manatee is butchered by people living along the Jurua' River. Photograph © Miriam Marmontel

TOP: *Ivory Coast fishermen capture a West African manatee with a trap net. Various types of traps are used to catch West African manatees, including the fence trap, in which a hunter drops a trap door behind a manatee that is feeding among mangroves. Another is the spear trap, used in the Pujehun and Bonthe districts of Sierra Leone, in which a manatee moves through an opening between two posts and pushes against a net that crosses the opening. This drives a spear, propelled by the force of a heavy log behind it, deep into the animal, effectively tethering it until the hunters arrive. Photograph © J. Powell*
BOTTOM: *A manatee trap, Ivory Coast, Africa. Photograph © J. Powell*

An Amazonian manatee feeds on vegetation at the edge of a river. Photograph © Fernando Trujillo/Innerspace Visions

New Guinea began harpooning dugongs from *motomotos*, two-masted, double-hulled, sailing canoes. Most dugong hunting now is done with a harpoon from canoes or aluminum dinghies equipped with outboard motors. In West Africa, manatees are either speared from a platform, using fresh-cut grass as bait, or captured in nets or traps. In Florida, the Timucuan Indians hunted manatees from canoes, lassoed them, and then drove a sharpened stick or crude harpoon into their noses to stop their breathing and keep them from sinking out of reach. In the Amazon basin, manatees were shot with arrows, shot with poison darts from a blow gun, or harpooned.

The unusual method Orinocan Indians used to hunt manatees was first recorded in 1791 by Jesuit explorer José Gumilla. They used a double-barbed harpoon tied to their canoes by a rope of manatee hide. A paddler and a harpooner manned the canoe. Once the hunters harpooned and killed a manatee, they leaped into the water, holding onto the sides of the canoe and then tilting it so that it filled with water. The canoe was then easily pushed under the manatee and emptied of water by using bailers they wore on their heads as hats. Once the canoe had risen sufficiently with its load, the hunters paddled away. During his trip to the Amazon basin, Alexander von Humboldt described a similar method used by another tribe. Most indigenous people hunting with harpoons used a breakaway head tethered to a long line and some sort of float to track their quarry's movements.

In the Caribbean, manatees were traditionally harpooned. The Spanish used crossbows. The Carib Indians utilized perhaps the most creative and implausible means of catching manatees. A large species of remora, or "suckerfish" as they are commonly known (scientists believe it was *Echeneis*), was

A Kiwai harpooner hurls himself off the bow of his motu motu *(sail canoe) to plunge a harpoon deep into the back of a dugong. A* motu motu *requires a large crew, including a helmsman, dugong spotter, harpooner, and crew to operate the sails. A master hunter typically orchestrates the hunt and directs the crew. The* motu motu *is traditionally constructed with charms, including flowers and echidna quills, sealed into the bow piece. If the* motu motu *crew was successful, they raise a flag as they approach their village, signaling someone on shore to blow a conch horn to summon the people to the beach. One dugong will provide enough food for the entire village. Photograph © D. Parer and E. Parer-Cook/AUSCAPE*

A female dugong and her calf swim together in Shark Bay, Australia.

captured when young, possibly kept tethered in a shallow pool, and fed by hand. Once the fish, or "pegador" (catcher), grew large enough, it was secured by a line at the base of the tail and taken fishing for manatees, sea turtles, and larger fish. The fisherman would spot his prey, release the fish in the direction of the intended target, and the remora apparently rocketed away to attach itself to the unsuspecting animal. The remora and prey were then steadily (and probably very quietly) hauled in by the line. Once the prey was secured, the remora released its hold and reattached itself to the side of the boat. According to Raymond Gilmore in *Handbook of South American Indians*, "it is certain the natives generally prized their 'captives' [semi-domesticated remoras], spoke to them in endearing terms, and rewarded them with meat after each successful hunt." Several researchers observed this hunting practice; none believed the others until they had seen it for themselves.

Although laws protect manatees and dugongs in most places they are found, poaching for subsistence and sale at market still occurs regularly (with the exception of the Florida manatee), but apparently with decreasing frequency. Manatee meat in some places in West Africa and South America is sold openly in markets, and in East Africa and Asia dugongs are caught incidentally in nets and taken for food. As late as 1986, there was significant commercial demand by the military for Amazonian manatee meat in Ecuador. Most hunters know that killing manatees and dugongs is largely prohibited, but continue because the potential profit greatly outweighs the chance of significant punishment.

A case in point is the gruesome discovery in 1995 by Bob Bonde and a team of conservationists of at least thirty-five manatee carcasses at eleven remote sites in Belize. Bonde thinks the sites were used by Guatemalan fishermen who killed the manatees in Belize's Port Honduras, butchered them at processing sites at night, and then transported the meat back to Guatemala to be sold at market. According to Bonde, manatee meat on the Guatemalan market goes for $2.50 to $5.00 a pound, and poachers can carve 400 to 500 pounds of meat from a large manatee.

The reasons for limiting or altogether banning hunting are clear. Sirenians reproduce slowly and cannot recover quickly after a population crashes due to hunting or a natural calamity. According to

Helene Marsh, between 22,000 and 44,000 dugongs must exist in the Torres Strait region to sustain an annual harvest of 500 to 1,000 animals. Rough estimates of the dugong population suggest that more than 40,000 dugongs may indeed live in the Torres Strait. However, Marsh cautions that no accurate catch numbers, population estimates, or life history parameters exist, and an apparent abundance of dugongs should not lead to an unlimited harvest. According to Marsh's calculations, if a herd maintains healthy reproduction—every cow over age ten producing one calf every three years—the population still would be unlikely to increase at more than 5 percent a year. These figures indicate that for a regional population of 200 dugongs to remain stable, no more than five cows a year can be killed by humans.

Many native cultures respect the law and understand why sirenians can no longer be hunted. Some tribes, such as the Siona in Ecuador, initiated self-imposed bans to conserve the remaining animals. Others, such as the Mornington Island Aboriginals, avoid killing pregnant female dugongs—which are traditionally viewed as the fattest and most desireable—as a conservation measure. Aboriginal communities elsewhere have agreed to limiting their hunting to certain areas, leaving other places as refuges for dugongs. Some mainland Aboriginal communities have turned to hunting wild cattle, buffalo, and pigs to take the pressure off dugongs. All of these measures offer hope for the future survival of sirenians and their place in the lives of native cultures.

In this example of Australian Aboriginal bark art, created in a traditional motif by Marrirra Marawili of the Madarrpa Clan, Yirritja Moiety, hunters successfully spear a dugong from a canoe.

Finding Sanctuary

LEFT: *Two manatees play at Blue Spring State Park, Florida. Approximately 2,600 Florida manatees remain in the wild.*

ABOVE: *Two snorkelers approach a Florida manatee in a spring near Crystal River.*

MANATEES AND DUGONGS have few predators, yet in most parts of the world, their populations continue to decline. Natural mortality claims sirenians every year, but it is the high percentage of deaths resulting from humans and human-related activity that is so alarming. Some 35 percent of all manatee deaths in Florida in 1998 were directly attributable to humans. What is unforgivable is that many of the human-caused deaths are preventable. In other parts of the world, neither the total number of sirenian deaths from all causes nor the percentage of deaths caused by humans is known.

Why do people have such an impact on sirenians? Manatees and dugongs are restricted to coastal areas and rivers where human activity is concentrated. They are slow to reproduce. They have no real physical defenses and no defensive behavior except to swim away. Although sirenians have contended with a low level of natural mortality throughout their evolution, their

In Australia, killing dugongs is prohibited except for harvesting by certain indigenous tribes.

slow reproduction and lack of physical defense and behavior are thought by scientists to be an outcome of the lack of a significant predatory presence—at least for the four living species. We are the primary predators of manatees and dugongs—even if we never pick up a rifle or harpoon—armed with boats, floodgates and salinity barriers, nets, marine refuse, dams, and the ability to alter and destroy coastal habitat. Countless examples exist of animal species evolving in the absence of predators and then, after humans arrive (with associated exotic baggage, including cats, pigs, goats, chickens, snakes, monkeys, and mongooses), soon becoming extinct. Dodo, Tasmanian wolf, passenger pigeon, New Zealand laughing owl, Jamaican iguana, Guam rail, Laysan honeycreeper, Cuban yellow bat, Antarctic wolf, Steller's sea cow—these are only a few names in the litany of animal extinctions caused directly or indirectly by humans within the last three hundred years. Are manatees and dugongs next?

A common question asked by politicians, developers, boating lobbyists, and representatives of other groups inconvenienced by regulatory complications is "How many of these animals do we really need?" Obviously no moral answer exists to such a question, but Miriam Marmontel, Stephen Humphrey, and Thomas O'Shea address this issue in their controversial 1996 article for Conservation Biology. Using the layers of growth in the inner ear bones of 1,212 carcasses obtained throughout Florida from 1976 to 1991, Marmontel and her colleagues were able to obtain age specific data on the reproduction and survival of the Florida manatee.

Their population viability analysis indicates that the short term Florida manatee population is stable, but the long term population is threatened with extinction. Using an estimated current population of 2,000 animals, they found that over the next one thousand years, the manatee population has only a 44 percent chance of survival—"an unacceptably low probability of persistence." A 10 percent increase in the adult mortality rate of the Florida manatee would "drive the population to extinction." They also found that if the initial size of the population is doubled from 2,000 to 4,000, the probability of survival increases by 50 percent, indicating that a higher initial population leads to a greater chance of ultimate survival. Given the estimated 1996 minimum population of 2,600 manatees, which is 30 percent more than the study's base population, probability of survival creeps up to about 57 percent—still precarious for a species to survive over the next millennium.

Although the World Conservation Union suggests that "one hundred years is realistic in terms of prediction accuracy and legal expectations," Marmontel and her colleagues argue that "a millennium is a more appropriate time scale to evaluate population trends and enable adaptive and evolutionary processes to operate." (A similar scale was adopted by scientists for grizzly bears, which also have long life spans and are slow to reproduce.) The problem is that to the human mind one thousand years is an inconceivably long time, and the average person has difficulty fathoming the necessity of implementing measures now that are designed to increase a species' probability of maintaining a viable population over the course of a millennium.

A Florida manatee rests in Blue Spring State Park, Florida, where it is protected under the United States Endangered Species Act and Marine Mammal Protection Act.

This Florida manatee's fluke has been mutilated by a boat propeller.

Another important note: Thirteen coastal counties were targeted by Florida in 1989 as "key" to mortality-reduction efforts through local boat-speed zoning; Marmontel, Humphrey, and O'Shea point out that only one additional adult manatee death in each of these counties (fourteen to seventeen manatee deaths statewide) would be enough to increase the mortality rate by 10 percent and nudge the Florida manatee toward extinction. According to the U.S. Fish and Wildlife Service, between 1976 and 1997, the number of manatee carcasses collected has increased by an average of 6.3 percent each year. Things are not improving for manatees.

Marine mammalogists are concerned about how well dugongs can survive in the face of continued human-related losses in shark nets around popular beaches in Australia, incidental capture in fishermen's nets throughout the dugong's range, land use practices that cause habitat loss, and continued subsistence hunting by Aborigines and Torres Strait Islanders in northern Australia and Papua New Guinea. According to computer simulations, if dugongs are to continue to survive, more than 95 percent of the adult females alive at the beginning of a year must be alive at the end of the year. Based on this information, no more than a 2 percent mortality of adult females from all human impacts can be sustained each year. Further, if dugongs do not find enough to eat because of habitat deterioration, the females will probably produce fewer calves and the percentage of sustainable mortality will be even less.

Human-related mortality

Collisions with watercraft are by far the primary human-related cause of death in Florida manatees. In a typical collision, a manatee swimming at or near the surface is struck by a boat or ship and is either crushed by the hull or lacerated by the propellers. Most deaths result from blunt impact by the boat hull rather than from propeller cuts. In 1997, out of a total of 242 manatee mortalities, 55 deaths (23 percent) were deemed watercraft-related. In 1998, out of a total of 231 manatee mortalities, the number of watercraft-related deaths rose to 66, or 35 percent of the year's total mortality. The actual number of manatees killed by boats may be higher

since most recovered carcasses are too badly decomposed to determine cause of death. The U.S. Fish and Wildlife Service reports that over the last two decades, deaths caused by watercraft strikes increased at 7.1 percent per year. This statistic is alarming because it means that watercraft-related deaths continue to rise despite increased efforts to educate boaters about manatees and the establishment of manatee speed zones in areas frequented by manatees. Mortality from boat strikes is usually highest in Brevard County in the Cape Canaveral area on Florida's east-central coast.

An analysis of 406 manatees killed by watercraft found that the majority (55 percent) were killed by impact and a substantial number (39 percent) were killed by propeller cuts. Most propeller wounds were on the manatees' backs and sides rather than their heads, suggesting the animals were diving to avoid a collision when they were struck. Propeller guards do little to prevent boat injury to manatees. Overall, the wounds suggested that most lethal propeller wounds were caused by mid-sized or large boats, but that impact injuries appear to be caused by fast-moving small to mid-sized boats. Because manatees may have difficulty hearing boat engines, researchers at Florida Atlantic University are developing a high-speed sonic beam that would be mounted on the boat's engine. The beam would alert manatees to boat presence earlier than the engine noise, giving the animals more time to move away.

Part of the problem is the number of boats on the water. Bureau of Vessels and Titling records show that for the 1996 to 1997 boating season, more than 795,000 boats were registered in Florida, 95 percent of which were for pleasure purposes. Of these registered boats, 85,000 were personal watercraft, which are often operated at high speed in fragile, shallow areas. More than 300,000 boats registered in other states are launched on Florida's waters each year as well, swelling the total number of boats plying state water at any given time to about 1.1 million. That's about 400 boats to every manatee. The number of boats on the water will only increase as the human population continues to grow. As the number of boats increases, the likelihood of manatees being hit will also rise.

Floodgates and canal locks are yet another source of human-related manatee mortality. Several manatees die each year after becoming trapped in water control structures and navigation locks. In some cases, manatees are crushed when doors close on them. Sometimes they drown when they are pinned against narrow door openings by rushing water. Since scientists began counting and evaluating manatee mortalities in 1974, more than 130 manatees have been killed by water control structures. Dade County, which has many of these structures, accounts for the majority of these deaths in recent years.

Each year, a few additional manatees die from poaching and vandalism, entrapment in shrimp nets and other fishing gear, entrapment in water pipes, and ingestion of marine debris. In 1997, 8 manatees died from these causes, the highest recorded number since 1979. Between 1976 and 1991, deaths in this category have ranged from 2 percent to 5 percent of the total mortality. Incidents of poaching or vandalism are fairly rare in Florida, and the state's ban on certain types of net fishing reduces the chance that manatees will be entangled in nets. Marine debris, however, remains a threat to manatees. Researchers Cathy Beck and Nelio Barros found monofilament fishing line, plastic bags, string, twine, rope, fish hooks, wire, paper, synthetic sponges, stockings, and rubber bands in the stomachs of 14.4 percent of 439 manatee carcasses salvaged between 1978 and 1986. Discarded monofilament line, the most common debris found, and rope (such as from commercial crab traps) are frequently

This manatee's flipper is entangled in line from a crab trap. Photograph © Sirenia Project

A Florida manatee calf flosses on an anchor line near Crystal River.

discovered wrapped around flippers of wild, living manatees. Tightly wrapped lines act like a tourniquet, cutting off the supply of blood to the flippers and causing the limbs to die; entanglement in lines can easily be fatal to a manatee. It is now illegal in Florida to discard monofilament fishing line or netting into the water.

In total, seventy-one manatee deaths in Florida due to human-related causes were tallied in 1997. In less than twenty-five years, more than 1,500 manatees—more than half of the current estimated population of Florida manatees—died in Florida as a result of human activity.

For dugongs, human-related mortality data is available only for Australia. However, the data are sketchy, mainly because scientists must cover a much greater area than in Florida. According to Helene Marsh, dugongs in Australia are affected by hunting, fishing, coastal development, and unsustainable agricultural practices. Mortality statistics, which are collected by the Queensland Shark Control Program, show that since shark nets were introduced in the 1960s, nearly a thousand dugongs have died in shark nets in northeastern Australia.

Most of these shark net entanglements and resulting deaths occurred in the early years of the program. In the early 1990s, after the program was modified and steps were taken to reduce the mortality of protected wildlife, the number of dugongs captured in shark nets in eastern Queensland dropped dramatically.

Subsistence hunting continues to draw from the dugong population in the Torres Strait. Helene Marsh and her colleagues estimate that from 1991 to 1993, more than 1,200 dugongs were caught each year, a few of which were sold illegally at the Daru market in Papua New Guinea. Marsh has stated repeatedly that she is not certain if the dugong population in the Torres Strait region can withstand such a harvest, particularly because no accurate estimate of the region's total dugong population exists, and because the life history of that population is not fully understood.

Conserving Sirenians

Given the grim mortality statistics, the critical need for sirenian conservation is easy to see. Manatees and dugongs are protected by law in virtually every

Dugongs and other large marine animals are often caught in nets set off Australian beaches to protect swimmers from sharks, like this great white. Photograph © Ron and Valerie Taylor/Innerspace Visions

country they inhabit. Protection ranges from international treaties to local edicts, but enforcement of these laws varies considerably from country to country.

International Protection

The Convention on International Trade in Endangered Species of Wild Fauna and Flora provides an international structure for regulating trade in species that are, or may soon be, threatened with extinction. The United States and 102 other countries are signatories to this agreement. Species currently threatened with extinction are listed under Appendix I of the Convention. Those species that could become threatened if trade is not regulated are listed under Appendix II. The dugong is listed under Appendix I throughout its range, except in Australia, where it appears under Appendix II. Both subspecies of the West Indian manatee and the Amazonian manatee are listed under Appendix I, and the West African manatee appears under Appendix II.

All three species of manatees and the dugong receive protection in U.S. Territorial waters under the United States Endangered Species Act and Marine Mammal Protection Act. The Endangered Species Act (ESA) protects any species of fish or wildlife currently endangered or threatened with extinction from being taken (defined as "to harass, harm, pursue, hunt, shoot, wound, kill, trap, capture, or collect, or attempt to engage in any such conduct"). Under the ESA, any endangered species, its parts, or any products made from that species, may not be imported, exported, possessed, or sold, whether within or outside of the United States. The ESA also requires the designation of critical habitat essential to the conservation of a listed species, including adequate area for the species to expand its range and recover to a healthy population level. The Marine Mammal Protection Act (MMPA) makes it illegal, with certain exceptions (including subsistence hunting), to kill, injure, capture, or harass any species of marine mammal, or to attempt any of these activities in U.S. waters. The MMPA also makes it unlawful to import marine mammals or related products into the United States.

West African manatees are protected under

Class A of the African Convention for the Conservation of Nature and Natural Resources, originally signed in 1969 by thirty-eight African countries.

Protection of Florida Manatees

In Florida, government efforts to conserve manatees began in 1892, when the Florida legislature enacted manatee protection laws after extensive hunting by settlers earlier in the century significantly reduced the population. Federal protection for manatees came in 1972 and 1973 with the passage of the MMPA and ESA, respectively. The state of Florida followed these acts with the Florida Manatee Sanctuary Act of 1978, declaring the state a manatee refuge and sanctuary. This act and its amendments gave the Florida Department of Environmental Protection (FDEP) the lead role in state manatee protection, including the authority to limit boat speeds and activities in areas critical to manatees, such as zones through warm-water winter-gathering sites.

Effective manatee conservation in Florida requires the cooperation of various state and federal agencies, private organizations, and individuals. Key organizations and agencies involved are the U.S. Fish and Wildlife Service, Marine Mammal Commission, Sirenia Project, Florida Department of Environmental Protection, Georgia Department of Natural Resources, and Save the Manatee Club. Under the umbrella of FDEP, research is directed by the Marine Mammals Team of the Florida Marine Research Institute in St. Petersburg, and management is coordinated by the Bureau of Protected Species Management in Tallahassee. The Florida Marine Patrol (a division of FDEP) handles law enforcement. The Florida Game and Fresh Water Fish Commission, Florida Power & Light Company, Florida Power, and Florida Audubon Society, as well as marine research and rescue facilities including Mote Marine Laboratory, Miami Seaquarium, SeaWorld, and Lowry Park Zoo, also provide valuable research and public awareness assistance.

The U.S. Fish and Wildlife Service (USFWS) bears the overall responsibility for shepherding the recovery of the Florida manatee and has developed a Florida Manatee Recovery Plan, as required by the

A dugong swims over a bright sand bottom flanked by golden pilot jacks and sharksuckers off the coast of Australia.

ESA. The initial plan, developed in 1980, has undergone several revisions. In the latest revision, the USFWS delegated 126 tasks to cooperating agencies and organizations. These tasks fall into several categories, including habitat acquisition, education, law enforcement, research, permit reviews, and information-gathering.

The recovery plan's ultimate goal is to downlist and eventually de-list the Florida manatee. Their 1997 annual report explains that before manatees can be down-listed from endangered to threatened, their populations need to grow or stabilize, their deaths need to be stable at or decreasing from acceptable levels, their habitat must be secure, and threats must be controlled or decreasing. According to the report, habitat loss and watercraft collisions are the greatest threats to manatee recovery in Florida. Manatees along the Atlantic and southwest Florida coasts are at the greatest risk, primarily because of human-related threats; the risk of

A Florida manatee pauses at the boundary of a manatee sanctuary in the Crystal River National Wildlife Refuge. Manatee sanctuaries are closed to boats and swimmers.

another catastrophic red tide also threatens the southwest Florida coast population.

Protection of Dugongs in Australia

Dugongs are legally protected from intentional killing in Australia, except for a harvest by certain indigenous peoples. Dugong management in the Great Barrier Reef region relies on a close working arrangement between the Great Barrier Reef Marine Park Authority, the Queensland Environmental Protection Agency, the Queensland Department of Primary Industries, the Queensland Fisheries Management Authority, and stakeholder groups including local government, indigenous peoples, commercial and recreational fishermen, conservation groups, and local communities.

Within the Great Barrier Reef Marine Park, the dugong harvest is controlled with a permit system, allocated through a Council of Elders that represents the interests of Aboriginal and Torres Strait Islanders communities. The harvest is regulated with consideration for community requirements of dugongs for ceremonial occasions, including weddings, births, and deaths. "Preservation Zones" are designated in which even traditional hunting is not permitted. An 80 percent decline in the dugong population in a large area of the Great Barrier Reef region has prompted most indigenous groups to agree not to hunt along the urban coast of the region. Traditional hunting of dugongs is no longer permitted in southern parts of the region. The Darumbal-Noolar Murree Aboriginal Corporation for Land and Culture of Rockhampton have signed a formal agreement with the Great Barrier Reef Marine Park Authority, agreeing that it would be inappropriate for indigenous hunting to occur in the Great Barrier Reef Marine Park within the Shoalwater Bay Military Training Area.

However, traditional hunting is apparently unregulated in the Torres Strait Protection Zone, an area within which Australia and New Guinea exercise sovereign rights for marine life, including the traditional dugong fishery. Management objectives for a dugong fishery that are mutually agreeable to Torres Strait Islanders and the government are sorely needed for dugongs to survive in this region.

In 1992, the Queensland Shark Control Program responded to the decline of the dugong population by changing its shoreline protection methods. In the Great Barrier Reef region, baited hooks

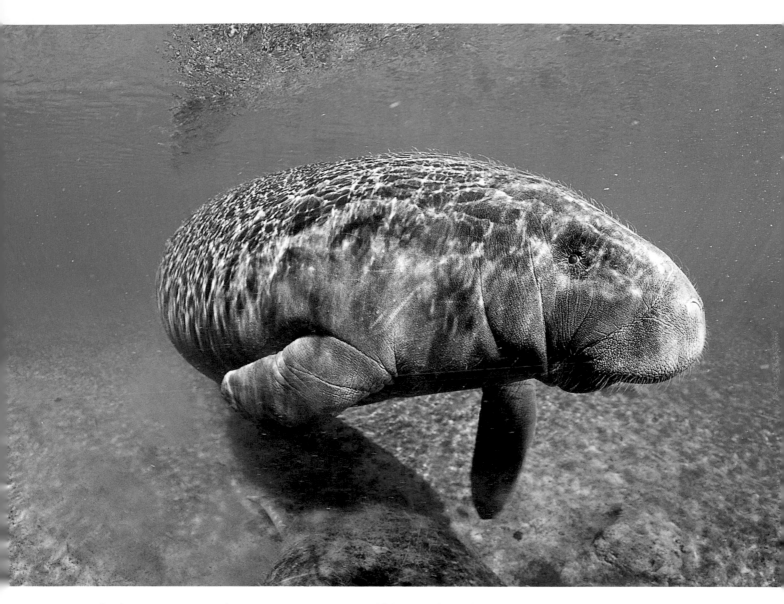

A Florida manatee swims at the Homosassa Springs State Wildlife Park, where recovering manatees are reacclimated to other manatees and a semi-wild environment.

have replaced shark nets along most beaches to reduce the bycatch of dugongs.

A controversial chain of dugong protection areas (DPAs) has been established to reduce the deaths in commercial gill nets in the southern part of the Great Barrier Reef Marine Park. The areas in which gill nets have been completely banned are called Zone As; the areas in which gill-netting activity has been modified are called Zone Bs. According to Helene Marsh, the 958 square miles (2,395 km²) that include six Zone A areas support 55 percent of the dugongs in the southern Great Barrier Reef region, while the 894 square miles (2,235 km²) that include the eight Zone B areas support 13 percent of the dugongs in this region. Commercial gill-netting has also been modified in Hervey Bay, which once again supports a sizable number of dugongs. The closures have been accompanied by a proportional reduction in the number of commercial fishers allowed to gill net in the area and affected fishers have received almost $4 million in compensation. Many conservationists claim the DPAs are inadequate to prevent dugong mortality and contend that commercial nets do not belong in a sanctuary at all.

As with manatees and all endangered wildlife, habitat protection must be a primary consideration in dugong conservation. According to Helene Marsh, "the greatest challenge ahead will be to ensure the conservation of inshore seagrass beds in the Great Barrier Reef region." This area is plagued by polluted runoff from large agricultural areas and an increasing demand for the development of tourist resorts on islands and the coastline. Only 59 percent of seagrass habitat used by dugongs is protected in the northern half of the Great Barrier Reef, and 72 percent of seagrass meadows in the southern half is protected. In addition to extending protection to more marine habitat, more money and effort need to be targeted toward educating people about the impact of intensive human land use in areas connected hydrologically or otherwise with fragile coastal environments and wildlife. "Experience has shown that it is hard to convince a pro-

Signs featuring manatees can be found everywhere in Crystal River, Florida.

spective developer that a resort may have adverse impacts on dugongs and their habitats," writes Marsh. "It will be even harder to convince a farmer that erosion from his property may threaten the survival of sea cows grazing on submarine pastures many kilometers downstream!"

The Road to Recovery

The Florida Manatee Recovery Plan includes four primary objectives:

· Identify and minimize causes of manatee disturbance, injury, and mortality.

· Protect essential habitats.
· Determine and monitor the status of manatee populations and essential habitat.
· Coordinate recovery activities, monitor and evaluate progress, and update/revise the Recovery Plan.

The causes of manatee disturbance, injury, and mortality in Florida and what must be done to minimize them have been extensively researched and are well understood. Thirteen coastal counties have been identified as "key" to the recovery of the Florida manatee: The counties of Duval, Volusia, Brevard, Indian River, St. Lucie, Martin, Palm Beach, Broward, Dade, Collier, Lee, Sarasota, and Citrus border waters that are frequented by manatees. Research shows these areas have the highest manatee mortality rates, as well as the most significant habitat destruction.

In 1989, the Manatee Protection Bill, which amended the Florida Manatee Sanctuary Act of 1978, directed the FDEP to work with these key coastal counties to improve the condition of the Florida manatee. These counties were asked to designate watercraft speed zones in areas heavily used by manatees. Each county was also asked to develop a comprehensive manatee protection plan (MPP), which would include assessing boating activity patterns, assessing manatee sighting and mortality information, identifying land acquisition projects for manatee protection, and planning a manatee education and awareness program. The key counties have reacted to these directives in a variety of ways.

This aerial view of King Spring in the Crystal River National Wildlife Refuge shows tour boats waiting for manatees to leave a roped-off sanctuary.

ABOVE: *Florida manatees shelter in the warm spring run on a cold winter morning at Blue Spring State Park. A long boardwalk bordering the spring run gives visitors excellent views of manatees in the clear water.*

RIGHT: *Manatees living in salt water are attracted to any source of fresh water and in Florida canals will park beneath running hoses and drink gallons of water. Unfortunately, fresh hose water tempts them to spend more time around docks and marinas, where they are susceptible to being injured by boats.*

Only three counties (Dade, Citrus, and Collier) have adopted their MPP. And, although all but Lee county have agreed to speed limits in manatee zones, the levels set by some counties are too high and inadequate to protect manatees.

Most scientists agree that habitat loss is the most critical fish and wildlife problem in the United States today. The human population in Florida is expected to reach 15 million by 2000. Urbanized land expanded from 0.7 million acres in 1936 to 4.6 million acres in 1994—a 650 percent increase. Approximately 900 people move into the state each day. Perhaps 80 percent settle within six or so miles (16 km) of the coast, where boating is a major recreational activity.

In Tampa Bay on Florida's west coast, 81 percent of the seagrasses and 44 percent of the mangroves and tidal marshes have been destroyed. Charlotte Harbor, also on the west coast and significantly less developed than Tampa Bay, has lost 23 percent of its original wetlands, including 22 percent of its seagrasses and 51 percent of its salt marshes. These quickly disappearing wetlands are important habitat for the Florida manatee and other wildlife.

In their book *Manatees and Dugongs,* Drs. John Reynolds and Dan Odell contend that several conservation actions—all politically unpopular—taken together would go far toward ensuring suitable manatee habitat in the future. First, federal and state governments would need to acquire extensive stretches of undeveloped waterfront land as an initial step toward establishing a system of sanctuaries and refuges where human activities would be prohibited or minimized. Next, human activities (including building marinas or other boating facilities) would need to be limited in critical manatee areas. Finally, and probably most difficult, say Reynolds and Odell, concrete steps toward planning for, and perhaps curbing, population growth in the state would need to be taken.

In response to the need to acquire critical habitat specifically for manatees, the USFWS in 1983 established the Crystal River National Wildlife Refuge on the west coast of Florida. The refuge encompasses approximately forty-six acres of Kings Bay, which is nourished by numerous warm, freshwater springs and forms the headwaters of the Crystal River. More than 300 manatees congregate in the bay during cold winter weather. The refuge draws more than 90,000 visitors a year, primarily boaters,

snorkelers, and divers who want to get a close look at the manatees gathered in the bay during the winter. Seven manatee sanctuaries—off-limits to humans—are posted with buoys and set up around manatee feeding areas and warm springs. The newest of these sanctuaries was established at Three Sisters Spring after a number of reports of manatee harassment by divers and swimmers. The manatees have flocked to these sanctuaries and seem to know they can rest, feed, and nurse there without being disturbed by curious people.

Refuge staff patrol Kings Bay, educating people about manatees, enforcing boat speed zones and sanctuary restrictions, and watching for incidents of people harassing manatees. Harassment, as defined by the Endangered Species Act, is any activity that causes an animal to change its behavior. With manatees, harassment includes chasing, poking, kicking, grabbing, or attempting to ride an animal. Feeding or giving manatees water may also be considered harassment. A conviction can include a $50,000 fine and/or a year in jail.

Other protected winter areas in Florida include Blue Spring State Park on the upper St. Johns River and various other refuges established near the warmwater outflow from power plants throughout the state.

Research

Modern manatee research traces its beginnings to the work of Joseph Curtis Moore in the late 1940s and 1950s and Daniel S. Hartman in the late 1960s. Research for the Florida Manatee Recovery Plan is conducted primarily by the Sirenia Project, the Florida Marine Research Institute, SeaWorld of Florida, Miami Seaquarium, and Mote Marine Laboratory, as well as by other independent researchers and facilities.

The Sirenia Project, a team of federally funded scientists based in Gainesville, Florida, is at the forefront of long-term research dedicated to the Florida manatee. Its work includes assessing habitat, analyzing population trends, gathering life history information, and studying the behavior of wild Florida manatee. Although the Sirenia Project concentrates its research on the manatee in Florida, it exchanges information with sirenian scientists and conservationists worldwide. In 1997, Sirenia Project scientists, working with the Georgia Department of Natural Resources and FDEP, initiated a study

on how manatees respond to the elimination of a regularly used warm-water refuge in northeast Florida. They also initiated a study on manatee population genetics. The Project continues its development of a computerized "Scar Catalog" of manatee sightings and its tracking of manatees tagged on the Atlantic coast with satellite/radio transmitters, among other projects. The Sirenia Project provides invaluable information on manatee population dynamics and habitat requirements, research which allows scientists to potentially improve the future of the Florida manatee.

The Florida Marine Research Institute (FMRI) also contributes significantly to Florida manatee research and conservation efforts. Based in St. Petersburg, Florida, FMRI conducts aerial surveys over manatee habitat in Florida and southeast Georgia to gather data regarding manatee distribution and abundance. In 1997, FMRI began a radio telemetry study of tagged manatees in southwest Florida to track their daily and seasonal movements and establish blood chemistry profiles. Telemetry—the recording of data from a remote source, in this case a radio transmitter attached to a manatee's tail—allows researchers to follow the movements of rehabilitated manatees returned to the wild. FMRI scientists also perform necropsies on recovered

manatee carcasses to determine cause of death, a grim task that is fundamental to determining the success of protection measures and identifying new solutions to reduce manatee mortality.

The information FMRI gleans through its aerial surveys, telemetry studies, and necropsies is compiled in their Manatee Geographic Information System (GIS), a computer-based mapping system. This system allows wildlife managers to combine numerical data, such as mortality statistics and regional population numbers, with pictorial data, such as where manatees live and migrate, where carcasses have been recovered, boat traffic patterns, seagrass distribution, proposed development sites, and locations of marinas and boat ramps. The Manatee GIS, which presents a vast quantity of valuable information, helps FMRI scientists to estimate trends in manatee populations and wildlife managers to gain insight into manatees and their environment.

To deal with the problem of manatees being killed in flood control structures and navigation locks, the FDEP has coordinated with the South Florida Water Management District and the Army Corps of Engineers. A promising technological solution is a manatee protection device designed for the wide vertical lift gates that are raised and lowered to manage water level. The device, which consists of strips of piezoelectric film imbedded in tough blocks of polyurethane placed on either side of the lift gate, responds to even the lightest touch of a manatee or other solid living object, but is not triggered by inanimate debris. Unlike former protection devices, this one does not have moving parts that can jam or corrode. It has caused no significant problems on the two gates on which it was installed. Another new device has been developed for water control structures fitted with swinging gates. This device uses closely spaced sets of acoustic beams. When an object passes through the gap between the gates, the beams' signal is interrupted, and the gates are prevented from lowering or closing. Both devices are being tested on coastal structures in south Florida, where the most structure-related manatee mortalities have occurred.

Rescue and Rehabilitation

Over the past five years, between twenty-five and fifty manatees in distress have been rescued annually. In 1997, rescue crews aided nine manatees

This Florida manatee at Blue Spring State Park is tagged with a radio collar on its tail. The transmitters also allow researchers to monitor the movements of manatees released after rehabilitation to ensure they are making a smooth transition to life in the wild.

TOP: *Biologist Bob Bonde from the Sirenia Project records scar patterns to identify individual Florida manatees.*
BOTTOM: *Manatees gather in the warm-water discharge from a power plant at Riviera Beach, Florida. Photograph ©*
Patrick O'Neill/Innerspace Visions.

A B O V E : *An animal care staffer at SeaWorld of Florida adjusts a special wetsuit on an injured manatee calf. The wetsuit is designed to provide flotation and retain body heat.*
R I G H T : *Torres Strait Islanders secure a dugong they have killed. Traditional hunting of dugongs continues in the Torres Strait without governmental regulation. Photograph © Ben Cropp Productions/Innerspace Visions*

struck by watercraft, eight orphaned calves, eight manatees trapped in storm drains and water intake structures, seven tangled in fishing gear, and three suffering from cold-related stress.

In a typical rescue situation, an individual reports an injured manatee to the Florida Marine Patrol on their toll-free hot line (1-800-DIAL FMP, *FMP on a cellular phone, or VHF Channel 16 on marine radio). An officer is dispatched to the scene and, if the manatee is truly injured, a veterinarian and rescue crew are called. Depending on location, the crew may consist of personnel from SeaWorld, Miami Seaquarium, Lowry Park Zoo, Mote Marine Laboratory, Amber Lake Wildlife and Rescue Center, FDEP, and USFWS, among others. When the crew arrives, the animal is captured and its condition evaluated. If possible, it is treated and released. In more serious cases, the manatee is transported to SeaWorld, Lowry Park Zoo, or Miami Seaquarium—the state's three "critical care" facilities. These facilities have medical equipment and staff to care for injured, sick, and orphaned manatees. Beginning in 1997, a few manatees that are generally healthy, but not yet ready for release into the wild, have been transferred to SeaWorld at San Diego, the Columbus Zoo, and the Cincinnati Zoo to make room at the Florida facilities for critically injured manatees.

Manatees whose health has stabilized are transferred to a long-term-care or "soft-release" facility, such as Homosassa Springs State Wildlife Park, where the animals are reacclimated to other manatees and a semiwild environment before being released. The USFWS decides when to release a manatee back into its home waters, based on recommendations by veterinarians and critical care staff. Researchers mark with a PIT (Passive Integrated Transponder) tag, freeze-brand, and/or photograph manatees for future identification before they are released. Some are fitted with a satellite transmitter. These measures allow researchers to track the movements of rehabilitated manatees and find them again should they require medical attention or encounter a dangerous situation. In the past, rehabilitated manatees have attempted to migrate solo to Cuba and the Dry Tortugas—both outside the usual range of Florida manatees—or failed to find warm water during a winter cold snap. In these cases, researchers were able to capture the endangered manatees and return them to a safe environ-ment.

In 1997, of the thirty-five manatees rescued, eight were treated and released on site. Of the twenty-seven that were brought to rehabilitation facilities, fifteen did not survive, seven continue to receive treatment, and five were successfully returned to the wild. Rescue costs run about two million dollars a year, or $30,000 per animal, and include money spent on rescue operations, medical care, and care for captive and rehabilitating manatees. Except for $400,000 from the Save the Manatee Trust Fund, the rehabilitation facilities provide the funding for the rescue efforts. Much of the trust fund money is derived from proceeds of the "Save the Manatee" license tag, one of the more than fifty special license plates in Florida from which a portion of the license fee benefits a particular fund, such as manatee, sea turtle, or panther research.

Law Enforcement

Without adequate law enforcement, regulations protecting manatees are useless. The USFWS and Florida Marine Patrol are the primary agencies responsible for enforcing manatee protection laws in Florida. USFWS officers concentrate their activities in National Wildlife Refuges, enforcing watercraft speed limits in posted manatee zones. Florida Park Service Rangers have jurisdiction regarding manatees living in state park waters, and rangers in national parks, such as Everglades National Park, are able to handle enforcement problems regarding manatees within national park boundaries.

The Florida Marine Patrol has 300 law enforcement officers statewide, a number insufficient to cover Florida's estimated 1,350 miles of coastline and police the more than one million registered boats on the water. During 1997, Florida Marine Patrol officers issued citations for more than 1,600 manatee speed zone violations. Citations issued for violations in Brevard, Dade, Duval, Volusia, and Lee—all "key" counties—accounted for almost 70 percent of those issued.

Studies and polls have indicated that most people support manatee zones and don't mind slowing down to reduce the chance of injuring a manatee. But not everyone complies. In the summer of 1997, the USFWS conducted a six-week manatee speed zone enforcement operation in Brevard County. The operation focused on speed zones in the Banana River, the Indian River, and the Barge

Canal—areas with the highest manatee mortality in the state. A total of 304 speeding tickets was issued, of which 64 percent involved Brevard County residents and nearly 34 percent involved personal watercraft. Most offenders were men in their forties.

Mote Marine Laboratory recently completed a year-long evaluation of boater compliance with speed zone regulations in Sarasota County. The study indicated that an average of 60 percent of boaters complied with posted speed regulations, although compliance was highly variable from one area to the next. The study also found that operators of personal watercraft were the least compliant, with an average of only 36 percent obeying posted speeds. The presence of law enforcement increased the level of boater compliance significantly.

The findings of the Brevard and Sarasota County evaluations serve as a reminder that although public opinion generally sways toward the preservation of the manatee, many people who are actually out on the water ignore manatee speed zones. The Sarasota study recommends the alloca-

A manatee mailbox on Highway 19 near Crystal River, Florida.

tion of additional funds, personnel, and resources for law enforcement activities throughout Florida.

Education and Advocacy

Education forms a major component of the manatee protection and recovery effort. Information about Florida manatees is widespread throughout the state; it is difficult to go anywhere on the coast without learning something about manatees. Children study them in school, signs are posted in parks and by boat ramps near manatee habitats, and aquariums such as SeaWorld of Florida, Miami Seaquarium, and The Living Seas at Walt Disney World offer educational manatee programs. Both Homosassa Springs and Blue Spring State Park offer excellent manatee programs, and during the winter, Blue Spring is one of the best places to observe— from an elevated boardwalk—up to 100 wild manatees gathering in the clear, warm water.

In 1997, a Manatee Education Center was opened at the entrance to Homosassa Springs State Wildlife Park in the Crystal River National Wildlife Refuge. Through the center, schools, chambers of commerce, and other outlets, the refuge provides educational outreach, such as a video on proper manatee-watching etiquette; this video is distributed to dive shops that conduct underwater dive training and provide manatee tours in the Crystal River area.

Funded by the USFWS in cooperation with the FDEP, the center is one of many programs on which FDEP expends considerable effort and money to educate people about manatee conservation. The Bureau of Protected Species Management recently produced new manatee behavior posters, as well as a manatee travel activity sheet for families visiting coastal areas. Outreach staff respond to information requests and provide an Internet site (see Appendix III). The Florida Marine Research Institute developed six educational presentations on manatee topics for distribution to selected United States schools; additionally, FMRI provides educational displays, handles requests for manatee information, and maintains its Internet site (see Appendix III) with current manatee information and recent data. Founded by singer/songwriter Jimmy Buffet and U.S. Senator Bob Graham in 1982, the Save the Manatee Club (SMC) is the principal grassroots manatee advocate in the country. The club's stated purpose is to promote public awareness and educa-

A B O V E : *The back of this manatee has been extensively mutilated by repeated boat strikes.*

L E F T : *This sign posted in Crystal River, Florida, signals boaters to idle through this area or face fines if caught speeding. Because approximately 1.1 million boats—or about 400 boats to every manatee—ply Florida's waterways at any given time, it is important for boaters to look out for manatees and obey posted speeds.*

tion; to sponsor research, rescue, and rehabilitation efforts; and to advocate and take appropriate legal action when manatees' interests are threatened. A nonprofit organization that boasts more than 40,000 members, SMC is one of the most important manatee education providers in the United States.

Among its many services, SMC provides free manatee education packets and staff interviews for students; an educator's guide, four-color poster, coloring and activity book, and free in-service programs for educators; volunteer speakers to schools and civic groups in Florida and select areas across the United States; and equipment for educational manatee programs, such as the Blue Spring State Park's manatee interpretive program. An educational manatee video was produced by SMC and the Florida Advisory Council on Environmental Education and is distributed without charge to schools throughout Florida. In cooperation with USFWS and the Professional Association of Diving Instructors, SMC printed and distributed 40,000 "If You Love Me, Don't Disturb Me" pamphlets designed for swim-with-the-manatee programs. The club also prints and distributes thousands of public awareness signs and stickers for shoreline property owners and boaters.

As manatee advocates, SMC staff review plans, make recommendations, and lobby to implement

Manatees rarely get respite from the throngs of eager snorkelers who invade the warm-water springs in winter to swim with these large, gentle animals.

manatee protection in Florida's key manatee counties. The club also files legal challenges against development projects that may harm manatees and their habitat. In 1997, SMC staff helped prevent a casino cruise ship from using a marina on the Crystal River as a point of departure; the ship caused documented destruction of river bottom habitat and posed a threat to manatees wintering in the river. If a boat speed limit is challenged by a county, SMC intervenes on the state's behalf, and the club challenges state laws that are not strong enough to ensure adequate manatee protection.

The investment of time, money, and resources that has been infused—and continues to be infused—into sirenian conservation by government, private organizations, and caring individuals is a tremendous worldwide effort. But we must continue to learn about sirenians and their survival needs; we must support the development and *enforcement* of strict conservation laws protecting them and other vulnerable wildlife; and we must maintain habitat sirenians need to thrive over the next millennium and beyond. Some of the actions we can each take to protect sirenians are ridiculously simple. For instance, we can slow our boats in manatee zones and refrain from feeding them when they nose up to a dock. These are small but critical steps. Other actions, such as developing a workable plan to curb the explosive growth of the human population and finding ways to live from the earth without damaging it, will require no small amount of resolve and sacrifice. But these, too, demand our immediate attention.

People have been telling stories about sirenians for thousands of years. The classical legends of mermaids and sirens and the myths of manatees and dugongs recounted by indigenous cultures provide vital clues to our history as humans and how we view our world. As we look to a new millennium, we are faced with important choices. Do we arrogantly continue our perceived dominion over the planet by developing its wild lands, eliminating other species, and reproducing without consideration for dwindling resources or future generations' welfare? Or do we look deep within ourselves and thumb through the pages of our own storied history to relearn how to coexist with all living things— knowledge we once held close, but now have largely forgotten.

Right now, we are writing the stories that will

A Florida manatee approaches a photographer for a scratch near Crystal River.

be told of us by coming generations. Two centuries from now, will our descendants describe how we crushed the sirenians with boats, entangled them in debris, and destroyed their habitat until none were left? Or will they recount how we slowed our boats where manatees played, protected valuable habitat, and kept garbage and toxins out of the environment? Will they tell of how we rekindled a reverence for our home planet and all its wondrous inhabitants?

We now have our chance to ensure manatees and dugongs remain a living part of our legacy and do not meet the sad, unalterable fate of the Steller's sea cow. We know well what must be done. What better time to write a story of reverence and preservation, one that will be retold many times in the centuries to follow.

A B O V E : *A Florida manatee enjoys a back rub from an underwater photographer near Crystal River.*
L E F T : *Manatees linger at the bottom of the spring run at Blue Spring State Park, Florida.*

Guidelines for Protecting Manatees

THE FOLLOWING ARE guidelines established through the cooperative effort of the Save the Manatee Club, Florida Power & Light Company, U.S. Fish and Wildlife Service, and Florida Department of Environmental Protection (Office of Protected Species Management).

Please follow these guidelines to ensure the safety of manatees when swimming or boating near them.

1. Being Near Manatees

· Look, but don't touch manatees. Also, don't feed manatees or give them water. If manatees become accustomed to being around people, this can alter their behavior in the wild, perhaps causing them to lose their natural fear of boats and humans, and this may make them more susceptible to harm. *Passive observation* is the best way to interact with manatees and all wildlife.

· Do not pursue or chase a manatee while you are swimming, snorkeling, diving, or operating a boat.

· Never poke, prod, or stab a manatee with your hands, feet, or any object.

· If a manatee avoids you, you should avoid it.

· Don't isolate or single out an individual manatee from its group, and don't separate a cow from her calf.

· Don't attempt to snag, hook, hold, grab, pinch, or ride a manatee.

· Avoid excessive noise and splashing if a manatee appears in your swimming area.

· Use snorkel gear when attempting to watch manatees. The sound of bubbles from SCUBA gear may cause manatees to leave the area.

· When snorkeling, don't wear a weight belt. Float at the surface of the water and passively observe the manatee. Look, but don't touch.

2. Don't Enter Areas Designated as "No Entry Manatee Refuge"

These areas have been identified by the Florida Department of Environmental Protection and the U.S. Fish and Wildlife Service as crucial for manatee survival.

3. When Boating or Jet Skiing

· Abide by the posted speed zone signs while in areas known to have manatees present or when observations indicate manatees might be present. Observations may include seeing a swirl at the surface caused by the manatee when diving; seeing the animal's back, snout, tail, or flipper break the surface of the water; or hearing it when it surfaces to breathe.

The underwater observatory at Homosassa Springs State Wildlife Park offers excellent views of manatees in their natural environment.

· Wear polarized sunglasses to reduce glare on the surface of the water. This will enable you to see manatees more easily.

· Try to stay in deep-water channels. Manatees can be found in shallow, slow-moving rivers, estuaries, lagoons, and coastal areas. Avoid boating over seagrass beds and shallow areas.

· Remain at least 50 feet away from a manatee when operating a powerboat. Don't operate a boat near large concentrations of manatees.

· If you like to water ski, please choose areas that manatees do not use, or cannot enter, such as land-locked lakes.

· Please don't discard monofilament line, hooks, or any other litter into the water. Manatees may ingest or become entangled in this debris and can become injured or even die. Note: discarding monofilament fishing line into the waters of Florida is unlawful.

Remember, to report manatee injuries, deaths, tag sightings, or harassment, call the Florida Marine Patrol at 1-800-DIAL FMP (1-800-342-5367).

Manatee Area Signs

Idle Speed Zone—a zone in which boats are not permitted to go any faster than necessary to be steered.

Caution area—an area frequently inhabited by manatees, requiring caution on the part of boaters to avoid disturbing or injuring the animals.

Resume Normal Safe Operation—a sign indicating that you may resume safe boating speed; visible as you leave a protected area.

No Entry Zone—a protected zone that prohibits boating, swimming, and diving for the protection of manatees.

Slow Speed Zone—a minimum-wake zone where boats must not be on a plane and must be level in the water.

Two Florida manatees. The animal on the right has been returned to the wild after being in captivity, as indicated by the number freeze branded onto its side.

Organizations Involved in Manatee and Dugong Conservation

Manatees

Amber Lake Wildlife Rescue and Rehabilitation Center
297 Artists Ave.
Englewood, FL 34223
(941) 475-4585

Blue Spring State Park
2100 West French Ave.
Orange City, FL 32763
(904) 775-3663
www.dep.state.fl.us/parks/BlueSpring/bluespring.html

Crystal River and Chassahowitzka National Wildlife Refuges
1502 S.E. Kings Bay Drive
Crystal River, FL 34429
(352) 563-2088
www.gorp.com/gorp/resource/us_nwr/fl_cryst.htm

Dolphin Research Center
P.O. Box 522875
Marathon Shores, FL 33052
(305) 289-1121
www.dolphins.org

Florida Marine Research Institute
Florida Department of Environmental Protection
100 Eighth Avenue, S.E.
St. Petersburg, FL 33701-5095
(727) 896-8626
www.fmri.usf.edu

Florida Power & Light Company
Environmental Services Department
P.O. Box 14000
Juno Beach, FL 33408
1-800-552-8440

Georgia Department of Natural Resources
Nongame and Endangered Wildlife Program
One Conservation Way
Brunswick, GA 31523
(912) 264-7218
www.dnr.state.ga.us/dnr/wild

Homosassa Springs State Wildlife Park
4150 South Suncoast Blvd.
Homasassa, FL 34446
(352) 628–2311
www.citrusdirectory.com\hsswp

Lowry Park Zoo
7530 North Boulevard

Tampa, FL 33604
(813) 935-8552

Miami Seaquarium
4400 Rickenbacker Causeway
Miami, FL 33149
(305) 361-5705
www.miamiseaquarium.com

Save the Manatee Club
500 N. Maitland Ave.
Maitland, FL 32751
(800) 432-JOIN
www.savethemanatee.org

SeaWorld of Florida
7007 SeaWorld Drive
Orlando, FL 32809
(407) 351-3600
www.4adventure.com

The Sirenia Project
U.S. Geological Survey
412 N.E. 16th Avenue, Rm. 250
Gainesville, FL 32601-3701
(352) 372-2571
www.fcsc.usgs.gov/sirenia

Dugongs

Australian Nature Conservation Agency
GPO Box 636
Belconnen, ACT
2617 Australia
(06) 250 0200
www.anbg.gov.au/anca/anca.html

Conservation Commission of the
Northern Territories
P.O. Box 496
Palmerston, NT
0831 Australia
PHONE: 250 0200
www.atn.com.au/parks/ntparks.html

Department of Conservation and
Land Management
Hackett Drive
Crawley, WA

6009 Australia
(08) 9442 0300
www.calm.wa.gov.au

NSW National Parks and Wildlife Service
P.O. Box 1967
Hurtsville, NSW
2220 Australia
1 300 36 1967 or (02) 9585 6333

The Department of Tropical Environment Studies
and Geography
James Cook University of North Queensland
Townsville, Queensland
4811 Australia
(77) 81 4761/4521

The Great Barrier Reef Marine Park Authority
P.O. Box 1379
Townsville, Queensland
4810 Australia
(077) 500 700
www.gbrmpa.gov.au

The Queensland Department of Environment
and Heritage
160 Ann Street
P.O. Box 155
Brisbane Albert Street, QLD
4002 Australia
(07) 3227 7111
www.env.qld.gov.au

Bibliography

Ackerman, Bruce et al. "Trends and Patterns in Mortality of Manatees in Florida 1974–1992." In: *Population Biology of the Florida Manatee, Information and Technology Report 1.* National Biological Service, Department of the Interior, 1995.

——. "The Behavior of the Dugong (Dugong dugon) in Relation to Conservation and Management." *Bulletin of Marine Science*, 31(3): 1981.

——. "Suckling in *Dugong dugon*." *Journal of Mammalogy*, 65(3): 1984.

Anderson, Paul K. "Dugong Behavior and Ecology." *The Explorers Journal*, 64(4): December 1986.

——. "Shark Bay Dugongs in Summer. I." *Behaviour*, 134: 1996.

Anonymous. Manatees and Boats. *Mote News*, (Mote Marine Laborary, Sarasota) 41(3): 1996.

Baughman, J.L. "Some Early Notices on American Manatees and the Mode of Their Capture." *Journal of Mammalogy*, 27(3): 1946.

Beck, Cathy A. and Nélio B. Barros. "The Impact of Debris on the Florida Manatee." *Marine Pollution Bulletin*, 22(10): 1991.

Best, Robin C. "Apparent Dry-Season Fasting in Amazonian Manatee (Mammalia: Sirenia)." *Biotropica*, 15(1): 1983.

Bradley, Richard et al. "The Pre-Columbian Exploitation of the Manatee in Mesoamerica." *University of Oklahoma Department of Anthropology, Papers in Anthropology*, 24(1): 1983.

Bryden, Michael et al. *Dugongs, Whales, Dolphins, and Seals: A Guide to the Sea Mammals of Australasia.* St. Leonards: Allen & Unwin, 1998.

Cumbaa, Stephen L. "Aboriginal Use of Marine Mammals in the Southeastern United States." *Southeastern Archaeological Conference Bulletin* 17: 1980.

Deutsch, Charles J. et al. "Radio-Tracking Manatees from Land and Space." *MTS Journal*, 32(1): 1998.

Dollman, Guy. "Dugongs from Mafia Island and a Manatee from Nigeria." *Natural History Magazine* (London), 4(28): 1933.

——. "Manatees of the Amazon." *Sea Frontiers*, 27(1): 1981.

Domning, Daryl P. "Commercial Exploitation of Manatees *Trichechus* in Brazil c. 1785–1973." *Biological Conservation*, 22(2): 1982.

——. "Evolution of Manatees." *Journal of Paleontology*, 56(3): 1982.

——. "West Indian Tuskers." *Natural History*, 103(4): April 1994.

——. "1997 Florida Manatee Mortality." *Sirenews*, No. 29, April 1998.

Eliot, T.S. "The Love Song of J. Alfred Prufrock." From *Collected Poems 1909–1962.* Harcourt Brace Jovanovich, 1963.

Gallivan, G. James et al. "Temperature Regulation in the Amazonian Manatee (*Trichechus inunguis*)." *Physiological Zoology*, 56(2): 1983.

Gilmore, Raymond M. "Fauna and Ethnozoology." In: Julian H. Steward (ed.), *Handbook of South American Indians*, Vol. 6. New York, Cooper Square Publishers, Inc., 1963.

Grigione, M.M. "Observations on the Status and Distribution of the West African Manatee in Cameroon." *African Journal of Ecology*, 34(2): 1996.

Hudson, Bridget E.T. "Dugongs." *Wildlife in Papua New Guinea*, 77/16: 1977.

Humboldt, Alexander von. *Voyage aux régions équinoxiales du Nouveau Continent, fait en 1799,*

A mangrove snapper shelters under a Florida manatee, Crystal River.

1800, 1801, 1802, 1803 et 1804, par Al. de Humboldt et A. Bonpland. . . . Tome second. English Edition, 1852–53.

Jones, Santhabpan. "The Dugong or the So-Called Mermaid, *Dugong dugon* (Müller) of the Indo-Sri Lanka Waters." *Spolia Zeylanica*, 35(I–II): 1981.

Kingdon, Jonathan. *East African Mammals: An Atlas of Evolution in Africa.* Vol. 1. London and New York, Academic Press, 1971.

Lefebvre, Lynn W. and James A. Powell, Jr. *Manatee Grazing Impacts on Seagrasses in Hobe Sound and Jupiter Sound in Southeast Florida During the Winter of 1988–89.* NTIS Document No. PB 90-271883: vi +36, 1990.

Loveland, Franklin O. "Tapirs and Manatees." In: M.W. Helms & F.O. Loveland (eds.), *Frontier Adaptations in Lower Central America.* Philadelphia, Inst. for Study of Human Issues, 1976.

Marden, Luis. "Guatemala Revisited." *National Geographic*, 92(4): 1947.

Marmontel, Miriam et al. "Population Viability Analysis of the Florida Manatee (*Trichechus manatus latirostris*), 1976-1991." *Conservation Biology*, 11(2): 1997.

Marsh, Helene. "An Ecological Basis for Dugong Conservation in Australia." In: M.L. Augee (ed.), *Marine Mammals of Australasia: Field Biology and Captive Management.* Sydney: Royal Zoological Society of New South Wales, 1988.

——. "Tropical Siren." *Australian Geographic*, 21: January–March 1991.

——. "Going, Going, Dugong." *Nature Australia*, Winter 1997.

Marsh, Helene, P.J. Corkeron, I. Lawler, J.M. Lanyon and A.R. Preen. "The Status of Dugongs in the Great Barrier Reef Region, South of Cape Bedford." *Great Barrier Reef Marine Park Authority Research Publication No. 41:* 1996.

Marsh, Helene et al. "Present-Day Hunting and Distribution of Dugongs in the Wellesyle Islands (Queensland)." *Biological Conservation*, 19: 1980-81.

Marsh, Helene et al. *Status of the Dugong in the Torres Strait Area: Results of an Aerial Survey in the Perspective of Information on Dugong Life History and Current Catch Levels.* Report to Australian National Parks & Wildlife Services, 1984.

Marsh, Helene et al. "The Distribution and Abundance of the Dugong in Shark Bay, Western Australia." *Wildlife Research*, 21(1): 1994.

Marsh, Helene et al. "Can Dugongs Survive in Palau?" *Biological Conservation*, 72: 1995.

Marsh, Helene et al. "The Sustainability of the Indigenous Dugong Fishery in Torres Strait, Australia/Papua New Guinea." *Conservation Biology*, 11(6): 1997.

McKillop, Heather I. "Prehistoric Exploitation of the Manatee in the Maya and Circum-Caribbean Areas." *World Archaeology*, 16(3): 1985.

Nietschmann, Bernard. "Hunting and Ecology of Dugongs and Green Turtles, Torres Strait, Australia." *National Geographic Society Research Report*, 17: 1984.

Nietschmann, Bernard and Judith. "Good Dugong, Bad Dugong; Bad Turtle, Good Turtle." *Natural History*, 90(5): 1981.

O'Shea, Thomas J. et al. "Distribution, Status, and Traditional Significance of the West Indian Manatee *Trichechus manatus* in Venezuela." *Biological Conservation*, 46: 1988.

Pain, Stephanie. "Where Manatees May Safely Swim." *New Scientist*, No. 2039: July 20, 1996.

Parer-Cook, Elizabeth and David Parer. "The Case of the Vanishing Mermaids." *Geo*, 12(3): 1990.

Powell, James A. Jr. "Evidence of Carnivory in Manatees (*Trichechus manatus*)." *Journal of Mammalogy*, 59(2): 1978.

Preen, Anthony. "Diet of Dugongs." *Journal of Mammalogy*, 76(1): 1995.

——. "Impacts of Dugong Foraging on Seagrass Habitats." *Marine Ecology Progress Series*, Vol. 124: 1995.

Preen, Anthony and Helene Marsh. "Response of Dugongs to Large-scale Loss of Seagrass from Hervey Bay, Queensland, Australia." *Wildlife Research*, 22(4): 1995.

Pritchard, Peter C.H. and Herbert W. Kale. *Saving What's Left.* Maitland, Florida Audubon Society, 1994.

Quammen, David. *The Song of the Dodo: Island Biogeography in an Age of Extinctions.* New York: Scribner, 1996.

Reynolds, John E., III and Daniel K. Odell. *Manatees and Dugongs.* New York: Facts on File, 1992.

Rosas, Fernando César Weber. "Biology, Conservation and Status of the Amazonian Manatee *Trichechus inunguis*." *Mammal Review*, 24(2):

1994.

Rouse, Irving. "The Arawak." In: Julian H. Steward (ed.), *Handbook of South American Indians*, Vol. 4. New York, Cooper Square Publishers, Inc., 1963.

Seifert, Douglas David. "The Sirenian's Final Aria, Part Two" *Ocean Realm*, Summer 1996.

Shankland, Jessie. "Predation of Dugong by Tiger Sharks—Shark Bay." Notes from James Scheerer Research Charter, July 1997.

Sikes, Sylvia. "How to Save the Mermaids." *Oryx*, 12(4): 1975.

Simpson, George Gaylord. "Sea Sirens." *Natural History*, 30(1): 1930.

———. "Some Carib Indian Mammal Names." *American Museum Novit.*, No. 1119: 1941.

Smith, Kenneth N. *Manatee Habitat and Human-Related Threats to Seagrass in Florida: A Review*. Tallahassee, Florida Department of Environmental Protection: 38 pp., 1993.

Smith, Nigel J.H. "Caimans, Capybaras, Otters, Manatees, and Man in Amazonia." *Biological Conservation*, 19(3): 1981.

Solov, Dean. "Researchers Discover Butchered Manatees." *Tampa Tribune*, September 28, 1995.

Steller, Georg Wilhelm. *Journal of a Voyage with Bering 1741–1742*. Edited by O.W. Frost. Translated by Margritt A. Engel and O.W. Frost. Stanford: Stanford University Press, 1988.

Thomson, Donald F. "The Dugong Hunters of Cape York." *Journal of the Royal Anthropology Institute of Great Britain and Ireland*, 64: 1934.

Timm, Robert M. et al. "Ecology, Distribution, Harvest, and Conservation of the Amazonian Manatee (*Trichechus inunguis*) in Ecuador." *Biotropica*, 18(2): 1986.

U.S. Fish and Wildlife Service. *Florida Manatee Recovery Accomplishments, 1997 Annual Report*. Jacksonville, FL., 1998.

Van Meter, Victoria. *The West Indian Manatee in Florida*. Juno Beach: Florida Power & Light Company, 1987.

Wells, Randy. "New State-Funded Manatee Research at Mote." *Mote News*, (Mote Marine Laboratory, Sarasota) 42(3): 1997.

Zeiller, Warren. *Introducing the Manatee*. Gainesville: University Press of Florida, 1992.

Index

Amazonian manatee, *28, 55–60*
 anatomy, *28, 33-34, 37, 55*
 evolution, *18, 56*
 feeding, *33, 34, 37, 38, 40*
 human impact on, *60*
 populations, *55*
 range (map), *55*
 size, *55, 60*
 skin, *34, 44, 55, 57*
 swimming ability, *37, 56*
Anatomy, *17, 33–34, 37-38, 55-56, 71–72, 84*
 breathing, *37, 38, 56, 72, 82*
 digestive system, *37, 56*
 ears and earbones, *33–34, 100*
 flippers, *17, 28, 33, 55, 71, 84, 85*
 tail, *17, 33, 71, 84*
 toenails, *17, 28, 33, 38, 55, 71*
 see also Hearing; Smell, sense of; Taste, sense of; Touch, sense of; Vision
Antillean manatee, *28, 30, 52–53, 55*
 anatomy, *28, 33–34, 37*
 evolution, *18, 60*
 feeding, *13, 33, 34, 37, 38, 40, 53*
 human impact on, *55*
 populations, *30, 52*
 range (map), *52*
 size, *52*
 skin, *34, 44*
 swimming ability, *30, 37*
Behavior, *28–30, 32, 33, 34, 37, 38, 40–41, 45, 46–47, 49-50, 75–76, 81–82, 85*
 calf, *45, 49–50*
 defensive, *73, 78, 81, 82, 84, 108*
 feeding, *33, 34, 37, 40, 75, 78*
 survival, *84, 85*
 see also Mating; Migration; Habitat
Birth, *17, 45, 49, 78, 82*
Calves, *37–38, 49–50*
 cows and, *34, 45, 49–50, 56, 71, 78, 82, 84*

development of, *49–50, 60, 82*
diet of, *17, 37, 39–40, 82*
juvenile, *37*
mortality of, *82, 84*
orphan, *82*
size at birth *49, 82*
 see also Behavior, calf
Captive manatees, *56, 60*
Color. *See* Physical characteristics, skin
Communication, *17, 34, 56, 71, 81–82*
Conservation and management of the sirenian, *10, 11, 14, 23–24, 62, 112–113, 115–119, 121–128, 131–134, 136–137*
 see also Humans and sirenians
Cross-breeding, *55–56*
Description. *See* Physical characteristics
Development. *See* Calves, development of
Diet, *34, 37, 88, 40, 62, 72, 75, 76, 78*
 see also Calves, diet of; Feeding; Seagrass
Digestive system. *See* Anatomy, digestive system
Dugong, *65–84, 116, 117*
 anatomy, *71-72*
 evolution, *18, 66, 68*
 feeding, *14, 71, 72, 75–76, 78*
 human impact on, *84*
 populations, *14, 66, 68, 112*
 range (map), *66*
 size, *71, 82*
 skin, *71*
 swimming ability, *71, 72, 81–82*
Dugong dugon. See Dugong
Ears and earbones. *See* Anatomy, ears and earbones; Hearing
Education. *See* Humans and sirenians, education
Endangered species, *60, 116*
 Endangered Species Act, *10,*

109, 113
Estrus, *34, 45, 49*
 see also mating
Evolution, *17–18, 20, 66, 84*
 adaptations, *17–18, 33, 37, 56, 62, 85*
 see also individual species, evolution
Extinction, *18, 28, 85, 108*
 see also Steller's sea cow
Family Dugongidae, *14*
Family Trichechidae, *14*
Feeding. *See* Behavior, feeding; individual species, feeding
Florida manatee, *28–33, 109, 115–116, 118*
 anatomy, *28, 33–34, 37*
 evolution, *18, 33, 60*
 feeding, *27, 33, 34, 37, 38, 40, 41*
 human impact on, *6, 115–116, 118*
 populations, *28, 30, 33*
 range (map), *29*
 size, *33*
 skin, *33, 34, 44*
 swimming ability, *30, 37*
Fur. *See* Physical characteristics, skin
Gestation. *See* Mating; Calves, cows and
Habitat, *14, 18, 28, 52, 60, 62, 121*
 historic, *18, 60*
 threats to, *6, 8, 10, 14, 18, 23, 28, 33, 62, 88, 108, 121*
 water requirements, *28, 30, 37–38, 55, 60, 62*
Hearing, *17, 33-34*
 of infrasonic sounds, *17, 34, 111*
Humans and sirenians, *18, 21, 23, 24, 34, 75, 84, 85, 88–105, 108–113, 115–131*
 education, *6, 18, 111, 118, 126, 128*
 historical contact, *14, 18, 20, 66,*

68, 84–85, 96, 99

 laws regarding sirenians, *6, 10, 23, 97, 105, 108, 113, 115–116, 118, 121, 125–126, 127, 133*

 mythology, *18, 23, 66, 88, 90, 91–92*

 tourism, *8, 14, 18, 45, 118, 121*

 traditional beliefs, *18, 20, 23, 68, 88, 92, 95–96*

 see also Conservation and management of sirenians; Habitat, threats to; Hunting; Mortality, human-related; Threats, watercrafts

Hunting, *55, 60, 84, 85, 92, 95, 116, 124*

 commercial aspects of, *62, 96, 99–100*

 indigenous cultures and, *23, 62, 88, 91–92, 95–96, 116, 124*

 methods of, *84, 100–101, 103, 105*

 overhunting, *10, 14, 23, 60*

 poaching, *84, 112*

 subsistence, *23, 62, 84, 88, 100–101, 103, 105, 112*

 traditional practices and, *23, 84, 91–92, 95–96*

Hybrids. *See* Cross-breeding

Hydrodamalis gigas. *See* Steller's sea cow

Intelligence, *17*

Lifespan, *33, 72*

Mating, *34, 46–47, 49, 60, 71, 78, 81, 85*

 mating herds, *46–47, 49, 56*

 lek displays, *81–82*

 see also Birth

Metabolism, *34, 37–38, 56, 72*

Migration, *28–30, 33, 38, 52, 60, 62, 72, 125*

Mortality, *33, 50, 52, 60, 84, 88, 108, 110*

 causes of, *33, 38, 60, 76, 78, 84, 108, 122*

 cold-related, *33, 38, 52*

 human-related, *6, 10, 23, 34, 50, 55, 84, 88, 100, 108, 110–112, 125–126*

 see also Hunting

Physical characteristics, *14, 17, 28, 71*

 shape, *17, 33, 71*

 size, *33, 49, 60, 82, 84*

 skin, *17, 33, 34, 55, 71, 84, 85*

 weight, *33, 49, 52, 55, 84*

 see also Anatomy; Calves, development of; Teeth; Evolution, adaptations

Play, *45, 49*

Poaching. *See* Hunting, poaching

Populations, *14, 28, 30, 33, 56, 60, 62, 66, 100, 105, 108, 110, 116*

Range, *14, 28–30, 33, 52–55, 60, 62, 65, 68*

historic, *52, 60, 66*

 maps, *29, 52, 66*

 seasonal, *28–30, 33, 72*

Red tide. *See* Threats, red tide

Reproduction. *See* mating

Research, *28, 30, 56, 118, 121–122, 123*

Seagrass, *13, 14, 40, 72, 75–76, 78*

 abundance, *76, 78*

 recovery of, *75, 76*

 threat to, *10, 75, 76, 78, 121*

Sight. *See* Vision

Sirenia. *See* Taxonomy

Size. *See* Physical characteristics, size

Skin. *See* Physical characteristics, skin

Sleep, *45*

Smell, sense of, *34*

Social characteristics, *40–41, 45, 46–47, 49, 56, 59, 78, 85*

Speed. *See* Swimming

Steller's sea cow, *84–85*

 anatomy, *84–85*

 evolution, *18, 66, 84*

 feeding, *84*

 human impact on, *14, 85*

 populations, *14*

 range, *84*

 size, *14, 84*

 skin, *84, 85,*

Survival. *See* Conservation and management of the sirenians; Humans and sirenians

Swimming, *37, 71, 72, 81–82*

Tail. *See* Anatomy, tail

Taste, sense of, *34*

Taxonomy, *14, 17*

Teeth, *17, 18, 34, 37, 49, 55, 71–72, 84–85, 100*

 age and, *49*

 conveyor-belt, *56, 71*

 tusks, *18, 71–72*

Territory, *81–82*

Threats, *6, 10–11, 50, 52, 55, 62, 84, 110–112*

 marine debris, *111–112*

 net entanglement, *55, 62, 84, 111, 112*

 red tide, *10–11, 50, 52*

 sharks, *84*

 water control structures, *111*

 watercrafts, *6, 10, 34, 110–111, 118, 120, 127*

 see also Habitat, threats to

Toenails. *See* Anatomy, toenails

Touch, sense of, *33, 34, 44*

Tourism. *See* Humans and sirenians, tourism

Trichechus inunguis. *See* Amazonian manatee

Trichechus manatus. *See* Antillean manatee; Florida manatee

Trichechus manatus latirostris. *See* Florida manatee

Trichechus manatus manatus. *See* Antillean manatee

Trichechus senegalensis. *See* West African manatee

Vision, *33, 71*

Weight. *See* Physical characteristics, weight

West African manatee, *28, 60–62*

 anatomy, *28, 33–34, 37, 60, 62*

 evolution, *60*

 feeding, *33, 34, 37, 38, 40, 62*

 human impact on, *62*

 populations, *60, 62*

 range (map), *62*

 skin, *34, 44*

 swimming ability, *37*

West Indian manatee. *See* Antillean manatee; Florida manatee

About the Author and Photographer

Jeff Ripple, natural history writer and photographer, has devoted nearly fifteen years to exploring and photographing the natural areas of Florida.

His articles and photographs have appeared in publications such as *The New York Times*, *Outside*, *BBC Wildlife*, *Cortlandt Forum*, *Men's Fitness*, *Sail*, *River Magazine*, *Ocean Realm*, *Backpacker*, *Birder's World*, and *Defenders*, among others. Jeff is the author of *Big Cypress Swamp and the Ten Thousand Islands* (University of South Carolina Press, 1992), *The Florida Keys: The Natural Wonders of an Island Paradise* (Voyageur Press, 1995), *Sea Turtles* (Voyageur Press, 1996), *Southwest Florida's Wetland Wilderness* (University Presses of Florida, 1996), and *Florida: The Natural Wonders* (Voyageur Press, 1997). He also edited and contributed to *The Wild Heart of Florida* (University Presses of Florida). He is currently working on a photography project in the Fakahatchee Strand of southwest Florida.

Jeff, his wife Renée, and their cats Tabatha, Suwannee, and Natalie live in a small house in the woods near Gainesville, Florida.

Doug Perrine, freelance photojournalist, has been photographing manatees since 1981. His first published photographs accompanied articles on manatees in *Florida Wildlife & Underwater USA* in 1985. He has since contributed his photographs to hundreds of magazines, including *National Geographic*, *Smithsonian*, *Natural History*, *National/International Wildlife*, *BBC Wildlife*, *Time*, *Newsweek*, *USNews & World Report*, and *Omni*, as well as books, calendars, posters, and notecards. In 1995, he took first place in the animal behavior category in the Wildlife Photographer of the Year Competition. Doug is the author of *Sharks* (Voyageur Press, 1995), *Mysteries of the Sea* (1997), *Ripley's Whales and Dolphins* (1999), and *Sharks and Rays of the World* (Voyageur Press, 1999).

Doug earned his master's degree in marine biology from the University of Miami and served as a Peace Corps volunteer in Morocco and Micronesia.

PROGRAM AUTHORS

Dr. James A. Banks
Professor of Education and Director of the Center for Multicultural Education
University of Washington
Seattle, Washington

Dr. Barry K. Beyer
Professor Emeritus, Graduate School of Education
George Mason University
Fairfax, Virginia

Dr. Gloria Contreras
Professor of Education
University of North Texas
Denton, Texas

Jean Craven
District Coordinator of Curriculum Development
Albuquerque Public Schools
Albuquerque, New Mexico

Dr. Gloria Ladson-Billings
Professor of Education
University of Wisconsin
Madison, Wisconsin

Dr. Mary A. McFarland
Instructional Coordinator of Social Studies, K–12, and Director of Staff Development
Parkway School District
Chesterfield, Missouri

Dr. Walter C. Parker
Professor and Program Chair for Social Studies Education
University of Washington
Seattle, Washington

NATIONAL GEOGRAPHIC SOCIETY
Washington, D.C.

Acknowledgments

GRANDMA, BUFFALO, MAY AND ME by Carol Curtis Stilz. © 1995 by Carol Stilz. Sasquatch Books, Seattle.

UNCLE NACHO'S HAT by Harriet Rohmer. ©1989 by Harriet Rohmer. Children's Book Press.

Excerpts from 50 SIMPLE THINGS KIDS CAN DO TO SAVE THE EARTH by John Javna. ©1990 by John Javna. The EarthWorks Group.

THE GREAT KAPOK TREE: A TALE OF THE AMAZON RAIN FOREST by Lynne Cherry. ©1990 by Lynne Cherry. Harcourt Brace Jovanovich, Inc.

Excerpts from MARY MCLEOD BETHUNE by Eloise Greenfield. ©1977 by Eloise Greenfield. (T.Y. Crowell) Harper & Row, Publishers, Inc.

(continued on page 138)

McGraw-Hill School Division
A Division of The McGraw-Hill Companies

Copyright © McGraw-Hill School Division, a Division of the Educational and Professional Publishing Group of The McGraw-Hill Companies, Inc.

All rights reserved. Permission granted to reproduce for use with McGRAW-HILL ADVENTURES IN TIME AND PLACE. No other use of this material or parts thereof, including reproduction, distribution, or storage in an electronic database, permitted without the prior written permission of the publisher except as provided under the United States Copyright Act of 1976.

McGraw-Hill School Division
Two Penn Plaza
New York, New York 10121

Printed in the United States of America

ISBN 0-02-147554-7 / 2

3 4 5 6 7 8 9 079 02 01 00

SOURCES, STORIES, AND SONGS

READ ALOUD ANTHOLO

People Together

ADVENTURES IN TIME AND PLACE

- **Biographies**
- **Folk Tales, Tall Tales, and Fables**
- **Nonfiction Selections**
- **Plays**
- **Poems**
- **Songs**
- **Stories**

**McGraw-Hill
School Division**

New York Farmington

LITERATURE

In social studies, literature is used to motivate and instruct. It also plays a large role in helping students to understand their cultural heritage and the cultural heritage of others. For example, folk tales such as "How Hawk Stopped the Flood with His Tail Feather" offer children a glimpse of the wisdom various cultures deem important to impart. The songs, stories, and poetry of different cultures offer students opportunities to compare and contrast and, hence, understand aspects of cultural identity. Biographies, such as *Grandma Moses: Painter of Rural America*, expose children to informational text about people who make a difference. Plays, especially written to reflect social studies concepts or historical information, afford children opportunities to work together cooperatively on a production while learning valuable content.

As you read aloud the various selections in this Anthology to children, you can encourage them to predict what will happen next, to listen for main ideas and details, to sequence, and to identify cause-and-effect relationships, all thinking skills emphasized in *Adventures in Time and Place*. You can invite them to sing along with the songs and chime in with the poetry. Children can respond to the selections in a variety of ways, including through drawing, writing, pantomiming, and movement activities. Proficient readers will be able to read aloud some of the selections to each other.

Suggest to children that, as they listen to the literature selections in this Anthology, they ask themselves these questions:

- *Who* is the author of the selection?
- *What* is the author's background?
- *What* is the author's purpose and point of view?

People All Around

Mi Hogar
(My Home)

Isis Peréz de Méndes–Peñate
María Luisa Muñoz

Es mi ca - si - ta que - ri - da, tan bo -
This is my dear lit - tle house. It's as beau -

ni - ta co un Sol ___
ti - ful as the sun. ___

es un ho - gar muy di - cho - so que me
It's a ve - ry hap - py home. Look how it

guar - da con a - mor ___
wraps me up with love. ___

a - llí es - tán los que yo quie - ro,
All the peo - ple I love are here,

mi ma - mi - tay mi pa - pá ___
my mom - my, my dad - dy too, ___

mis her - ma - ni - tos y a - bue - los. ¡Es mi ho -
broth - ers, sis - ters and grand - par - ents. This is my

gar, un dul - ce ho - gar! ___
home, my home sweet home! ___

2

Dumpling Soup

by Jama Kim Rattigan

The girl in this story, Marisa, has a family tree that includes people from many different places, even though many of her relatives now live in Hawaii. When her family gets together for a special New Year's Eve, they bring with them the customs and languages from these different places. What are some of the customs and languages seen in this story and where do you think they come from?

Every year on New Year's Eve, my whole family goes to Grandma's house for dumpling soup. My aunties and uncles and cousins come from all around Oahu. Most of them are Korean, but some are Japanese, Chinese, Hawaiian, or *haole* (Hawaiian for white people). Grandma calls our family "chop suey," which means "all mixed up" in pidgin. I like it that way. So does Grandma. "More spice," she says.

This year, since I am seven, Grandma says I can help make dumplings, too. Everybody in my family loves to eat, so we have to makes *lots and lots* of dumplings.

The night before New Year's Eve, Grandma, Auntie Elsie, Auntie Ruth, and Auntie Grace come to our house to work on the filling. My mother has bought great big piles of beef, pork, and vegetables to fill the dumplings and special dumpling wrappers from the Gum Chew Lau Noodle Factory in Honolulu. Everyone brings her own cleaver and cutting board and sits at the kitchen table, chopping and talking, chopping and talking, late into the night.

"Too much gossip!" says Grandma in Korean. "Mince that cabbage! More bean sprouts!" It is her recipe, so she is very picky.

"What about me?" I want to help.

"Tomorrow, Marisa," answers Grandma. "You can help us wrap."

So tonight I watch Grandma mix everything in a big metal pan— more tofu, more onion, more salt, more soy sauce. My aunties keep

3

working, and I fall asleep listening to the *chop-chop* pounding, *chop-scrape-scrape*. Later, when my mother wakes me up to go to bed, her hands smell like garlic.

The next morning, I am the first one up. I wake my brother, Hiram. Then together we tiptoe to my mother and father's room.

"Get up, get up! It's New Year's Eve! We have to go to Grandma's to wrap the *mandoo*."

"Not yet," my mother says with her eyes still closed.

"Please wait till the sun comes up," says my father.

But we are too excited to sleep. Today, everyone will be at Grandma's. We will see cousins we haven't seen all year, and we will stay up all night. Hiram will help my uncles with the fireworks. But best of all, I will learn to wrap dumplings for dumpling soup.

When we finally get to Grandma's, other aunts who live near Wahiawa have already started wrapping. All of Auntie Faye's dumplings are rectangles, and she lines them up like soldiers. Auntie Ruth pinches her dumplings along the edges to make them look fancy. Auntie Grace puts more filling in the middle than anyone else. "I like fat ones," she says.

"Okay, Marisa, these are for you." Grandma places a small stack of wrappers in front of me. My mother pushes her bowl of finger-dipping water closer.

I want to make good dumplings. I want to show my aunties. I try to copy them, but sometimes I put too much filling in the middle. Sometimes I don't put enough water along the edges. My dumplings look a little funny, not perfect like the ones my aunts have made. What if no one wants to eat them? I feel Grandma's hand on my shoulder and look up.

"*Cha-koo hae bo-ra*, Marisa." I don't understand all of Grandma's Korean, but I can tell by her face what she's saying: "Don't worry—keep trying."

Soon there are trays and trays of beautifully wrapped dumplings all over the kitchen. They look like hundreds of baby bottoms wrapped in diapers, powdered on the outside. Mine look a little sad, all different lumpy shapes. One by one, my mother tosses all of them into Grandma's biggest pot full of boiling water.

When the dumplings are cooked, they float up, wrinkled and shiny. Grandma calls my father for the official taste test. No one knows

4

spices like he does. He bites into one of the cooled dumplings, chews slowly and wrinkles his forehead.

"What, too *mae wo*?" ("Too spicy hot?") My mother is anxious. "*Seen gu wa*?" ("Not enough salt?") "Or *jaah*?" ("Too salty?")

He gobbles up the rest of the dumpling, smiling and nodding.

"Mmmm! *Ono*!! One more to make sure."

I watch the pot carefully for my dumplings. There they are! But some float up without their wrappers. And others look like they lost their filling. Grandma scoops all of them into a colander to cool.

"We'll eat your *mandoo* later," she tells me.

But I worry that they are bad *mandoo* and that no one will want to eat them. Is Grandma putting them away so they won't spoil the soup? Maybe it's bad luck to eat ugly dumplings on New Year's.

Before I can ask her, more relatives knock on the door. They come from far away, from Kaneohe, Kahala, and Waialae. Now Wahiawa, which means "place of noise" in Hawaiian, becomes a place of *big* noise.

I hold the screen door open for all the aunties carrying heaping plates of food. "Watch out! Coming through!" They bring homemade *sushi*, *jhun*, and *sashimi*.

Auntie Mori arrives last with a special treat: Japanese *mochi*. She says *mochi-ii* means "to stay in your stomach for a long time." *Mochi-zuki* means "full moon." The little cakes do look like white moons, and the sweet, chewy bites feel so good in our stomachs.

"*Mochi* help keep the family stuck together!" my Uncle Myung Ho says after swallowing seven in a row.

More cars drive up. Now they line the whole street. By six o'clock, Grandma's front steps are covered with big, medium, and little slippers, sandals, and shoes. So many Yangs!

New Year's Eve is the only night in the whole year we are allowed to stay up all night. Grandma told us that in Korea, if you fell asleep before midnight, your eyebrows would turn snowy white. But staying awake is easy for us. We never run out of games.

"Let's hug Grandma!" shouts my *haole* cousin, Maxie. This is our favorite game. We line up in front of Grandma. When it is my turn, I stretch my arms to reach around her bouncy, soft tummy and then rest my head against it. She laughs, and my head bobs up and down. My grandma is like a warm pillow.

Inside and out, everyone finds something to do. We play a game we can play only on New Year's: shoe store. We go to the front steps. "I'll be the shoe store lady!" shouts Carrie. The rest of us take turns trying on all our favorite styles.

"Do you have these gold slippers in size fifty and a half?" asks Maxie.

"Aren't these red high heels just *perfect* with my muumuu?" Alicia shows off.

After a while, all the slippers and shoes get mixed up and seem to be walking all over Grandma's yard. Since it has gotten so late, we really should pick them up. But we're too tired.

When it is almost midnight, we hear Hiram and the older cousins running to poke big sparklers into the grass.

"Somebody check the clock!" orders Hiram. Alicia presses her face against the screen door.

"Twelve minutes to twelve!" she yells. All of a sudden it is almost time, and everybody moves quickly.

From every corner of the house the Yangs come. Everyone finds a place to stand on the cool grass. All the cousins gather under the litchi tree. The babies rub their eyes and whine. My Chinese cousin, Helen, says fireworks scare away the evil spirits. We want good luck in the coming year. Grandma takes one last look around to make sure everyone is there.

For a moment, the only sound is the shush of the *hapuu* plants. "Good-bye, Old Year," I whisper.

Finally we count down the seconds till midnight: Five, four, three, two, one . . .

"Happy New Year!"

Thousands of firecrackers explode, filling the sky with smoke. All up and down Grandma's street, there is popping and snapping. Our eyes water and our ears ring. Hiram and I run to light all the sparklers, then write our names in the night sky. Cousins, aunts, uncles, brothers, sisters, and friends hug and shake hands.

Finally, Grandma calls, *"Ppalli! Mo-gup-sida!"* Time for *dumpling soup!*

"If we eat first thing on New Year's Day, we won't go hungry for the rest of the year," my father reminds us. The table is set with deep bowls and big spoons.

"Eh!" says Uncle Myung Ho. "What kind *mandoo* this?" I quickly look in some of the bowls. Oh, no! Grandma has put one of my funny-looking dumplings in each!

"Must be the ones Risa made," says Hiram. "They look like little elephant ears."

Everybody laughs. My face feels hot.

Uncle Myung Ho blows on his spoon and takes a bite. "*Ono*, Marisa! Delicious!"

Grandma walks over. Her bowl is full of my *mandoo*!

"I've been waiting all night to taste these," she says. "Here, have one." She puts another funny-looking triangle in my bowl.

We bite into our dumplings at the same time.

"*Ai-go chŭm!*" she says. "This is the best *mandoo* I have ever tasted!"

I finish my funny-looking dumpling. Mmmm! Grandma's right! It is good! The spices tickle my tongue.

"Who wants more of Marisa's *mandoo*?" Grandma asks. Everybody holds out his bowl. I hold out my bowl, too. More dumplings! More lip-smacking chicken broth! Warm, steamy, and delicious!

With our dumplings, we eat roast pork, three kinds of *kimchi*, spinach and bean sprout *namul*, spicy seaweed, *taegu*, boiled tripe, and octopus. Hiram and I love the Korean dessert we get only on New Year's: *yak pap*. He pulls off a chunk of the brown sticky rice mixed with honey, dates, and pine nuts and hands it to me. I lick every bit off my fingers.

"Your elephant ears sure tasted better than they looked!" he says to me.

I think about how much everyone liked the dumpling soup. Even my funny dumplings. Maybe it was because we ate them at Grandma's, all of us together.

"Next year," I tell everyone, "I will make even *better* dumplings."

I can hardly wait.

Hello, *brand-new year!*

Yagua Days

by Cruz Martel

In this story, we learn that Adan's parents grew up in Puerto Rico and then moved to New York. Adan gets to go to Puerto Rico for the first time and stays at his uncle's farm in the mountains. While he is there, he gets to experience a fun, rainy-day activity that his parents enjoyed as children. What kinds of fun things might Adan do in the city that his relatives in Puerto Rico might not have experienced?

It was drizzling steadily on the Lower East Side. From the doorway of his parents' bodega, Adan Riera watched a car splash the sidewalk.

School had ended for the summer two days ago, and for two days it had rained. Adan wanted to play in East River Park, but with so much rain about the only thing a boy could do was watch cars splash by.

Of course he could help father. Adan enjoyed working in the bodega. He liked the smells of the fruits and the different colors of the vegetables, and he liked the way the mangós, ñames, and quenepas felt in his hands.

But today he would rather be in the park. He watched another car spray past. The rain began to fall harder.

Mailman Jorge sloshed in, slapping water off his hat. He smiled. "Qué pasa, Adan? Why the long face?"

"Rainy days are terrible days."

"No—they're wonderful days. They're yagua days!"

"Stop teasing, Jorge. Yesterday you told me the vegetables and fruits in the bodega are grown in panel trucks. What's a yagua day?"

"Muchacho, *this* day is a yagua day. And Puerto Rican vegetables and fruits *are* grown in trucks. Why, I have a truck myself. Every day I water it!"

Adan's mother and father came in from the back.

"Hola, Jorge. You look wet."

"I *feel* wetter. But it's a wonderful feeling. It's a yagua-day feeling!"

His mother and father liked Jorge. They had all grown up together in Puerto Rico.

"So you've been telling Adan about yagua days?"

"Sí. Mira! Here's a letter for you from Corral Viejo, where we all had some of the best yagua days."

Adan's father read the letter. "Good news! My brother Ulise wants Mami, Adan, and me to visit him on his finca for two weeks."

"You haven't been to Puerto Rico in years," said Mailman Jorge.

"Adan's *never* been there," replied his mother. "We can ask my brother to take care of the bodega. Adan will meet his family in the mountains at last."

Adan clapped his hands. "Puerto Rico! Who cares about the rain!"

Mailman Jorge smiled. "Maybe you'll even have a few yagua days. Hasta luego. Y que gocen mucho!"

Tío Ulise met them at the airport in Ponce.

"Welcome to Puerto Rico, Adan."

Stocky Uncle Ulise had tiny blue eyes in a round, red face, and big, strong arms, but Adan, excited after his first plane ride, hugged Uncle Ulise even harder than Uncle Ulise hugged him.

"Come, we'll drive to Corral Viejo." He winked at Adan's father. "I'm sorry you didn't arrive yesterday. Yesterday was a wonderful yagua day."

"You know about yagua days too, tío Ulise?"

"Sure. They're my favorite days."

"But wouldn't today be a good yagua day?"

"The worst. The sun's out!"

In an old jeep, they wound up into the mountains.

"Look!" said Uncle Ulise, pointing at a river jumping rocks. "Your mother and father, Mailman Jorge, and I played in that river when we were children."

They bounced up a hill to a cluster of bright houses. Many people were outside.

"This is your family, Adan," said Uncle Ulise.

Everyone crowded around the jeep. Old and young people. Blond-, brown-, and black-haired people. Dark-skinned and light-skinned people. Blue-eyed, brown-eyed, and green-eyed people. Adan had not known there were so many people in his family.

Uncle Ulise's wife Carmen hugged Adan and kissed both his cheeks. Taller than Uncle Ulise and very thin, she carried herself like a soldier. Her straight mouth never smiled—but her eyes did.

The whole family sat under wide trees and ate arroz con gandules, pernil, viandas and tostones, ensaladas de chayotes y tomates, and pasteles.

Adan talked and sang until his voice turned to a squeak. He ate until his stomach almost popped a pants button.

Afterward he fell asleep under a big mosquito net before the sun had even gone down behind the mountains.

In the morning Uncle Ulise called out, "Adan, everyone ate all the food in the house. Let's get more."

"From a bodega?"

"No, mi amor. From my finca on the mountain."

"You drive a tractor and plow on the mountain?"

Tía Carmen smiled with her eyes. "We don't need tractors and plows on our finca."

"I don't understand."

"Vente. You will."

Adan and his parents, Aunt Carmen, and Uncle Ulise hiked up the mountain beside a splashy stream.

Near the top they walked through groves of fruit trees.

"Long ago your grandfather planted these trees," Adan's mother said. "Now Aunt Carmen and Uncle Ulise pick what they need for themselves or want to give away or sell in Ponce."

"Let's work!" said Aunt Carmen.

Sitting on his father's shoulders, Adan picked oranges.

Swinging a hooked stick, he pulled down mangós.

Whipping a bamboo pole with a knife tied to the end, he chopped mapenes from a tall tree.

Digging with a machete, he uncovered ñames.

Finally, gripping a very long pole, he struck down coconuts.

"How do we get all the food down the mountain?" he asked.

"Watch," said Aunt Carmen. She whistled loudly.

Adan saw a patch of white moving in the trees. A horse with a golden mane appeared.

Uncle Ulise fed him a guanábana. The horse twitched his ears and munched the delicious fruit loudly.

"Palomo will help us carry all the fruit and vegetables we've picked," Adan's mother said.

Back at the house, Adan gave Palomo another guanábana.

"He'll go back up the finca now," his father said. "He's got all he wants to eat there."

Uncle Ulise rubbed his knee.

"Que te pasa?" asked Adan's mother.

"My knee. It always hurts just before rain comes."

Adan looked the cloudless sky. "But it's not going to rain."

"Yes, it will. My knee never lies. It'll rain tonight. Maybe tomorrow. Say! When it does, it'll be a yagua day!"

In the morning Adan, waking up cozy under his mosquito net, heard rain banging on the metal roof and coquies beeping like tiny car horns.

He jumped out of bed and got a big surprise. His mother and father, Uncle Ulise, and Aunt Carmen were on the porch wearing bathing suits.

"Vamonos, Adan," his father said. "It's a wonderful yagua day. Put on your bathing suit!"

In the forest he heard shouts and swishing noises in the rain.

Racing into a clearing, he saw boys and girls shooting down a runway of grass, then disappearing over a rock ledge.

Uncle Ulise picked up a canoelike object from the grass. "This is a yagua, Adan. It fell from this palm tree."

"And this is what we do with it," said his father. He ran, then belly-flopped on the yagua. He skimmed down the grass, sailed up into the air, and vanished over the ledge. His mother found another yagua and did the same.

"Papi! Mami!"

Uncle Ulise laughed. "Don't worry, Adan. They won't hurt themselves. The river is down there. It pools beneath the ledge. The rain turns the grass butter-slick so you can zip into the water. That's what makes it a yagua day! Come and join us!"

That day Adan found out what fun a yagua day is!

Country Road, City Song

The city doesn't look like the country. The country doesn't sound like the city. But both kinds of places have great things about them. In which kinds of places has your family lived?

Country Road, Spring Walk

by Frank Asch

Roll up the moon,
raise the sun,
time for a change of scene.
Look at a rose,
swim in its red.
Have you ever seen
such a green?
Holes in my socks,
toes in my holes,
as plain as the day
on your face.
Dew in the grass,
sun in the dew,
shining all
over the place.

Sing a Song of Cities

by Lee Bennett Hopkins

Sing a song of cities.
If you do,
Cities will sing back to you.

They'll sing in subway roars and
 rumbles.
People-laughs, machine-loud-
 grumbles.

Sing a song of cities.
If you do,
Cities will sing back to you.

Grandma Buffalo, May, and Me

by Carol Curtis Stilz

Poppy and her mother go on an adventure to create an exciting story for a branch of their family tree. In this adventure, they travel by car. Along the way, they visit buffalo that came to the valley area from the plains many years ago. How did they get there? How does this story show that transportation for the buffalo, and for people, has changed over the years?

As darkness crept over our campsite, Mama lit a lantern whose two tiny baskets made white light. I took Grandma's leather-covered photo album from our bag, opening it to our family tree.

Mama, Gray Bear, and I are going to visit my Montana grandma. Mama says we are on an adventure, creating a story for the branch that is ours.

"Mama, tell me again about our family tree."

"The roots of a family tree grow deep in time, Poppy. Each branch is a story of the people in our family who lived before us. Our album shows photographs of some relatives and tells part of their stories."

I named these relatives "the greats": great-grandparents, great-great-grandparents, and great-aunts and -uncles. They have old-fashioned names like Melvin, Harriet, Zillah, and Asahel.

I searched for a picture of May, who looked just like me.

"Tell me again about Great-Grandma May."

"May was my grandmother," Mama said. "When she was young, her wavy hair was the color of poppies and her eyes were green as moss. Her laugh sounded like the spring we heard today bubbling from the earth. When May was your age, she learned to catch fish, plant a garden, and feed buffalo."

"Tell me again about the buffalo."

"My great-uncle told of a man named Samuel Walking Coyote, who brought buffalo to the Flathead and Mission valleys in Montana.

14

Long ago, four baby buffalo followed him from the plains, where buffalo were hunted, to these valleys, where they were protected. The baby buffalo grew up and had calves of their own. The buffalo May fed were related to those baby buffalo."

"Will we see buffalo?"

"I hope so. Buffalo don't roam free now, but they aren't tame like cows. They're wild animals living in parks and on ranches. Some descendants of May's buffalo live near Grandma. They are probably fast asleep, and it's our bedtime too."

In the dark I listened for coyotes like those that sang May to sleep. I heard one call far away as I watched the moon rise. That night I dreamed of buffalo, May, and me in Montana.

The next morning we drove down the mountainside, stopping beside a stream.

Mama said, "Let's see if the fish are biting."

She tied a hook covered with soft fur to my line. The fur hid the hook and looked like the bugs on the water below. I held my new fly rod and Mama wrapped her hand around mine.

"Move your hand just past your shoulder, then bring your arm forward quickly."

On my first try, the hook caught on the bush behind me. On my second try, the line tangled in the grass. The third time, my line swished past my ear and my fly hit the water. Then Mama cast. Her line sang in the air before her fly touched the stream.

Suddenly I felt a tug.

Mama helped me reel in my line. A silvery fish flip-flopped from the end. I stroked its slippery body.

"Can we let it go? This fish is so big and sparkly!"

Mama slipped the fish off the hook. I helped her rock it gently back and forth underwater so it could breathe. It wiggled. When we opened our hands, it darted away.

After lunch we drove through wheat fields, past tall, round towers called silos. We drove down a dusty road toward a sign that read: Buffalo Bridge. I didn't see any buffalo. Neither did Gray Bear.

"Where are the buffalo?" I asked.

"Long ago, buffalo lived here," Mama said. "Now let's find May's place."

We stopped at a big, white farmhouse surrounded by poppies. We knocked on the door and introduced ourselves to the woman inside. Mama had written to ask if we could visit, explaining that May lived there when she was my age.

The woman smiled, gave me a sack, and said, "You're welcome to gather apples from May's McIntosh trees." We followed her out back.

Mama gave me a boost into a tree. Higher and higher I climbed, under an umbrella of green leaves and red apples, imagining May gathering apples too. I searched for buffalo but didn't see any. Instead I saw faraway farmhouses, golden grass, and a rainbow of flowers.

When I climbed down, the woman gave me two surprises. The first was a sealed envelope. She said, "I save the seeds from May's poppies. Plant them and next spring you'll have flowers the color of your hair."

The second surprise was a carefully wrapped twig. "This cutting from May's apple tree will root if you put it in rich soil. When its roots grow strong, plant it outside. With cuttings from May's trees, we grew the trees you see now."

"Thanks! Now I'll have my own little McIntosh tree."

"Perhaps someday your daughter will pick apples from your tree, and you can tell her the story of Great-Grandma May," Mama said. "Now let's find buffalo."

Back in the car, we drove along straight, dusty roads. I was hungry, so I took three apples from the sack. I gave one to Mama. Gray Bear wasn't hungry, so I stuffed his apple in my pocket.

I saw a sign that read: Buffalo Crossing.

"Are the buffalo here?" I asked.

"I hope so. Grandma knows the man who runs this ranch."

We stopped at a big log house, stepped up on the porch, and knocked on the door. The man who answered told us, "Buffalo are shy and stay away from folks they don't know. Still, you may see them on the hillsides, under trees, or near the river."

"My great-grandma May fed buffalo when she was my age, and I want to feed buffalo too."

The man's forehead wrinkled while he thought. "There is only one buffalo gentle enough to feed. Grandma Buffalo. She's my oldest, seventy-four in buffalo years. That's twenty of our years. I bottle-fed her as a baby, and she will eat from people's hands."

As Mama drove, she said, "Poppy, watch for buffalo."

"Look! Is that one?" I asked.

Our car inched along so we wouldn't scare the buffalo, but it moved farther and farther away until it disappeared. I searched the hillsides, watched the bushes, and stared into shadows beneath the trees. I didn't see any more buffalo, but I felt them staring at me.

"They must be hiding," I said.

Soon we would be leaving the ranch. I held my breath, hoping we would find Grandma Buffalo.

"Stop!" I shouted.

Mama parked our car. This buffalo was big and brown, with a hump and horns. We walked on short grass that crunched with every step. The buffalo ambled through long grass, quiet as a whisper.

We followed, strolling toward a woman waiting near the fence.

"Hi," she said. "I'm Mary Elizabeth Hawk. I visit Grandma Buffalo whenever I can. My family has raised buffalo since my ancestor Walking Coyote first brought them to this valley."

"I know about Walking Coyote," I said. "Are you related to him?"

"Yes, I am, just as Grandma Buffalo is related to the buffalo he brought with him."

"My great-grandma May fed buffalo when she was my age, and I want to feed buffalo too."

"Grandma Buffalo has four stomachs, so you won't spoil her appetite. She is very strong, but gentle."

I turned to Grandma Buffalo. A short, woolly coat covered her back. A shaggy mane covered her head and shoulders. Gray Bear thought Grandma Buffalo needed a haircut. I stroked her long, soft mane. Then I reached for Gray Bear's apple in my pocket.

"Grandma Buffalo, this apple is from Great-Grandma May's McIntosh tree."

Grandma Buffalo looked at me with big chocolate-drop eyes. She wrapped her long, purplish black tongue around the apple. Her tongue tickled. She rubbed her head against my hand, chewed, and swallowed. A soft sound in her throat said, "Thank you."

Mama laughed.

"She's talking to you, Poppy. Maybe her great-great-great-grandmother told her of a little girl with wavy hair the color of poppies who fed her apples long ago."

I gently patted Grandma Buffalo. "Do you remember?"

Later, Mama lit the lantern. She said, "Tomorrow night we'll see Grandma and sleep in her house."

I took Grandma's leather-covered photo album from our bag. Gray Bear and I turned its yellowed pages, searching for May's picture.

I imagined May feeding apples from her tree to a buffalo who lived long ago. I heard her buffalo rumble its thanks.

"Does Grandma know my story is like Great-Grandma May's?"

"What will you tell her?"

"Great-Grandma May and I shared an adventure. We learned to catch fish, plant a garden, and feed buffalo. Today I picked apples from her tree. Soon I will plant my twig and watch its roots grow strong. Someday I will pick apples from my McIntosh tree."

I touched the little branch of our family tree where my name was written. Then I said, "The roots of my family grow deep in time, just like Grandma Buffalo's."

The Chalk Doll

by Charlotte Pomerantz

Where do family treasures come from? Often, they are hand-made by members of one's family and passed on through time. In this story, many things are made by hand. Rose's mother made herself a doll when she was younger. Her mother made a taffeta dress for her. In the end of the story, Rose sets out to make a doll. What sorts of family treasures would you choose to make?

Rose had a cold.
The doctor said to stay in bed
and try to nap during the day.
Rose's mother kissed her
and drew the curtains.
"You forgot to kiss me," said Rose.
"I did kiss you," said Mother.
"You didn't kiss me good night."
Mother went over and kissed her.
"Good night, Rosy," she said.
"I need my bear," said Rose.
"Your bear?" said Mother.
"You haven't slept with your bear
since you were little."
"I'm still little," said Rose.
She hugged her bear.
"Mommy," she said, "did you have
a bear when you were
a little girl in Jamaica?"
"No," said Mother. "But I had
a rag doll."
"I took a piece of material
and folded it over once.
With a pencil, I drew
the outline of the doll
on the material. Then I

cut along the outline and sewed
the two sides together.
Before I finished sewing
up the head, I stuffed the doll
with bits of rags."
"Did you like your rag doll,
 Mommy?"
"Yes, Rose, because I made it.
But I liked the dolls in
the shop windows more.
We called them chalk dolls."
"Did you ever have a chalk doll,
 Mommy?"
"Yes, my aunt worked for a family
who gave her a chalk doll,
and my aunt gave it to me.
The doll was missing an arm,
and her nose was broken."
"Poor doll," said Rose.
"Oh, no," said Mother.
"To me she was the most perfect
doll in the world."
"That's because she belonged to
you," said Rose.
Mother smiled.
"Now try and rest," she said.

"I'll bring you a glass of milk."
Mother brought the milk.
Rose drank half, then looked up.
"Did you like milk when you
were a little girl?"
"I loved milk," said Mother.
"But the milk was different.
It came in a can and it was
sweeter and thicker.
Every morning, my mother
took out two tablespoons
and dropped them into the tea.
We all got a taste. After breakfast,
Mother would cover the can
 with foil and hide it."
"Where did she hide it, Mommy?"
Mother shrugged.
"I never found out," she said. "But
I watched her every morning. And
I dreamed that one day when
 I grew up,
I was going to buy a whole can
and drink it all."
"Did you?" said Rose.
Mother was quiet.
"No," she said finally.
"I never thought about it
till just now."
"Tell me another story," said Rose.
"I can't think of any," said Mother.
"Tell me the story of your
birthday party."
Mother looked puzzled.

"My birthday party?
We didn't have birthday parties."
"What about the three pennies?"
said Rose.
"Oh," said Mother. "That time."
"On the day I was seven years old,
my mother gave me three pennies.
I had never had so much money.
The pennies were cool
and smooth in my hand.
I went to a store and bought a
little round piece of sponge cake
for a penny. Then I went to
another store and bought a
penny's worth of powdered sugar.
In the third store, I bought six
tiny candies for a penny.
When I got home, I sprinkled
powdered sugar on the top."
"I bet I know what happened then,"
said Rose. "Five friends came
over. You cut the cake into
six little pieces
and you had a party. . . .
But Mommy,
you didn't get any presents."
"No, I never did."
"Never, never?"
"Well," said Mother, "I did,
if you count the pink taffeta dress.
My mother was a seamstress.
She worked at home, sewing
for other people.

One year she brought home some
pink taffeta. Pink taffeta
was my favorite.
She said she would try
and make me a dress
for my birthday.
But she was so busy
sewing dresses for other people
that weeks and weeks went by
and she still hadn't touched
the pink taffeta.
The night before my birthday,
I went to bed hoping she would
make the dress while I was asleep.
But when I woke up,
the pink taffeta material
was still there.
I went to the yard and cried."
Rose leaned over
and hugged her mother.
"Poor Mommy," she said.
"Did she ever make the dress?"
"Yes," said Mother.
"She finished the dress
a month after my birthday.
It was the most beautiful dress

I ever had."
"What kind of shoes did you
wear with it, Mommy?"
"No shoes, Rose.
We only wore shoes
to church on Sunday."
"You mean you went to
school barefoot?"
"Yes," said Mother. "Nobody
wore shoes except the teacher. . . .
But I *did* wear high heels.
The road to and from school
was paved with tar, and
there were mango trees
on both sides.
We ate the sweet fruit
and dropped the pits.
They dried in the sun.
We took the dried pits
and rubbed them into
the tar on the road.
The tar was soft and sticky.
After we rubbed the mango pits
in the tar, we pressed
the sticky pits
against the heels of our feet

21

until they stuck.
Then we walked home
clickety click clacking
on our mango heels."
Rose smiled.
"Clickety click clack," she said.
"You had fun when you were
a little girl, didn't you, Mommy?"
"Yes, Rosy, I did."
"Do I have as much fun
as you did?" Rose asked.
"Mm," said Mother,
"what do you think?"
"I think I have fun too,"
said Rose. "But there is one thing
I'd like to have that you had."
Rose got out of bed
and went to the sewing basket

in the hallway.
She took out a needle and thread,
a pair of scissors, and some
scraps of material.
"What are you doing?"
said Mother.
"I'm getting everything ready."
"Ready for what, Rose?"
"Ready to make a rag doll."
"But Rose," said Mother,
"you have so many dolls."
"I know," said Rose.
"But they are all chalk dolls.
I've never had a rag doll."
Mother laughed.
"Poor Rosy," she said.
And together they made
a rag doll.

Earth, Our Home

Letter from Crinkleroot

by Jim Arnosky

We can look at Earth on a globe, or we can look at it as Crinkleroot does in this story—under our feet and all around. Although we probably won't get to see as many as "one billion six million two thousand four hundred and three and two-thirds" creatures, we can still join Crinkleroot in keeping our eyes open for all living things. What new creatures would you like to see?

Hello! My name is Crinkleroot. I was born in a tree and raised by bees! My home is the forest, but I've been to the desert and walked in the sea. I've climbed hills and mountains and explored river valleys. Wherever I go, I go on foot, so I can always feel the Earth under me.

On my walks, I look for all the other creatures that share the Earth. Already I've seen more animals than I can count. Well, yes, I can count them. I've seen one billion six million two thousand four hundred and three and two-thirds (if you count the lizard that lost its tail!). And I'm still counting.

To do the job right, to see all the living things for whom the Earth is home, I'd have to search in every backyard and woodlot, look up every tree, and peek down every hole. I'd have to examine up close every crack in every rock and pavement. I'd need to look everywhere on land and underwater.

I'm not sure I'll be able to get to all these places and see every living thing. But I'm going to try. And every time I find something—a bird or bug or wildflower or fern—I haven't seen before, I'll tell everyone I meet. Then they will know how rich and wonderful the planet Earth is!

It's such a big job, I'll need some help. Perhaps you can talk to your friends and your family about any creatures you see in your own neighborhood. We can all find and see a great many things. We can learn and share a lot.

So keep your eyes open and your nose poked out. Maybe we'll bump into one another somewhere in the great outdoors.

Your friend,

Crinkleroot

The Legend of the Bluebonnet

retold by Tomie dePaola

People, animals, and plants all need rain to stay alive. This Comanche legend, retold by Caldecott Award-winning author Tomie dePaola, tells about a time when no rain fell. It also tells how the bluebonnet, the state flower of Texas, came to be. How does a small girl named She-Who-Is-Alone save the land for everyone?

"Great Spirits, the land is dying. Your People are dying, too," the long line of dancers sang. "Tell us what we have done to anger you. End this drought. Save your People. Tell us what we must do so you will send the rain that will bring back life."

For three days, the dancers danced to the sound of the drums, and for three days, the People called Comanche watched and waited. And even though the hard winter was over, no healing rains came.

Drought and famine are hardest on the very young and the very old. Among the few children left was a small girl named She-Who-Is-Alone. She sat by herself watching the dancers. In her lap was a doll made from buckskin—a warrior doll. The eyes, nose and mouth were painted on with the juice of berries. It wore beaded leggings and a belt of polished bone. On its head were brilliant blue feathers from the bird who cries "Jay-jay-jay." She loved her doll very much.

"Soon," She-Who-Is-Alone said to her doll, "the shaman will go off alone to the top of the hill to listen for the words of the Great Spirits. Then, we will know what to do so that once more the rains will come and the Earth will be green and alive. The buffalo will be plentiful and the People will be rich again."

As she talked, she thought of the mother who made the doll, of the father who brought the blue feathers. She thought of the grandfather and the grandmother she had never known. They were all like shadows. It seemed long ago that they had died from the famine. The People had named her and cared for her. The warrior doll was the only thing she had left from those distant days.

"The sun is setting," the runner called as he ran through the camp. "The shaman is returning." The People gathered in a circle and the shaman spoke.

"I have heard the words of the Great Spirits," he said. "The People have become selfish. For years, they have taken from the Earth without giving anything back. The Great Spirits say the People must sacrifice. We must make a burnt offering of the most valued possession among us. The ashes of this offering shall then be scattered to the four points of the Earth, the Home of the Winds. When this sacrifice is made, drought and famine will cease. Life will be restored to the Earth and to the People!"

The People sang a song of thanks to the Great Spirits for telling them what they must do.

"I'm sure it is not my new bow that the Great Spirits want," a warrior said.

"Or my special blanket," a woman added, as everyone went to their tipis to talk and think over what the Great Spirits had asked.

Everyone, that is, except She-Who-Is-Alone. She held her doll tightly to her heart. "You," she said, looking at the doll. "You are my most valued possession. It is you the Great Spirits want." And she knew what she must do.

As the council fires died out and the tipi flaps began to close, the small girl returned to the tipi, where she slept, to wait.

The night outside was still except for the distant sound of the night bird with the red wings. Soon everyone in the tipi was asleep, except She-Who-Is-Alone. Under the ashes of the tipi fire one stick still glowed. She took it and quietly crept out into the night.

She ran to the place on the hill where the Great Spirits had spoken to the shaman. Stars filled the sky, but there was no moon. "O Great Spirits," She-Who-Is-Alone said, "here is my warrior doll. It is the only thing I have from my family who died in this famine. It is my most valued possession. Please accept it." Then, gathering twigs, she started a fire with the glowing firestick. The small girl watched as the twigs began to catch and burn.

27

She thought of her grandmother and grandfather, her mother and father and all the People—their suffering, their hunger. And before she could change her mind, she thrust the doll into the fire.

She watched until the flames died down and the ashes had grown cold. Then, scooping up a handful, She-Who-Is-Alone scattered the ashes to the Home of the Winds, the North and the East, the South and the West.

And there she fell asleep until the first light of the morning sun woke her.

She looked out over the hill, and stretching out from all sides, where the ashes had fallen, the ground was covered with flowers— beautiful flowers, as blue as the feathers in the hair of the doll, as blue as the feathers of the bird who cries "Jay-jay-jay."

When the People came out of their tipis, they could scarcely believe their eyes. They gathered on the hill with She-Who-Is-Alone to look at the miraculous sight. There was no doubt about it, the flowers were a sign of forgiveness from the Great Spirits.

And as the People sang and danced their thanks to the Great Spirits, a warm rain began to fall and the land began to live again. From that day on, the little girl was known by another name—"One-Who-Dearly-Loved-Her-People."

And every spring, the Great Spirits remember the sacrifice of a little girl and fill the hills and valleys of the land, now called Texas, with the beautiful blue flowers.

Even to this very day.

Someday Someone Will Bet That You Can't Name All Fifty States

by Judith Viorst

The United States is made up of 50 different states. Here is a poem that includes the names of all of the states—well, almost all of them. It's your job to guess which state is not here. It's also fun to fill in the missing parts of state names. What word comes before "Jersey, Mexico, and Hampshire"?

California. Mississippi,
North and South Dakota.
New York, Jersey, Mexico, and
Hampshire. Minnesota.
Vermont, Wisconsin, Oregon,
Connecticut, and Maine.
Hawaii, Georgia, Maryland.
Virginia (West and plain).
Tennessee, Kentucky. Texas,
Illinois, Alaska.
Colorado, Utah, Florida,
Delaware, Nebraska.
The Carolinas (North and South).
Missouri. Idaho.
Plus Alabama, Washington,
And Indiana. O-
Klahoma. Also Iowa,
Arkansas, Montana,
Pennsylvania, Arizona,
And Louisiana.
Ohio, Massachusetts, and
Nevada. Michigan,
Rhode Island, and Wyoming. That
Makes forty-nine. You win
As soon as you say _____.

Answer: As soon as you say "Kansas!"

29

If I Built a Village. . .

by Kazue Mizumura

With this poem Kazue Mizumura helps us to think about the kinds of land, water, and living things found in different kinds of communities.

If I built a village
Upon the hill
Along the river
In the woods,
There would be rabbits
Leaping in the sun,
Their white tails
A streak and a flash
Against the wind.

There would be trout
That shine like rainbows
Swimming in the river
As their shadows
Flicker and swirl
Through the ripples.

There would be owls, too,
For me to listen to when they
 hoot
In the woods at night,
Their eyes full of
Moon lights.

If I built a town
In the valleys
Around the lakes
Beside the forests,
I would leave the jumping mice
Sound asleep
In their nests,
Deep under the frosted valley,
Until the spring melts the ice.

And I would welcome the geese
From Canada
As they line grandly
On the lake,
To glide in and out
Of the drifting mist.

I would keep quiet for the deer
Tasting the raindrops
Scattered from the fiddleheads
In the forest.

If I built a city
By the sea,
Beneath the ground,
High against the sky,
There would be whales' spouts
Fountain high,
Far out at sea
Sprinkling pearl sprays
Over the Northern Lights.

There would be moles
Seeking their meals along the
 tunnels
Where the fallen leaves
Turn into earth
Soft and dark.

And there would be eagles
To soar to the sky
With their wings
Spread and still
Amid the summer clouds
As long as they wished.

If I built my village,
My town and my city—
There would be people
Who would care and share
With all living things
The land they love.

If you built a village, town, or city, what would you like to see in it?

Lorenzo & Angelina

by Eugene Fern

Young Angelina Garcia wants to climb to the top of El Padre Mountain to see the beautiful view of her country, but her donkey, Lorenzo, reaches a point where he won't take one more step. In this story we hear the thoughts of both the girl and the donkey. At what points in the story do you agree with Angelina? At what points do you agree with Lorenzo?

Angelina's story

Every morning, when the air is fresh and the dew lies like shining jewels over the fields and trees, I go to Lorenzo's stable. I carry with me the milk which Umberto has put into a heavy wooden barrel and the eggs which Jacinta has carefully packed in a wooden box. I open the door and out comes Lorenzo. "Good morning, my Lorenzo," I say. I pat his back, rub the top of his head, and give him a hug. Then I pack the barrel and box on him and I am ready to leave for the village.

But not Lorenzo!

Lorenzo's story

Every morning, when Angelina comes to let me out of my house, she is glad to see me. She rubs my head, puts her face next to mine, gives me a squeeze, and says, "Good morning, my Lorenzo."

And every morning, to be sure, I am glad to see her too—that is, until she starts to scold.

Angelina's story

Every morning it is the same. I talk to him politely, but he looks this way and that. He smells the air. He chews the grass. He nibbles at the clover. He does everything but what he is supposed to do!

32

I begin to lose my temper, of course. I shout at him. He pays no attention. He stands like a rock.

Though I love him dearly, there is no doubt that my Lorenzo is the most stubborn creature in the whole world.

Lorenzo's story

Every morning, Angelina says, "Lorenzo, it is time for us to go to the village, so please begin to walk." But anyone should know I am not yet ready to go. I have to smell the morning air. I have to chew the grass under the eucalyptus tree.

"Lorenzo," she says, "let us go this very minute." But I am still too busy. "Move, you stubborn donkey!" she screams. "Move those stubborn feet!"

But of course I have to see if the house is in the right place, if the south fence has moved, if the sheep are where they're supposed to be. Naturally, I cannot leave yet.

It is only when she stamps her feet that I move. I am very fond of Angelina and don't like to see her upset, but is it not wrong for her to insult me this way?

Angelina's story

One morning, like all the other times, we finally set out for the village. My stubborn Lorenzo had finished whatever it was he was doing, and I could tell by the way his ears stood straight up and by the quick movements of his feet that he was as pleased as I to leave for the marketplace at Cuzoroca.

Lorenzo's story

One morning we finally set out for the village. Angelina had finished shouting and stamping. As always, she was happy once we started. I could tell by the way she began to sing and laugh—and every once in a while to skip along the road. She liked the little trip to the village, and, to tell the truth, so did I.

Angelina's story

However, this day was to be different, for I had decided to go to the top of El Padre Mountain! Ever since I can remember, I had heard of the beauty and the glory to be seen from there. It is said that from the top of El Padre one can touch the sky.

I was so excited about my great adventure that I hardly knew where I was going.

33

Lorenzo's story

This day was like all other days. We went beside El Padre Mountain, through Quesada Pass, across the flat meadows, through the forest, and into the village.

Angelina's story

When we came to the marketplace, I quickly took care of my business with Señor Vives. He counted the eggs, weighed the milk, and paid me for them. I thanked him politely and then I climbed on Lorenzo's back. I could hardly wait to begin the trip to the top of El Padre Mountain!

As one might expect, when we came to the crossroads my stubborn donkey refused to move. Only after much shouting did he agree to take the right fork instead of the left.

Lorenzo's story

Señor Vives was at his place, as usual. He took the milk and eggs from my back, counted the eggs, weighed the milk, and paid Angelina for them. As usual, he took the money from his strong little box under the counter. Then, as usual, we started for home.

But things no longer went as usual, for Angelina decided to go home a different way. Instead of taking the left turn after the road leaves the forest, she decided to take the right. At first I wouldn't budge. Who knows what might be in a strange land? Finally, with all her shouting, I gave in and went where *she* wanted to go!

Angelina's story

This road was different from the hard dirt road leading to our farm. It passed over rushing streams, between tall trees and huge rocks, always moving up—higher and higher. It was rough and rocky, and the higher we went, the rougher it got. Though I knew the sun would soon be sinking, I was determined to reach the top of El Padre Mountain. Lorenzo moved more and more slowly, but I urged him on.

Soon the road had almost disappeared. There was nothing ahead of us but a little rocky path. It was getting dark and Lorenzo stopped. Again I had to shout and scold until he moved on.

Lorenzo's story

This road was not like the other. It was rough and rocky. It did not go through Quesada Pass but behind it, toward the top of El Padre

Mountain. Higher and higher we climbed, and the higher we went, the harder it was to see the road. Soon there was no road at all, just a rocky path.

And still Angelina had to explore!

Once or twice I stopped, but she shouted so much that I kept moving. It was growing dark, and we were up so high I could hardly breathe. There were rocks on all sides, and every once in a while a poor little bush.

Angelina's story

Though the wind was stronger and the path even rockier than before, I was not worried. My Lorenzo is as sure-footed as a mountain goat and I knew he would not fall. Besides, any moment I expected to see the glory and beauty of our country, and this would make everything worthwhile.

But once more my stubborn donkey refused to go. Again I had to scream to make him move those stubborn legs.

Lorenzo's story

I was getting worried. It was not easy to walk, and I knew that if I stumbled we would have a long fall before we reached the good earth again.

So once more I stopped, but my little Angelina insisted on climbing that mountain. She shouted. "Stubborn, stubborn donkey!" she screamed at me.

So what was there to do but move higher and still higher?

Angelina's story

It was when we came to two huge rocks that stood like sentinels over the others that Lorenzo made up his mind not to move another inch. He sat down in front of the rocks in such a way that not even a tiny lizard could pass by.

Lorenzo's story

Finally, what seemed to be the path went between two huge rocks. And then it ended! A bush grew between the rocks, and after that— who knows?

This time I decided the trip was over. Not another step would I take!

I sat down.

Angelina's story

I yelled at Lorenzo. I shouted. I pleaded. I screamed. I pulled at him. I pushed him from behind. He would not budge. He sat there looking like one more rock, among all the others.

Lorenzo's story

The great explorer Angelina did not take to this kindly. Her shouts before were as nothing compared to the noise she now made. "Move!" she screamed. "We are almost at the top!" She pushed and pulled me. Tears of anger were in her eyes, but it did no good. This time I would not take another step.

Angelina's story

At this very moment I heard footsteps, and there behind us appeared my father, followed by Señor Vives and Señor Quiñones of the police. Suddenly I realized how late it must be. I was sure Papá would be furious. Instead he picked me up and kissed me. All he said was:

"Little one, I am not angry because you took the right turn instead of the left. Children are always looking for new paths. This I understand. But why have you stayed so long? Didn't you know your mother and I would be worried? Everyone is looking for you."

I tried to explain how much I wanted to see the glory of the world from the top of El Padre Mountain and how much time I had wasted trying to get that stubborn Lorenzo to move.

Lorenzo's story

Suddenly there were sounds behind us and who should appear but Señor Garcia, Señor Vives, and Señor Quiñones of the police! How happy they were to see us! Señor Garcia picked up little Angelina. He hugged her and whispered to her, while the other gentlemen, with big smiles, slapped him on the back.

Angelina looked ashamed and said, "I did so much want to see the top of the mountain, Papá, but that stubborn Lorenzo would not move. He simply refused to budge."

Angelina's story

Papá said nothing. He took my hand and led me between the two huge rocks. He pushed the little bush aside so I could see beyond it. I looked and my knees turned to water! Beyond the bush was the end of

the path and also the end of the mountain. Had Lorenzo and I taken but one step beyond the bush, we should never have taken a step again!

Lorenzo's story

Señor Garcia did not say a word. He took Angelina by the hand and led her between the two rocks. Beyond the bush was nothing—no path, no rocks, just nothing.

It was, of course, as *I* suspected. What could one expect to find up here so near the sky, where even the poorest bush finds it difficult to breathe?

Angelina said nothing. She just stood there, pale and trembling. My poor Angelina!

Angelina's story

I do not remember too clearly what happened after that, for I was weak from fear and could hardly stand. But I do remember one thing. Seeing that dear, stubborn donkey standing there, I felt such a love for him that I kissed him gently and whispered, "Thank you, my Lorenzo!"

Lorenzo's story

Señor Garcia said, "You should be grateful to have such a stubborn donkey, my little flower. If not for him, I would have neither Angelina nor Lorenzo." He put his arms around my neck and gave me such a squeeze that I could hardly breathe. When Angelina kissed me, my happiness was complete.

All Living Things

Words and music by W. Jay Cawley

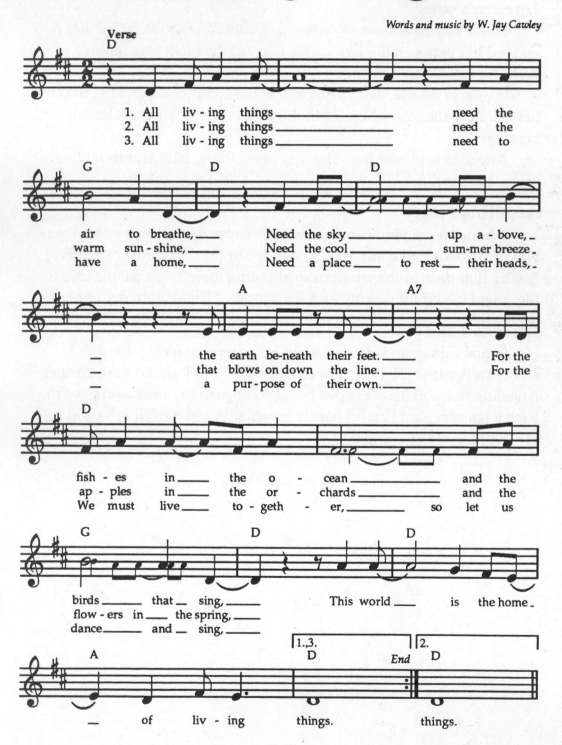

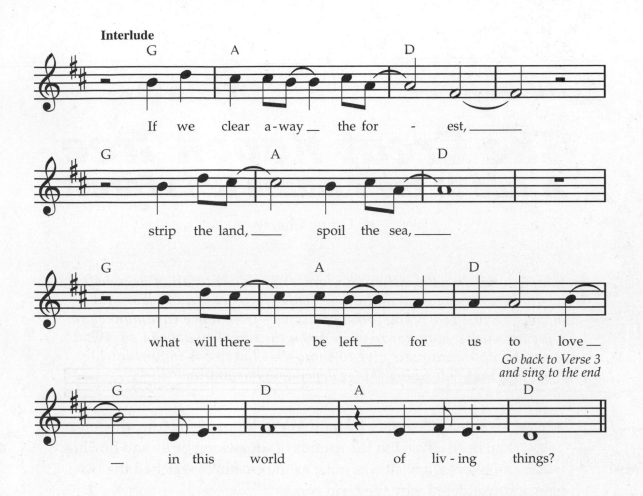

*Go back to Verse 3
and sing to the end*

Copyright © 1992 W. Jay Cawley. Appears in SHARE THE MUSIC,
Book 3, Copyright © 1995 Macmillan/McGraw-Hill School
Publishing Company

The Great Kapok Tree
A Tale of the Amazon Rain Forest

by Lynne Cherry

Why is a tree in a Brazilian rain forest important to all of us, whether we live near it or far away from it? This story helps us to learn the answer. In this tale many forest creatures—from a bee to a monkey to a jaguar—ask a man not to chop down the tree they depend on. What examples do the animals give to show that the tree is important to them and that "all living things depend on one another"?

Two men walked into the rain forest. Moments before, the forest had been alive with the sounds of squawking birds and howling monkeys. Now all was quiet as the creatures watched the two men and wondered why they had come.

The larger man stopped and pointed to a great Kapok tree. Then he left.

The smaller man took the ax he carried and struck the trunk of the tree. Whack! Whack! Whack! The sounds of the blows rang through the forest. The wood of the tree was very hard. Chop! Chop! Chop! The man wiped off the sweat that ran down his face and neck. Whack! Chop! Whack! Chop!

Soon the man grew tired. He sat down to rest at the foot of the great Kapok tree. Before he knew it, the heat and hum of the forest had lulled him to sleep.

A boa constrictor lived in the Kapok tree. He slithered down its trunk to where the man was sleeping. He looked at the gash the ax had made in the tree. Then the huge snake slid very close to the man and hissed in his ear: "Senhor, this tree is a tree of miracles. It is my home, where generations of my ancestors have lived. Do not chop it down."

A bee buzzed in the sleeping man's ear: "Senhor, my hive is in this Kapok tree, and I fly from tree to tree and flower to flower collecting pollen. In this way I pollinate the trees and flowers throughout the rain forest. You see, all living things depend on one another."

A troupe of monkeys scampered down from the canopy of the Kapok tree. They chattered to the sleeping man: "Senhor, we have seen the ways of man. You chop down one tree, then come back for another and another. The roots of these great trees will wither and die, and there will be nothing left to hold the earth in place. When the heavy rains come, the soil will be washed away and the forest will become a desert."

A toucan, a macaw, and a cock-of-the-rock flew down from the canopy. "Senhor!" squawked the toucan, "you must not cut down this tree. We have flown over the rain forest and seen what happens once you begin to chop down the trees. Many people settle on the land. They set fires to clear the underbrush, and soon the forest disappears. Where once there was life and beauty only black and smoldering ruins remain."

A bright and small tree frog crawled along the edge of a leaf. In a squeaky voice he piped in the man's ear: "Senhor, a ruined rain forest means ruined lives...many ruined lives. You will leave many of us homeless if you chop down this great Kapok tree."

A jaguar had been sleeping along a branch in the middle of the tree. Because his spotted coat blended into the dappled light and shadows of the understory, no one had noticed him. Now he leapt down and padded silently over to the sleeping man. He growled in his ear: "Senhor, the Kapok tree is home to many birds and animals. If you cut it down, where will I find my dinner?"

Four tree porcupines swung down from branch to branch and whispered to the man: "Senhor, do you know what we animals and humans need in order to live? Oxygen. And, Senhor, do you know what trees produce? Oxygen! If you cut down the forests you will destroy that which gives us all life."

Several anteaters climbed down the Kapok tree with their young clinging to their backs. The unstriped anteater said to the sleeping man: "Senhor, you are chopping down this tree with no thought for the future. And surely you know that what happens tomorrow depends upon what you do today. The big man tells you to chop down

41

a beautiful tree. He does not think of his own children, who tomorrow must live in a world without trees."

A three-toed sloth had begun climbing down from the canopy when the men first appeared. Only now did she reach the ground. Plodding ever so slowly over to the sleeping man, she spoke in her deep and lazy voice: "Senhor, how much is beauty worth? Can you live without it? If you destroy the beauty of the rain forest, on what would you feast your eyes?"

A child from the Yanomamo tribe who lived in the rain forest knelt over the sleeping man. He murmured in his ear: "Senhor, when you awake, please look upon us all with new eyes."

The man awoke with a start. Before him stood the rain forest child, and all around him, staring, were the creatures who depended upon the great Kapok tree. What wondrous and rare animals they were!

The man looked about and saw the sun streaming through the canopy. Spots of bright light glowed like jewels amidst the dark green forest. Strange and beautiful plants seemed to dangle in the air, suspended from the great Kapok tree.

The man smelled the fragrant perfume of their flowers. He felt the steamy mist rising from the forest floor. But he heard no sound, for the creatures were strangely silent.

The man stood and picked up his ax. He swung back his arm as though to strike the tree. Suddenly he stopped. He turned and looked at the animals and the child.

He hesitated. Then he dropped the ax and walked out of the rain forest.

50 Simple Things Kids Can Do to Save the Earth

by The EarthWorks Group

The suggestions for recycling and reusing natural resources in this children's guide to saving our planet are simple, practical, and fun. Idea number 31 tells us that if everyone in the United States recycled just the Sunday newspapers, we would save 500,000 trees a week. Do you think that one person's effort to improve the environment can make a difference? Why or why not?

25. EVERY LITTER BIT HURTS

Take A Guess.

Which of these is considered litter?

A) A goose B) A banana tree C) A candy wrapper

(Answer: C. Almost anything you throw on the ground and leave there is litter!)

Riddle: When is a street like a garbage can? Answer: When there's litter in it!

That's not very funny, is it? Candy wrappers, soda cans, old newspapers, and other garbage on the ground make it look as though no one cares about the Earth.

But that's not the worst thing about litter. It can also be harmful to animals. It can even kill them.

So every time you get ready to toss out your trash, you have a chance to protect some special creatures.

43

Did You Know

- Deer and other animals often cut their tongues on half-opened cans.
- Animals are sometimes injured when they eat cigarette butts, plastic wrappers, or Styrofoam.
- Little animals like squirrels sometimes stick their heads in small plastic containers, trying to get the food that's left, and get stuck there. They die because they can't eat.
- Even an apple core thrown out of a moving car can be dangerous. An animal smelling food can be drawn to the highway and get hit by oncoming traffic.
- How long does litter hang around? It takes a month for a piece of paper to become part of the Earth again. It takes a woolen sock a *year* to do the same thing. And a soda can lying on the ground won't disappear for over *200 years!*

What You Can Do

- Throw garbage in trash cans, not on the ground.
- If you see trash lying on the ground, take time to put it in the garbage.
- When you go for a hike with your friends or family, bring some bags along for trash—the trash you make along the way, as well as the trash you find.
- Organize a "Litter Drive" at school. Get everyone together to make a difference in a park or a playground in your town.

28. DON'T BAG IT!

Take A Guess.
What's the best kind of bag to use when you go shopping?
A) Plastic B) Cloth C) Paper

(Answer: B. Cloth is best; you can use it many times.)

Did you ever stop to think how weird it is that everything we buy gets put in bags?...Even when it's only one item, like a candy bar...or a bag of chips? A bag in a bag—now that's crazy!

But it happens all the time. And then we just throw the bag away.

What a waste! Bags are made from the Earth's treasures. Paper bags are made out of trees; plastic bags are made from oil. And manufacturing either of them adds a lot of pollution. But you can help. Just say "No" to bags you don't really need.

Did You Know
- According to Save a Tree, if you had a 15-year-old tree and wanted to make paper bags out of it, you would only get about 700 of them.
- How long would they last? In a big supermarket, the clerks could give those bags out with groceries in less than an hour!
- In some other parts of the world, there aren't enough forests left to make paper bags. So people there have found other ways to carry what they buy. They put their groceries in little carts, or in cloth sacks that they bring from home.

What You Can Do
- Next time you buy something small, tell the clerk you don't need a bag for it. Just say politely, "No thanks, I'd rather have the tree."
- If you don't notice the clerk putting your things in a bag (or if you forget to tell him or her not to), don't be afraid to give the bag back. Say, "Sorry, I really don't need this." Even if the clerk looks at you funny, you'll feel great knowing you're doing the right thing.
- It's cool to bring a bag with you when you go shopping. Use a paper or plastic bag saved from another shopping trip. Or bring a cloth sack or backpack. When the clerk asks you if you want a bag, say, "No thanks, I brought my own. Gotta save the Earth, y'know."

See For Yourself
When you're at the supermarket, watch people leaving the store. Try to count all the bags they've got. Imagine people all over the U.S. leaving supermarkets every day with all those bags. Imagine how many trees are being cut down and how much plastic is used in a single day just for carrying groceries.

31. BE A PAPER-SAVER
Take A Guess.
If you stacked up all the paper an average American uses in a year, the pile would be as tall as...
A) A car B) An elephant's eye C) A two-story house

(Answer: C. Believe it or not, as high as a two-story house!)

It takes years for a tree to grow enough to be made into paper. And it takes many forests to make all the paper we use...and throw away.

Wouldn't it be great if old paper could be turned back into new paper? Then we'd have more trees and a greener world.

We can make that happen—there *is* a way. We can recycle our paper.

Does that really work? You bet! Want proof? Take a good look at this book—it's printed on recycled paper!

Did You Know
- Americans use 50 million tons of paper every year, or about 580 pounds for each person.
- How much is that? The paper that four people use in a year weighs as much as a big car.
- To make all that paper, we use almost a *billion* trees!
- If everyone in the U.S. recycled their Sunday newspapers (including the comics), we'd save 500,000 trees every week.
- How is paper recycled? It's shredded and mashed into a glop called pulp, which is then turned back into paper. It's so simple you can do it yourself!

What You Can Do
- You can recycle all kinds of paper—cereal boxes, note paper, bags, newspaper, and so on.
- To start recycling in your house, first find a place where you can put a pile of newspapers and a box for collecting other types of paper.
- Whenever you empty a cereal box, or get ready to toss out a piece of paper, put it in the box instead of the garbage. If you get a newspaper at your house, stack it neatly on the pile every day.
- Don't put shiny paper or paper with plastic attached to it in your box—you can't recycle that stuff.
- Ask a parent to find out where the nearest recycling center is. Maybe your neighborhood has a curbside recycling program. That would really make it easy!
- Every week or two, tie the newspapers into small bundles and take them (and other paper) to the recycling center or put them on the curb for pickup.
- **Extra Tip:** Don't use just one side of a piece of paper—use the other side for scrap paper. That's recycling, too.

A Working World

Mexicali Soup

by Kathryn Hitte and William D. Hayes

In this story about a family that has moved from the mountains to the city, Mama plans to make her Special Mexicali Soup—a soup that her family has always loved. The city's markets offer every vegetable a cook could want, and Mama knows just which market to go to for each. On her way, however, different family members ask Mama to leave out different ingredients, because they believe that city people do not eat them. What does the family learn when they sit down to dinner?

All the way across town Mama sang to herself—to herself and the little one, little Juanita. Here on the streets of the great fine city, she sang an old tune from the old home in the mountains. And she thought of what she would buy in the markets.

Only the best of everything. Potatoes and peppers—the best! Tomatoes and onions—the best! The best garlic. The best celery. And then, cooked all together, ah! The best soup in the world! Mama's Special Mexicali Soup. The soup that always made everyone say, "Mama makes the best soup in the world."

"Ah, *si!*" Mama thought with a smile. "Yes! Our supper tonight will be a very special supper for my Rosie and Antonio and Juan and Manuel and Maria, and for the little one—and for Papa, too. A very special supper of my Mexicali Soup."

"Mama! Yoo-hoo, Mama!"

There was the fine new school building where Juan and Manuel and Maria went to school, and there was Maria with her new city friend, waving and calling.

"Wait a minute, Mama!" Maria came running to put her schoolbooks in the stroller with Juanita.

"Mama, may I play a while at Marjorie's house? Please?"

48

"Very well," Mama said. "A while. But do not be late for supper, Maria. I am making my special soup tonight."

"Mmmm-mmm, Mexicali Soup!" Maria said. Then she looked thoughtful. Then she frowned. "But—Mama?"

"Yes, Maria?"

"Mama, there is such a lot of potatoes in your Mexicali Soup."

"Of course," Mama said, smiling.

"Marjorie doesn't eat potatoes. Her mother doesn't eat them. Her sister doesn't eat them. Potatoes are too fattening, Mama. They are too fattening for many people in the city. I think we should do what others do here. We are no longer in the mountains of the West, Mama, where everyone eats potatoes. We are in the city now. So would you—Mama, would you please leave out the potatoes?"

"No potatoes," Mama said thoughtfully. She looked at Maria's anxious face. She shrugged. "Well, there are plenty of good things in the Mexicali Soup without potatoes. I will add more of everything else. It will still make good soup."

Maria kissed Mama's cheek. "Of course it will, Mama. You make the best soup in the world."

Mama went on with Juanita to the markets, to the street of little markets, thinking aloud as she went. "Tomatoes, onions, celery. Red peppers, chili peppers, good and hot. And garlic. But no potatoes."

Mama went to Mr. Santini's little market for the best tomatoes and celery. She went to Mr. Vierra's little market for the best onions and garlic. "And the peppers," she said to Juanita. "We will buy the peppers from Antonio. Our own Antonio, at the market of Mr. Fernandez. Here is the place. Ah! What beautiful peppers!"

Antonio came hurrying out of the store to the little stand on the sidewalk.

"Let me help you, Mama! I hope you want something very good for our supper tonight. I get very hungry working here," Antonio said.

"Ah, *si!*" Mama said. "Yes, Antonio. For tonight—something special!" She reached for the hot red peppers strung above her head. "Mexicali Soup."

"Hey! That's great," Antonio exclaimed. Then he looked thoughtful. Then he frowned. "But—Mama—"

"Yes?" Mama said, putting some peppers in the scale.

"Well—Mama, you use a lot of hot peppers in your soup."

"Of course," Mama said, smiling.

"A lot," Antonio repeated. "Too many, Mama. People here don't do that. They don't cook that way. They don't eat the way we did in the mountains of the West. I know, Mama. I have worked here for weeks now, after school and Saturdays. And in all that time, Mama, I have not sold as many hot peppers to other ladies as you use in a week.

"*Mamacita*," Antonio said. "Please don't put hot peppers in the soup."

"No peppers," Mama said thoughtfully. She looked at Antonio's anxious face. "Well—" Mama shrugged. "There are plenty of good things in the soup without peppers. I will add more of something else. It will still make good soup."

Antonio took the peppers out of the scale and put them back on the stand. "Of course it will, Mama." He kissed her cheek. "Everyone knows you make the best soup in the world."

Mama went on with Juanita toward home. "Tomatoes, onions, garlic, celery," she said to herself. "Yes. I can still make a good soup with those."

She hummed softly to herself as she crossed a street blocked off from traffic, a street that was only for play.

"Hey, Mama! *Mamacita!*"

Juan and Manuel left the game of stickball in the play street. They raced each other to the spot where Mama stood.

"Oh, boy! Food!" said Juan when he saw the bags in the stroller. He opened one of the bags. "Tomatoes and celery—I know what that means."

"Me, too," said Manuel. He peeked into the other bag. "Onions and garlic. Mexicali Soup! Right, Mama?" Manuel rubbed his stomach and grinned. Then he looked thoughtful. Then he frowned. "But, Mama—listen, Mama."

"I am listening," Mama said.

"Well, I think we use an awful lot of onions," Manuel said. "They don't use so many onions in the lunchroom at school, or at the Boys' Club picnics. You know, Mama, they have different ways of doing things here, different from the ways of our town on the side of the mountain. I think we should try new ways. I think we shouldn't use so many onions. *Mamacita*, please make the Mexicali Soup without onions."

"Manuel is right!" Juan said. "My teacher said only today that there is nothing that cannot be changed, and there is nothing so good that it cannot be made better, if we will only try. I think there may be

better ways of making soup than our old way. Make the soup tonight without tomatoes, Mama!"

"No tomatoes?" Mama said. "And no onions? In Mexicali Soup?" Mama looked at the anxious faces of Juan and Manuel. Then she shrugged. She closed the two bags of groceries carefully. She pushed the stroller away from the play street. She shrugged again.

Voices came after her. Juan's voice said, "We will be hungry for your soup tonight, Mama!"

Manuel's voice called, "*Mamacita!* You make the best soup in the world!"

In the big kitchen at home, Mama put the groceries on the table by the stove. She hummed a little soft tune that only Mama could hear. She stood looking at the groceries. No potatoes. No peppers. Tomatoes—Mama pushed the tomatoes aside. Onions—she pushed the onions aside.

Mama sat down and looked at what was left.

The front door clicked open and shut. Rosie came into the kitchen. Rosita, the young lady of the family.

"Hi, Mama. Oh, Mama—I hope I'm in time! I heard you were making—" Rosie stopped to catch her breath. She frowned at the groceries on the table. "All the way home I heard it. The boys and Maria—they all told me—and Mama! I want to ask you—please! No garlic."

Mama stopped humming.

Rosie turned up her nose and spread out her hands. "No garlic. Please. Listen, Mama. Last night, when my friend took me to dinner, I had such a fine soup! Delicious! The place was so elegant, Mama—so refined. So expensive. And no garlic at all in the soup!"

Rosie bent over and kissed Mama's cheek. "Just leave out the garlic, *Mamacita.* You make the best soup in the world."

A deep voice and many other voices called all at once, and the front door shut with a bang. "Mama! We are home, Mama!"

Then all of them, Juan and Manuel and Antonio, with Maria pulling Papa by the hand—all of them came to stand in the kitchen doorway. Papa reached for the baby, the little Juanita, and swung her onto his shoulders.

"I have heard of something special," Papa said. "I have heard we are having Mexicali Soup tonight."

Mama said nothing. But Mama's eyes flashed fire. She waited.

51

"Your soup, Mama—" Papa said. "It is simply the best soup in the world!"

"Ah, si! But you want me to leave out something?" Mama's voice rose high. "The celery, perhaps? You want me to make my Mexicali Soup without the celery?"

Papa raised his eyebrows. "Celery?" Papa opened his hands wide and shrugged. "What is celery? It is a little nothing! Put it in or leave it out, *Mamacita*—it does not matter. The soup will be just as—"

"Enough!" Mama said. "Out of my kitchen—all of you!"

Mama waved her arms wide in the air. The fire in Mama's eyes flashed again. "I am busy! I am busy getting your supper. I will call you. Go."

"But, Mama," said Rosie, "we always help you with—"

"No!" Mama said. "Out!"

Rosie and Juan and Manuel, Antonio and Maria, and Papa with the baby, tiptoed away to the living room.

There was only silence coming from the kitchen. Then, the sound of a quiet humming. Soon the humming mixed with the clatter of plates and spoons, the good sounds of the table being set for supper.

The humming turned into singing. Mama was singing a happy song from the old home in the mountains. Juan and Manuel, Antonio and Maria, Rosie and Papa, looked at one another and smiled and nodded. Mama was singing.

Then from the kitchen Mama's voice called to them.

"The soup is finished. Your supper is ready. Come and eat now."

"Ah! That is what I like to hear," said Papa, jumping up with Juanita. "The soup is ready before I have even begun to smell it cooking."

"Mmm-mmm!" said Juan and Manuel, racing for the big kitchen table.

"Mmm-mmm!" said Maria and Antonio and Rosie, when they saw the steaming bowls on the table. "Mama makes the best soup in the world."

But what was the matter?

"This doesn't look like Mexicali Soup," said Maria, staring at the bowl before her.

"It doesn't smell like Mexicali Soup," said Antonio, sniffing the steam that rose from his bowl.

"It doesn't taste like Mexicali Soup," said Juan and Manuel, sipping a sip from their spoons.

"This is not Mexicali Soup," said Rosie, setting her spoon down hard with a clang. "This is nothing but hot water!"

Everyone looked at Mama.

Mama smiled and hummed the old tune from the mountains.

"You have forgotten to bring the soup, *Mamacita?*" suggested Papa.

"No," Mama said, still smiling. "The soup is in your bowls. And it is just what you wanted. I made the soup the way my family asked me to make it. I left out the potatoes that Maria does not want. I left out the peppers Antonio does not want. I left out the tomatoes that Juan does not want. I left out the onions that Manuel does not want. For Rosita, I left out the garlic. And for Papa, I left out the celery, the little nothing that does not matter."

"The *new* Mexicali Soup!

It is so simple! So quick! So easy to make," Mama said. "You just leave everything out of it."

Truck Song

by Diane Siebert

This poem about transportation takes us through a day in the life of trucks and their drivers. All over the country, on all sorts of roads, trucks are carrying goods from one place to another. What are some of the goods the trucks in this poem could be carrying?

country sprawling
lined with roads
trucks are hauling
heavy loads
trucks of metal
trucks of chrome
foot on pedal
far from home
tall trucks
small trucks
parked-for-overhaul trucks
grand trucks
sand trucks
folks who understand trucks:
drivers dressed in hats and boots
regulation truckers' suits
crossing interstate frontiers
with eighteen wheels
and
thirteen gears
twin stacks smoke
airhorns blast
brake called "Jake"
to slow down fast

twenty big rigs in a row
down the highway, see them go
giant convoy heading west
"In Dallas, boys, we'll take a rest!"
country music symphonies
truckers talking on CBs
"Thanks, good buddy, big 10-4
I see your rig at my back door!"
white lines
road signs
coffee up ahead
south of town
slowing down
brake lights glowing red
at the truckstop
truckers meet
for road talk
and
a bite to eat
sipping coffee
hot and strong
jukebox plays
a country song

54

say good-bye
check your load
climb aboard
hit the road
heading out across the plains
checking mirrors, changing lanes
past the farms and fields of wheat
through the rain so cool and sweet
windshield wipers keeping time
lower gear to make the climb
up mountain roads
'round hairpin curves
with eagle eyes
and steely nerves
tractors pull
trailers full
deadlines must be met
journey's end
around the bend
gonna get there yet
off the freeway
into town
shifting
shifting
shifting
down
on every street and thoroughfare
trucks haul goods from here to there
city trucks
pretty trucks
greasy grimy gritty trucks
trucks for moving
trucks for rent
big striped trucks that hold cement

armored trucks that carry cash
garbage trucks that carry trash
tuneful trucks with ice-cream bars
trucks for towing broken cars
trucks
and
more trucks
on the go
through heat
and rain
and sleet
and snow
now up the street and past the light
the loading dock comes into sight
the workers wave as I drive past
I say "Hello!" with one deep blast
then backing slowly to the dock
I sign my papers
check the clock
unload the goods
and when I'm done
I sign up for tomorrow's run
another route
another load—
my rig and I back on the road!

A New Coat for Anna

by Harriet Ziefert

A New Coat for Anna, based on a true story, tells of a young girl whose family does not have money to buy her the new coat she needs. This does not stop the girl's mother, though. She finds people who will trade services for goods, and Anna sees her coat made, step by beautiful step. What does each person do to help make Anna's coat?

Winter had come and Anna needed a new coat. The fuzzy blue coat that she had worn for so many winters was no longer fuzzy and it was very small.

Last winter Anna's mother had said, "When the war is over, we will be able to buy things again and I will get you a nice new coat."

But when the war ended the stores remained empty. There still were no coats. There was hardly any food. And no one had any money.

Anna's mother wondered how she could get Anna a new coat. Then she had an idea. "Anna, I have no money," she said, "but I still have Grandfather's gold watch and some other nice things. Maybe we can use them to get what we need for a new coat. First we need wool. Tomorrow we will visit a farmer and see about getting some."

The next day Anna and her mother walked to a nearby farm.

"Anna needs a new coat," Anna's mother told the farmer. "I have no money, but I will give you this fine gold watch if you will give me enough wool from your sheep to make a coat."

The farmer said, "What a good idea! But you will have to wait until spring when I shear my sheep's winter wool. Then I can trade you their wool for your gold watch."

Anna waited for spring to come. Almost every Sunday she and her mother visited the sheep. She would always ask them, "Is your wool growing?" The sheep would always answer, "Baaa!" Then she would feed them nice fresh hay and give them hugs.

56

At Christmastime Anna brought them paper necklaces and apples and sang carols.

When spring came the farmer sheared the sheep's wool.

"Does it hurt them?" asked Anna.

"No, Anna," said the farmer. "It is just like getting a haircut."

When he had enough wool to make a coat, the farmer showed Anna how to card the wool. "It's like untangling the knots in your hair," he told Anna.

Then he gave Anna's mother a big bag of wool and Anna's mother gave him the gold watch.

Anna and her mother took the bag of wool to an old woman who had a spinning wheel.

"Anna needs a new coat," Anna's mother told the woman. "I have no money, but I will give you this beautiful lamp if you will spin this wool into yarn."

The woman said, "A lamp. That's just what I need. But I cannot spin quickly, for I am old and my fingers are stiff. Come back when the cherries are ripe and I will have your yarn."

When summer came, Anna and her mother returned. Anna's mother gave the old woman the lamp and the old woman gave them the yarn—and a basket of delicious red cherries.

"Anna, what color coat would you like?" Anna's mother asked.

"A red one!" Anna answered.

"Then we will pick some lingonberries," said Anna's mother. "They make a beautiful red dye."

At the end of summer, Anna's mother knew just the place in the woods to find the ripest lingonberries.

Anna and her mother boiled water in a big pot and put the berries into it. The water turned a deep red. Anna's mother dipped the pale yarn into it.

Soon red yarn was hanging up to dry on a clothesline strung across the kitchen.

When it dried, Anna and her mother wound the yarn into balls.

They took the yarn to the weaver.

"Anna needs a new coat," Anna's mother said. "I have no money, but I will give you this garnet necklace if you will weave this yarn into cloth."

The weaver said, "What a pretty necklace. I will be happy to weave your yarn. Come back in two weeks."

When Anna and her mother returned, the weaver gave them a bolt of beautiful red cloth. Anna's mother gave the weaver the sparkling garnet necklace.

The next day Anna and her mother set off to see the tailor.

"Winter is coming and Anna needs a new coat," Anna's mother told the tailor. "I have no money, but I will give you this porcelain teapot if you will make a coat from this cloth."

The tailor said, "That's a pretty teapot. Anna, I'd be very happy to make you a new coat, but first I must take your measurements."

He measured her shoulders. He measured her arms. He measured from the back of her neck to the back of her knees. Then he said, "Come back next week and I will have your coat."

The tailor set to work making a pattern, cutting the cloth, pinning, and sewing and stitching and snipping. He worked and worked for almost a whole week. When he was finished, he found six pretty matching buttons in his button box and sewed them on the coat.

He hung the coat proudly in the window for everyone to see.

When Anna and her mother returned to the tailor's shop, Anna tried on her new coat. She twirled around in front of the mirror. The coat was perfect!

Anna thanked the tailor. Anna's mother thanked him, too, and gave him the pretty porcelain teapot.

Anna wore her new coat home. She stopped at every store to look at her reflection in the window.

When they got home her mother said, "Christmas will soon be here, and I think this year we could have a little celebration."

Anna said, "Oh, yes, and please could we invite all the people who helped to make my coat?"

"Yes," said Anna's mother. "And I will make a Christmas cake just like I used to."

Anna gave her mother a big hug.

On Christmas Eve the farmer, the spinner, the weaver, and the tailor came to Anna's house. They all thought Anna looked beautiful in her new coat.

The Christmas cake that Anna's mother baked was delicious. Everyone agreed that this was the best Christmas they had had in a long time.

On Christmas Day Anna visited the sheep. "Thank you for the wool, sheep," she said. "Do you like my pretty new coat?"

The sheep seemed to smile as they answered, "Baaa! Baaa!"

Uncle Nacho's Hat

Adapted from a Nicaraguan folk tale by Harriet Rohmer

In this story based on a Nicaraguan folk tale, Uncle Nacho needs a new hat, because the hat he has is full of holes. Still, when his niece Ambrosia gives him a beautiful new hat, Uncle Nacho has trouble getting rid of his old one. How does Ambrosia's advice help her uncle Nacho?

Every day Uncle Nacho woke up with the sun. He said "Good morning" to his cat and his dog. He said "Good morning" to his parrot and his monkey. And he said "Good morning" to his hat which was old and full of holes.

Uncle Nacho lit a fire to make his morning coffee. When the fire started to go out, he fanned it with his hat. But since his hat was old and full of holes, it didn't do any good.

The little house filled with smoke. The cat meowed. The dog barked. The parrot screeched. The monkey screamed. And Uncle Nacho began to yell at his hat: "You're useless and full of holes. You're no good for anything anymore!"

"Uncle Nacho! Uncle Nacho!" came a voice at the door.

It was Ambrosia, Uncle Nacho's niece. She always stopped in for a little visit on her way to school.

"What's the matter, Uncle Nacho? Is the house burning down?"

"No, Ambrosia. I'm just fighting with my hat again. It's no good to me anymore."

"You say that every morning, Uncle Nacho. So today I have a present for you—a new hat!"

Uncle Nacho put on the new hat and looked at himself in the mirror.

"See how handsome it makes you look, Uncle Nacho," said Ambrosia.

"It's true. All the girls will fall in love with me."

"That's for sure, Uncle Nacho. Well, I have to go to school now. I'll come by later."

"Take care of yourself, Ambrosia. And thank you for the hat."

"Now I have a new hat," said Uncle Nacho to himself. "But what am I going to do with this old hat that's not good for anything anymore?"

"Hat," he said to his old hat. "What am I going to do with you?"

"I know. I'll put you in my trunk."

"Wait a minute. What if the mice get in and start to eat you? No, no, no. I'd better not put you in my trunk."

"But hat, you're really not good for anything anymore," said Uncle Nacho. "You don't keep me dry in the rain. I should throw you away. I'll just take you outside right now and throw you away in the street."

"Wait a minute. I think I see a car coming. You might get run over. No, no, no. I'd better not throw you away in the street."

"But hat, you're really not good for anything anymore," said Uncle Nacho. "You don't keep the sun off my head. I should throw you away. I'll just take you outside right now and throw you in the trash."

"There! May some good man find you. Someone who will appreciate you. A decent person. God bless you both!"

A few moments later, along came Chabela, Ambrosia's mother. She was coming from the market and trying to count her change. Then she saw Uncle Nacho's hat.

"I know this hat. It's Uncle Nacho's hat. Somebody must be playing a trick on poor old Uncle Nacho. Hat, you're coming with me right away! I'm taking you home to Uncle Nacho!"

"Look, Uncle Nacho! Look what I found! Your hat!"

"Thank you very much, Chabela. But I threw this old hat away because your daughter Ambrosia gave me a new one. See, doesn't it look good on me?"

"Ambrosia gave you a new hat so you threw away your old one? Ay! How will anyone know you without your hat?"

"You're right. Chabela. Thank you." And Uncle Nacho took back his old hat.

"But in truth, hat, you're not good for anything anymore," said Uncle Nacho. "I really should throw you away. This time I'm taking

you far away from here. Then my heart won't break when I think about you."

So Uncle Nacho took his old hat to the very edge of the town where the town became the country and he hung it on the branch of a flowering tree.

"There. At last we can say goodbye."

Under the tree an old gentleman was just waking up from his nap. He saw Uncle Nacho's hat. "Sir! Sir! You've forgotten your hat."

"I'm leaving it here," said Uncle Nacho. "It isn't any use to me anymore."

"Can you give it to me, then?"

"Take it. The hat is yours."

"Thank you, sir! Thank you very much!"

Uncle Nacho watched the old gentleman walk away wearing the hat. "At last a deserving person has my hat. May it serve him well."

The old gentleman was so happy with his hat that he didn't see Pedro and Paco following him.

"Hey look!" said Pedro. "That old guy's wearing Uncle Nacho's hat. He must have stolen it!"

"We're taking back the hat you stole!" cried Paco.

"I did not steal it!" protested the old gentleman.

"That's a lie! You stole it!" The boys and the old gentleman fought over the hat until it was completely torn apart. Finally the boys grabbed it and ran away.

"We got it! Let's take it to Uncle Nacho! Uncle Nacho will be so happy to have his hat!"

"Uncle Nacho! Uncle Nacho!"

"What's going on boys?"

"Look what we've got! We got your hat back from that old thief who stole it!"

Uncle Nacho was angry. "I gave that hat to the old gentleman and now you've ruined it. It isn't even a hat anymore!"

Uncle Nacho took back what was left of the old hat and slammed the door.

A little later, Ambrosia arrived for a visit on her way home from school. "What's the matter, Uncle Nacho? Why aren't you wearing your new hat?"

"I've been too busy worrying about my old hat, Ambrosia. The more I try to get rid of it, the more it comes back. I don't know what to do."

Ambrosia thought for a few moments. "Stop worrying about the old hat, Uncle Nacho. Think about your new hat instead."

"Ah! I never thought of that before. How intelligent you are, Ambrosia."

Uncle Nacho put on his new hat. "Hat, let's go. I'm taking you to meet my friends!"

Oats, Peas, Beans

English Singing Game

Moderately fast

1. Oats, peas, beans and bar - ley grow; Oats, peas, beans and bar - ley grow;

Do you or I or an - y - one know how oats, peas, beans and bar - ley grow?

2. First the farmer sows his seed,
 Then he stands and takes his ease;
 He stamps his foot and claps his hands,
 And turns around to view his lands.

3. Waiting for a partner,
 Waiting for a partner,
 Open the ring and take one in
 While we all gaily dance and sing.

Responsibility
A Jataka Tale

edited by Nancy DeRoin

Jataka Tales are very old stories from India, but they are about problems that we still face today. This Jataka Tale begins with a king's gardener who does not want to miss a holiday. He asks some monkeys to water the trees while he is away. Why does the king blame the gardener for what happens to the trees? Who do you think is responsible, and why?

Once upon a time when he ruled Benares, King Vissanena proclaimed a holiday week. The king's gardener didn't want to miss any of the fun, so he called together all the monkeys that lived in the king's park and said:

"Oh, monkeys, this park is a great blessing to you. I want to take a week's holiday, but these young trees need watering. Will you water the saplings while I am away?"

"Gladly!" they agreed. So the gardener gave them watering-skins to hold and carry water, and then he left on his holiday.

In the middle of the week, the chief of the monkeys called his troop together and told them to fill the skins with water. Then he said:

"We must water the trees according to their needs. If they have long roots, they need lots of water. If they have short roots, they need just a little. You must pull up the trees to see how long their roots are before you water them."

So some of the monkeys pulled up the young trees, and others poured water on them. Of course, the sudden shock of being uprooted caused the young trees to wither and die.

The king happened to be passing by on his way to the fair, and he discovered what the monkeys were doing. He stopped and said, "Who told you to do that?"

"Why, our chief told us," the monkeys replied. The king sent for the chief of the monkeys, thinking to himself:

> If he was chosen as their chief,
> The others must be dumb beyond belief!

The monkey chief came before the king, trembling. The king demanded: "Why did you tell your troop of monkeys to pull up the young trees in the park?"

The monkey replied, "Don't be angry, Oh, king! The gardener told us to water the saplings during his holiday. If we do not know the length of their roots, how can we tell how much water to give them? Why blame us, sir, for doing our best to carry out the gardener's wishes?"

The king said to the monkey, "I do not blame you, friend, or any other creature in this park. But I do know whom to blame."

When the gardener returned from his holiday, the king showed him all the dead trees in the park. Then he said to him:

> When you are made responsible,
> The job is up to you,
> And if you give that job to others,
> You're to blame for what they do.

Assembly Line Lunch

by Rachel Sheinkin

*Each person who works on an assembly line has a special job to do.
In this poem children work together to make lunch for their whole
group. What do you suppose Lucy adds to the lunch?*

I've got the peanut butter
Pytor has the bread
Jenny's got the jelly
(good thing she's wearing red!)
Pytor hands us each a slice—
It's our job to spread.
We glob it on and smooth it out
And pass it on to Fred.
Fred has a fun job
He puts the halves together
He makes sure that they're lined up well
Then passes them to Heather.
Heather cuts the sandwich
down the middle—but don't worry…
The knife she uses isn't sharp,
And Heather doesn't hurry.
Ahmed has the sandwich bags
(Reduce, reuse, recycle!)
He wraps each sandwich snugly
And passes it to Michael.
Michael adds a peach to each,
—mmmm—those look juicy…
Maria adds some carrot sticks
and passes off to Lucy.
I don't know what Lucy does
'Cause she's way down at the end
But it must be real important
'Cause she's everyone's best friend.

WE the PEOPLE

A Place to Skate

A play by Wendy Vierow

Have you ever wished you could help to solve a problem in your community? The children in this play wish they had a safe place to skate. What steps do they take to try to create one? Why do you think the city council makes the decision it does?

THE PLAYERS

Jim	Mrs. Padres
Seti	Mrs. Whitaker
Clara	Mr. Kimble
Rick	Mr. Chin
Sue	Mr. Cyrus
Neighbors and Friends	Mrs. Nagle

Time: *October*
Place: *Outside of Jim's house*

SCENE 1: AFTER SCHOOL

Jim: I wish there was a good place around here where we could skate.

Seti: The sidewalk is so bumpy.

Clara: I trip on the cracks in the sidewalk every time I skate.

Rick: So do I!

Jim: I wish we could skate in the park.

Rick: Why can't we skate there?

Sue: There's a law that says no skating!

Rick: Why?

Seti: Because some people are afraid that skaters will bump into them.

Rick: Oh, I see.

Jim: Why can't we have a small part of the park where we could skate? It wouldn't have to be very big.

Seti: That would be more fair. Then people who wanted to skate could be in one place. People who didn't want to skate could be in another place.

Sue: Let's do something about it.

Rick: What could we do?

Sue: We could write a petition!

Rick: What's that?

Seti: It's a letter you get people to sign asking for something special.

Rick: What do you do with it?

Sue: We sign it and send it to our city leaders.

Rick: Oh, I see.

Clara: I can write it. I can print very neatly.

(Clara takes a notebook and pencil from her knapsack.)

Rick: What should it say?

Sue: At the top we need to write what the petition is about. Clara, write this: "We want a special place to skate in Forest Park!"

(Clara writes this down.)

Seti: You do write very nicely.

Clara: Thanks. What do I do now, Sue?

Sue: Now we sign our names on the petition.

Clara: I'll sign it first. Then everyone else can sign it.

(Clara signs the petition and then the others sign it.)

Seti: Look at Clara's name. Isn't her writing beautiful?

Sue: We have to get more people to sign the petition. Let's set up a stand and make a sign that says "SIGN OUR PETITION!"

Clara: I can make that too.

(Clara makes the sign.)

Seti: I love the way you make your Rs.

Jim: I'll go get a table and some pencils.

Rick: I'll help!

(Jim and Rick set up a table. Friends and Neighbors come by, ask questions, and sign the petition.)

Clara: Look at how many people signed our petition!

Rick: Now what do we do?

Sue: We send it to our city leaders, at City Hall.

Clara: I can address the envelope.

Seti: I wish I could write like you.

Clara: I'll teach you.

Seti: Oh, that would be great! Thank you!

Sue: We can find out the address in the phone book.

Jim: There's one in my house. Let's go inside and find the address!

(Everyone goes into Jim's house.)

SCENE 2: THE CITY COUNCIL

Mrs. Padres: Today, we have a petition from some citizens. They want to be able to skate in Forest Park. We need to vote on whether or not we should set up a special place where they can skate in the park.

Mrs. Whitaker: I don't see why there can't be a special place for people to skate. There is room in the park for everyone.

Mr. Kimble: That will cost money.

Mr. Chin: I think we have some extra tax money left over this year. This would be a good thing to spend it on.

Mr. Cyrus: I agree. It would be safer for people to skate in the park than it would be for them to skate on the street.

Mr. Kimble: I think we should save the money for something else.

Mrs. Nagle: I agree. I think we should wait and see what other things we might want to spend the money on.

Mrs. Padres: Let's take a vote on this. All who want a place to skate in the park raise your hands.

(Mrs. Padres, Mrs. Whitaker, Mr. Cyrus, and Mr. Chin raise their hands.)

Mrs. Padres: All who don't want a place to skate in the park raise your hands.

(Mr. Kimble and Mrs. Nagle raise their hands.)

Mrs. Padres: Four people want to make a special skating place and two don't. That means we will make a special skating place in the park!

SCENE 3: THE LETTER

Clara: I got a letter from the city council!

Jim: Open it! What does it say?

(Clara opens the letter.)

Clara: It says, "This is to let you know that we have voted on your petition. We have decided to build a special place in the park so that you and your friends will have a safe place to skate. Sincerely, The City Council. P.S. You print very nicely."

Sue: Our petition worked!

Seti: Soon I'll be able to print like you, Clara! And we'll have a place to skate at last!

Rick: Hooray! Let's celebrate!

THE END

The Giant Jam Sandwich

by John Vernon Lord and Janet Burroway

The town of Itching Down has a big problem. Four million buzzing wasps are disturbing the peace. The villagers hold a meeting to discuss what they can do. What does this funny story in rhyming verse tell us about how a city can solve its problems?

One hot summer in Itching Down,
Four million wasps flew into town.
They drove the picnickers away,
They chased the farmers from their hay,
They stung Lord Swell on his fat bald pate,
They dived and hummed and buzzed and ate,
And the noisy, nasty nuisance grew
Till the villagers cried, "What *can* we *do*?"

So they called a meeting in the village hall,
And Mayor Muddlenut asked them all,
"What *can* we *do*?" And they said, "Good question!"
But nobody had a good suggestion.

Then Bap the Baker leaped to his feet
And cried, "What do wasps like best to eat?
Strawberry jam! Now wait a minute!
If we made a giant sandwich we could trap them in it!"
The gentlemen cheered, the ladies squealed,
And Farmer Seed said, "Use my field."

Bap gave instructions for the making of the dough.
"Mix flour from above and yeast from below.
Salt from the seaside, water from the spout.
Now thump it! Bump it! Bang it about!"

72

While they were working, and working hard,
Some more made a tablecloth out in the yard.
When they were done, the dough was left to rise
Till the loaf was a mountain in shape and size!

They hitched it up, with a bit of fuss,
To tractors, cars and the village bus,
And took it to the oven they had made on the hill—
Fifty cookers in an old brick mill.

For hours and hours they let it cook.
It swelled inside till the windows shook.
It was piping hot when they took it out,
And the villagers raised a mighty shout.
"Isn't it crusty, Aren't we clever!"
But the wasps were just as bad as ever.

The loaf was left to cool, and then
The people watched while six strong men
Took a great big saw and sliced right through.
Everybody clapped, and they cut slice two.

The village bus, they all agreed,
Would spoil the fields of Farmer Seed,
So eight fine horses pulled the bread
To where the picnic cloth was spread.

A truck drew up and dumped out butter,
And they spread it out with a flap and a flutter.
Spoons and spades! Slap and slam!
And they did the same with the strawberry jam.

Meanwhile, high above the field,
Six flying machines whirred and wheeled,
Ready for the wasps to take the bait.
And then there was nothing to do but wait.

Suddenly the sky was humming!
All four million wasps were coming!
They smelled that jam, they dived and struck!
And they ate so much that they all got stuck.

The other slice came down—kersplat!—
On top of the wasps, and that was that.
There were only three that got away,
And where they are now I cannot say.

Election Day

by Mary Kay Phelan

On Election Day citizens 18 years old and older vote for the people they think will make the best leaders. Long before you are 18, however, you can write to our leaders to tell them what <u>you</u> think! Election Day by Mary Kay Phelan explains more about elections and voting. Why do you think voting is important?

In the fall people all over the United States look forward to Election Day. It is always celebrated on the first Tuesday after the first Monday in November.

On this holiday we show how proud we are to live in a free country.

Election Day is different from all other American holidays. Some holidays celebrate something that happened long ago. Others honor an important person's birthday. But Election Day is a holiday when we plan for the future.

On Election Day we vote for the men and women who will govern our towns, our counties, our states, and our nation.

Plans for Election Day begin many weeks ahead of time. The people who want to be elected are called candidates. They make speeches. They write letters to the voters. They tell everyone what they will do if they are elected.

Then on Election Day the voters decide which candidates they want.

On Election Day people vote at polling places. Sometimes the polling place is a school or a church. In some towns it may be a firehouse, a store, or a courthouse.

All day long people stream into the polling places. Each person goes into a little booth all alone. His [or her] vote is secret.

Some people vote for one person. Some vote for another. Because this is a free country, no one tells us how to vote. We choose the candidate we think will do the best job.

After the polling places close, the votes are counted. Soon everyone knows who has won the election....

Americans...have always wanted the freedom to vote for the people who are to govern them. That is one of the reasons why the first colonists came to America from England.

As early as 1620 the settlers of Plymouth, Massachusetts, held elections for a governor. People voted by raising their hands in a public meeting. Then in 1634 the people of the Massachusetts Bay Colony tried something new. They used paper ballots and voted in secret....

Sometimes the early settlers used kernels of corn and Indian beans for voting. When a man dropped a white kernel of corn into the ballot box, he was voting for the candidate. If he used a black bean, he was voting against the candidate.

Not all the colonies used paper ballots or corn and beans for voting. Election Day in the colonies of New York, New Jersey, Maryland, Virginia, and Georgia was very different. At each polling place the man in charge of the election had a large book. The names of the candidates were written in the book.

When the voter arrived, he announced in a loud voice the men for whom he wished to vote. His choices were recorded in the book. The candidates rose and bowed in thanks. Their friends clapped....

Many of the colonists who voted [this way] came from England. They were voting the way people in England had voted for hundreds of years.

But the voice vote was not secret. Everyone knew how a man voted. Sometimes people were afraid to vote as they really wished.

[After the Declaration of Independence in 1776] the colonies were independent of England. Because they did not want to keep the English customs, the ways of voting were changed. One by one, the new states adopted paper ballots for their elections....

Election Day is one of our most exciting holidays. Even if you cannot vote yet, you can share in the excitement. You can listen to the candidates. You can learn what they hope to do if they are elected.

As long as Americans can vote for whom they wish, our country will always be strong and free. The future of the United States depends on its Election Days.

There Are Many Flags in Many Lands

Words by Mary H. Howliston

Composer Unknown

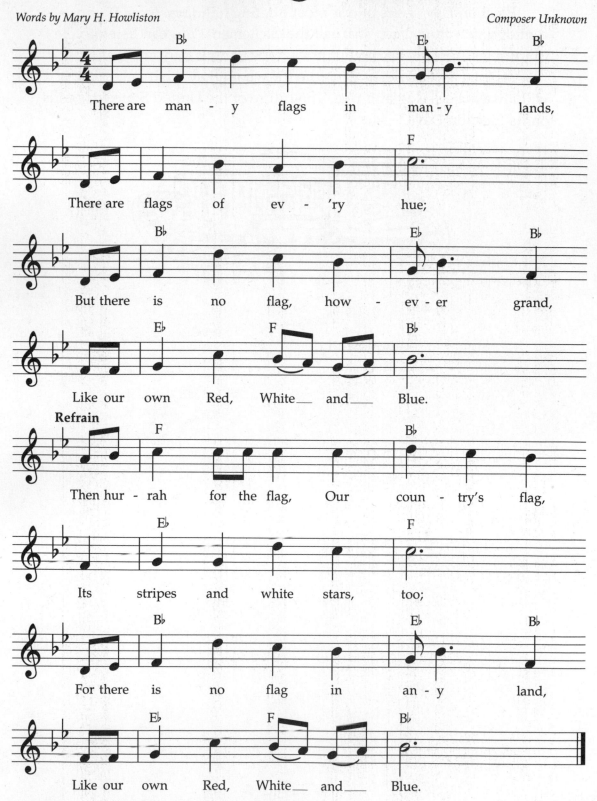

There are man - y flags in man - y lands,

There are flags of ev - 'ry hue;

But there is no flag, how - ev - er grand,

Like our own Red, White and Blue.

Refrain

Then hur - rah for the flag, Our coun - try's flag,

Its stripes and white stars, too;

For there is no flag in an - y land,

Like our own Red, White and Blue.

From THE GOLDEN FLUTE selected by Alice Hubbard and Adeline Babbitt. (John Day Company),
Copyright 1932, 1960 by Harper & Row, Publishers, Inc.

Monuments

There are many things to see in Washington, D.C. Two of the most popular places for visitors are the monuments to George Washington and Abraham Lincoln. What do these poems say about the monuments? What do the monuments say about the men?

Washington Monument
by Aileen Fisher

High above the town it soars,
five hundred feet and more,
made of marble, gleaming white,
it shines through peace and war.
A fitting way to honor one
who filled his country's needs—
a monument for Washington,
so tall in thoughts and deeds.

Lincoln Monument: Washington
by Langston Hughes

Let's go see old Abe
Sitting in the marble and the moonlight,
Sitting lonely in the marble and the moonlight,
Quiet for ten thousand centuries, old Abe.
Quiet for a million, million years.

Quiet—

And yet a voice forever
Against the
Timeless walls
Of time—
Old Abe.

I Have a Dream

Words and Music
by Teresa Jennings

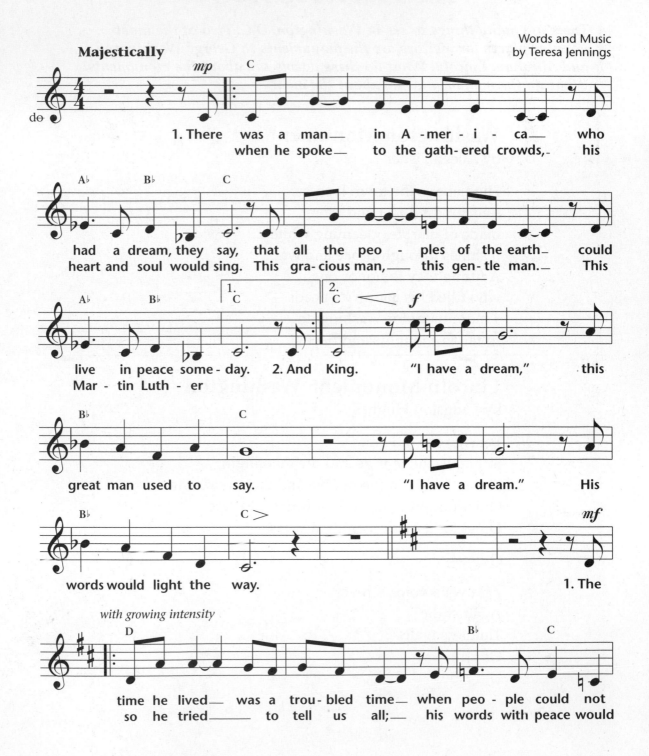

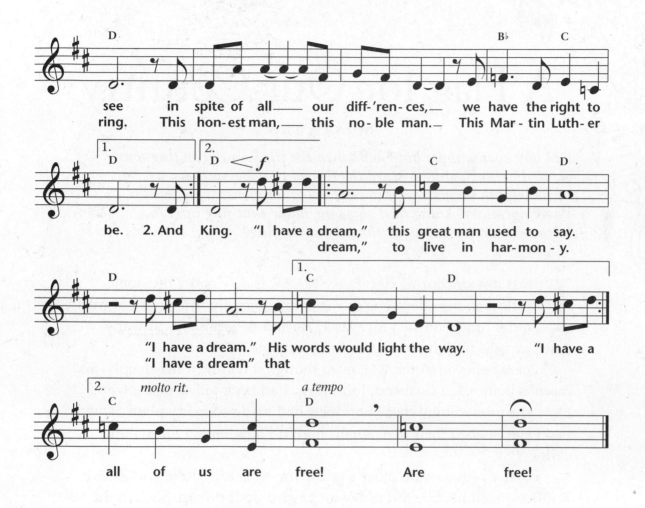

see in spite of all___ our diff-'ren-ces,___ we have the right to
ring. This hon-est man,___ this no-ble man.___ This Mar-tin Luth-er

be. 2. And King. "I have a dream," this great man used to say.
dream," to live in har-mon-y.

"I have a dream." His words would light the way. "I have a
"I have a dream" that

all of us are free! Are free!

© 1990 Plank-Road Publishing, Inc.
Used by permission. All rights reserved.

A Flag for Our Country

by Eve Spencer

Did you ever wonder how and when the first American flag was created? Maybe you've heard the legend that Betsy Ross, a Philadelphia seamstress, sewed the flag for General George Washington. We know that <u>someone</u> made that flag in 1776. What else do we know for sure about the flag?

It was a warm spring day. Betsy Ross was sewing by the open window in her shop. The day seemed quiet. But this was not really a quiet time. For the year was 1776, and America was at war. America was fighting to be free from England.

Betsy believed in the war, even though it had hurt her deeply. Six months before, her husband, John Ross, had been killed in the war. How she missed him! Betsy and John had made so many plans. They had even opened their own small shop in Philadelphia for making clothes.

Betsy's father wanted her to close the shop after John was killed. But Betsy said no. She did not want to give up the shop. She would run it alone.

There is a story about what happened to Betsy on that spring day in 1776.

Early that afternoon, the door of Betsy Ross's shop opened. She looked up from her sewing, amazed to see General George Washington in her shop. Behind him were Robert Morris and her uncle, George Ross.

General George Washington was the leader of the American army. He was a great hero. But most people were a little afraid of him.

Betsy Ross greeted the three men with a curtsy. She was thrilled that General Washington was in her shop. But why had he come?

Then the General spoke. He said that he and the men had come to ask her a favor. They wanted her to make a flag.

George Washington told Betsy Ross that this would be different from any other flag. This would be the first flag of the new nation, the United States of America.

There had been other American flags before. But now, things were different. America was no longer a part of England, and General Washington wanted a flag that showed America to be free.

Betsy Ross listened to George Washington. She had no idea how to make a flag. But she wanted to help win the war. And she wanted to say yes to General Washington.

"I can try," she told the General.

Betsy Ross led the men to the room in back of the shop. All eyes were on General Washington as he unfolded a drawing of the new flag. The flag had 13 red and white stripes. In the corner of the flag were 13 stars. The stars were in no real order. Each of the stars had six points.

Betsy looked at the drawing. The 13 stars and 13 stripes stood for the 13 American colonies. It would be a good flag, she thought. But it could use a little work.

Now, someone else might have been afraid to say anything to General Washington. But not Betsy Ross. She suggested that the stars would look better in a circle.

And another thing about the stars, she said. A star with five points would look better than a star with six points. General Washington thought so, too. But wouldn't a five-pointed star be harder to make? he asked.

"Nothing easier," Betsy said. She folded a sheet of paper a few times. Then she took just ONE SNIP with her scissors and unfolded the paper. Betsy had done an amazing thing. She had cut a perfect five-pointed star!

A smile spread across General Washington's face. Then and there he sat down at the desk and redrew the flag. Now the stars were in a circle. Each star had five points. This was the flag Betsy would make.

Betsy worked hard for a week. She borrowed an old flag to see how it was made. Then she bought some thread and bunting. Bunting is a cloth used for making flags.

First, Betsy cut out 13 five-pointed stars with one snip each. Then, with small, straight stitches, she sewed the stars onto a piece of blue

bunting. It was not easy. Betsy sewed and resewed the stars until they were perfect.

The stripes were not as hard to make. But she had to sew them many times to make sure they would stay together.

At last, Betsy Ross was pleased with her flag. She hoped that the General would be pleased, too.

And he was. In fact, he liked it so much he wanted her to make more flags.

This was good news. Now she would have work for a long time.

Long after the war had ended, Betsy Ross often told the story of the first flag to her children and grandchildren. And for many years, Betsy's family were the only people who knew the story.

Then, in 1870, Betsy's grandson, William Canby, made a speech about it. He thought what his grandmother had done was important.

Many people believed the story about the first flag. But other people weren't sure. The story was almost one hundred years old when William made his speech. And in telling the story, William could only say what he remembered hearing.

William tried to show that the story was true. He looked for proof. But he could not find any. There was only the family story.

We may never know whether or not Betsy Ross made our first flag. History keeps some secrets forever. But we do know Betsy Ross loved her country. And we know our flag still flies over a free nation.

Discovering Our Past

How Hawk Stopped the Flood with His Tail Feather

A Tsimshian folk tale retold by Gerald Hausman

This tale comes to us from the Tsimshian people. It tells how Hawk saved the land, first from having too little water, and then from having too much! What is special about Hawk in this story? Why do you think water was so important to the first Americans?

Now there was once a person named Water Monster.... The animal people were much afraid of her because it was she who controlled all the water in the land.

Every morning when she woke, she said: "Give me some water!" And the animal people had to run to the river, fill up their water jars, and rush them back to Water Monster.

Well, one day the river went dry. Badger complained to Weasel about it. "Now we have to walk all the way to the lake to get Water Monster's drinking water."

Weasel agreed, "That one is never satisfied."

Badger groaned, "Soon there will not be any water left."

"Then what will be done?" Weasel wanted to know.

And the day came when the lake did go dry The sun came up in the east and went down in the west, but it did not rain anymore. The sky was hot and there were no clouds. The animal people were fearful. Something terrible, they felt, was going to happen.

"Water Monster's to blame for this," Pine Marten said.

"What can we do?" Weasel persisted.

"I know," said Redbird. "We can send Wolf, the Big Wanderer, over the mountain to see if there is any water on the other side."

All agreed that this was a good plan. So Wolf was called and told what to do, and he went off with a smile on his face. However, Wolf did not come back.

"He moves like the rain," Redbird explained, "sometimes here, sometimes there. Hardly ever where you want it."

Weasel, who was always worried, added: "Maybe Water Monster drank him down."

"I do not think so," Little Hawk told them. "Your scout, Wolf, just got tired of looking, and he went away. He is selfish, that one."

"What do we do?" Weasel mumbled nervously.

None of the animal people seemed to know. So they sat in a circle and looked up at the sky. It was then that Mother Earth appeared in a garment of spotted clouds, with blue arrows of lightning on it.

"Do not fear," she told the animal people. "Someone among you has a special gift, and this gift will bring the water back."

"Who is this person?" questioned Redbird.

"He is the one with four black marks on his tail," Mother Earth replied. "Four marks for the four seasons of the year."

Right away, all the animal people looked at their tails.

Raccoon counted. "I have six marks."

"Too many," said Redbird.

"I have two," counted Skunk.

"Too few," said Redbird.

Bobcat said, "I have none."

"Too bad," said Redbird.

Then Little Hawk flew overhead. All the animal people looked up.

"Do you not see?" Mother Earth asked. "Little Hawk is the one who will set things right."

And so the animal people gave Little Hawk the honor of being named the Scout of the Sky; for though he was not as large as Raven, nor as bold as Eagle, he was the only one with a four-marked tail. Then he flew all over the earth, looking for something. After a while, he came upon what looked like a swamp that breathed; it was as tall as a mountain and it smelled quite foul.

"I will put an end to it," Little Hawk said to himself, and he shot an arrow into the side of it. That was the end of Water Monster. But then Little Hawk flew down to retrieve his arrow. As he pulled it out, a flood came out of Water Monster's belly. The water filled the whole valley.

Then the animal people had to climb to the top of the highest mountain to keep from being drowned.

"Little Hawk has caused this terrible flood," Redbird cried.

"Patience, children," Mother Earth said. "Put your faith in Little Hawk, and he will see you through this difficult time."

So the animal people promised to have faith in Little Hawk. But Redbird said to him, "What can you do to make the flood go away?"

Little Hawk dropped out of the sky and plucked one of his four-marked tail feathers. "The flood," he said, "shall go no farther than this." He planted his tail feather on top of that mountain, and his feather was his faith.

The flood rose to the fourth mark on that tail feather, and went no farther; then it began to recede. After this, the animal people praised Little Hawk. They said a good many things about him, all of them very fine. And Little Hawk took the feather out of the mountaintop and put it back in his tail. The flood was gone, the rivers and lakes were full of water; and Little Hawk, to this day, is still called the Scout of the Sky, in honor of his watchfulness.

It Is I, the Little Owl

Chippewa Song

From SONGS OF THE CHIPPEWA, adapted from the collections of Frances Densmore and Henry Rowe Schoolcraft, and arranged by John Bierhorst
© 1974 John Bierhorst

Columbus Day

by Paul Showers

You have learned about the explorer from Europe named Christopher Columbus. This is a part of his life story. It tells about Columbus's love for the sea and the journey that brought him to America in 1492. If you could talk to Columbus today, what would you like to ask him?

Every day ships with big white sails came from faraway places to the city of Genoa in Italy. A boy named Christopher sometimes stood on the pier, with the wind blowing in his hair and the gray gulls flying overhead, and watched the ships. He liked to watch the sailors as they worked, and when they sailed away again, it made him sad to see them wave goodbye. He wanted to go with them.

Christopher's father was a weaver. He had a shop in Genoa where he made cloth on looms. Christopher worked in the shop, but he didn't like weaving nearly as much as he liked the sea.

In a few years Christopher was old enough to get a job on a ship. Then he began making long trips to faraway ports. By the time he was a man he had become a very good sailor. He was not afraid of danger and he knew how to handle a ship in all kinds of weather. He left Genoa and went to live in the city of Lisbon in Portugal. Merchants hired him to be the captain of their ships and to go on long voyages. Now he was called by his full name—Christopher Columbus.

In those days many merchants traveled to China, Japan and India. They called these countries the Indies. There they bought gold, pearls, spices and fine silk cloth.

It was a long and dangerous journey to the Indies. There were robbers and wild animals along the way. The merchants went in caravans over high mountains and hot deserts. Always they went east toward the rising sun.

Columbus wanted to go to the Indies, too, but he thought there was a better way to get there. He had read many books and had studied maps. He knew the world was round.

If you can go east around the world and reach the Indies, why can't you go west around the world and reach them too, he asked. It would be easy to sail west across the ocean toward the setting sun. It would be quicker, too, he thought.

Columbus gathered up his books and maps and went to see the King of Portugal. He explained his plan and asked the King to help him buy some ships. The King called in his wise men. They listened to Columbus and looked at his maps. Then they shook their heads. Nobody had ever done such a thing before, they said.

Next Columbus went to see the King and Queen of Spain. Again he brought out his books and maps and begged the King and Queen to help him. At last they agreed that Columbus might be right, and they gave him money to pay for three ships and to hire men to sail them.

The ships were the *Santa Maria*, the *Nina* and the *Pinta*. They were small, but they were sturdy and fast. In September Columbus started to sail west across the ocean. It was the year 1492. No one on board the three little ships knew what was ahead, for none of them had ever sailed that way before. But Columbus said this was the way to go to the Indies. And everybody hoped he was right.

The sun shone brightly and the sea was calm. The ships raced along smoothly in a steady wind. Day after day went by. A week passed. Then a second week. And a third.

The sailors could see nothing but water. Land was far behind them. Little by little they began to be afraid. None of them had ever been so far from land before. They grumbled. They said they had gone far enough and that it was time to turn around. But Columbus would not turn back.

Some of the men began to talk secretly among themselves. They wanted to push Columbus overboard. They could say he had slipped and had fallen into the sea. Then they could turn the ships around and head for home.

Columbus knew the men were against him, but he kept sailing west. He was sure he would find land. He scolded the men for grumbling. Then he cheered them up by talking about the gold and the pearls they would find when they reached the Indies.

Every day the sailors kept watch. One evening as the sun was setting one of the men thought he saw land. Everybody shouted for joy. Even Columbus kneeled on deck and said a prayer of thanks. But it was not land. It was only some low clouds in the distance.

The birds helped the men keep up their courage. Almost every day, sea birds flew over the ships. Whenever the sailors saw them, they felt better. They were sure land could not be far away if there were birds.

The last day of September, which was Sunday, eight birds flew over. On Monday and Tuesday they saw more birds. But on Wednesday they counted only a few. The sailors were afraid they had been near an island and had passed by. They begged Columbus to turn back, but he would not. He kept on sailing west.

Another day passed and another. The food and water were almost gone. On October 7 there was a great shout and everybody rushed to look. Again a sailor thought he saw land ahead. But again it was only clouds. The men were more frightened than ever.

Then a wonderful thing happened. Suddenly out of the sky from the north came thousands of birds. They were strange birds with many different colors and markings. All day they passed over the ships in great flocks.

Columbus watched them carefully. They made him think of the little birds that sang in the fields back home. They were land birds and they were flying to the southwest.

That day for the first time the ships changed direction. They turned from the west to the southwest. Columbus had decided to follow the birds.

That night he and his men got little sleep. They watched the sea ahead. There was a bright moon and against it they could see the flying birds. But the next morning there was no land in sight, only waves stretching to the horizon. Some of the birds settled down on the ship to rest.

Early the next morning there was a shout from a sailor on the *Pinta*. Land! Land ahead! The captain of the *Pinta* fired off a gun as a signal.

This time it was no false alarm. As the sun rose, the sailors saw an island before them with white sandy beaches and green forests. It was the morning of October 12. . . .

Yankee Doodle

Traditional

Appears in MUSIC AND YOU, Book 5, Barbara Staton & Merrill Staton, Senior Authors.
Copyright © 1988 Macmillan Publishing Company, a division of Macmillan, Inc.

...If You Grew Up With George Washington

by Ruth Belov Gross

George Washington was born in 1732. What would it have been like to grow up with him? The questions and answers that follow describe what it was like to live when our country's first President was a boy. How was life different then?

What kind of house did George Washington live in when he was a little boy?

George Washington was born in a farm house. His family moved to another farm when he was three years old. They moved to a third farm when he was almost seven.

There were cows and pigs and chickens and dogs and horses on each farm. There were fields of corn and wheat and tobacco. And at the edge of the farm there was a river.

The houses that the Washingtons lived in are not there anymore, and nobody knows exactly what they looked like. They were probably ordinary farm houses. They might have had four rooms downstairs and two rooms upstairs. They did not have bathrooms or kitchens in them. . . .

What kind of school did George Washington go to?

Most likely George Washington went to a school near his farm. He probably went there from the time he was seven or eight years old until he was eleven or twelve—but nobody knows for sure.

What would you learn in school?

Farm children usually learned to read a little, write a little, and do some arithmetic. Boys were likely to go to school longer than girls, and they were more likely than girls to study arithmetic. . . .

94

Were there any Indians?

There were Indians in Virginia long before the English colonists lived there.

By the time George Washington was born, nearly all the Indians were in the western part of Virginia. So he did not see many Indians when he was growing up.

Most likely the Indians showed the first colonists how to grow corn and watermelons and sweet potatoes. The colonists learned from the Indians how to preserve pork by smoking it, how to make bread out of corn, and how to make medicines out of plants.

At times the Indians and the colonists were at war. When George Washington was in his twenties, he led a group of soldiers across the mountains to fight the Indians and the French in the French and Indian War. . . .

Could you hear the news on radio or TV?

No. Radio and TV were not invented until about two hundred years after George Washington was born.

Just a few years after George Washington was born, though, a man in Williamsburg started the first newspaper in Virginia. His paper was called *The Virginia Gazette*. It came out once a week.

Williamsburg was the biggest town in Virginia. The people who lived there could read the newspaper as soon as it came out. In other parts of the colony, people had to wait until special messengers on horseback could bring it to them.

How did people get their mail?

When you had a letter to send, you would take it to the nearest tavern and put it on a table. In a tavern, people were always coming and going. If someone was going in the right direction, he would probably take your letter with him. . . .

When George Washington was still very young, a post office was opened in Virginia. But for many years the post office wasn't much help in getting the mail around. People still thought that the best way to mail a letter was to leave it at a tavern.

What kind of money did people use in Virginia?

Sometimes the people used English money—pounds and shillings and pence. There wasn't much English money around, though.

Sometimes they used money from other countries. They used

gold and silver coins from Spain and France and Portugal. There wasn't a lot of that money around, either.

Most of the time the people in Virginia used tobacco instead of money. There was plenty of tobacco in Virginia. Everyone knew they could send tobacco to England and sell it. So having tobacco was as good as having money.

You could buy a horse with tobacco. You could pay the doctor with tobacco. You could pay your taxes with it. And if you broke a law and had to pay a fine, you could pay the fine with tobacco.

If you killed a wolf around your farm, you would get fifty or one hundred pounds of tobacco as a reward.

How did people carry their tobacco around?

People did not drag barrels of tobacco around with them. They didn't have to. All they needed was a special piece of paper that said the tobacco was in a warehouse.

As long as you kept the piece of paper, the tobacco was yours. As soon as you gave the paper to someone else, the tobacco belonged to that person.

Who made the laws for the colony?

The people of Virginia made their own laws. But the King of England could veto any law he didn't like.

The laws were made in the town of Williamsburg. Every two years, the voters in each county picked two people to go to Williamsburg and help make the laws.

Election time was like a holiday. Just before the election, the people who wanted to get elected would give parties for the voters.

Then, on election day, the voters would gather at the court house in their county. They came to see their old friends, to hear the latest news, to have fun, and to vote.

When it was a person's turn to vote, he walked up to a long table. The sheriff would be sitting at the table, and so would the people who wanted to be elected.

"And how do you vote, sir?" the sheriff would ask.

In a voice that everybody could hear, the voter would call out the name of the man he was voting for.

The man would stand up and bow. Then he would say something like this: "Thank you, sir. As long as I live I will treasure your vote in my memory."

People crowded around so they could see who was winning the election and who was losing. They would shout when they liked a vote, and they would boo when they didn't.

After the election, the winners were expected to give another party. . . .

What were some of the laws in Virginia?

One law said that people in Virginia had to go to church. Even so, many people didn't go unless they felt like it. Sometimes they went to church just to see their friends.

It was against the law to swear. Gambling was not against the law, but it was against the law for people to cheat or fight when they gambled.

Another law said that people had to keep their pigs and goats from running loose in town.

People were usually punished when they broke a law. Sometimes they had to pay a fine. Sometimes they got a whipping. If they murdered somebody, or if they stole a horse, they might be put to death.

Did they have doctors when George Washington was a young boy?

Yes. But there weren't many doctors. In those days, there were no schools in the colonies where you could learn to be a doctor.

A boy who wanted to be a doctor usually left home and went to live in a doctor's house. He watched the doctor and helped him. By the time he was twenty-one years old he could call himself a doctor.

There were some fake doctors too. These were people who said they had all kinds of secret ways to cure anything.

Mostly, though, people in Virginia took care of themselves when they were sick. Many families had a book called *Every Man his own Doctor.* They would read the book and do what it told them to do. . . .

What happened when you got sick?

. . . Babies and children died because no one knew about germs in those days. They did not know it was important to have clean food and water. They did not have shots to keep children from getting sick or the medicines we have to make people well.

But George Washington lived a long and healthy life. When he was fifty-seven years old he became the first President of the United States.

He was President for eight years. Then he went home to Mount Vernon, his beautiful plantation in Virginia. He died there in 1799. He was sixty-seven years old.

Harriet Tubman

by Polly Carter

This biography tells about Harriet Tubman, who grew up in slavery but became a symbol of freedom. Once, when she was young, Harriet ran away but only made it as far as a nearby pigpen. Listen to hear what happened to her next. What special qualities did Harriet Tubman have?

Harriet's Escape

Harriet did not want to be a slave all her life. "I will run away again. Next time," she said, "I'm going to go farther than the pigpen."

Her father told her, "Only the Southern states have slaves. If slaves run away and get as far north as Pennsylvania, they can be free."

"But the slave catchers are always watching. Runaway slaves have to hide by day. They have to travel north by night. They use the North Star to guide them," her mother said in a hushed voice. "They also use the Underground Railroad."

"What's the Underground Railroad?" Harriet wanted to know.

Her father answered, "It's not a real railroad. It's the name for secret paths north. The slave catchers do not know about these secret paths. Some people help slaves escape by the Underground Railroad. Their houses are called 'stations.'"

"Maybe one day I'll be a 'passenger' and escape by the Underground Railroad," Harriet thought.

When Harriet was twenty-four years old, she decided to go north.

"Will you come with me?" she asked her family.

They were afraid. They knew that slaves who ran away were often beaten or shot. No one would go north with Harriet.

Harriet set out alone. She walked all night through the woods. The North Star helped her find her way.

Her first stop was nearby, in Bucktown. Harriet knew a white woman there. One day, the woman had whispered to Harriet. The

98

woman had said that she was a "conductor" on the Underground Railroad. Harriet was sure the woman would help her escape.

"Here I am," Harriet said. "I ran away last night."

"Quick, take this broom and sweep the yard," said the woman. "This way, people will think you're my slave. You will be safe here!"

That night, the woman's husband hid Harriet in his wagon. He drove her to the next town. He told her how to find the next station. Her trip on the Underground Railroad had begun.

For a long time, Harriet traveled by night. She slept during the day. She slept in attics, in haystacks, or in potato cellars.

On cloudy nights, she couldn't see the North Star. She knew that moss grows on the north side of a tree. She felt the trees to find moss. The moss showed her the way north.

Finally, she reached Pennsylvania. She was free.

"I looked at my hands to see if I was the same person, now that I was free," she said later. "There was such a glory over everything. The sun came like gold through the trees and over the fields, and I felt like I was in heaven."

The Underground Railroad

"I was free," Harriet said, "but there was no one to welcome me to the land of freedom. My home was down with the old folks and my brothers and sisters. But I was free, and they should be free. I would make a home in the North, and with the Lord helping me, I would bring them all there."

Harriet knew the slave catchers were always watching for her. But she went back to the South to get her family anyway. She became part of the Underground Railroad. The first slaves she led to freedom were her sister and her sister's family.

But even Pennsylvania wasn't safe for long. There was a new slave law. All runaway slaves had to be sent back to their masters. Anyone who helped a runaway slave could be put in jail.

"We'll send our passengers north to Canada," Harriet said angrily. "In Canada, they'll be safe."

People who owned slaves wanted to stop Harriet. She was in danger every minute. But she kept going back to free more slaves. Sometimes she dressed as a man. Sometimes she wore a veil to hide her face.

Sometimes she played tricks. Once, she was sitting in a train station. There was a poster that told about her. It said that she had a scar. It also said that the person who found her would get a lot of money.

A man pointed at Harriet. He said, "She could be the woman the poster tells about."

Harriet couldn't read, but she picked up a book and held it open in front of her face.

"No, it can't be her," said another man. "The poster says Harriet Tubman can't read or write."

Another time, Harriet was walking down the street. She saw her old master. She had to think quickly.

She let go of the chickens she was holding. Then she bent down to chase them. She ran around in circles after the chickens. Her old master laughed. He did not see Harriet's face. He was too busy watching the chickens.

Harriet helped more than three hundred slaves escape by the Underground Railroad.

"On my Underground Railroad, I never ran my train off the track, and I never lost a passenger," she said. And she never got caught.

The Civil War

War broke out between the northern and southern states. Harriet became a nurse. She took care of wounded northern soldiers. She took care of southern soldiers, too.

Harriet still wanted to help slaves escape to freedom. She became a spy for the northern army. She went with northern soldiers to rescue slaves.

After four years, the North won the war. Slavery ended. All slaves were now "forever free."

Harriet became a symbol of freedom. She fought for what she knew was right. And she won her fight.

Aurora Means Dawn

by Scott Russell Sanders

As the east coast of the United States became more populated, families, traders, and other adventurous pioneers moved westward in wagons to make homes on the vast new lands. This story shows some of the challenges and uncertainty that faced one family who moved to the territory of Ohio, which became a state in 1803. How would you feel if the village you traveled so far to find turned out to be only a post with a red streamer?

When Mr. and Mrs. Sheldon reached Ohio in 1800 with seven children, two oxen, and a bulging wagon, they were greeted by a bone-rattling thunderstorm. The younger children wailed. The older children spoke of returning to Connecticut.

The oxen pretended to be four-legged boulders and would budge neither forward nor backward, for all of Mr. Sheldon's thwacking. Lightning toppled so many oaks and elms across the wagon track that even a dozen agreeable oxen would have done them no good, in any case.

They camped. More precisely, they spent the night squatting in mud beneath the wagon, trying to keep dry.

Every few minutes, Mrs. Sheldon would count the children, touching each head in turn, to make sure none of the seven had vanished in the deluge.

Mrs. Sheldon remarked to her husband that there had never been any storms even remotely like this one back in Connecticut. "Nor any cheap land," he replied. "No land's cheap if you perish before setting eyes on it," she said. A boom of thunder ended talk.

They fell asleep to the roar of rain.

Next morning, it was hard to tell just where the wagon track had been, there were so many trees down.

Husband and wife tried cutting their way forward.

After chopping up and dragging aside only a few felled trees, and with half the morning gone, they decided Mr. Sheldon should go fetch help from Aurora, their destination.

On the land-company map they had carried from the East, Aurora was advertised as a village, with mill and store and clustered cabins. But the actual place turned out to consist of a surveyor's post topped by a red streamer.

So Mr. Sheldon walked to the next village shown on the map— Hudson, which fortunately did exist, and by morning he'd found eight men who agreed to help him clear the road. Their axes flashed for hours in the sunlight. It took them until late afternoon to reach the wagon.

With the track cleared, the oxen still could not move the wagon through the mud until all nine men and one woman and every child except the toddler and the baby put their shoulders to the wheels.

They reached Aurora at dusk, making out the surveyor's post in the lantern light. The men from Hudson insisted on returning that night to their own homes. Ax blades glinted on their shoulders as they disappeared from the circle of the campfire.

Huddled together like a basketful of kittens, the children slept in the hollow of a sycamore tree. Mr. and Mrs. Sheldon carried the lantern in circles around the sycamore, gazing at this forest that would become their farm. Aurora meant dawn; they knew that. And their family was the dawn of dawn, the first glimmering in this new place.

The next settlers did not come for three years.

How My Family Lives in America

by Susan Kuklin

Americans come from many different places. Eric's family comes from Puerto Rico, an island that is part of the United States. Eric tells about how he and his family live in New York City. How does your family live in our country?

My name is Eric. I live in a tall apartment building in New York City with my mommy and daddy and our pet parrot called Pepí.

My daddy and all my grandparents came to New York from Puerto Rico. Daddy showed me how to find Puerto Rico on a map. It is an island in the ocean not too far from Florida. Mommy, Pepí, and I were born in New York City.

When Daddy comes home from work we play our favorite sport, baseball. It's hard to catch the ball when I wear my heavy winter jacket. Last winter Mommy and Daddy took me to Puerto Rico for a vacation. I learned lots of things about my heritage.

Daddy grew up where there are palm trees, like in Florida. And it is warm every day in Puerto Rico, so warm that people can always play baseball without a jacket. Everyone in Puerto Rico speaks Spanish, just like my grandparents.

In our home we speak two languages, English and Spanish. Even Pepí speaks English and Spanish. My friends, Irma and Glen, speak Spanish, too. They come from another island called the Dominican Republic. If you come from a place where the people speak Spanish, you are called a Hispanic. We call ourselves Hispanic Americans because part of us is Spanish and part of us is American. In my city,

there are lots of Hispanics from many different countries, but they all speak the same language, Spanish.

Sometimes Irma and Glen stop by to help me with my chores. We clean beans, then set them in a pot of water overnight to make them soft. Then Mommy shows me how to crush garlic for *sofrito* (so-frée-to), which is a mixture of Spanish spices that will go into the bean pot.

The next night, Mommy, Daddy, and I have our favorite dinner, *arroz con pollo y habichuelas* (a-rós kom bóy-jo ee a-bich-wél-as). It's rice with chicken and beans. Mommy and I are good cooks.

When my parents are at work, my mommy's mommy, Nana Carmen, takes me shopping at the *carniceria* (kar-nees-eriá, rhymes with Maria), the Spanish meat market. I get to pay.

"*Muchas gracias*" (móo-chas gráss-ee-as), the grocer says to thank me. To answer, I say "*De nada*" (day natha), which means "don't mention it."

My Nana Carmen visits me every single day. At bedtime she comes to our home just to kiss me good-night. Sometimes she shows me her tiny hurts so I can tell her my special Spanish healing poem:

Sana, sana, sana (sah-na)	Heal, heal, heal
Si no te curas (see no tay kóoras)	If you don't heal
hoy, (oy)	today,
Te curas (tay kóoras)	You'll heal
mañana. (man-yá-na)	tomorrow.

Then I say my prayers to my guardian angel just like my mommy and daddy did when they were little. Nana Carmen says the guardian angel watches over children and keeps them safe while they sleep. When Mommy is home from work, she plays Spanish music on the stereo. Then my friends, Mommy, and I dance the *merengue* (me-rén-gay). When we hear the music we shake our hips and move to the beat: one-two, one-two. In Spanish we count like this: *uno* (oono), *dos* (sounds almost like toast).

In my family, next to baseball, we love Spanish dances best. When my *madrina* (ma-dreé-na), that's my godmother, stops in for a visit, she dances with us. Sometimes Daddy, Nana Carmen, and my friends' mommy join in.

And Pepí sings, "¡MERENGUE!"

People, Places, and Holidays

Mary McLeod Bethune

by Eloise Greenfield

This story is taken from a biography of Mary McLeod Bethune written by award-winning writer Eloise Greenfield. Mary McLeod was born in 1875. She did not get the chance to go to school until she was eleven years old. She went on, however, to become a teacher and start her own school. She made life better for many people. What do you think was special about Mary McLeod that allowed her to do so much?

The sun had just come up when Mary Jane McLeod left the house with her mother and father and her brothers and sisters to go to the fields. Every morning, the whole family had to get up very early to work on the farm. But they didn't mind. The farm belonged to them. It gave them vegetables to eat and cotton to sell.

Mary knelt on the ground and pulled the weeds from around a head of cabbage. She had pulled weeds so many times before that she didn't have to think about it with her whole mind. She used part of her mind to think about her favorite dream. She thought about one day being able to read, and about having her own book and going to school.

Where Mary lived, near Mayesville, South Carolina, there were no schools for black children. She had been born there, not many years after the slaves were freed. No one in her family could read. During slavery, it had been against the law and very dangerous for anyone to teach slaves to read. Some black people had gone to secret hiding places to study and learn, but many had not been able to do that....

...Mr. and Mrs. McLeod were both slaves on the same plantation. Their first fourteen children were slaves, too. They had to work on other people's farms and clean other people's houses and wash other

people's clothes, all without pay. They were not happy. They wanted a place of their own where they could work and live in freedom.

Several years after the law against slavery was passed, Mr. and Mrs. McLeod were able to start their own farm. Mr. McLeod and his sons went into the woods and cut down trees to get logs. They built a four-room log cabin for the family.

Mary was born in the log cabin on July 10, 1875. She was the fifteenth child and two others were born later. Mary loved the farm. When she was very small, her father let her ride on the back of Old Bush, the mule with the bushy tail, as he pulled the plow. When she was a little older, she weeded the vegetables and picked cotton. In the house, she swept the floor and washed and shined the kerosene lamps and helped take care of the younger children.

Every morning and evening the family stood in front of the fireplace and said prayers and sang hymns together. After dinner, the children gathered around their mother as she sat in her favorite chair and told them true stories about Africa and talked about the Bible.

Listening to the stories, Mary wanted even more to be able to read. She talked about reading all the time. She told everybody in her family over and over that she didn't know how but someday she would learn to read.

One day when Mary was eleven years old, Miss Emma Wilson, a black teacher, came with the answer. She told Mary's parents that the Presbyterian Church had sent her to Mayesville to start a one-room school for black children.

Mr. and Mrs. McLeod wanted all of their children to go to school, but there was too much work to be done on the farm. Only one could go. That one, they decided, would be Mary.

On the first day of school, Mary left home early, carrying her lunch in a tin bucket. The school was five miles away, but she was happy to walk each mile. Every step was taking her closer to something that she had wanted for a long, long time.

Miss Wilson was a good teacher and Mary was a good student. She studied hard every day, and soon she could read short words and work arithmetic problems. In the evening, she taught her family what she had learned in school. Sometimes neighbors would ask her to read their mail for them or figure out the money they should get for selling their cotton. A few years later, Mary was graduated from Miss Wilson's school. Her parents sat with the others who had come to hear their

children recite and sing on their last day there. Mary received a scholarship to Scotia Seminary, a school for black girls in Concord, North Carolina. The scholarship meant that she would not have to pay.

Mary was nervous about leaving her family for the first time and taking her first train ride. But she was excited, too. Her mother made a dress for her out of a piece of cloth that was pretty, although it wasn't new. Neighbors knitted stockings and crocheted collars as gifts. They made some of their dresses over to fit Mary. . . . Mary was going off to get an education. . . .

Mary had classes in mathematics, languages, history, geography, and the Bible. She learned about people who lived in other countries and about people who had lived many years before. She learned about islands and oceans and mountains. . . .

On graduation day, no one in her family was in the audience. They could not afford to pay the train fare. But Mary knew that they were proud of her and happy for her. She had received another scholarship, this time to Moody Bible Institute in Chicago, Illinois.

Moody Bible Institute would teach Mary to be a missionary. She believed in the Christian religion and wanted other people to believe in it, too. She wanted to teach Christianity, especially in Africa. . . .

By the time Mary finished her work at Moody, she had grown up. She was a woman now, rather large, with smooth dark skin. She had learned all that Moody could teach and was ready to be a missionary. But she had a very unpleasant surprise. She could find no openings for a black missionary in Africa.

Mary went home to Mayesville. During the years that she was in school, she had not often been able to return home, and she was glad to see her family. But she was disappointed to have to go back home without the job she had studied so hard for. She helped Miss Wilson in Mayesville School until she got a job as a teacher at Haines Institute in Augusta, Georgia. . . .

Most of what Mary earned she sent home to her family. She helped to pay for the education of her younger sisters and to buy her parents a new home. Their old one had burned down.

A few years after she began teaching, Mary met Albertus Bethune, also a teacher, who became her husband. The following year, their son, Albert, was born.

When Albert was five years old, Mary Bethune made a big decision. She wanted to start a school of her own. . . . There were many

black children like her who lived in places without schools. They had questions but no answers. They wanted to learn and she wanted to teach them.

She heard about Daytona Beach, Florida, where a new railroad was being built. . . .There were no schools. Mrs. Bethune decided that she would go there.

When Mrs. Bethune arrived in Daytona Beach, she had only one dollar and fifty cents. She stayed with a friend and every day she went for a walk, looking for a building that she could use as a school. Finally, she found an old two-story cottage. The owner said he would rent it to her for eleven dollars a month. He agreed to wait a few weeks until she could raise the first month's rent.

Mrs. Bethune visited the homes of black families, telling them about her school. Neighbors came to paint the cottage and to fix the broken steps. Children helped with the cleaning.

On an autumn day in 1904, Mrs. Bethune stood in the doorway of the cottage, smiling and ringing a bell. It was time for school to start. Five little girls came in and took their seats. The school was named the Daytona Normal and Industrial School for Girls. It was an elementary school, and Albert would learn there, too, until he was older.

Mrs. Bethune and the students used wooden boxes as desks and chairs. They burned logs and used the charcoal as pencils. They mashed berries and used the juice as ink.

The children loved the school. Some of them lived there with Mrs. Bethune. All of them wanted to help raise money for the rent and for the books and paper and lamps and beds that they needed.

After classes, they made ice cream and pies to sell. The children peeled and mashed sweet potatoes while Mrs. Bethune rolled the crust. They gave programs at hotels and in churches. The children sang and recited. Mrs. Bethune spoke to the audiences about the school. She bought a secondhand bicycle and rode all over Daytona Beach, knocking on doors and asking people for their help.

Many people gave. Some of them were rich, and some of them did not have much money themselves but were willing to share the little that they had.

When too many children wanted to attend and a larger building was needed, adults in the community again gave their time and work. They took away the trash from the land that Mrs. Bethune bought. Those who were carpenters helped to put the building up. Those who

were gardeners planted flowers and trees around it.

Mrs. Bethune named the new building Faith Hall in honor of her favorite building at Scotia Seminary. She had faith in God, in herself, and in black people. Over the door she hung a sign that said "Enter to learn...."

Mrs. Bethune did not spend all of her time at school. She joined groups of people who were working for the rights of black men, women, and children. She wrote articles for newspapers and magazines. She traveled across the United States making speeches about the need for public schools, jobs, houses, and food....

Mrs. Bethune was asked by President Franklin D. Roosevelt to live in Washington, D.C., and work with the National Youth Administration. She did not want to leave her school, but she knew she was needed for this special job. She moved to Washington and was in charge of finding jobs for young blacks all over the country....

After eight years, she returned to her home....Not many years later, Mrs. Bethune had to stop working. She was sick more often and her heart was weak....

In 1955 at the age of seventy-nine, Mary McLeod Bethune died.... She was buried on the grounds of the school she loved....

In her will Mrs. Bethune left a message for black people. She said that they must believe in themselves and help each other. She said that it is through learning that children grow up to be strong men and women. She said that children must never stop wanting to build a better world.

On a hot summer day, nineteen years after Mrs. Bethune's death, thousands of people gathered in a park in Washington, D.C., in her memory. They watched as the large cloth covering a tall statue was lifted for the first time.

The statue is of Mrs. Bethune. She is handing her will to a girl and a boy. Some of the words from the will are written on the base of the statue. People from all over the world go to Washington to visit the park. Children like to play there. They run close to the statue and walk all the way around it to read the last words of Mary McLeod Bethune: "I leave you faith, I leave you love."

110

Grandma Moses
Painter of Rural America

by Zibby Oneal

This story is from a biography of a special American: Grandma Moses. Moses taught herself to paint when she was 76 years old. She used her favorite colors to show what country life in her time was like. By her 100th birthday she was famous for her paintings. What lessons can we learn from the life of Grandma Moses?

Grandma Moses is called a primitive painter or folk artist, meaning that she never had lessons or formal training in painting. What she knew about painting, she taught herself.

There have been many such self-taught painters in America, though few as famous as Grandma Moses became....

...She studied the pictures on greeting cards and calendars, the illustrations that appealed to her in magazines and newspapers. She especially liked lithographs of New England farm scenes that were published by Currier and Ives. These recalled her own childhood— sledding and skating, sugaring and sleigh-riding, and the many farm tasks she remembered well. They were the subjects she painted most often. She liked, she said, to paint "old-timey" things.

For some time, these illustrations were her models and she copied them closely. Sometimes she cut figures from the illustrations and pasted them right onto her own work. Other times she merely used the cutouts to help her to compose a scene, arranging them here and there on her picture, pinning them down with sewing needles until she had a composition she liked.

Then one day, she happened to glimpse the shiny hubcap of a car in her yard. In it she saw a tiny scene reflected—the house and trees and figures around her—all mirrored there in a perfect little picture.

111

This was a far better picture than any she'd been copying, she thought, and it was a scene she could see through her own window. By standing at the window and moving a little to the right or left, she could frame the scene in a number of ways. This changed her ideas about painting.

From this time on, her inspiration came from the landscape around her, though she continued to use her little cutouts as models for the figures in the paintings. She was never so comfortable with figures as she was with the countryside. In all her work, the figures remain clumsy in comparison to the soft blue hills and the yellow or green or snowy fields that are their setting.

Grandma Moses worked in her bedroom at a tip-up table that had belonged to an ancestor. Mostly she painted on Masonite board because it lasted. Before she began to paint, she found frames, then sawed the board up to fit them. A picture without a frame was like a woman without a dress, she thought. All her pictures had frames.

Next she took a big house-painter's brush and gave the board a few coats of white paint. When this dried, she was ready to pencil in a scene. Then she painted.

To create the shades she wanted, Grandma Moses mixed her paints in the lids of preserve jars. Sometimes she didn't mix them at all, but squeezed paint from the tube directly onto the brush, like toothpaste. For small details like eyes and mouths, she abandoned a brush altogether and used a pin or a matchstick. She liked to sprinkle her snow scenes with "glitter," even though experts tried to tell her that no true painter would do that. Well, why not? she wanted to know. Anyone looking at snow on a sunny day could see right away that it glittered.

Like many painters, Grandma Moses usually worked on several paintings at once. Her reasons were practical. "I squeeze out a spot of green on my palette, then I paint everything that's going to be green in the pictures I'm working on." She added, "Saves lots of paint to work this way. Don't dry up on you."

The more she painted, the surer she became in handling her materials. She liked to say that the better brushes and paints that were sent from New York City were responsible for her improvement, but in fact the more she painted the more she learned. She was teaching herself more about painting all the time.

"I never know how I'm going to paint until I start in," she wrote. She started in every day, getting up at six o'clock and painting for five or six hours. . . .

Grandma Moses had her own way of saying things, and this delighted people, too. Once, when asked about the colors she chose, she replied, "There's no gettin' away from it, certain colors fascinate me. Take this bluish green edgin' my apron. I could almost eat that color, I like it so well. . . ."

In 1941 one of her paintings, *The Old Oaken Bucket*, won the New York State Prize for painting. A year later, there was an exhibition of her work at the American British Art Center in New York City. Soon she was being invited to enter her paintings in exhibits all over New York State. . . .

Her paintings have not grown old. There are the memories of a busy country life in all the bright colors Grandma Moses loved. There are the misty blue hills of her childhood, the sleighs rushing over glittering snow. There are the ploughings and hayings, sugarings and celebrations remembered over a lifetime. There the seasons change, one following another, and the clouds drift over the curves of the earth.

"If I didn't start painting, I would have raised chickens," Grandma Moses wrote. We are lucky that she decided to paint.

Roberto Clemente

by Kenneth Rudeen

Meet a very special American, the baseball hero Roberto Clemente. A Puerto Rican whose ancestors came from Africa, Clemente worked hard to become one of the greatest players in the history of baseball. This was at a time when major league baseball was only beginning to open to black and Spanish-speaking players. Clemente also helped others, on and off the baseball field. In 1972 he died in a plane crash while bringing help to Nicaraguans who were in an earthquake. How did Roberto Clemente want to be remembered? Do you think he is remembered as he wished?

In Puerto Rico baseball was the favorite sport. Baseball players were heroes to Roberto.

Puerto Rico is one of the islands that stretch out like stepping-stones from the southern tip of Florida into the warm, blue sea. The island is beautiful, but for most of the people life is hard. In the sky the sun shines brightly. Foamy waves splash against the shore. Green mountains rise up from the sea. Birds with gaily colored feathers sing in the trees.

But men are not free to fly like birds. They must work long hours in the cities or in the fields. To be a baseball player is to be like a bird. That is a way to fly up from the hard life.

Roberto Clemente was born in the town of Carolina on August 18, 1934. The town is nestled in a valley not far from the big city of San Juan. When Roberto was growing up, there were large fields of sugar cane all around Carolina. They looked a little like the cornfields of the United States. The canes were slender and tall, growing to a height well above a man's head. They had sharp, narrow leaves that cut like a razor if you brushed against one by mistake. . . .

In Roberto's family there was no money for luxuries like new baseballs. But there was always enough rice and beans and chicken

and pork on the table. Roberto's small house, which was made of wood and had a zinc roof, stood near a grove of bamboo trees. . . .

From Monday to Friday, Roberto went to school. Often his thoughts were tugged from his books by the warm sun and gentle breezes outside the classroom window—tugged to the ball park, where someday he hoped to play.

In the meantime he had to be content, after school, with balls made of string and tape and games played in a rough clearing that was not even level.

There were other boys much better at baseball than Roberto. People did not say, "Roberto is going to be a great ballplayer." He was small and thin. He could not hit the ball as hard or throw it as far as the bigger boys of his age. . . .

While he loved baseball and played as much as he could on the field the boys used, after school Roberto always ran first to the sugar cane fields. There he met his father and rode home with him on his horse. Papa Clemente climbed into the saddle and Roberto scrambled up behind him. Then off they rode to the house with the bamboo trees. . . .

When time came for Roberto to go to high school, he was happy. The high school had a real baseball field. It had real baseballs, gloves, and masks.

Roberto played in the outfield. He had to run fast to get to balls that were hit in his direction and throw hard to keep the hitter from running to extra bases. . . .

In high school Roberto was a quiet and serious boy. "He did not want to be just an ordinary person, he wanted to be the best," one of his friends says.

Just before Roberto was graduated from high school he was chosen to play for the team in Santurce. Santurce is a town near Carolina. Roberto was paid to play baseball for this town. He did not make a great deal of money, but it was more than anyone in the sugar fields could make. . . .

Roberto wanted to be the best. He wanted to play in the major leagues. Men who look for new players for the major leagues came to see him in Puerto Rico. They saw him hit the ball hard. They saw him catch it in the outfield with sure hands. They saw him throw the ball fast and true. They saw him run swiftly.

In 1954, when Roberto was nineteen years old, he was chosen by one of the most famous teams in the National League, the Brooklyn Dodgers.

He was very happy to have this chance. The Dodgers were the team of Jackie Robinson. Jackie was the first black man to play in the major leagues. He was a wonderful player, but he had many problems with white people who did not accept black men as equals.

Like Robinson, Roberto Clemente was black. But while growing up in Puerto Rico, he did not think about the color of a person's skin. Black men and men with light skin had always played baseball together in Puerto Rico.

So while Roberto was happy, he was also scared. He was going far from home for the first time in his life, and to places where black men still were not always treated fairly.

First Roberto was sent to Montreal in Canada to play for a farm team of the Dodgers. A farm team helps prepare young players for the major leagues.

Roberto probably was good enough to be on the Dodgers. But this was still a time when there were not very many black men in the major leagues. Some people said that the major leagues did not want to have more than four black players on any one team.

The Brooklyn Dodgers already had four black players. That was one of the reasons, people said, why Roberto was sent to the Montreal farm team.

But now the Dodgers had a problem. They wanted to keep Roberto for the future, but by sending him to a farm team just then they ran the risk of losing him. Scouts for other teams might discover him. One of these teams might take him.

The Dodgers did not want that to happen. They wanted to hide Roberto from these scouts. . . .

It was not easy to hide Roberto. The manager of the Montreal team did his best. When Roberto was doing fine in a game, the manager would take him out. When Roberto was having just an ordinary day, the manager would leave him in.

Roberto did not know why he was being treated this way. He became confused and angry. He was lonely, anyway, living among strangers so far from home. He had grown up speaking Spanish. The people on his team spoke English, and the people in Montreal mostly spoke French. . . .

The Dodgers just could not make him look bad enough. Other teams could see that he was a fine player. Scouts for the Pittsburgh Pirates, another team in the National League, watched Roberto closely. They decided to take him and have him play for them.

Pittsburgh is not a place of tall sugar cane fields and gaily colored birds. It is a big, smoky city. But its people do have one thing in common with the people of Carolina, Puerto Rico. They love their baseball team.

Right from the start they loved Roberto. He was tremendous as a fielder....He thought nothing of crashing into walls and fences if he had to do that to catch a ball.

He became an excellent hitter....

More and more black men, more and more Spanish-speaking players like Roberto were coming into major league baseball. Soon there was no more talk of keeping the number of black players on a team down to four.

But still there were times when Roberto felt that he and other Spanish-speaking players were treated unfairly. He believed that they were not given as much praise and publicity as the others, even when they were just as good. Roberto was the kind of man who could make people listen to him. He asked for equal treatment for Spanish-speaking players. Whenever he could help one of them, he did....

By 1960 Roberto's Pirates were strong enough to win the championship of the National League. They played the American League champions, the New York Yankees, in the World Series. There were seven games in that World Series. Roberto made a hit in every game and the Pirates won.

Roberto was getting better and better as a player, but he was not always happy. Often he was sick or injured. Playing as hard as he did, he would tear muscles. Once he had malaria, an illness of chills and fevers.

Even so, Roberto went on to win four batting championships in the National League. Nearly every year he was a member of the All-Star team—the best players from all the teams in the National League.

Every winter, after the major league baseball season ended in the United States, Roberto went home to Puerto Rico....

Each spring he returned to the United States to play for the Pirates. But not until 1971 did he and the Pirates win another National League championship and go into another World Series....

Just as he had in 1960, Roberto made a hit in every game of the World Series. He was voted the most valuable player of the Series by the reporters who wrote about it. Of all the players on both teams, Roberto Clemente was the very best. . . .

There was just one more thing left in baseball for Roberto to do. That was to make 3,000 hits. He would soon be thirty-eight years old— very old for a ballplayer. Only ten men in the entire history of baseball had ever played long enough or well enough to make 3,000 hits. These were special heroes.

At the very end of the 1972 season, on September 30 in Pittsburgh, Roberto hit Number 3,000.

Roberto went home to his family in Rio Piedras. He wanted to rest and also to plan for the sports city for the boys and girls of Puerto Rico.

In December he heard terrible news. In the city of Managua in the Central American country of Nicaragua there had been an earthquake. The ground trembled and shook beneath the city. Buildings cracked and fell. Fires broke out. More than 10,000 people were killed. More than 200,000 people lost their homes.

Around the world people began sending money and food and medicine and clothing to help the earthquake victims. Roberto asked the many Puerto Ricans he knew to help out as much as they could. He did more.

On December 31 he climbed aboard a plane loaded with supplies to take them to the people of Managua. The plane, heavily laden, rose slowly from the San Juan airport and headed out to sea. Then, when it was just a mile away, it plunged into the ocean.

That night was New Year's Eve, usually a time of gaiety and celebration, but there was no gaiety in Puerto Rico. Thousands of people went to the beach to look for the wreckage of the plane. When it became clear that Roberto had drowned, Puerto Ricans and many people in the United States felt sad. A great player—and man—was gone.

In the United States Roberto was elected to baseball's Hall of Fame. This is the greatest honor a baseball player can receive. The Hall of Fame building is in Cooperstown, New York. In it there are pictures of the best players, and things like their bats and caps.

A sign was placed on the door of the room Roberto had lived in during spring training with the Pirates in Florida. It read, "I want to be remembered as a ballplayer who gave all he had to give."

It was signed, "Roberto Clemente."

Wise Ben Franklin

Words and music by
Lloyd Norlin

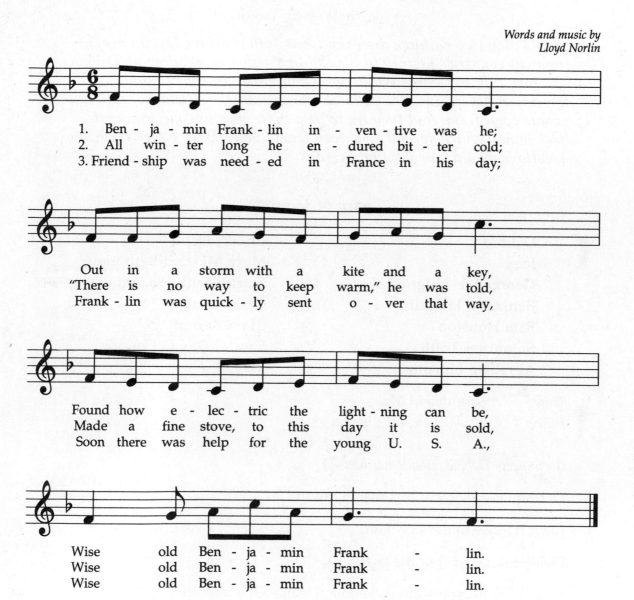

1. Ben - ja - min Frank - lin in - ven - tive was he;
2. All win - ter long he en - dured bit - ter cold;
3. Friend - ship was need - ed in France in his day;

Out in a storm with a kite and a key,
"There is no way to keep warm," he was told,
Frank - lin was quick - ly sent o - ver that way,

Found how e - lec - tric the light - ning can be,
Made a fine stove, to this day it is sold,
Soon there was help for the young U. S. A.,

Wise old Ben - ja - min Frank - lin.
Wise old Ben - ja - min Frank - lin.
Wise old Ben - ja - min Frank - lin.

From AMERICAN SINGER, Book 4, reprinted by permission of D. C. Heath & Co.

A Trip Through Time

A play by Wendy Vierow

In this play two children discover a watch that brings special people from our country's history to the children's own neighborhood. Debbie and Joey talk to George Washington, Sojourner Truth, and other important Americans. The children learn about the special places these people come from. And they try to help these special Americans get back home. Which special American would you like to meet? What questions would you ask that person?

THE PLAYERS

Debbie	Chief Joseph
Joey	Mary McLeod Bethune
George Washington	Martin Luther King, Jr.
Benjamin Franklin	César Chávez
Sam Houston	Clara Barton
Sojourner Truth	Sandra Day O'Connor
Abraham Lincoln	Maya Lin

Time: *A Saturday in May*
Place: *Outside of Debbie's house*

(Joey meets Debbie outside her house.)

Debbie: Joey, look at this watch I found.

Joey: It looks like it's broken.

Debbie: I found it in the park.

Joey: Why do you want to keep it, Debbie? It's broken.

Debbie: I didn't say I was going to keep it. My mother said she would bring it to the police station. That way the person who lost the watch can go there to pick it up.

Joey: There sure are a lot of buttons on it. Let me take a look.

(Debbie gives the watch to Joey. He pushes two buttons. Suddenly George Washington and Benjamin Franklin appear.)

Debbie: What did you do?

120

Joey: I just pushed two buttons.

George Washington: Where am I?

Ben Franklin: I don't know, General Washington.

George Washington: Are you trying out one of your crazy inventions on me, Ben?

Ben Franklin: No, General Washington.

George Washington: Did you children have anything to do with this? Now tell the truth.

Joey: I just pushed a few buttons.

Ben Franklin: Well push a few more buttons, and get us out of here. We were in the middle of a very important meeting in Philadelphia.

George Washington: Yes! The Constitution of the United States of America cannot wait!

Ben Franklin: Get us back to Philadelphia immediately, young man!

Joey: Yes, sir!

(Joey pushes another button. George Washington and Benjamin Franklin disappear. Sam Houston appears.)

Joey: Who are you?

Sam Houston: I believe the question, boy, is who are you? And where am I?

Debbie: That's Sam Houston.

Sam Houston: That is correct! I don't know what you did, but you better undo it fast. We Texans are in the middle of a very big battle with Mexico.

Debbie: Quick, Joey, push some more buttons or Texas might not become free!

Joey: I've always wanted to visit The Alamo!

Debbie: Joey, hurry!

(Joey pushes three buttons. Sam Houston disappears. Sojourner Truth, Abraham Lincoln, and Clara Barton appear.)

Debbie: You must have pushed something for the Civil War! It's Abraham Lincoln, Sojourner Truth, and Clara Barton!

Sojourner Truth: Mr. President! Where are we?

Abraham Lincoln: I don't know, Miss Truth! I'm sorry your visit to the White House has been upset.

Joey: My family went to the White House once.

Abraham Lincoln: I don't remember meeting you there.

Sojourner Truth: We still need to discuss freedom for people in slavery. Miss Barton! Where did you come from?

Clara Barton: I was helping soldiers in Virginia. I must get back! There aren't enough nurses to care for them!

Abraham Lincoln: Miss Barton, I've been meaning to talk to you. I would like you to search for missing soldiers in this Civil War.

Clara Barton: Mr. President, I would be glad to help. But I really must get back to Virginia to help the soldiers.

Joey: There were many battles in Virginia during the Civil War.

Debbie: This is all very interesting, but I think you should send these people back, Joey.

Joey: I'll take care of this.

(Joey pushes a button. Sojourner Truth, Abraham Lincoln, and Clara Barton disappear. Chief Joseph appears.)

Chief Joseph: Now where am I?

Joey: It's Chief Joseph.

Chief Joseph: First soldiers forced me to leave my home, and now this. What strange clothes you children are wearing!

Joey: Do you want to look at my watch?

Debbie: Joey, this really must stop.

Chief Joseph: I need to get back to my people. The war was very hard on us. We have been forced to move from our home in Oregon to Oklahoma.

Joey: Oregon and Oklahoma have very different landforms!

Chief Joseph: You're right about that. But this place looks different from any I've ever seen. How do I get back to Oklahoma?

Joey: Just a moment. It was an honor to meet you.

(Joey pushes a button. Chief Joseph disappears. Mary McLeod Bethune appears.)

Mary McLeod Bethune: Why aren't you children in school?

Debbie: It's Mary McLeod Bethune!

Mary McLeod Bethune: Don't you know how important an education is?

Joey: It's Saturday! We don't have school.

Mary McLeod Bethune: Well I have work to do at my school in Florida. I need to get back to Daytona Beach.

Joey: Is that near the Everglades?

Debbie: I'm sorry, Mrs. Bethune. Don't worry. We'll have you back in no time.

Joey: No problem.

(Joey pushes two buttons. Mrs. Bethune disappears. Martin Luther King, Jr., and César Chávez appear.)

Martin Luther King, Jr.: Where are all the people I was talking to?

César Chávez: Where are the farm workers I was talking to?

Martin Luther King, Jr.: I was in Washington, D.C., making an important speech.

César Chávez: I was in California talking to farm workers about their rights.

Joey: You came from two different coasts. California is near the Pacific Ocean, and Washington, D.C., is near the Atlantic Ocean.

César Chávez: And where are we now?

Martin Luther King, Jr.: Yes, where are we? I must get back to our country's capital to finish my speech.

Debbie: Joey, please give me the watch. I don't think you know what you're doing.

Joey: No, let me try one more time.

(Joey pushes two buttons. Martin Luther King, Jr., and César Chávez disappear. Sandra Day O'Connor and Maya Lin appear.)

Sandra Day O'Connor: Where's the rest of the Supreme Court?

Maya Lin: Where's my drawing board?

Debbie: Now we're in trouble! Supreme Court judge Sandra Day O'Connor is standing in front of us.

Joey: Maya Lin, I just want to tell you that I think the Vietnam Memorial is a wonderful monument.

Maya Lin: Thank you.

Sandra Day O'Connor: Only this doesn't look like Washington, D.C.

Debbie: Joey, I think it's time for you to give me back the watch.

Joey: Let me try one more time.

Debbie: I think it's my turn to try.

Joey: Okay.

(Joey gives the watch to Debbie.)

Debbie: Let me try to remember what this watch looked like before you began pushing all those buttons.

(Debbie pushes some buttons. Sandra Day O'Connor and Maya Lin disappear.)

Debbie: Finally!

Joey: I like that watch! You know, Debbie, if you don't want to keep it, I could maybe take care of it for a while.

Debbie: Sorry, Joey. This watch is going to the police station! I don't want to take chances with our country's history.

Joey: Good point. Can I come with you when you go?

Debbie: Sure.

Joey: Let's ask our parents if we can stop for ice cream!

Debbie: Good thinking. (*to audience*) I'm happy to see that life hasn't changed. I guess that means all those people made it back to where they were going!

THE END

Celebration

by Alonzo Lopez

This poem was written about a Hopi festival, a special celebration for the poet's family. The excitement of looking forward to a holiday is something all people can share. What do you think the poet likes best about celebrations?

I shall dance tonight.
When the dusk comes crawling,
There will be dancing
 and feasting.
I shall dance with the others
 in circles,
 in leaps,
 in stomps.
Laughter and talk
 will weave into the night,
Among the fires
 of my people.
Games will be played
And I shall be
 a part of it.

May Your Kwanzaa Be Happy!

by Catherine Tamblyn

On each day of Kwanzaa, a child asks, "Habari gani?" (hah BAH ree GAH nee) and is answered by a different reply. What are some of the lessons of Kwanzaa?

Habari gani? What's new?
"Umoja!"(oo MOH jah) we say, that means unity.
On the first day of Kwanzaa a black candle is lit
From the unity cup we all take a sip.

Habari gani? What's new?
The reply is *"Kujichagulia"* (koo jee chah goo LEE ah) on day two.
We define who we are and who we might be.
The flame of two candles in the *kinara* (kee NAH rah) we see.

Habari gani? What's new?
On the third day of Kwanzaa we answer *"Ujima!"* (oo JEE mah)
Three candles to light—black, red, then green.
We all work together to reach our dreams.

Habari gani? What's new?
On day four, *"Ujamaa!"* (oo jah MAH ah) we say.
The coins we've saved buy a gift we can share.
We buy from our neighbors to show that we care.

Habari gani? What's new?
"Nia" (NEE ah) means *purpose*. Developing pride,
We speak of our goals on day number five.
We learn our history to keep our culture alive.

Habari gani? What's new?
"Kuumba!" (koo OOM bah) we shout on day six.
We express ourselves, we make old things new.
We share an African feast called *karamu* (kah RAH moo).

Habari gani? What's new?
On the last day of Kwanzaa we say, *"Imani!"* (ee MAH nee)
We have faith in ourselves and our family
So join us, and shout with joy: *"Harambee!"* (hah RAHM bay)

New Year's Hats for the Statues

by Yoshiko Uchida

People around the world celebrate the new year in many different ways. In this tale about New Year's Day in Japan, a poor couple is rewarded for a good deed. Why do you think we tell stories like this one when we are about to begin a new year?

Once a very kind old man and woman lived in a small house high in the hills of Japan. Although they were good people, they were very, very poor, for the old man made his living by weaving the reed hats that farmers wore to ward off the sun and rain, and even in a year's time, he could not sell very many.

One cold winter day as the year was drawing to an end, the old woman said to the old man, "Good husband, it will soon be New Year's Day, but we have nothing in the house to eat. How will we welcome the new year without even a pot of fresh rice?" A worried frown hovered over her face, and she sighed sadly as she looked into her empty cupboards.

But the old man patted her shoulders and said, "Now, now, don't you worry. I will make some reed hats and take them to the village to sell. Then with the money I earn I will buy some fish and rice for our New Year's feast."

On the day before New Year's, the old man set out for the village with five new reed hats that he had made. It was bitterly cold, and from early morning, snow tumbled from the skies and blew in great drifts about their small house. The old man shivered in the wind, but he thought about the fresh warm rice and the fish turning crisp and brown over the charcoal, and he knew he must earn some money to

buy them. He pulled his wool scarf tighter about his throat and plodded on slowly over the snow-covered roads.

When he got to the village, he trudged up and down its narrow streets calling, "Reed hats for sale! Reed hats for sale!" But everyone was too busy preparing for the new year to be bothered with reed hats. They scurried by him, going instead to the shops where they could buy sea bream and red beans and herring roe for their New Year's feasts. No one even bothered to look at the old man or his hats.

As the old man wandered about the village, the snow fell faster, and before long the sky began to grow dark. The old man knew it was useless to linger, and he sighed with longing as he passed the fish shop and saw the rows of fresh fish.

"If only I could bring home one small piece of fish for my wife," he thought glumly, but his pockets were even emptier than his stomach.

There was nothing to do but to go home again with his five unsold hats. The old man headed wearily, back toward his little house in the hills, bending his head against the biting cold of the wind. As he walked along, he came upon six stone statues of Jizo, the guardian god of children. They stood by the roadside covered with snow that had piled in small drifts on top of their heads and shoulders.

"*Mah, mah*, you are covered with snow," the old man said to the statues, and setting down his bundle, he stopped to brush the snow from their heads. As he was about to go on, a fine idea occurred to him.

"I am sorry these are only reed hats I could not sell," he apologized, "but at least they will keep the snow off your heads." And carefully he tied one on each of the Jizo statues.

"Now if I had one more there would be enough for each of them," he murmured as he looked at the row of statues. But the old man did not hesitate for long. Quickly he took the hat from his own head and tied it on the head of the sixth statue.

"There," he said looking pleased. "Now all of you are covered." Then, bowing in farewell, he told the statues that he must be going. "A happy New Year to each of you," he called, and he hurried away content.

When he got home the old woman was waiting anxiously for him. "Did you sell your hats?" she asked. "Were you able to buy some rice and fish?"

The old man shook his head. "I couldn't sell a single hat," he explained, "but I did find a very good use for them." And he told her how he had put them on the Jizo statues that stood in the snow.

"Ah, that was a very kind thing to do," the old woman said. "I would have done exactly the same." And she did not complain at all that the old man had not brought home anything to eat. Instead she made some hot tea and added a precious piece of charcoal to the brazier so the old man could warm himself.

That night they went to bed early, for there was no more charcoal and the house had grown cold. Outside the wind continued to blow the snow in a white curtain that wrapped itself about the small house. The old man and woman huddled beneath their thick quilts and tried to keep warm.

"We are fortunate to have a roof over our heads on such a night," the old man said.

"Indeed we are," the old woman agreed, and before long they were both fast asleep.

About daybreak, when the sky was still a misty gray, the old man awakened for he heard voices outside. "Listen," he whispered to the old woman. "What is it? What is it?" the old woman asked.

Together they held their breath and listened. It sounded like a group of men pulling a very heavy load.

"*Yoi-sah! Hoi-sah! Yoi-sah! Hoi-sah!*" the voices called and seemed to come closer and closer.

"Who could it be so early in the morning?" the old man wondered. Soon, they heard the men singing:

> *Where is the home of the kind old man,*
> *The man who covered our heads?*
> *Where is the home of the kind old man,*
> *Who gave us his hats for our heads?*

The old man and woman hurried to the window to look out, and there in the snow they saw the six stone Jizo statues lumbering toward their house. They still wore the reed hats the old man had given them and each one was pulling a heavy sack.

"*Yoi-sah! Hoi-sah! Yoi-sah! Hoi-sah!*" they called as they drew nearer and nearer.

"They seem to be coming here!" the old man gasped in amazement. But the old woman was too surprised even to speak.

As they watched, each of the Jizo statues came up to their house and left his sack at the doorstep.

The old man hurried to open the door, and as he did, the six big sacks came tumbling inside. In the sacks the old man and woman found rice and wheat, fish and beans, wine and bean paste cakes, and all sorts of delicious things that they might want to eat.

"Why, there is enough here for a feast every day all during the year!" the old man cried excitedly.

"And we shall have the finest New Year's feast we have ever had in our lives," the old woman exclaimed.

"Ojizo Sama, thank you!" the old man shouted.

"Ojizo Sama, how can we thank you enough?" the old woman called out.

But the six stone statues were already moving slowly down the road, and as the old man and woman watched, they disappeared into the whiteness of the falling snow, leaving only their footprints to show that they had been there at all.

The Fourth

by Shel Silverstein

The Fourth of July is the birthday of our country—the United States of America. Many people celebrate our country's independence by watching fireworks with friends and neighbors. How does the poet create the look and sound of fireworks?

Oh
CRASH!

my
BASH!

it's
BANG!

the
ZANG!
Fourth

WHOOSH!

of

BAROOOM!

July
WHEW!

America, the Beautiful

Words by Katharine Lee Bates

Music by Samuel Ward
Arranged by Mary Val Marsh

Index by Category

Biographies

Columbus Day, 90
Grandma Moses: Painter of Rural America, 111
Harriet Tubman, 98
Mary McLeod Bethune, 106
Roberto Clemente, 114

Folk Tales, Tall Tales, and Fables

How Hawk Stopped the Flood with His Tail Feather, 86
Legend of the Bluebonnet, The, 26
Responsibility, 64

Nonfiction

Election Day, 75
50 Simple Things Kids Can Do to Save the Earth, 43
Flag for Our Country, A, 82
How My Family Lives in America, 103
. . . If You Grew Up with George Washington, 94

Plays

Place to Skate, A, 68
Trip Through Time, A, 120

Poems

Assembly Line Lunch, 66
Celebration, 126
Country Road, Spring Walk, 13
Fourth, The, 132
Giant Jam Sandwich, 72
If I Built a Village . . ., 30

Lincoln Monument: Washington, 79
May Your Kwanzaa Be Happy!, 127
Sing a Song of Cities, 13
Someday Someone Will Bet That You Can't Name All Fifty States, 29
Truck Song, 54
Washington Monument, 79

Songs

All Living Things, 38
America, the Beautiful, 133
I Have a Dream, 80
It Is I, the Little Owl, 89
Mi Hogar, 2
Oats, Peas, Beans, 63
There are Many Flags in Many Lands, 78
Wise Ben Franklin, 119
Yankee Doodle, 93

Stories

Aurora Means Dawn, 101
Chalk Doll, The, 19
Dumpling Soup, 3
Grandma Buffalo, May, and Me, 14
Great Kapok Tree: A Tale of the Amazon Rain Forest, The, 40
Letter from Crinkleroot, 24
Lorenzo & Angelina, 32
Mexicali Soup, 48
New Coat for Anna, A, 56
New Year's Hats for the Statues, 128
Uncle Nacho's Hat, 59
Yagua Days, 8

Index by Title

All Living Things, 38

America, the Beautiful, 133

Assembly Line Lunch, 66

Aurora Means Dawn, 101

Celebration, 126

Chalk Doll, The, 19

Columbus Day, 90

Country Road, Spring Walk, 13

Dumpling Soup, 3

Election Day, 75

50 Simple Things Kids Can Do to Save the Earth, 43

Flag for Our Country, A, 82

Fourth, The, 132

Grandma Buffalo, May, and Me, 14

Grandma Moses: Painter of Rural America, 111

Great Kapok Tree: A Tale of the Amazon Rain Forest, The, 40

Harriet Tubman, 98

How Hawk Stopped the Flood with His Tail Feather, 86

How My Family Lives in America, 103

If I Built a Village . . . , 30

. . . If You Grew Up with George Washington, 94

I Have a Dream, 80

It Is I, the Little Owl, 89

Legend of the Bluebonnet, The, 26

Letter from Crinkleroot, 24

Lincoln Monument: Washington, 79

Lorenzo & Angelina, 32

Mary McLeod Bethune, 106

May Your Kwanzaa Be Happy!, 127

Mexicali Soup, 48

Mi Hogar, 2

New Coat for Anna, A, 56

New Year's Hats for the Statues, 128

Oats, Peas, Beans, 63

Place to Skate, A, 68

Responsibility, 64

Roberto Clemente, 114

Sing a Song of Cities, 13

Someday Somebody Will Bet That You Can't Name All Fifty States, 29

There Are Many Flags in Many Lands, 78

Trip Through Time, A, 120

Truck Song, 54

Uncle Nacho's Hat, 59

Washintgon Monument, 79

Wise Ben Franklin, 119

Yagua Days, 8

Yankee Doodle, 93

Index by Author

Asch, Frank, 13

Bates, Katharine Lee, 133
Burroway, Janet, 72
Carter, Polly, 98
Cawley, W. Jay, 38
Cherry, Lynne, 40

dePaola, Tomie, 26
DeRoin, Nancy, 64

EarthWorks Group, The, 43

Fern, Eugene, 32
Fisher, Aileen, 79

Greenfield, Eloise, 106
Gross, Ruth Belov, 94

Hausman, Gerald, 86
Hayes, William D., 48
Hitte, Kathryn, 48
Hopkins, Lee Bennett, 13
Howliston, Mary H., 78
Hughes, Langston, 79

Jennings, Teresa, 80

Kuklin, Susan, 103

Lopez, Alonzo, 126

Martel, Cruz, 8
Mizumura, Kazue, 30

Norlin, Lloyd, 119

Oneal, Zibby, 111

Pomerantz, Charlotte, 19
Phelan, Mary Kay, 75

Rattigan, Jama Kim, 3
Rohmer, Harriet, 59
Rudeen, Kenneth, 114

Sanders, Scott Russell, 101
Sheinkin, Rachel, 66
Showers, Paul, 90
Siebert, Diane, 54
Silverstein, Shel, 132
Spencer, Eve, 82
Stilz, Carol Curtis, 14

Tamblyn, Catherine, 127

Uchida, Yoshiko, 128

Vierow, Wendy, 68, 120
Viorst, Judith, 29

Ward, Samuel, 133

Ziefert, Harriet, 56

Index by Subject

A

America, 133
American Revolution, 93
Animals, 30–31, 89
Arts, 111–113
Assembly line, 66

B

Barter, 56–58
Barton, Clara, 120–125
Bethune, Mary McLeod, 106–110, 120–125
Buffalo, 14–18

C

Celebrations, 126, 127, 128–131, 132
Chávez, César, 120–125
Cities, 13
Clemente, Roberto, 114–118
Clothing, 56–58, 59–62
Columbus, Christopher, 90–92
Comanche, 26–28
Conservation, 40–42, 43–46
Cooperation, 66
Country living, 13
Courage, 26–28

E

Earth, 24–25
Education, 106–110
Election Day, 75–77

F

Family, 48–53, 59–62
Flag, American, 82–84
Food, 48–53, 63, 66, 72–74
Fourth of July, 132
Franklin, Benjamin, 119, 120–125
Friendship, 32–37

G

Grandma Moses, 111–113

H

Hawaii, 3–7
Houston, Sam, 120–125

I

Immigrants, 103–104

J

Jamaica, 19–22
Japan, 128–131
Joseph, Chief, 120–125

K

King, Martin Luther, Jr., 80–81, 120–125
Kwanzaa, 127

L

Laws, 18–22
Lin, Maya, 120–125
Lincoln, Abraham, 79, 120–125
Lincoln Monument, 79

M

Monuments, 79

N

Native Americans, 86–88, 89, 126
Nature, 24–25, 30–31, 38–39, 40–42, 43–46
New Year's Day, 128–131

O

O'Connor, Sandra Day, 120–125
Owls, 89

P

Patriotism, 75–77, 79, 82–84
People helping others, 14–16, 106–110
Problem solving, 68–71
Puerto Rico, 8–12, 103–104

R

Rain forest, 40–42, 43–46
Responsibility, 64–65
Ross, Betsy, 82–84

S

Settlers, 101
Skating, 68–71
Slavery, 98–100
States, 29

T

Transportation, 54–55
Trucks, 54–55
Truth, Sojourner, 120–125
Tubman, Harriet, 98–100

U

Underground Railroad, 98–100

V

Voting, 75–77

W

Washington, D.C., 79
Washington, George, 79, 82–84, 94–97, 120–125
Washington Monument, 79

(continued from copyright page)

"There Are Many Flags in Many Lands" (originally titled "Our Flag") from THE GOLDEN FLUTE by Mary Howliston. Selected by Alice Hubbard and Adeline Babbitt. (John Day Company). ©1932, 1960 by Harper & Row, Publishers, Inc.

Text in poem form from IF I BUILT A VILLAGE....by Kazue Mizumura. ©1971 by Kazue Mizumura. T.Y. Crowell.

Excerpt from COLUMBUS DAY by Paul Showers. ©1965 by Paul Showers. T.Y. Crowell.

Excerpt from TRUCK SONG by Diane Siebert. Text ©1984 by Diane Siebert. T.Y. Crowell.

MEXICALI SOUP by Kathryn Hitte and William D. Hayes. ©1970 by Kathryn Hitte and William D. Hayes.

"Responsibility" from JATAKA TALES by Nancy Deroin. Text ©1975 by Nancy Deroin. Houghton Mifflin Company.

"Yankee Doodle" from MUSIC AND YOU, by Barbara Staton & Merrill Staton, Senior Authors. ©1988 Macmillan Publishing Company, a divison of Macmillan, Inc.

YAGUA DAYS by Cruz Martel. © 1976 by Cruz Martel. Dial Books for Young Readers, a division of Penguin Books, USA Inc.

From LORENZO & ANGELINA by Eugene A. Fern. © 1968 by Eugene A. Fern. McIntosh and Otis, Inc.

THE LEGEND OF THE BLUEBONNET by Tomie DePaola. ©1983 by Tomie DePaola. G.P. Putnam's Sons.

THE CHALK DOLL by Charlotte Pomerantz. © 1989 by Charlotte Pomerantz. J. B. Lippincott, NY.

A NEW COAT FOR ANNA by Harriet Ziefert. ©1986 by Harriet Ziefert. Random House, Inc.

Excerpts from ...IF YOU GREW UP WITH GEORGE WASHINGTON by Ruth Belov Gross. ©1982 by Ruth Belov Gross. Scholastic, Inc.

Excerpts from GRANDMA MOSES: PAINTER OF RURAL AMERICA by Zibby Oneal. ©1986 by Zibby Oneal. Viking Penguin, a division of Penguin USA Inc.

DUMPLING SOUP by Jama Kim Rattigan. © 1993 by Jama Kim Rattigan. Little, Brown and Company.

"Country Road, Spring Walk" from COUNTRY PIE by Frank Asch. Copyright © 1979 by Frank Asch. By permission of Greenwillow Books, a division of William Morrow & Company, Inc.

"Sing a Song of Cities" from GOOD RHYMES, GOOD TIMES by Lee Bennett Hopkins. Reprinted by permission of Curtis Brown Ltd. Copyright © 1974, 1995 by Lee Bennett Hopkins.

"Letter from Crinkleroot" from THE BIG BOOK FOR OUR PLANET EARTH by Jim Arnosky. ©1993 Dutton Children's Books, a division of Penguin Books USA Inc., NY.

"Someday Someone Will Bet That You Can't Name All Fifty States" from SAD UNDERWEAR AND OTHER COMPLICATIONS by Judith Viorst. ©1995 Judith Viorst. Atheneum Books for Young Readers, an imprint of Simon & Schuster Children's Publishing Division, NY.

"All Living Things" by W. Jay Cawley. ©1992 W. Jay Cawley. From SHARE THE MUSIC, Book 3. ©1995 Macmillan/McGraw-Hill School Publishing Company, NY.

Excerpts from THE GIANT JAM SANDWICH by John Vernon Lord with verses by Janet Burroway. ©1972 John Vernon Lord. Houghton Mifflin Company, Boston.

Excerpts from ELECTION DAY by Mary Kay Phelan. Text copyright © by Mary Kay Phelan.

"Washington Monument" from MY FIRST PRESIDENT'S DAY BOOK by Aileen Fisher. ©1987 Regensteiner Publishing Enterprises, Inc., Childrens Press, Chicago.

"Lincoln Monument: Washington" from THE DREAM-KEEPER AND OTHER POEMS by Langston Hughes. Copyright © 1932 by Alfred A. Knopf, Inc., and renewed 1960 by Langston Hughes. Reprinted by permission of Alfred A. Knopf, Inc.

"I Have a Dream" by Teresa Jennings. ©1990 Plank Road Publishing, Inc., All Rights Reserved.

A FLAG FOR OUR COUNTRY by Eve Spencer. Reprinted with permission from Steck-Vaughn Company, Austin, Texas.

"How Hawk Stopped the Flood with His Tail Feather" from HOW CHIPMUNK GOT TINY FEET, Tsimshian folktales retold by Gerald Hausman. Text copyright © 1995 by Gerald Hausman.

"It is I, the Little Owl" from SONGS OF THE CHIPPE-WA. Adapted from the collections of Frances Densmore and Henry Rowe Schoolcraft, and arranged by John Bierhorst. ©1974 John Bierhorst.

"Harriet Tubman" from LET'S CELEBRATE: HARRIET TUBMAN AND BLACK HISTORY MONTH by Polly Carter. ©1990 Kirchoff/Wohlberg, Inc. Silver Press, a division of Silver Burdett Press, Inc., Simon & Schuster, Inc., Prentice-Hall Bldg, NJ.

AURORA MEANS DAWN by Scott Russell Sanders. © 1989 by Scott Russell Sanders. Bradbury Press, NY.

Excerpt from HOW MY FAMILY LIVES IN AMERICA by Susan Kuklin. Reprinted with permission of Simon & Schuster Books for Young Readers from HOW MY FAMILY LIVES IN AMERICA by Susan Kuklin. Copyright © 1992 Susan Kuklin.

"Celebration" from WHISPERING WIND by Alonzo Lopez. ©1972 Institute of American Indian Arts. Reprinted by permission of Doubleday & Co.

"New Year's Hats for Statues" from SNOWY DAY; STORIES AND POEMS by Yoshiko Uchida. ©1986 Caroline Feller Bauer. J.B. Lippincott Junior Books, NY.

"Mi Hogar (My Home)" from MIS PRIMERAS CANCIONES by Isis Peréz de Méndes-Peñate and María Luisa Muñoz. ©1986 Caroline Feller Bauer. J.B. Lippincott Junior Books, NY.

"The Fourth" from WHERE THE SIDEWALK ENDS by Shel Silverstein. ©1974 by Evil Eye Music, Inc. Reprinted by permission of HarperCollins Publishers.

Teachers share a common goal—to help their students become successful learners who can understand, remember, and apply important knowledge and skills. This important goal is best supported when students are offered a variety of ways in which to learn.

The Social Studies Anthology offers you the varied tools that you need to help your students learn. It includes such diverse sources as stories, folk tales, biographies, poems, songs, and plays — all of which draw children into the sights and sounds of the places and times they are studying.

You may invite students to explore the Anthology selections in different ways — drawing pictures or posters, writing their own songs, poems, or stories, or dramatizing the selections. We have provided a strategy for teaching each selection in the Anthology. But these strategies, of course, are only suggestions. You should feel free to teach the selections in any way that you feel is best suited for your own classroom.

A Cassette accompanies the Social Studies Anthology and provides additional support in teaching the documents. A Cassette logo lets you know which selections have been recorded.

MI HOGAR (MY HOME)
by Isis Peréz de Méndes-Peñate
and María Luisa Muñoz
Page 2 🔲

Use with Unit 1, Lesson 1

Objectives

❑ *Recognize how the song entertains as well as describes a family living together in a house.*

❑ *Write a letter to the songwriters.*

Writing a Letter

After you have read aloud the lyrics to the song to students, play the song for them on the cassette or on the piano if you have access to one. Invite students to sing along in Spanish or in English. Ask students to talk about the kind of house they think is being described in the songs. (Responses will vary but should include that it sounds like a warm place, full of people who love and care for each other.)

Have students think of questions they would like to ask the songwriters. Since the song was written in Spanish, perhaps students would like to know where the songwriters live, whether it is in the city or the country, what the weather is like there, what the schools are like, how they came up with the idea for the song, and so on. Jot down students' questions on the chalkboard. Then help them compose a class letter to the songwriters based on their questions. Read the finished letter aloud to the class.

DUMPLING SOUP
by Jama Kim Rattigan
Pages 3–7

Use with Unit 1, Lesson 2

Objectives

❑ *Recognize the importance of food in the appreciation of different cultures.*

❑ *Have students plan a party with foods of various cultures.*

❑ *Discuss where their selected foods are from.*

Planning a Dinner Party

After you have read the story to the students, discuss the foods that were eaten. Jhun (food fried in egg batter), kimchi (pickled vegetables), mandoo (dumplings), namul (seasoned vegetables), taegu (shredded codfish), and yak pap (rice desserts) are Korean foods. Mochi (chewy cakes), sashimi (raw fish), and sushi (raw fish with rice) are Japanese foods. Talk about how enjoying food can be an important way for people to appreciate different cultures.

If you were planning a party, and you wanted to have many foods from different cultures, which foods would you choose? Have students plan for a party by making a menu of different foods they would serve. Have students include food that is from their own culture or family traditions or the culture or traditions of a family they know. Students can draw or write the names of the dishes. Where are your dishes from? Are there similar dishes from other places? Do you know their recipes? Is there a special occasion for your party that relates to the food?

YAGUA DAYS
by Cruz Martel
Pages 8–12

Use with Unit 1, Lesson 3

Objectives

❑ *Discuss how experiencing new places can be exciting.*

❑ *Recognize how different places have their own wealth of fun and exciting activities.*

❑ *Plan fun activities specific to the area in which students live.*

Planning a Visit from a Friend or Relative

After you have read the story to the students, discuss how exciting it must have been for Adan to experience fun and new activities in Puerto Rico. (picking fruit from trees, skimming into the river on a yagua, or palm tree leaf) Point out that Adan's experiences in Puerto Rico were tied to family traditions because his mother, father, and many of his other relatives had had similar experiences. Do you think it was fun for Adan's relatives to show him these things?

Have students imagine that a friend or relative is coming from a far-away place to visit them. Have students plan a visit from a friend or relative by drawing or listing fun activities that are specific to the area in which they live. Does the list include summer or winter activities? Are they done indoors or outdoors?

Translations

bodega: grocery store
ñames: root vegetable similar to potato
quenepas: fruit with a green peel
muchacho: boy
mira: look
finca: plantation
hasta luego: until then
que gocen mucho: have a good time
tío: uncle
arroz con grandules: rice with peas
pernil: pork
viandas: vegetables
tostones: fried plantains
ensaladas de chayotes y tomates: avocado and tomato salads
pasteles: dumplings **vente:** come on
tía: aunt **vamonos:** let's go

COUNTRY ROAD, CITY SONG
by Frank Asch and Lee Bennett Hopkins
Page 13 🔲

Use with Unit 1, Lesson 3

Objectives

❑ *Recognize how the poets use language to describe the country and the city.*

❑ *Identify differences in the country and the city.*

❑ *Write a poem.*

Writing a Poem

After you have read aloud the poems to students, ask them to describe the images, or pictures, that they saw as they listened. Point out that poets sometimes use very few words to paint a picture of a place. Then ask students to discuss the differences between the city and the country that the poems emphasize. (The country is quieter than the city; there is more evidence of nature, such as plants and dew on the grass, in the country than in the city.) You may wish to point out the rhyming pattern in each of the poems to students, but you can also emphasize that poems do not have to rhyme.

Then invite students to write a poem of their own about the place where they live. You may wish to have the whole class brainstorm some describing words and list those on the chalkboard to serve as a word bank for students as they write.

GRANDMA BUFFALO, MAY, AND ME

by Carol Curtis Stilz

Pages 14–18

Use with Unit 1, Lesson 4

Objectives

- ☐ *Review the adventure in the story.*
- ☐ *Discuss other forms of transportation one could use on an adventure.*
- ☐ *Make a map of an adventure that reflects the type of transportation chosen.*

Making a Map of an Adventure

Review that in this story the narrator, her mother, and Gray Bear set out by car on an adventure. Ask the students to tell what happened on their adventure. (They camped, caught fish, picked apples, got seeds and a cutting for an apple tree, and met a friendly buffalo.)

Have students imagine that they have had a similar adventure, but using a different form of transportation. What are some of the ways you could have traveled? (by foot, by canoe, by plane, by hot-air balloon) Have students make a map that shows the route of their adventure and the different things they saw. How does the method of transportation you pick affect the kinds of things you would see?

THE CHALK DOLL

by Charlotte Pomerantz

Pages 19–22

Use with Unit 1, Lesson 5

Objectives

- ☐ *Appreciate the reward and satisfaction of making something by hand.*
- ☐ *Discuss how family treasures can be made by hand.*
- ☐ *Have students make something that could become a family treasure.*

Making a Family Treasure

Ask students why, at the end of the story, Rose wanted to make a rag doll even though she had so many dolls already. (Her mother had had a rag doll as a child; also, Rose probably thought it would be fun and special to make a doll by hand.) Family treasures can be many different things— things that are bought, made by hand, or found. Why might a family treasure that is made by hand be extra special? (It has a special connection to the person who made it.)

Have students think about what kind of treasure they would like to make and pass on to their children or relatives or ones they love. What kinds of things could be made with classroom materials? (depending on materials available—pictures, collages, sculptures, books, picture frames, stuffed animals, puppets, etc.) Have students make something that could become a treasure in their family. If this treasure were someday to be given to a loved one, what would it say about you and the time in which you lived?

LETTER FROM CRINKLEROOT
by Jim Arnosky
Pages 24–25

Use with Unit 2, Lesson 2

Objectives
- [] *Recognize that Earth is the home for many living things.*
- [] *Write a letter to Crinkleroot.*

Writing a Letter

After you have read aloud the letter to students, ask them what job Crinkleroot has taken on. (Crinkleroot is traveling our planet to see just how many plants and animals inhabit it.) Then ask students what Crinkleroot has discovered. (that "one billion six million two thousand four hundred and three and two-thirds" creatures live on Earth) Encourage students to discuss the main message of Crinkleroot's letter to us. (We must be aware of the living things that inhabit Earth.)

Then invite students to write a letter to Crinkleroot. In it they can mention the living creatures that they have observed in their neighborhoods. Students might find it interesting to keep a tally of what they observe so that they can tell Crinkleroot how many living things they saw. Encourage volunteers to read their letters to the class.

THE LEGEND OF THE BLUEBONNET

retold by Tomie dePaola
Pages 26–28

Use with Unit 2, Lesson 2

Objectives

- ❏ *Identify the story as an example of a legend.*
- ❏ *Recognize that Earth must be protected.*
- ❏ *Create illustrations for the story.*

Illustrating a story

After you have read aloud the story to students, you may wish to explain to them that a **legend** is a story that explains how something came to be. Ask students what came to be as a result of She-Who-Is-Alone's sacrifice. (The bluebonnets grew as a sign of the Great Spirits' forgiveness.)

Then ask students what caused the Great Spirits to become angered with the people. (The people were selfish; they took from the land and gave nothing back.) *What did the Great Spirits do because of their anger?* (They sent drought and famine to the people.)

Point out that through giving up something dear to her (her doll), She Who Is Alone gained something for her people.

Tell students that they will have an opportunity to create illustrations for this story. You may wish to divide the story into scenes and assign different scenes to individual students or to pairs of students to illustrate. Or you may wish to have students choose their favorite part of the story to draw. Ask students: *What is the most important thing to show for this part of the story?* Have them include their answers in their drawings.

When the illustrations are finished, display them in story order on the bulletin board. Invite students to retell the legend by looking at the pictures and telling what happens in each.

SOMEDAY SOMEONE WILL BET THAT YOU CAN'T NAME ALL FIFTY STATES

by Judith Viorst
Page 29 📼

Use with Unit 2, Lesson 1

Objectives

- ❏ *Identify how the poet uses language cleverly to name the states.*
- ❏ *Write a poem about your state.*

Writing a Poem

After you have read aloud the poem to students, encourage them to try to guess the missing state. Students can use the map of the United States to find the answer.

Then ask students if they think the title of the poem is true. (Responses will vary but should get at the idea that these kinds of challenges are pretty common.) Invite students to name as many states as they can in a stated time period (perhaps two or three minutes).

Invite students to write a poem of their own about their state. You may wish to spend time with the whole class brainstorming ideas about your state. Write words and phrases on the chalkboard so that students can refer to them when they write their poems.

IF I BUILT A VILLAGE

by Kazue Mizumura
Pages 30–31

Use with Unit 2, Lesson 2

Objectives

☐ *Identify how the poet uses language to describe the environment and the living things that are a part of it.*

☐ *Write a poem about Earth, our home.*

Writing a Poem

After you read aloud the poem to students, ask them to discuss the images in the poem. *Which animals that inhabit Earth does the poet describe?* (rabbits, trout, owls, mice, geese, deer, whales, moles) What descriptive words does he use? (shine like rainbows, eyes full of moon lights, sprinkling pearl sprays) *How do you think the poet feels about the animals?* (Responses will vary but should indicate that the poet is fond of the animals and appreciative of them.) Point out to students that the poet is speaking about an ideal world that he would create if he had the chance to build a village or a town and fill it with the animals that he loves.

Tell students that they will have an opportunity to write a poem describing the parts of Earth and nature that they like. You may wish to brainstorm ideas with students and chart their ideas on the chalkboard, using a web to capture descriptive words. Then have them write their poems and share them with the class.

LORENZO AND ANGELINA

by Eugene Fern
Pages 32–37

Use with Unit 2, Lesson 2

Objectives

☐ *Recognize how the story portrays the relationship between people and animals, and how they relate to the natural environment.*

☐ *Dramatize a story.*

Dramatizing a Story

After you have read the story aloud to the class, encourage students to discuss the relationship that Lorenzo and Angelina have. (They are extremely loyal to each other and good friends, even though they are sometimes impatient with each other.) Then have students discuss Lorenzo's relationship with the environment. (Lorenzo is familiar with the environment and respectful of it.) Ask students how they think Lorenzo knew that the path was dangerous. (Sometimes animals who are very familiar with the environment and protective of their friends are especially sensitive to dangers in the environment.) Encourage students to discuss what they can learn from Lorenzo's respect for the environment.

Have the class prepare a dramatization of the story. Alternate characters so that everyone has a chance to act out a portion of the story as either Angelina or Lorenzo.

ALL LIVING THINGS
by W. Jay Cawley
Pages 38–39 📼

Use with Unit 2, Lesson 3

Objectives

❑ *Recognize that the song entertains as well as presents a message about Earth, our home.*

❑ *Identify the ways in which all life on Earth is connected.*

❑ *Write a verse for the song.*

Writing a Song Verse

After you have read aloud the words to the song to students, play the song on the cassette or on a piano if you have access to one. Encourage students to sing along. Ask students to summarize the message of the song. (If we spoil Earth, we spoil the place where we and many other living things live.)

Then ask students to discuss other things that all living things on Earth need. Write student suggestions on the chalkboard. Have students work with partners to come up with another verse for the song, using the ideas from the chalkboard. You may wish to supply the first few words of the verse for students: All living things need_____.

THE GREAT KAPOK TREE
by Lynne Cherry
Pages 40–42

Use with Unit 2, Lesson 3

Objectives

❑ *Identify the repetitive elements in the story that the author uses to teach a lesson.*

❑ *Restate the lesson of the story.*

❑ *Link the story to environmental issues today.*

Background

Before reading aloud the story to students, you may wish to explain to them that this story takes place in a rain forest in Brazil. A rain forest is a tropical woodland that has at least 100 inches of rainfall every year. A rain forest has very tall, broad-leaved evergreen trees that form a continuous canopy (or roof) over the area. Many animals and native people live in or near the rain forests of South America. There is much concern over disturbing the ecological balance of the rain forest as developers move into the area.

Linking to Today

After you read the story aloud to students, encourage discussion about the various animals who paid a visit to the sleeping man. *Why do you think the author chose to have so many visitors whisper in the man's ear?* (Each had a point to make, and each reinforced the point—do not destroy our home.) Remind students that developers are seeking to move into the rain forest today, and many people are concerned about this. Encourage students to discuss other environmental issues that are of concern to people today. (water pollution, air pollution and so on)

Have students collect information about threats to the environment in their area. Have them make cards containing facts about these threats, with possible solutions. Help students create a bulletin-board display of their cards and conduct a discussion of their findings.

50 SIMPLE THINGS KIDS CAN DO TO SAVE THE EARTH

by The EarthWorks Group
Pages 43–46

Use with Unit 2, Lesson 3

Objectives

- ❑ *Identify specific things people can do to protect the environment.*
- ❑ *Write a guide for protecting the environment.*

Writing a Guide

Since each of the sections of the selection will inspire a good, rich discussion, you may want to read aloud this selection over a period of three days. Students can review the previous day's reading before you begin a new section, concentrating particularly on the things they can do about littering and recycling.

Then after you have finished the entire selection, encourage students to think of other environmental issues. (destruction of rain forests, swamps, national park areas; pesticide issues; wildlife protection) Ask students to think about what they could do about these issues. Then, using the same format as *50 Simple Things…*, have students add a new section to the guide. Students may wish to add to their guides on an ongoing basis.

MEXICALI SOUP

by Kathryn Hitte and William D. Hayes
Pages 48–53

Use with Unit 3, Lesson 1

Objectives

- ❑ *Identify the way in which the story illustrates the difference between needs and wants.*
- ❑ *Write a recipe for a family dish.*

Writing a Recipe

This story is a long one, so you might wish to read aloud the selection in two parts. Students can retell what went on in the first part before you read the second part. After you have read aloud the entire selection, invite students to discuss the needs that each of the family members expresses to Mama. (Each family member requested that Mama leave something out of the soup.) Ask students why they think the family members did that. (Some wished to sever their ties with their past ways of doing things; Papa did not think the celery was an important ingredient.) Then ask students what kind of soup Mama eventually served. (hot water) Point out that the soup actually turned into something the family did not want. Encourage students to discuss needs and wants and the differences between them.

Then have students write a recipe that uses ingredients that can be bought in a market, such as fresh fruit and vegetables. Students may wish to create a recipe box for the classroom.

TRUCK SONG
by Diane Siebert
Pages 54–55

Use with Unit 3, Lesson 3

Objectives

- ☐ *Recognize a story in verse.*
- ☐ *Identify the role transportation plays in supplying our needs and wants.*
- ☐ *Write an interview.*

Writing an Interview

After you read aloud the verse to students, ask them to discuss what the life of a trucker must be like. (Responses should get at the notion that truckers put in long days and nights driving to make sure that goods get delivered on time or that services are performed.) Encourage students to mention some of the specific goods and services that are mentioned in the verse. (goods: foods, building supplies; services: collecting trash, towing broken cars) Ask: *What kinds of trucks are mentioned in the poem?* (for example, cement trucks, garbage trucks, armored trucks) Ask them if they can think of any other kinds of trucks.

Then tell students that they will have an opportunity to write interview questions for a truck driver. (If you know of a truck driver who would be willing to come to the class to be interviewed, all the better.) Help students brainstorm in small groups to come up with three or four questions that they would like to ask. Then as a whole-group activity, consolidate the questions into one master list. Assist students in finding the answers to their questions.

A NEW COAT FOR ANNA
by Harriet Ziefert
Pages 56–58

Use with Unit 3, Lesson 4

Objectives

- ☐ *Identify the way in which the characters in the story got the goods they needed.*
- ☐ *Recognize that raw materials are needed to create goods.*
- ☐ *Write a story.*

Writing a Story

After you read aloud the story to students, ask them to discuss why Anna's mother had to trade to get Anna's coat. (There was very little money after the war, and the stores did not have coats.) *What would people do today?* (They would probably use money to purchase a coat at a store.) Then ask students to think about where Anna and her mother went first. (to get wool from the sheep farmer) Point out that wool is the raw material from which the coat is made. Ask students to discuss other products that might come from this raw material. (hats, rugs, sweaters) Then encourage students to discuss in sequence how the coat was finally created. (The wool was made into yarn that was dyed and then woven into cloth, which was made into a coat by a tailor.) Remind students that this is very similar to the process that would be followed today in creating a woolen coat. Ask students to speculate how today's process might be different. (More of the work would be done by machines.)

Tell students that they will have a chance to write a story in which they trade to get the goods they need or want. Let partners brainstorm and write a story about things they want and what they would trade to get them.

UNCLE NACHO'S HAT

Adapted from a Nicaraguan Folk Tale
by Harriet Rohmer
Pages 59–62

Use with Unit 3, Lesson 4

Objectives

- ☐ *Recognize that the story entertains as well as teaches a lesson.*
- ☐ *Identify the story's lesson.*
- ☐ *Write an advertisement.*

Writing an Advertisement

After you read aloud the story to students, encourage them to discuss the various ways in which Uncle Nacho tried to dispose of his hat. (put it in his trunk, threw it in the street, put it in the trash, took it far away to the country, gave it to an old man) Then ask them to talk about what happened when the old man took it. (Uncle Nacho's two nephews thought the old man had stolen the hat, and fought with him to get it back.)

Ask students if Uncle Nacho needed a new hat. (Responses may vary but should get at the idea that Uncle Nacho's hat was old and full of holes and that he probably needed a new one.) Then tell them that they will have an opportunity to write an advertisement for a hat. Their advertisement should include a description of the hat, what the hat is made of, and how much the hat costs.

OATS, PEAS, AND BEANS

English Singing Game
Page 63

Use with Unit 3, Lesson 2

Objectives

- ☐ *Identify how the song entertains as well as explains how some crops grow.*
- ☐ *Write a report.*

Writing a Report

After you read aloud the words to the song to students, play the song for them on the cassette or on the piano if you have access to one. Encourage students to sing along.

Point out that the song tells about how some crops grow and how the farmer has to plant the seeds to get oats, peas, and beans to grow. Encourage students to discuss crops that grow in rural areas of your state or area.

Then ask students to do some research about agricultural crops in your area. *What is grown where you live? How long is the growing season? When are the crops harvested? How big are the farms?* Students can report their findings to the class.

RESPONSIBILITY
edited by Nancy DeRoin
Pages 64–65

Use with Unit 3, Lesson 4

Objectives

☐ *Recognize the story as an example of a folk tale.*

☐ *Identify the characteristics of folk tales.*

☐ *Write a paragraph about responsibility.*

Writing a Paragraph

After you read the folk tale to students, ask them what the lesson of the story is. (If you are responsible and ask others to do your work, you must accept responsibility for their work, too.) Encourage students to discuss whether they think this is fair.

Then point out to students that this story is a **folk tale** that comes from India. Tell students that folk tales are stories that sometimes use animals as characters and that take place long ago. Even though a folk tale may take place in another time, it usually teaches a lesson that is still important today. The lesson in this folk tale has to do with responsibility.

Ask students to name some of the things that they have accepted responsibility for. (for example, walking the dog, cleaning their room, putting away library books, taking care of the class pet) Encourage students to discuss why it is important to accept and follow through on responsibility.

Then tell students that they will have a chance to write a short paragraph about some of the responsibilities that they have. Allow partners to brainstorm ideas before they write their paragraphs independently.

ASSEMBLY LINE LUNCH
by Rachel Sheinkin
Page 66

Use with Unit 3, Lesson 3

Objectives

☐ *Identify how the poet uses language to describe the ways in which work gets done.*

☐ *Write a set of instructions.*

Writing Instructions

After you have read aloud the poem to students, read it a second time and encourage students to chime in if they can. Then point out that an assembly line is very common in some factories, where every person has a special job to do. For example, automobile factories often have assembly lines. Ask students if they can think of other kinds of factories that might have assembly lines. (Responses will vary but should get at the idea that factories that manufacture large items— televisions, radios, stereos, appliances, for example—might have assembly lines.) Then ask students why the poem is called "Assembly Line Lunch." (because everyone has a job to do in making lunch for the whole group) Ask students to discuss the job that each child does, including what they think Lucy's job is. (Responses will vary but might include that Lucy adds dessert to the lunches.)

Invite students to write a set of instructions that tell how to make something. Encourage students to think of each step as something someone on an assembly line could do.

A PLACE TO SKATE
by Wendy Vierow
Pages 68–71

Use with Unit 4, Lesson 1

Objectives

- ❑ *Recognize the role of citizens in shaping laws and policy.*
- ❑ *Write a petition.*

Writing a Petition

Since this play may be too long to read in one sitting, you may want to divide it up into three scenes. If at all possible, enlist the assistance of students in an older grade who can come to read the play in parts to your class. If that is not possible, you may wish to read aloud the play to students yourself. After students have heard the entire play, discuss with them what the children in the play wished to accomplish. (They wanted a safe place to skate.) How did the children go about accomplishing their goal? (They wrote a petition to the city council for a place to skate.) Point out to students that in a democracy, citizens have the right to petition, that is, make their feelings about issues known to government officials so that changes can take place.

You may wish to have students take parts and read aloud the play a second time. Then have students decide on an issue that they feel strongly about and have them write a petition of their own. Students can work in small groups to write their petitions and then share them with the class. Encourage interested students to explore ways to get involved in school or community issues.

THE GIANT JAM SANDWICH
by John Vernon Lord and Janet Burroway
Pages 72–74 🔲

Use with Unit 4, Lesson 1

Objectives

- ❑ *Recognize how the poet uses language to describe how a community solved a problem.*
- ❑ *Identify exaggeration in the poem.*
- ❑ *Write a story about working together to solve a problem.*

Writing a Story

After you have read aloud the poem to students, ask them to think about how the community solved its problem with the wasps. *What did the people do first?* (They called a town meeting to discuss the problem.) *Why was calling a town meeting a good idea?* (Everyone could think about the problem together to come up with a solution.) Who came up with the solution, and what was it? (The baker came up with the solution to attract the wasps to a giant jam sandwich and trap them inside it.) Point out to students that the poet uses exaggeration in the poem, that is, overstates what could actually happen. Writers use exaggeration to add humor to their writing. Ask students what exaggerations they can find in the poem. (The loaf of bread was as big as a mountain; they had to use tractors to get it to the oven; the bread rose until the windows shook, and so on.)

Have students think of another problem the people of this village might have. *How would you solve it?* You may wish to have students brainstorm as a whole class before they write their stories about working together to solve a problem.

ELECTION DAY
by Mary Kay Phelan
Pages 75–77

Use with Unit 4, Lesson 2

Objectives

- ☐ *Recognize the role elections play in a democratic society.*
- ☐ *Create a poster encouraging people to vote.*

Building Citizenship

After you have read aloud the selection to students, discuss with them the significance of Election Day. Ask students how old people have to be to vote. (18) Then ask students why they think it is important to have a secret vote. (so that people can vote for whomever they wish in privacy) Discuss with students the ways in which people voted in the early days of our country. (by a show of hands, with kernels of corn or Indian beans, by announcing in a loud voice) *What changed the ways of voting in this country?* (the Declaration of Independence, which broke ties with English ways of voting and doing things) Finally, ask students why they think the author calls Election Day "a holiday when we plan for the future." (Responses will vary but should get at the idea that the candidates we vote for have told us what they will do in the future if they are elected; by voting for them, we are voting for a future plan.)

Have students create posters encouraging people to vote. Remind students to include some reasons that voting is important on the poster.

THERE ARE MANY FLAGS IN MANY LANDS
Words by Mary H. Howliston
Page 78

Use with Unit 4, Lesson 4

Objectives

- ☐ *Recognize that songs can describe symbols of our country.*
- ☐ *Understand that the flag is a symbol of our country.*
- ☐ *Create a poster using the United States flag.*

Creating a Poster

After you have read aloud the words to the song to students, play the song on the cassette or on the piano if you have access to one. Then play the song a second time and invite students to sing along.

Ask students what the song tells about our flag. (It is red, white, and blue; it has stripes and white stars.) Remind students that the flag is one of our country's symbols and that a symbol is something that stands for or represents something else. Ask students how many stripes our flag has and why. (13, for the original colonies) Then ask how may stars our flag has and why. (50, one for each of the 50 states)

Tell students that they are going to have a chance to make a poster about our country's symbols. The poster will include a drawing of the United States flag and tell why the flag has the number of stars and stripes that it has.

MONUMENTS
by Aileen Fisher and Langston Hughes
Page 79 📼

Use with Unit 4, Lesson 3

Objectives

- ☐ *Recognize how the poets use language to describe two national heroes.*
- ☐ *Recognize that monuments are symbols of a nation's history.*
- ☐ *Write a poem about a national figure.*

Writing a Poem

After you have read aloud the poems to students, pause for a moment to let students think about the messages in the poems. Then ask them to describe the images of the Washington Monument and the Lincoln Monument that they see. *How are they the same?* (They are both made of marble.) *How are they different?* (The Washington Monument is very tall; the Lincoln Memorial includes a statue of Lincoln seated) Then ask students to speculate on why the monuments are different. (Responses will vary but should consider the idea that the very tall monument honors the person for whom our nation's capital is named and who is considered the "father of our country." Lincoln, another of our great Presidents, had many difficult decisions that he alone could make, and he was President during a war in which people of our country fought against each other—perhaps that is why he sits alone and lonely.)

Invite students to write a poem about a national figure that they choose. They may wish to write another poem about Washington or Lincoln, or they may choose another person. Encourage students to share their poems with the class.

I HAVE A DREAM
by Teresa Jennings
Pages 80–81 📼

Use with Unit 4, Lesson 2

Objectives

- ☐ *Identify the ways in which the song tells a story about Martin Luther King, Jr.*
- ☐ *Recognize that songs can commemorate the accomplishments of great Americans.*
- ☐ *Write another verse to the song.*

Writing a Song Verse

After you have read aloud the lyrics to the song to students, play the song for them on the cassette or on the piano if you have access to one. Students might enjoy singing along with the cassette or the piano. Discuss with students what they learned about Martin Luther King, Jr., from the song. (He wished for peace among all people; he was a gracious and gentle man; he made many speeches; he was honest and noble; he had a dream; he lived during troubled times.) Then point out to students that songs are a way of celebrating people and their accomplishments.

Invite students to create another verse for the song. You may wish to have students do some further research on Martin Luther King, Jr., to come up with ideas for their new verse. Encourage students to share their verse with the class.

A FLAG FOR OUR COUNTRY

by Eve Spencer
Pages 82–84

Use with Unit 4, Lesson 4

Objectives

- ☐ *Recognize that the flag is a symbol of our country.*
- ☐ *Identify the way in which legends become part of a nation's heritage.*
- ☐ *Design a flag for your school.*

Designing a Flag

After you have read aloud the selection to students, discuss why they think General Washington wanted Betsy Ross to make a flag. (Responses will vary but should consider the idea that the country was new and needed a symbol.) *What was the significance of the 13 stars and the 13 stripes?* (They stood for the original 13 colonies that became the first 13 states of the United States.) *What suggestion did Betsy offer to General Washington about his flag design?* (She suggested that stars with five points would look better than stars with six points and that the stars should be arranged in a circle.) Then ask students to discuss what kind of woman they think Betsy Ross was. (She was a good seamstress with ideas of her own, who did not seem intimidated by the great George Washington.)

Point out to students that the story of Betsy Ross and our country's first flag was passed down from family member to family member in the Ross family. Because the story was never written down, it became part of the Ross family's oral tradition. Today it is considered a legend, that is, a story that explains how something came to be but cannot necessarily be proved to be true.

Invite students to create a flag for their school or classroom. Students should think about the characteristics of their class or school and design a flag that illustrates those characteristics.

HOW HAWK STOPPED THE FLOOD WITH HIS TAIL FEATHER

retold by Gerald Hausman
Pages 86–88

Use with Unit 5, Lesson 1

Objectives

- ☐ *Recognize the story as a folk tale.*
- ☐ *Identify the place folk tales have in the tradition of a culture.*
- ☐ *Write a folk tale.*

Writing a Folk Tale

After you have read aloud the selection to students, discuss what event first concerned the animal people in the story. (The Water Monster was taking all the water.) Then point out to students that this story is a folk tale. Ask students to discuss what they know about folk tales. (Folk tales often have animals as characters, involve some magical occurrences and powerful characters, and explain how things came to be.) *In this folk tale who appeared to the animals and told them who would solve their problem?* (Mother Earth) Then encourage students to discuss what happens next in the story. (Little Hawk kills Water Monster and causes a flood; Little Hawk then pledges his feather that the flood waters will not rise, and the water begins to recede.)

Point out to students that folk tales such as this one are important to the cultures from which they come. Many such tales are passed on from generation to generation. Then tell students that they will have a chance to write their own folk tale. In their tales encourage students to offer an explanation for why something came to be; for example, students might write about how something in nature came to be.

IT IS I, THE LITTLE OWL

Chippewa Song
Page 89 📼

Use with Unit 5, Lesson 1

Objectives

☐ *Recognize that the song entertains as well as describes an aspect of Chippewa culture.*

☐ *Write a response to the song.*

Writing a Response

After you have read aloud the lyrics to the song to students, play the song on the cassette or on a piano if you have access to one. Invite students to sing along. Ask students to discuss the image that the song lyrics describe. Ask: *Why do you think the owl's eyes are shining? How do you imagine the Chippewa might feel about the owl?*

Then ask students to write a response to the song. Ask students to write about the mood of the song and what images the song brought to mind. Invite students to illustrate their descriptions.

COLUMBUS DAY

by Paul Showers
Pages 90–92

Use with Unit 5, Lesson 2

Objectives

☐ *Recognize the selection as a biography.*

☐ *Identify some of the hardships faced by early explorers.*

☐ *Write a diary entry.*

Writing a Diary Entry

After you have read aloud the selection to students, point out to them that this is an excerpt from a biography. Tell students that a **biography** is the story of a person's life, told from beginning to end. Ask students if they have read any other biographies and what they remember and liked about them.

Then ask students to discuss some aspects of Columbus's early life. (He lived in Genoa, Italy, and worked with his father, who was a weaver. As soon as he could, he became a sailor and moved to Lisbon, Portugal.) Ask students why Columbus thought there was an easier way to get to the Indies. (He knew the world was round and believed that you could reach the East by sailing west.) *Who did Columbus get to support his idea?* (the king and queen of Spain) Ask students to discuss some of the hardships that the sailors on the three ships that sailed for the Indies faced. (weeks and weeks on the water, fear of the unknown, dwindling supplies) *What kind of people did the early explorers have to be?* (courageous and willing to take risks)

Have students write a diary entry dated October 7, when the sailors first saw the birds. *Explain how they must have felt after their long journey.*

YANKEE DOODLE

Traditional Song
Page 93 🔲

Use with Unit 5, Lesson 3

Objectives

☐ *Identify how the song serves as a symbol of our country.*

☐ *Build knowledge about the American Revolution by doing small-group research.*

Building Knowledge

After you have read aloud the lyrics to the song, play the song on the cassette or on the piano if you have access to one. Then remind students that a symbol is something that stands for something else. This song is a symbol of our country that traces its history back to the days of the Revolutionary War when it was sung frequently.

Divide the class into small groups. Provide them with reference books and perhaps a junior encyclopedia to research some facts about the American Revolution. Have members of each group write on the chalkboard one or two facts they discovered from their research.

IF YOU GREW UP WITH GEORGE WASHINGTON

by Ruth Belov Gross
Pages 94–97

Use with Unit 5, Lesson 3

Objectives

☐ *Identify characteristics of the colonial period in our nation's history.*

☐ *Recognize some of the influences that shaped the character of George Washington.*

☐ *Write questions about the colonial period.*

Writing Questions

Since this selection is long, you may wish to divide it into two or three sections. Students can review each section before you read aloud the next one. When you have read aloud the entire selection, remind students that the period of history when George Washington was a boy is called the Colonial Period. This was a time before the American Revolution when the colonies were ruled by England. Encourage students to discuss what they found out about this period through the questions that were asked and what they found most interesting about the period.

Then ask students to discuss what it must have been like for George to grow up during this time. *What did he learn about in school? Did he read the newspaper? What did he think of the laws?*

Have students write some other questions they would like to ask about this period in history. *What else would you like to know about?* After students have written two or three questions, have them share them with the class and develop a plan for finding the answers.

HARRIET TUBMAN
by Polly Carter
Pages 98–100

Use with Unit 5, Lesson 4

Objectives

☐ *Identify the story as a biography.*

☐ *Recognize the qualities that made Harriet Tubman a symbol of freedom.*

☐ *Write an interview of Harriet Tubman.*

Writing an Interview

After you have read aloud the selection to students, tell them that this selection is a biography. Remind students that a biography is the story of a person's life, told in order from beginning to end. Ask students when this selection from Tubman's biography begins. (when Harriet is an adult) Then discuss with students the experiences that Harriet had when she escaped. (She had to go alone, travel by night with the North Star as a guide, and depend on the people who supported the Underground Railroad to help her.) Then ask students to describe the Underground Railroad and discuss what Harriet decided to do once she had escaped to freedom. (The Underground Railroad was a name given to secret paths to the North that escaping slaves followed. They were able to stop at houses or "stations" along the way where people helped them on their journey to freedom. Harriet decided that she wanted to work on the Underground Railroad and help others escape.) Encourage students to discuss some of the qualities that made Harriet a symbol of freedom. (She was fearless and fought for what she believed was right, even putting her life in danger to do so.)

Have students think of some questions they would like to ask Harriet. Students should try to come up with two or three questions, share them with the class, and make plans to get their questions answered through further research.

AURORA MEANS DAWN
by Scott Russell Sanders
Pages 101–102

Use with Unit 5, Lesson 5

Objectives

☐ *Recognize the dangers and perils that faced early pioneers.*

☐ *Have students create an adventure board game that reflects some of the challenges of early American pioneering.*

Create an Adventure Game

After reading the story, discuss with the students the hardships that faced these early settlers of Aurora in 1800. (They had to seek shelter from the rain under their wagon; they almost lost the trail the next morning; fallen trees blocked their way; the wagon was stuck in the mud.) What other obstacles might one face traveling west in a wagon during this time period?

Have students work in pairs or in a group to make a simple game board with large squares connecting a path from start to finish. Students can take turns drawing or writing in each square a different challenge that might have faced pioneers. (Possible examples are: a broken bridge, losing sight of the trail in a mountain valley, a flood.) Have students take turns rolling a number cube or flipping a coin. (Heads could mean 1 square forward, tails could mean 2.) They should explain to the others how they and their party would overcome the challenges on which they land. Do the plans to overcome these challenges seem like they would work?

HOW MY FAMILY LIVES IN AMERICA
by Susan Kuklin
Pages 103–104

Use with Unit 5, Lesson 5

Objectives

- [] *Recognize that immigrants retain parts of their native heritage and adopt new customs as well.*
- [] *Identify some Hispanic American customs.*
- [] *Write a description of a family custom.*

Writing a Description

After you have read aloud the selection to students, discuss with them where some members of this recent immigrant family comes from. (Puerto Rico) Then encourage students to talk about what life is like in this family that lives in New York City. *What language does the family speak?* (both English and Spanish) *What kinds of things does the family do together?* (play baseball, listen to Spanish music, go to the market) *What parts of their Puerto Rican heritage has this family kept?* (their language, their music, some of their foods, their dances) Point out that all groups that come to a new country retain some of their customs so that they do not forget their heritage.

Have students describe a custom they know of that originated in another country. It could be a particular food people eat, a holiday that they celebrate, music that they like. Encourage students to share their descriptions with the class.

MARY McLEOD BETHUNE
by Eloise Greenfield
Pages 106–110

Use with Unit 6, Lesson 1

Objectives

- [] *Recognize the contribution Mary McLeod Bethune made to education in the United States.*
- [] *Identify the selection as a biography.*
- [] *Write a biography.*

Writing a Biography

Since this selection is rather long, you may wish to divide the reading into two parts. Students can retell what happened in the first part before you read aloud the second part. After you have read aloud the entire selection, ask students what they know about biographies. (They are the story of a person's life, often told in order from beginning to end.) Then ask students why they think Eloise Greenfield wrote a biography of Mary McLeod Bethune. (because she was very important to education in the United States and to the education of African Americans in particular) Encourage students to discuss the most memorable parts of the biography. (Responses will vary but may likely include descriptions of Bethune's commitment and hard work to get an education for herself and then for others.)

Have students research some other famous Americans who struggled to get an education for themselves and others. (for example, Abraham Lincoln, George Washington Carver, Horace Mann) Have them write a few facts about their lives. Some students may wish to find out more information about Mary McLeod Bethune. Encourage students to share their findings with the class.

GRANDMA MOSES
by Zibby Oneal
Pages 111–113

Use with Unit 6, Lesson 1

Objectives

❏ *Identify the contributions of Grandma Moses to the fabric of American rural life.*

❏ *Recognize how one artist worked.*

❏ *Write a review of a Grandma Moses painting.*

Writing a Review

After you have read aloud the selection to students, discuss with them why Grandma Moses was such a special artist. (She did not begin painting until she was 76 years old, and she was completely self-taught.) Then discuss with students what subjects Grandma Moses chose to paint. (She painted landscapes that depicted life in the rural areas where she lived.) Point out that her art serves as a visual record of a time and a place in our country that is like no other.

Then tell students that they will have an opportunity to look at some of Grandma Moses's paintings and to write a review of one of them. (The encyclopedia usually includes samples of her work, or perhaps you can get art books from the library.) Have students describe the painting and tell what they like about it.

ROBERTO CLEMENTE
by Kenneth Rudeen
Pages 114–118

Use with Unit 6, Lesson 1

Objectives

❏ *Identify the contribution Roberto Clemente made to the game of baseball in America.*

❏ *Recognize Clemente's concern for others.*

❏ *Create an award for Roberto Clemente.*

Creating an Award

Since the story is a long one, you may wish to divide it into thirds. Students can retell what went on in each section before you read aloud the next one. After you have read aloud the entire selection, discuss with students the kind of man they think Roberto Clemente was. Then ask students to tell about the various hardships he faced as he tried to break into professional baseball and what he ultimately accomplished as a player. Point out that in addition to being an exceptional baseball player, Clemente also had great concern for others. *How did he express this concern?* (He tried to help other ballplayers, he wanted to help the boys and girls of Puerto Rico who wanted to play sports, and he wanted to help the victims of the earthquake in Nicaragua.)

Have students create an award for Roberto Clemente. They can mention his accomplishments as a baseball player and his accomplishments as a citizen on the award. Students can work together in small groups to design the award.

WISE BEN FRANKLIN
by Lloyd Norliln
Page 119 🔲

Use with Unit 6, Lesson 1

Objectives

❑ *Recognize that the song entertains as well as tells of the accomplishments of a famous American—Benjamin Franklin.*

❑ *Write another verse about Ben Franklin.*

Writing a Song Verse

After you have read aloud the lyrics to students, play the song for them on the cassette or on the piano if you have access to one. Invite students to sing along if they would like. Ask students to tell which of Ben's accomplishments are mentioned in the song. (using lightning to make electricity, inventing the Franklin stove, and serving as ambassador to France) Ask students if they know of any other things that Ben Franklin did or invented. Help students to brainstorm some of these things. (invented bifocals, was signer of the Constitution, started first public library, organized first fire department, published almanac)

Then have students write another verse to the song. The new verse should mention another of Franklin's accomplishments.

A TRIP THROUGH TIME
by Wendy Vierow
Pages 120–125

Use with Unit 6, Lessons 1 and 2

Objectives

❑ *Recognize that the play entertains as well as provides information about important people in United States history.*

❑ *Identify achievements of some famous American citizens.*

❑ *Perform a play.*

Performing a Play

After you have read through the play, ask students to discuss the people from history who appeared on the trip through time and talk about some of their contributions to the history of our country. *What did Washington and Franklin do?* (worked on the Constitution of the United States) *What did Sam Houston do?* (led the battle for Texas independence from Mexico) Continue discussing the other characters in the play.

Then tell students that they will have an opportunity to perform this play. You may wish to have students approach the play as a Readers Theatre presentation, or you may wish them to read the play at their seats. You also may want to have several casts so that all students can participate.

CELEBRATION
by Alonzo Lopez
Page 126

Use with Unit 6, Lesson 3

Objectives

- ☐ *Recognize how the poet uses language to describe a special celebration.*
- ☐ *Write a poem about a celebration.*

Writing a Poem

After you read aloud the poem to students, pause for a moment to let students think about the images that the poet has conveyed. Then ask students what the poem describes. (a celebration where there will be dancing and feasting) *What else will happen at the celebration?* (There will be fires and laughter and talk and games.) Then read the poem again to students. Ask students if the poem rhymes. Point out that some poems rhyme and some do not.

Have students write poems about a celebration that they have had or that they have looked forward to. You may wish to brainstorm ideas with the whole class before students go off to write their poems. Encourage students to share their poems with the class.

MAY YOUR KWANZAA BE HAPPY!
by Catherine Tamblyn
Page 127

Use with Unit 6, Lesson 3

Objectives

- ☐ *Identify how the selection entertains as well as teaches about an important holiday.*
- ☐ *Identify the important aspects of the holiday.*
- ☐ *Write a report about Kwanzaa.*

Background Information

Kwanzaa is an African American holiday that honors black people and their history. An African American teacher named Maulana Karenga created Kwanzaa in 1966. Dr. Karenga wanted to teach his people about African ways and holidays. Many of the words used at Kwanzaa time come from Swahili, an African language. Swahili, also called Kishwahili, sounds a lot like English. At Kwanzaa time African Americans think about their people, their struggles, and their future. Kwanzaa lasts for seven days. During this time African Americans gather together symbols of Kwanzaa to use in their celebrations.

Writing a Report

After you have read aloud the selection to students, have them discuss some of the African words they learned. Ask students what they think is the most important thing about Kwanzaa. (Responses will vary but should include that Kwanzaa is a holiday that celebrates the history of African American people.) Ask students: *Why is it important for people to know about their history?* (Responses will vary but might include that people take pride in what they have achieved and like to know about their ancestors' struggles and accomplishments.)

Have students form small groups. Have each group write a report about Kwanzaa. Either have them use the background information presented here or direct them to do more research. Encourage the groups to illustrate their reports, and display them on the bulletin board.

NEW YEAR'S HATS FOR THE STATUES

by Yoshiko Uchida
Pages 128–131

Use with Unit 6, Around the World

Objectives

☐ *Identify how the author reveals features of Japanese culture in the story.*

☐ *Dramatize the story.*

Dramatizing the Story

After you have read aloud the story to students, discuss what the couple decides to do to get food for New Year's Day. (They decide to try to sell some reed hats to get fish and rice for the feast.) Ask students to discuss what happens in the story. (The old man is not able to sell his hats and instead puts them on the heads of six statues who are getting covered with snow.) *How do the statues repay the old man?* (They bring him and his wife enough food for a year.)

Then have the class prepare a dramatization of the story. The only props you will need are the hats, which you can make out of construction paper. Assign parts or ask for volunteers. You might wish to begin with one scene, perhaps the scene where the old man approaches various people in the village to sell his hats. When students are satisfied with that scene, you can move on to another (where the old man places the hats on the statues, for example). When everyone is ready, have them act out the story.

THE FOURTH

by Shel Silverstein
Page 132

Use with Unit 6, Lesson 2

Objectives

☐ *Recognize how the poet uses words to convey the sound and excitement of the holiday.*

☐ *Understand the meaning of the Fourth of July to our country's history.*

☐ *Plan a celebration.*

Planning a Celebration

After you have read aloud the poem to students, pause for a moment to allow students to think about the sounds the poet has made with his words. Ask students why such sounds are appropriate. (We celebrate the Fourth of July with fireworks that make such sounds.) Then ask students why we celebrate this holiday. (We celebrate it to remember our nation's birthday, the day we declared our independence from England.) Ask students what other things we do on this holiday. (have parades, picnics, vacation from work and school, barbecues, and so on) Have students plan a celebration for the Fourth of July. They might want to plan a parade or a picnic. Encourage students to list who will be in the parade, what foods will be served at the picnic, and so on. When students have finished their plans, encourage them to share their ideas with the class.

AMERICA, THE BEAUTIFUL
by Katharine Lee Bates and Samuel Ward
Page 133 🔲

Use with Unit 6, Lesson 4

Objectives

- ❏ *Recognize that the song celebrates our country and its history.*
- ❏ *Identify the song as a symbol of our country.*
- ❏ *Write a paragraph about our beautiful country.*

Creating a Collage

After you have read aloud the lyrics of the song to students, play the song for them on the cassette or on a piano if you have access to one. Invite students to sing along. Then ask students what features of our country are mentioned in the song. (the mountains, the plains, fields of grain) *What people are mentioned?* (the Pilgrims, the people who explored the country, the heroes who fought in our wars) Point out that this song is a symbol of our country, just like our flag.

Have students create a collage about some of the other features of our country that make it beautiful. Invite students to cut out pictures from old magazines or to draw their own pictures that show different aspects of our country's beauty. Students can work together in groups or as a whole class to paste their pictures onto one large collage.